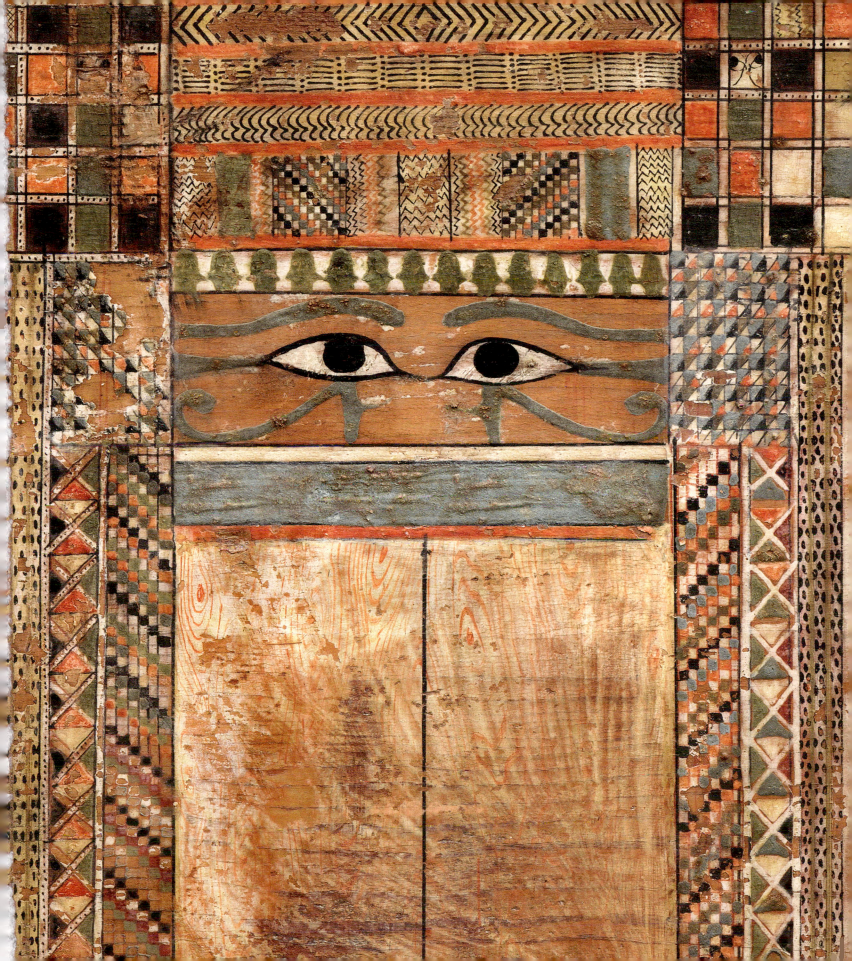

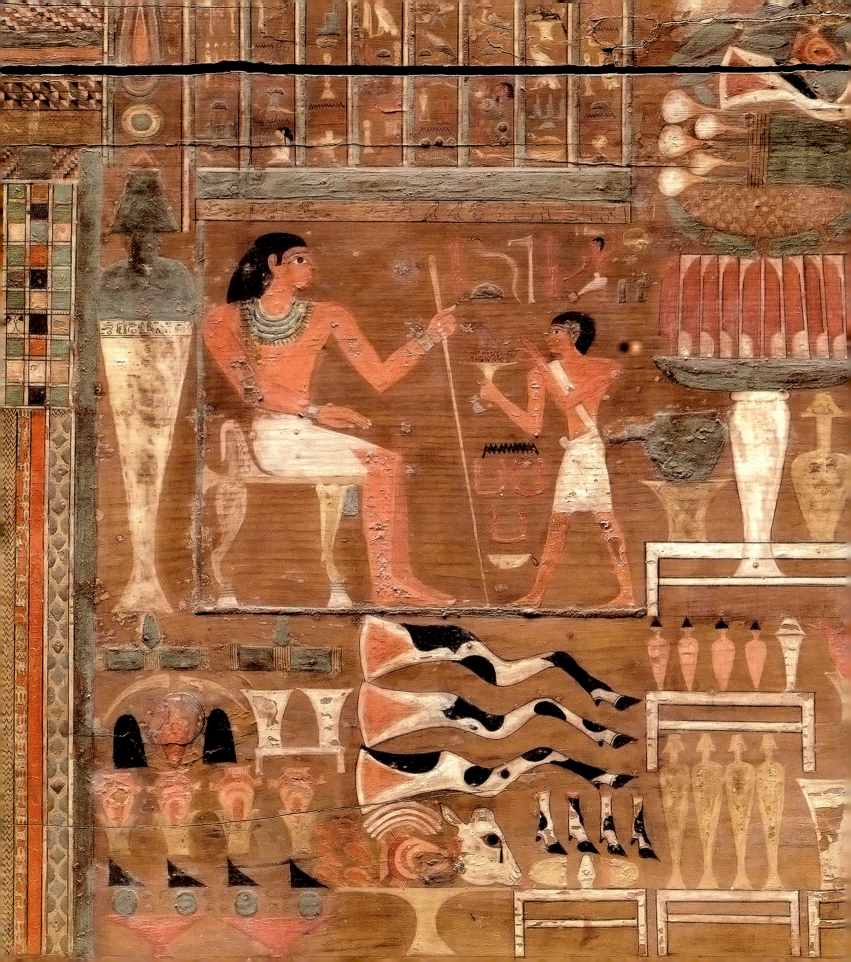

THE SECRETS OF TOMB 10A

EGYPT 2000 BC

RITA E. FREED

LAWRENCE M. BERMAN

DENISE M. DOXEY

NICHOLAS S. PICARDO

MFA PUBLICATIONS

Museum of Fine Arts, Boston

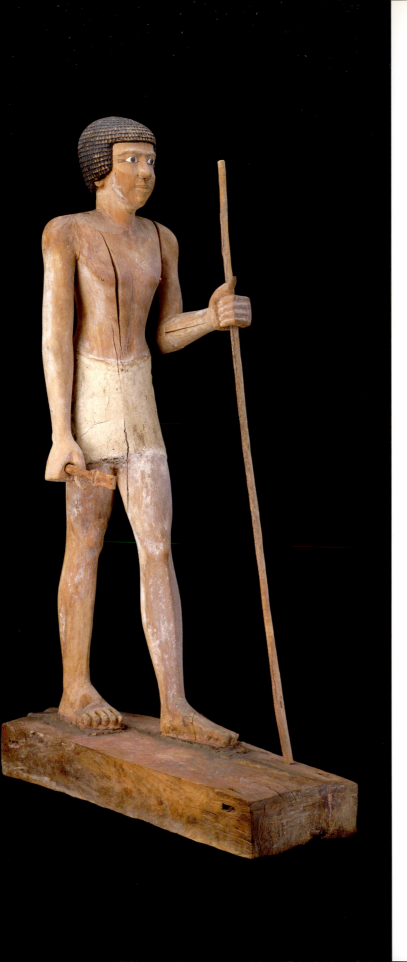

MFA Publications
Museum of Fine Arts, Boston
465 Huntington Avenue
Boston, Massachusetts 02115
www.mfa.org/publications

This book was published in conjunction with the exhibition "The Secrets of Tomb 10A: Egypt 2000 B.C.," organized by the Museum of Fine Arts, Boston, from October 18, 2009 to May 16, 2010.

The exhibition is supported by Bank of America.

Major funding is provided by The Calderwood Charitable Foundation.

Additional support for the exhibition is provided by the Institute of Museum and Library Services.

Support for this publication was provided by the Andrew W. Mellon Publications Fund.

© 2009 by Museum of Fine Arts, Boston

ISBN 978-0-87846-747-1 (hardcover)
ISBN 978-0-87846-748-8 (softcover)
Library of Congress Control Number: 2009928560

While the objects in this publication necessarily represent only a small portion of the MFA's holdings, the Museum is proud to be a leader within the American museum community in sharing the objects in its collection via its Web site. Currently, information about more than 330,000 objects is available to the public worldwide. To learn more about the MFA's collections, including provenance, publication, and exhibition history, kindly visit www.mfa.org/collections.

For a complete listing of MFA publications, please contact the publisher at the above address, or call 617 369 3438.

Hardcover: Retouched detail of the false door (front) and detail of Governor Djehutynakht with offerings (back) on the front panel of the governor's outer coffin, Museum of Fine Arts, Boston, 20.1822

Softcover back: Detail, model of a procession of offering bearers (The Bersha Procession), Museum of Fine Arts, Boston, 21.326

Page 1: Retouched detail of the false door on the front panel of Governor Djehutynakht's outer coffin, Museum of Fine Arts, Boston, 20.1822

All illustrations in this book were photographed by the Imaging Studios, Museum of Fine Arts, Boston, except where otherwise noted.

Edited by Emiko K. Usui
Copyedited by Dalia Geffen
Designed by Cynthia Rockwell Randall
Produced by Terry McAweeney and Jodi Simpson
Printed and bound at Graphicom, Verona, Italy

Available through
D.A.P. / Distributed Art Publishers
155 Sixth Avenue, 2nd floor
New York, New York 10013
Tel.: 212 627 1999 · Fax: 212 627 9484

FIRST EDITION
Printed and bound in Verona, Italy
This book was printed on acid-free paper.

CONTENTS

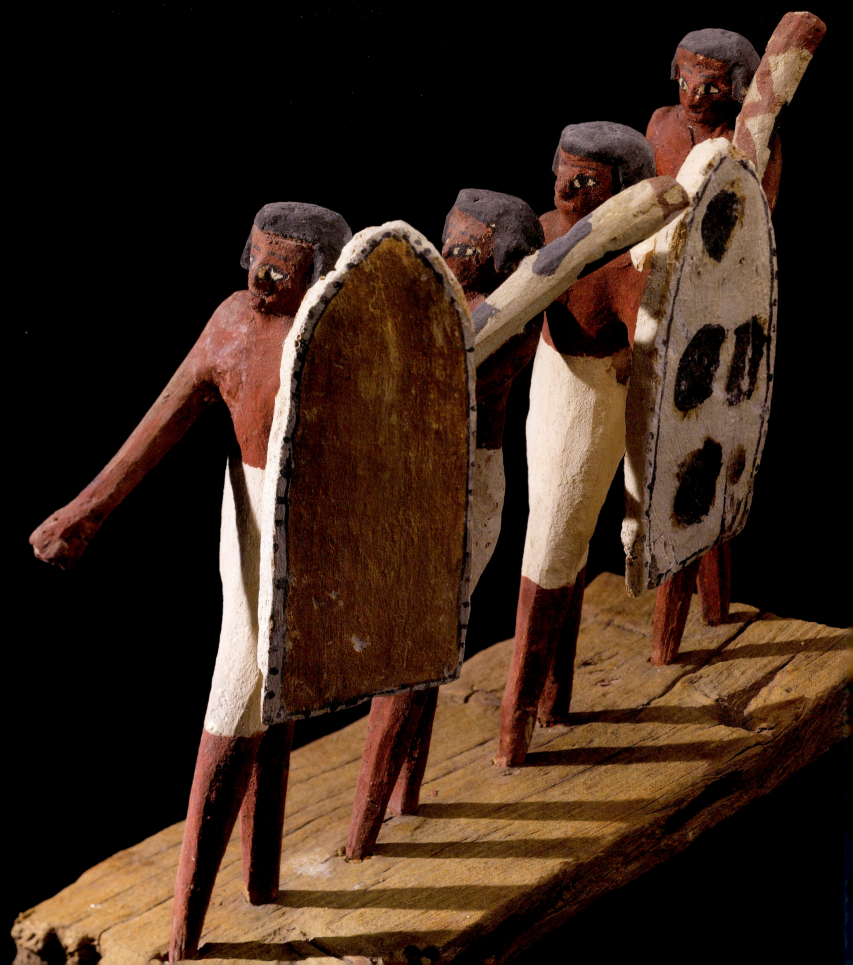

DIRECTOR'S FOREWORD

SINCE ITS DISCOVERY IN 1915 by members of the Harvard University–Boston Museum of Fine Arts Expedition, tomb 10A of Deir el-Bersha has been heralded worldwide for yielding the largest assemblage of material ever found in a single Middle Kingdom burial. Although certain spectacular objects from the tomb, such as a painted coffin and a delicately carved procession of offering figures, could be introduced to the public immediately, the majority of its contents had suffered badly from the ravages of ancient grave robbers and could not be shown. Only now, nearly one hundred years later and thanks to curators and conservators working together, has it been possible to bring the material back to life. We are pleased to present the treasures of tomb 10A in their entirety and reveal their many mysteries for the very first time.

Special thanks are due to exhibition curator and John F. Cogan Jr. and Mary L. Cornille Chair of the Art of the Ancient World Department Rita Freed; Norma Jean Calderwood Senior Curator of Ancient Egyptian, Nubian, and Near Eastern Art Lawrence Berman; Curator of Ancient Egyptian, Nubian, and Near Eastern Art Denise Doxey; and Research Associate Nicholas Picardo for their hard work and flexibility in adapting to changing schedules and formats. The objects are restored and protected for future generations thanks to the skills of Assistant Conservator Gwynne Ryan; Robert P. and Carol T. Henderson Head of Objects Conservation Pamela Hatchfield; and Conservator Suzanne Gänsicke, as well as Nadia Lokma from the Supreme Council of Antiquities of Egypt.

No exhibition is possible without the help of funders. We are most grateful to Bank of America for its commitment to the arts and The Calderwood Charitable Foundation for its extraordinary support. We also wish to recognize the Institute of Museum and Library Services for a grant that made the conservation of many objects possible, and the Andrew W. Mellon Publications Fund for funding the exhibition catalogue.

MALCOLM ROGERS
Ann and Graham Gund Director
Museum of Fine Arts, Boston

ACKNOWLEDGMENTS

"THE SECRETS OF TOMB 10A: EGYPT 2000 B.C." attempts to explore new ground in the presentation of archaeological material in an art museum, and in this it has benefited from the wisdom and knowledge of a broad and multifaceted group of people. First, for recognizing the exciting potential of the material, the curators are grateful to Ann and Graham Gund Director Malcolm Rogers and members of the exhibition committee. A small portion of the Djehutynakhts' tomb was first featured in "Mummies and Magic," a special exhibition curated by Sue D'Auria, Peter Lacovara, and Catherine Roehrig in 1988. Recognizing the need for further work, Peter Lacovara was instrumental in procuring an American Research Center in Egypt grant to support the work of then-Chief Wood Conservator Nadia Lokma of the Supreme Council of Antiquities of Egypt. She worked patiently for three summers beginning in 1992 to reassemble a small army of model figures by matching hundreds of torsos to twice as many arms.

Once the exhibition was approved, then-Research Fellow Yvonne Markowitz meticulously assembled a bibliography, compiled object lists, and organized records. Assistant Conservator Gwynne Ryan worked tirelessly for three years to consolidate, conserve, and restore the entirety of the tomb's extant wooden material, including four wonderful coffins. In this she was aided by Robert P. and Carol T. Henderson Head of Objects Conservation Pamela Hatchfield and Conservator Susanne Gänsicke. Comparing the "before" and "after" images makes clear the enormity of the task they faced and the successes they achieved.

For the excellent photographs in both this volume and the exhibition, thanks are due Senior Photographer Michael Gould, Photographer Jared Medeiros, Manager of Imaging Studios Greg Hines, and Digital Systems Manager John Woolf. Movement and housing of the objects during all stages of preparation were undertaken efficiently and without mishap by Collections Engineer Dante Vallance, Conservation Engineer Jean-Louis Lachevre, Collections Care Specialist James Cain, and Assistant Conservator Craig Uram.

For using the latest of scientific techniques to explore the human remains, we are particularly grateful to Paul Chapman, M.D., Nicholas T. Zervas Professor of Neurosurgery, Harvard Medical School and Visiting Neurosurgeon, Massachusetts General Hospital; and Rajiv Gupta, Ph.D., M.D., Assistant Radiologist and Director, Ultra-High Resolution Volume CT Lab, Massachusetts General Hospital; and their colleague Dr. Fabio P. Nunes, Instructor in Neurology, Massachusetts General Hospital, Harvard Medical School. Thanks to them, we know that those responsible for the mummification of the Djehutynakhts used hitherto unacknowledged, sophisticated surgical techniques to remove bone and muscle.

The MFA's finely honed team helped fashion the exhibition into something that both appeals to the general public and offers substance for the scholar, all in a compressed time frame. The curators are particularly grateful to Manager of Exhibitions and Installations Christopher Newth for keeping us to a tight schedule in his kind but firm manner. Exhibition Designer Virginia Durruty devoted countless hours to creating a design that is dramatic,

lucid, and true to the objects. Her patience and good humor in the changing nature of the exhibition will always be appreciated. Senior Exhibition Graphic Designer Jennifer Liston Munson worked with us from the start to create the exciting graphics. Thanks are also due to Exhibition Preparation Collections Care Manager Brett Angell whose delicate work in creating mounts makes the objects appear to stand—or float—on their own.

From the Education Department, Alfond Curator of Education Barbara Martin and Manager of Adult Learning Resources Benjamin Weiss helped us bring clarity to the material and make complex concepts of the Egyptian afterlife comprehensible to all. Hand in hand with the on-site interpretation of the material is the Web component, ably handled by Manager of New Media Jenna Fleming, whose enthusiasm for the Djehutynakhts comes through in the material she designed with the assistance of New Media Specialist George Scharoun.

Even when the exhibition is over, its memory will live on through this catalogue. For her enthusiasm, gentle pushing, and hard work to meet tight deadlines, the curators are grateful to Senior Editor Emiko Usui. Thanks are due to Designer Cynthia Randall for the book's appealing design and to Production Manager Terry McAweeney and Production Editor Jodi Simpson for their overall management of the project. On the curatorial side, Art of the Ancient World Interns Hayley Lacis and M. Willis Monroe worked tirelessly with the exhibition's curators to check details and compile information.

While the Djehutynakhts' tomb as a whole is unique, it is also a product of its time period. For allowing us to examine material in their collections and engage in fruitful conversations about it, the curators are particularly grateful to Richard Fazzini and Edward Bleiberg of the Brooklyn Museum; Dorothea Arnold and Adela Oppenheim of the Metropolitan Museum of Art; Robert Cohon of the Nelson Atkins Museum; Vivian Davies, Nigel Strudwick, and Richard Parkinson of the British Museum; Guillemette Andreu and Christiane Ziegler of the Musée du Louvre; and Mogens Jørgensen of the Ny Carlsberg Glyptotek.

The Egyptian Antiquities Organization's generous policy of partage made it possible for the MFA to have the wonderful objects from the Djehutynakhts' tomb, and we remain eternally grateful for this. Our understanding of the Djehutynakhts' tomb, the site of Deir el-Bersha, and the relation of the tombs to the city and temple across the river continues to grow, thanks to the excavations of the Katholieke Universiteit in Leuven, Belgium, ably led by Harco Willems and his assistant, Marleen De Meyer. Their current work, featured in the exhibition, has made Governor and Lady Djehutynakht come alive again.

The curators are most grateful to The Calderwood Charitable Foundation for supporting the exhibition, to Bank of America for its partnership, to the Institute of Museum and Library Services for its support of the conservation of wooden objects, and to the Andrew W. Mellon Publications Fund for funding this book.

RITA E. FREED
LAWRENCE M. BERMAN
DENISE M. DOXEY
NICHOLAS S. PICARDO

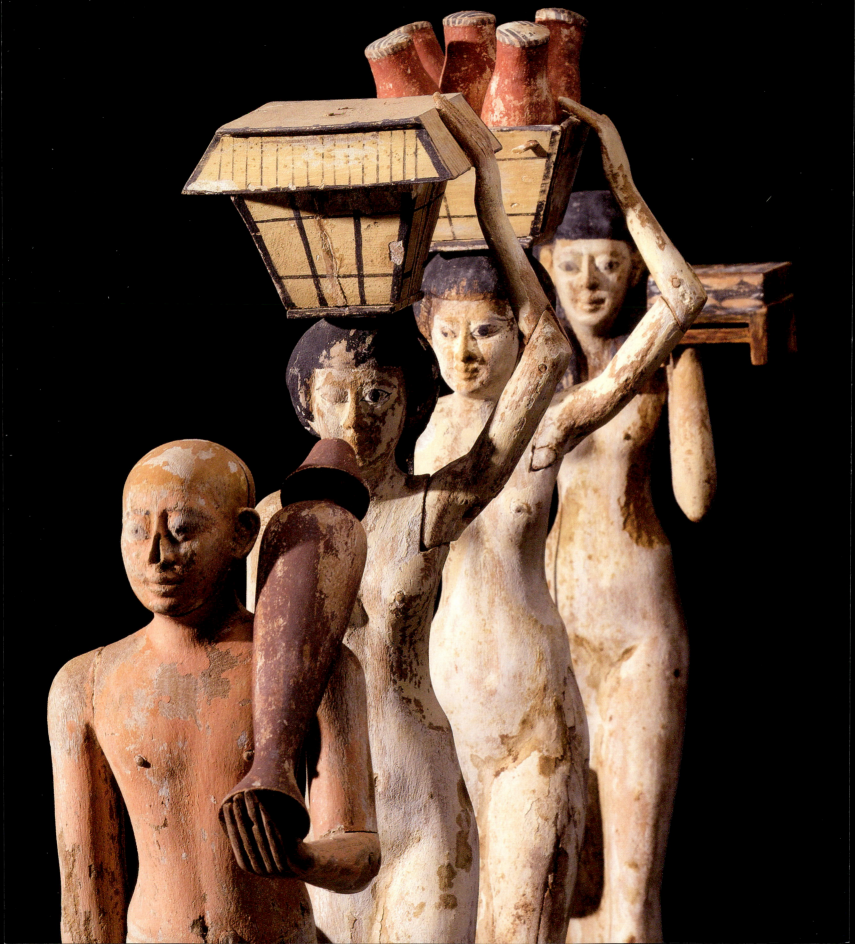

INTRODUCTION

RITA E. FREED

WHEN THE EXPEDITION team jointly sponsored by the Museum of Fine Arts, Boston, and Harvard University first blasted through the massive boulders blocking the entrance to tomb 10A at Deir el-Bersha in 1915, it found the largest burial assemblage of Egypt's Middle Kingdom (2040–about 1640 B.C.) ever recorded. The tomb was filled with the funerary equipment of a local governor by the name of Djehutynakht and his wife, who was also named Djehutynakht. Grave robbers in ancient times had stolen the finest jewels but left almost everything else, including a severed but nicely decorated mummified head, five beautifully painted coffins, the Djehutynakhts' remaining jewelry and other adornments, walking sticks, a canopic jar, and miniature models of what must have been the Djehutynakhts' ideal estate, including nearly sixty model boats and two dozen models of daily life. Because of extensive quarrying in antiquity for the site's fine limestone, the tomb's superstructure as well as the mountain around it had collapsed by the time of the expedition. Despite the discovery of so many splendid objects, without the reliefs and inscriptions that would have been included in an aboveground chapel, we are left with many mysteries about the tomb's occupants and the world in which they lived.

Compounding the problem is the state in which the ancient grave robbers abandoned the burial chamber. Typical of Middle Kingdom tombs, it stood at the bottom of a shaft over 10 meters (about 30 feet) deep that led from the ground-level cliff terrace where the chapel once stood. By the time the expedition team entered the room, Lady Djehutynakht's coffins had been partially disassembled and pushed aside to the right of the entry, and the models and other burial goods were in a jumbled heap, most likely from having been swept aside from atop the coffins.

The Djehutynakhts' room is quite small for two burials with such large coffins and numerous grave goods. This situation raises questions about the sequence of the two deaths and whether one was unexpected, like King Tutankhamen's some five hundred years later, which caused him to be buried hastily in a tomb not originally intended for him. Because of how the thieves scattered the chamber's contents, we cannot even be sure which objects belonged to the governor and which to Lady Djehutynakht. We can only imagine how it looked when the burial priests sealed the room, deposited their offerings in niches outside, and brushed away their footsteps.

Two particularly spectacular objects from among those that survive raise their own questions, although they answer others. The governor's outer coffin is exceptional in terms of the number of intricately carved spells and the fine details of its offering scenes painted on the inside. The coffin is fit for a pharaoh and arguably the finest of its type ever produced. Why and how then did a local governor come to possess such an object? The same question is raised by one of the larger models from the tomb, a processional group of four offering bearers whose quality of carving and painting equals that of the coffin.

The sheer quantity of the other models, which were meant to serve the Djehutynakhts' *kas*, or "life forces," for eternity, is another impressive aspect of the find. Their inclusion in the tomb helps to determine its date, as the

years around 2000 B.C. saw a fashion for such models. While they are believed to represent an ideal or anticipated living standard for the afterlife rather than an inventory of people and possessions on the tomb owner's estate, they still provide us with a sense of how the Djehutynakhts and their contemporaries envisioned such an ideal existence and what they would need for it. No other Middle Kingdom tomb uncovered to date has yielded so many models.

When the robbers committed their nefarious deed, they ripped off one end of the governor's coffin and tossed it into the burial shaft in order to get at the precious jewelry that adorned the body. When they departed, they left a mummified head atop the coffin, and in the far corner of the burial chamber, a torso minus head and limbs. The expedition team left the torso behind for reasons unknown to us today. The head has remained an enigma since it was accessioned by the Museum in 1921. No one has been able to definitively determine whether it is male or female. Recent scientific analysis of it by a medical team at Massachusetts General Hospital, however, provides important and hitherto unrecognized information about Egyptian mummification and surgical techniques.

The Middle Kingdom period in which the Djehutynakhts are believed to have lived followed the collapse of the Old Kingdom (2649–about 2100 B.C.), the "Pyramid Age," during which power centered on the king, who was thought to be divine. The intervening First Intermediate Period (about 2100–2040 B.C.) saw the dissolution of the state and power distributed among regional lords, now known as *nomarchs* (often translated as "governors"), who ruled like kings in their homelands. The first family to reexert control throughout Egypt and establish the Middle Kingdom did so with the cooperation or subjugation of nomarchs such as Governor Djehutynakht. He, like his contemporaries, chose to be buried in his own realm on a cliff terrace from which he could oversee his domains even in the afterlife. Tomb 10A is an important piece of the historic puzzle Egyptologists endeavor to assemble so that they may understand how the relationship between kings and nomarchs influenced or even drove the development of Egyptian politics, society, and art as the Middle Kingdom progressed.

Many of tomb 10A's mysteries and broader questions about the role of Deir el-Bersha on a national scale may find answers. A mission under the directorship of Harco Willems of the Katholieke Universiteit in Leuven, Belgium, reopened excavations at Deir el-Bersha in 2002. In 2009 it retraced the original Harvard–MFA excavators' footsteps and reentered the burial chamber of the Djehutynakhts in search of further clues. Members of the expedition may now be able to trace some of the tomb's superstructure. In the surrounding area, they have already discovered one unplundered Middle Kingdom tomb and are forming a clearer picture of the Deir el-Bersha necropolis as it looked in the Djehutynakhts' day. Layer by layer and excavation square by square, Deir el-Bersha and its Middle Kingdom nomarchs are revealing their secrets.

First Intermediate Period	about 2100–2040 B.C.
Dynasties 9 and 10	about 2100–2040 B.C.
Dynasty 11 (first part)	
Mentuhotep I	2140–2134 B.C.
Intef I	2134–2118 B.C.
Intef II	2118–2069 B.C.
Intef III	2069–2061 B.C.
Mentuhotep II (pre-unification)	2061–2040 B.C.

Middle Kingdom	2040–about 1640 B.C.
Dynasty 11 (second part)	
Mentuhotep II (post-unification)	2040–2010 B.C.
Mentuhotep III	2010–1998 B.C.
Mentuhotep IV	1998–1991 B.C.
Dynasty 12	
Amenemhat I	1991–1961 B.C.
Senwosret I	1971–1926 B.C.
Amenemhat II	1929–1892 B.C.
Senwosret II	1897–1878 B.C.
Senwosret III	1878–1841 B.C.
Amenemhat III	1844–1797 B.C.
Amenemhat IV	1797–1787 B.C.
Nefrusobek	1787–1783 B.C.
Dynasty 13	1783–about 1640 B.C.

This chronology is based on one devised by James P. Allen.

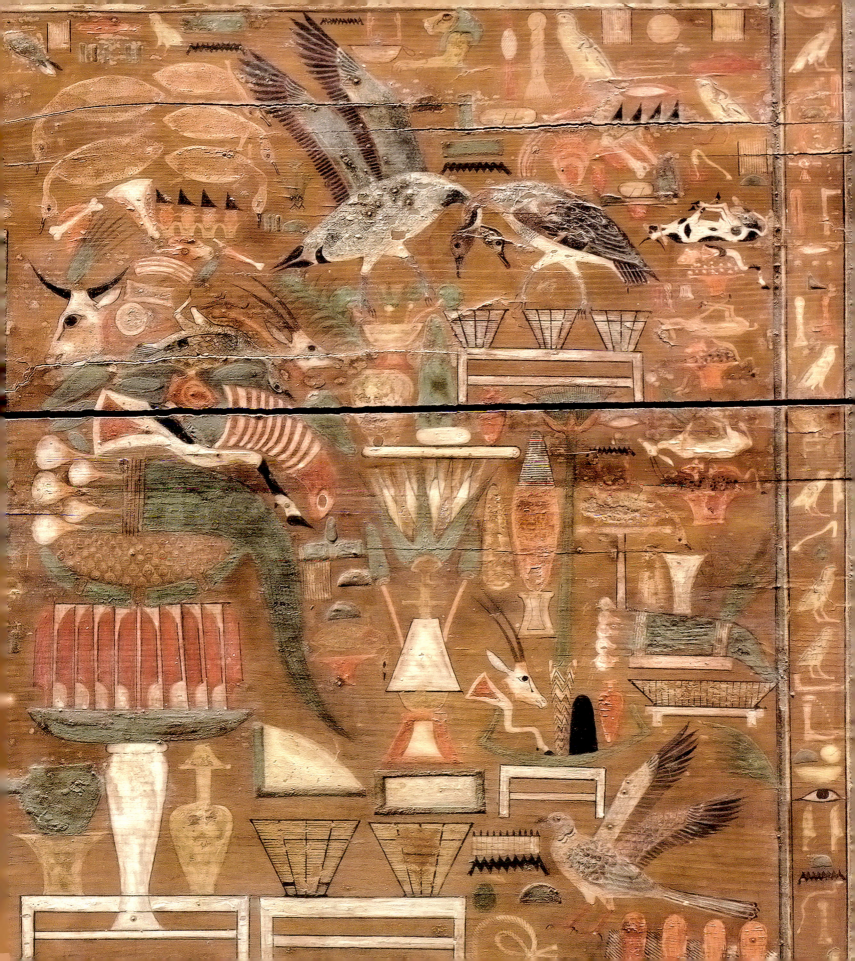

N.º 28 Grottes de Béni-Hassan.
H.te Égypte

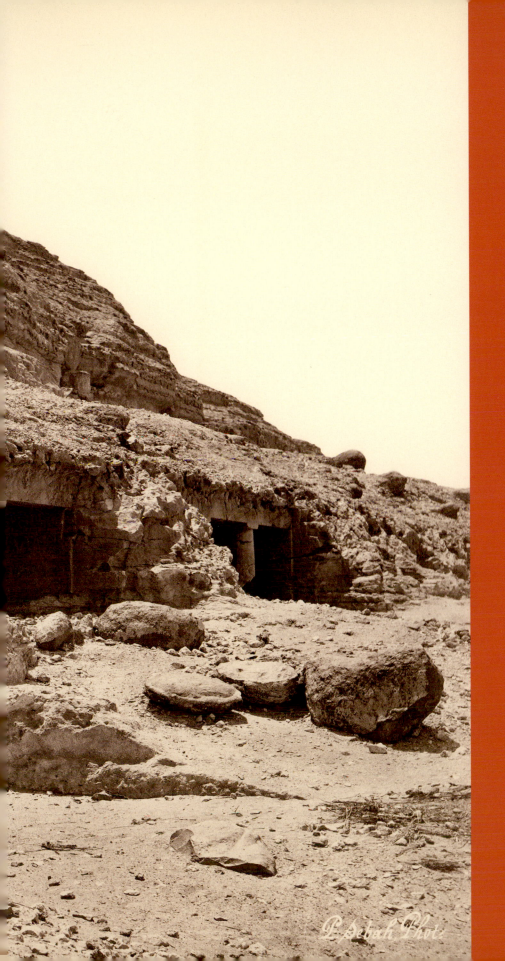

P. Sebah Phot:

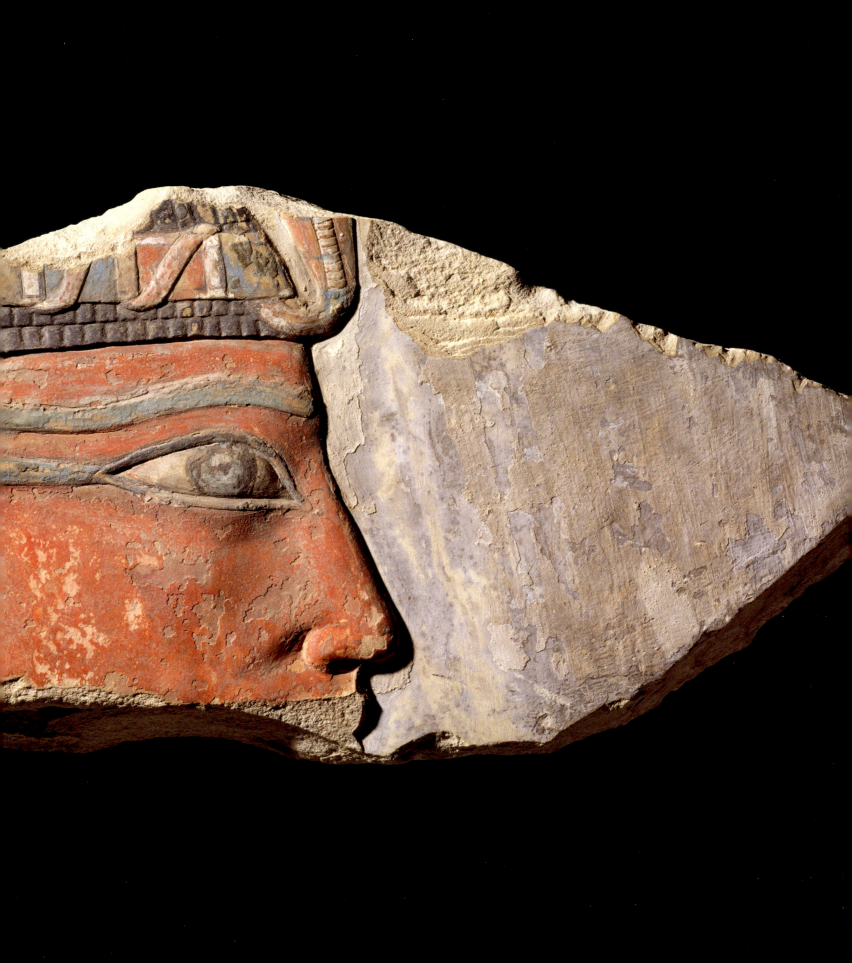

MIDDLE KINGDOM HISTORY, POLITICS, AND SOCIAL ORGANIZATION

NICHOLAS S. PICARDO

OF THE MAJOR CHRONOLOGICAL divisions that make up the approximately three and a half millennia of ancient Egyptian history, the Middle Kingdom (2040–about 1640 B.C.) rarely sits at the forefront of modern consciousness. Yet, both later Egyptians and modern scholars have regarded the Middle Kingdom as a classical age of cultural achievement. This disparity arises partly from an accident of time. The architectural remnants of the Middle Kingdom have not survived as well as the large monuments of some other periods, and much early archaeology of the nineteenth and twentieth centuries was guided by a bias toward large, well-preserved architecture. The Middle Kingdom archaeological record has yielded neither a singularly iconic monument such as the Great Pyramid of the Old Kingdom (2649–about 2100 B.C.) nor a sensation like the tomb of King Tutankhamen of the New Kingdom (1550–1070 B.C.). As interest in Egypt's social history has grown in recent decades, this situation has been changing gradually.

The Middle Kingdom followed the First Intermediate Period (about 2100–2040 B.C.), during which Egypt experienced the crises of a divided nation and civil strife. The pharaoh lost much of his political and religious clout owing to an inability to hold the nation together, as was his divine responsibility. After a successful recentralization by their immediate forebears of late Dynasty 11, the kings of the Middle Kingdom's central ruling family, Dynasty 12, were keenly aware of past failures and successes. Emulating earlier patterns of royal expression selectively at first, they ultimately established a course that distinguished the Middle Kingdom starkly from other historical periods. Their years comprised a time of pragmatic self-exploration and innovation, during which the very notion of kingship was recaptured and reshaped. Egypt's temples, cornerstones of religious and economic infrastructure, were restored, augmented, or founded anew. Royally sponsored expeditions reestablished access to valuable natural resources on the country's margins and beyond, and internal development amplified the agricultural productivity of Egypt's lands. Not content to recover just internally, the kings of Dynasty 12 pushed beyond past frontiers to pursue Egypt's first clear imperial ambitions by occupying neighboring territories and annexing new lands to their own.

Evidence of royal endeavors survives not only in the relatively sparse building remains of the Middle Kingdom, but more so in a voluminous textual record created by several levels of private society. The relationship between kings and this populace is central to an understanding of the period. At the upper end of the private socioeconomic spectrum, nomarchs, elite governors of Egypt's provinces, acted both under the auspices of the king and in their own interests while claiming some privileges once reserved for royalty. Their power, wealth, and status relative to their kings comprise a major theme in the history of this era. In their twilight, a burgeoning bureaucracy evolved that was more complex than those of centuries before, some aspects of which would be retained for centuries to come. All the while, the coordination of the state with its provinces brought new prosperity to Egypt. A larger portion of society gained access to written language and the financial means to prepare lasting

monuments in the hope of securing divine favor or an eternal afterlife. Amid times of opportunity, intellectual expansion, and cultural growth, a new literary consciousness produced compositions that became the classic tales and scribal practice texts of later generations.

LEGACY OF THE OLD KINGDOM AND FIRST INTERMEDIATE PERIOD

The Middle Kingdom was a period of renewal and revival, a designation that presupposes an earlier decline.[1] The end of the great Pyramid Age of the Old Kingdom gave way to the uncertain years of the so-called First Intermediate Period, which witnessed the first comprehensive political fragmentation of Egypt since the establishment of the state around 3000 B.C. It is likely that several causes worked in tandem to initiate a precipitous decline in the late Sixth Dynasty (2323–2150 B.C.). The truly monumental costs of constructing the royal pyramids may have sapped the state's resources beyond recovery. An unprecedented reign of up to ninety-four years by King Pepi II may have found an unfit man on the throne and left an uncertain royal succession. Poor Nile inundations also may have plagued the late Old Kingdom.[2] The Nile Valley was an environment in which variations in yearly flood levels could mean the difference between a season of feast or one of famine. If surpluses were depleted, the royal government's inability to assist in times of prolonged famine may have undermined public confidence. However, variability in the yearly flood season made food shortages a periodic inevitability. The extraordinary nature of the First Intermediate Period scenario probably was a failure of the central administration rather than the severity of a supposed famine.[3]

Although ancient historical tradition suggests that Dynasties 7–8 continued to rule from the Old Kingdom capital at Memphis, Dynasty 7 is now understood as a confusion of later historical memory.[4] While compiling an account of Egypt's past, third-century-B.C. historian Manetho was told of seventy kings ruling in an equal number of days, more likely a figurative statement by succeeding generations, but nevertheless an indication of the dissolution of central royal authority. Dynasty 8 (about 2143–about 2100 B.C.) existed, but with scarce

archaeological remains to show for twenty-two royal names that were preserved, not all of which can be isolated as belonging to specific individuals. Though some of these kings attempted to exert more than minimal authority, their capabilities were stunted compared with the achievements of their Old Kingdom forebears. The only royal burial monument known definitively is the diminutive pyramid of Qakara Ibi I at South Saqqara.[5]

A gradual decentralization of Egypt's state administration started many years before. Through the Old Kingdom, an expanding national bureaucracy fostered an increase in wealth and autonomy among high officials responsible for Egypt's provinces, called nomes (from *nomos*, Greek for "district"). The historical basis for these municipalities probably dates from the formative years of the Egyptian state, but from at least the Third Dynasty (2649–2575 B.C.) they comprised the formal organizing principle of regional administration.[6] Traditionally, the nomes numbered twenty-two in Upper (southern) Egypt and twenty in Lower (northern) Egypt. Variously titled "administrators" and "overseers" managed nomes as well as larger sectors of the country as localized representatives of the central government, answering to high officials such as the vizier or an overseer of Upper Egypt. Originally the king awarded these posts, orchestrating their placement and promotion, and for part of the Old Kingdom service by the governing elite was rewarded with space and tomb accoutrements in the private cemeteries surrounding their kings' pyramids in the royal necropolises of Memphis. The tomb inscriptions of these officials express an acute awareness that their fortunes in this life *and* the hereafter came directly from their service to the crown.

By the Sixth Dynasty many of these officials were rooting themselves more permanently in their districts of origin. In growing numbers they were buried in ancestral cemeteries, for which they commissioned increasingly large and elaborate tombs. As the reach of national government retracted, so did the binding authority that held the districts together. The old nodes of the civil administration became independent regional power bases. Offices once attained by royal appointment passed through family lines, effectively producing regional dynasties of local

rulers who enjoyed the largesse they once dispatched to the king. Calling themselves great overlords, or chief headmen—and now known as nomarchs—they described the economic and political sway they exercised in the biographical inscriptions and scenes adorning their tombs. In contrast with earlier practices, these texts no longer centered on exemplary service to the pharaoh as justification for the tombs and worthiness for a successful afterlife. Instead they boasted of the nomarchs' accomplishments and the care they proffered as champions of their own constituents—providing food, clothing, protection, humane treatment, counsel, and general advancement—during hard times.[7] The relative independence of the nomarchs amid a backdrop of a dissolved state also led to competition for territory, resources, and regional dominance. Infighting across nome boundaries eventually followed, with some nomarchs taking other districts by force.

Not much is known about the transition into the First Intermediate Period with Dynasties 9–10. Although several new kings emerged from Herakleopolis, located south of Memphis near the Fayum region, many royal names from this sequence are incomplete or unknown entirely. These rulers are traditionally divided into two dynasties but are collectively identified from inscriptions as the "House of Khety."[8] When recent archaeological work reascribed the "capless" or "headless" pyramid at Saqqara from a King Merykara of Dynasty 10 to King Menkauhor of Dynasty 5, the Herakleopolitan era was possibly left bereft of even a single known pyramid complex.[9] However, a nomarch may have succeeded where kings failed. At the site of Dara, near Asyut, a nomarch named Khui may have constructed a large, pyramidlike monument whose base measured 130 meters (over 425 feet) per side, large even by Old Kingdom standards.[10]

RECOVERY AND RENEWAL

The geographic limits of the Herakleopolitan kingdom at any one time are not easily determined, though many nomes of Middle Egypt fell within its sphere. A coalition of southern nomes, possibly united under a nomarch named Intef, eventually produced challengers to the northern dynasts. The Eleventh Dynasty traced its own past to an ancestral king, Mentuhotep I, who was said to hail from the region of Thebes in the fourth Upper Egyptian nome. Little else is known about him, and his status as king was probably a later, honorary attribution. The first Theban to consolidate sufficient forces to challenge the Herakleopolitans may have been Sehertawy Intef I, though his record is nearly as blank as that of his predecessor. A lengthy period of conflict thereafter between supporters of the Theban south and allies of a Herakleopolitan north is more certain.

Due to the limited number of surviving royal inscriptions from this period, historians turn to the manipulation of royal titulary by Eleventh Dynasty kings as signs of the Thebans' motives and successes. Since Dynasty 5, pharaohs listed a full royal titulary of five paired names and titles, each of which expressed an aspect of the king's office or his connection with important deities. Following Sehertawy Intef I, Wahankh Intef II employed the title "King of Upper and Lower Egypt," a statement of intent rather than accomplishment. References to fighting to justify this claim during the overlapping Tenth and Eleventh Dynasties are plentiful, presenting a picture of northward advances by the Thebans with periodic checks by Herakleopolitan loyalists, particularly near Abydos in the Thinite or eighth Upper Egyptian nome, and by the nomarchs of Asyut.

After the fifty-year career of Intef II, a third Intef, Nakhtnebtepnefer, ruled for a mere eight years. Following these hard-fought reigns, Nebhepetra Mentuhotep II displayed a telling evolution in one element of his titulary. The "Horus name" identified a pharaoh as the earthly manifestation of the god Horus, son of Osiris, the divine archetype of a king. Mentuhotep started his reign with a Horus name presenting him as "One Who Revives the Heart of the Two Lands." Further into his rule the name "God of the White Crown" highlighted a royal emblem that is specific to Upper Egypt. This title might be read as a dedication to his homeland or an indication of limits on the territory he governed firmly, or both. However, his final name, "One Who Unites the Two Lands," seems an unsubtle claim to sole rule of Egypt, and his unification of the country marks the start of the Middle Kingdom (fig. 1).[11] Mentuhotep's mortuary

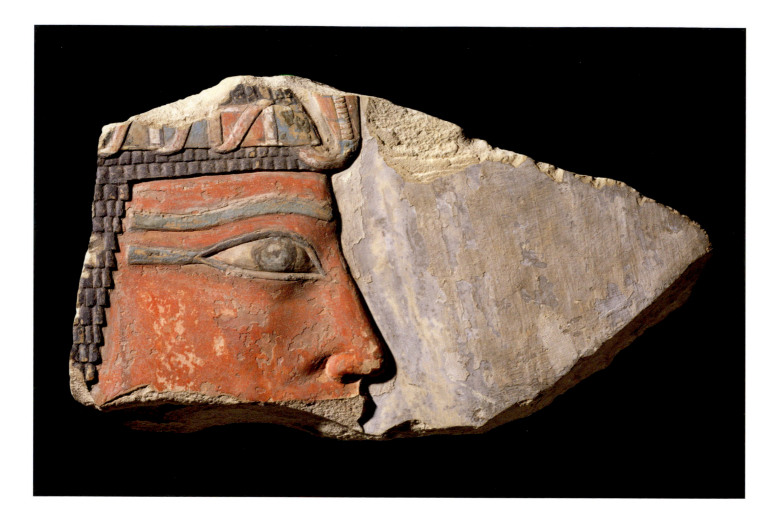

Fig. 1. Relief of Mentuhotep II, Dynasty 11, reign of Mentuhotep II, 2061–2010 B.C.

complex at Deir el-Bahri on west-bank Thebes is itself a commentary on his accomplishments. Its size alone reflects the return of consolidated power capable of harnessing resources to create a monument of royal display, and a nearby communal tomb of about sixty soldiers—many with skull wounds or arrows still embedded in their bodies—may offer a rare and vivid testament to the efforts required to achieve such capabilities.[12]

Sankhkara Mentuhotep III was the next legitimate ruler. After his reign, official records mention seven "empty years" to the close of the dynasty. King Nebtawyra Mentuhotep IV served the majority of this vague period but may have been regarded as a usurper, which may explain his omission from the records. Regardless of how

they came to power, Mentuhotep II's successors continued a program of restoration begun by him in the south. Their devotion to the regional god of their namesake, the warlike Montu (their name translates as "Montu Is Content"), as well as to the obscure Theban god Amen, shows prominently in remains of temples at sites where one or the other was worshiped, including Medamud, Armant, and Tod. The restriction of their activities largely to their native Upper Egypt intimates that their claim to control a fully united Egypt, though legitimate, was tenuous in more northerly regions.

Compared with Dynasty 11, Dynasty 12 enjoyed relative stability and could thus concern itself with the reconstitution of the political, economic, and religious

institutions of the entire country. Its success promoted an expansion of unprecedented scope. King Amenemhat I was probably the vizier of Mentuhotep IV who left inscriptions in the Wadi Hammamat to commemorate the successful expedition of ten thousand men to quarry stone for the king's sarcophagus.[13] As vizier, he held the highest office below king. His parentage was nonroyal.

Though he may have retained the seat of government at Thebes and started a funerary monument there, Amenemhat I relocated the capital.[14] Between the twentieth and thirtieth years of his reign, he transferred operations to the newly established city of Amenemhat-*Itjtawy*, or "Amenemhat Is the One Who Seizes the Two Lands." Its location is understood to be near the site of Lisht, about 30 kilometers (almost 19 miles) south of the old Memphite capital. Little is known of it archaeologically, though portions of a possible suburb were excavated at Lisht North.[15] The transfer of the government may reflect an attempt to fully realize the town's name. A capital at Thebes proper may have rendered it more difficult to maintain the country's northern extremes in the Delta, and Lisht marked roughly the midpoint of Egypt at the time. Given the questionable final years of Dynasty 11 and his own nonroyal ancestry, Amenemhat may have wished to distance himself from the Theban line and their home region as explicitly as possible. Last, economic considerations may have motivated the northward move. The Fayum, easily accessed via a desert route near Lisht, was an agriculturally rich zone, the potential of which would be developed substantially through the Twelfth Dynasty. Like Mentuhotep II before him, Amenemhat I altered his titles to make defining statements about his reign. Ascending to the throne with the Horus name of "One Who Pacifies the Two Lands," he changed it to "One Who Repeats Births," stating that from his perspective, his rule commenced an era of renewal.

If a kernel of truth is to be found in such Middle Kingdom literary compositions as *The Teaching of Amenemhat I for His Son Senwosret* and *The Story of Sinuhe*, Amenemhat I fell victim to assassination at the hands of his most intimate circle. The event is narrated in the voice of the deceased king in the former work, as though he were speaking to his son:

It was after supper, when darkness had fallen,
And I had decided to take an hour of relaxation;
I was lying on my bed, for I was tired,
And I started to drift off to sleep.
Weapons (intended for) my protection were raised against me,
While I acted like a snake of the desert.
I woke up to the fighting, pulled myself together,
And found that it was a skirmish of the palace guard.
If I could have quickly taken weapons in my hand,
I would have made the cowards retreat in turmoil.
But no one is strong at night, and none can fight by himself;
No successful result can come about without an ally.
And so ruin occurred while I was without you.[16]

The aftermath of this supposed assassination comprises a pivotal moment in an epic-style story about an official named Sinuhe and his flight from Egypt upon hearing news of the king's death, while Senwosret I returned hastily from a military expedition against Libyan tribesmen of the Western Desert.[17]

Threats to Amenemhat I, and indeed a turbulent close of Dynasty 11, may have inspired a new practice for reinforcing the royal succession in Dynasty 12. As the fictive Amenemhat imparts his wisdom to his son, he laments:

When the courtiers had not yet heard that I would hand over (the throne) to you,
When I had not yet sat down with you so as to confirm your succession;
For I was not ready for it, I did not expect it;
My heart had not conceived of indolence of the part of the servants.[18]

Through a new practice of coregency, a living king promoted his son as his successor to rule alongside him for the remainder of his reign, ensuring legitimate succession and supervision over a young king. The effectiveness of this policy became clear in the uninterrupted transfer of power mainly from father to son until the very end of the dynasty.[19]

As part of a conscious return to models of kingship established by Old Kingdom pharaohs, Amenemhat and his successors revived the long-neglected tradition of pyramid building. Though Middle Kingdom complexes matched neither the size nor the labor requirements of the great royal burial monuments of the Old Kingdom, the cumulative building activities of the Twelfth Dynasty

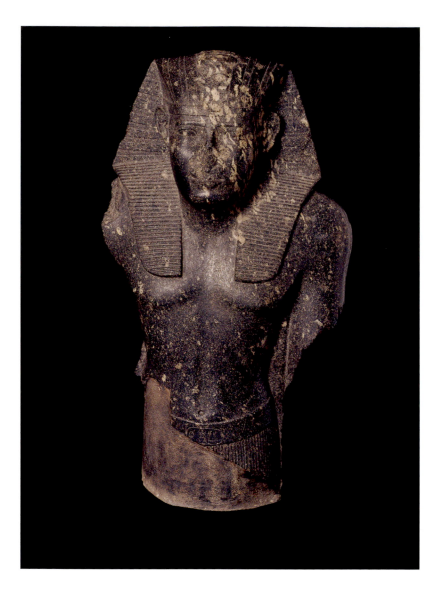

Fig. 2. Senwosret I, Dynasty 12, reign of Senwosret I, 1971–1926 B.C., British Museum, London, EA 44. Image © The Trustees of the British Museum.

glyphs or relief of the original owner, and rededicated statues of Middle Kingdom monuments to link themselves with exceptional royal predecessors whose reputations were already legendary.[20] Though most regional temples were fairly small, some remains indicate that a few might have approached or even surpassed the size of the mortuary temples of contemporary royal pyramid complexes.[21]

A king's investment in provincial institutions was as much a politically expedient maneuver as an expression of religious devotion or intent to commemorate his reign. Egypt's network of temples was a key component of its economic infrastructure. The erection of a temple, chapel, or statue was accompanied by an endowment of land from which offerings flowed to the temple—and subsequently to its staff as payment—in support of royal or divine cults. The king granted favors to the gods in the form of tax exemptions, a gesture surely aimed as much at local officials, the most prominent of whom held the highest priestly titles. Additionally, the temple setting presented a forum in which the king associated himself with local gods and goddesses to highlight his own divinity, an aspect of kingship that fell into doubt during the First Intermediate Period. By extension, this approach forged connections between the king and devotees of the temple's resident deity. The everyday religious practices of average Egyptians concentrated far more on their home deities than those promoted by the state, and a local temple was an epicenter of community activity and identity.[22]

Evidence of Amenemhat I's construction extends beyond Upper Egypt, but it was Senwosret I who fully realized his father's revitalization efforts by canvassing all of Egypt with the construction or renovation of temples and donations of statues (fig. 2). Senwosret's efforts established a benchmark for royal patronage at local temples that kings would follow for the rest of Egyptian history, though few surpassed his thoroughness. His White Chapel at Karnak is the best surviving example of early Middle Kingdom royal architecture (fig. 3). A roughly cubic kiosk of limestone with two opposing access ramps, decorated and inscribed over its entirety in raised or sunk relief, it originally functioned as a way station along a processional route. Scenes and texts cele-

may have outstripped the earlier era. Pharaohs paid concerted attention to the provincial temples dedicated to local gods and goddesses across Egypt on a scale not seen previously, and the use of stone in temple structures increased markedly. Yet, relatively little standing architecture remains now. The growing use of stone was both a blessing and a curse. In later projects kings dismantled these buildings to scavenge well-hewn blocks or to supply fill for their own monuments. Some later pharaohs incorporated blocks more deliberately into their own structures, in some cases preserving the

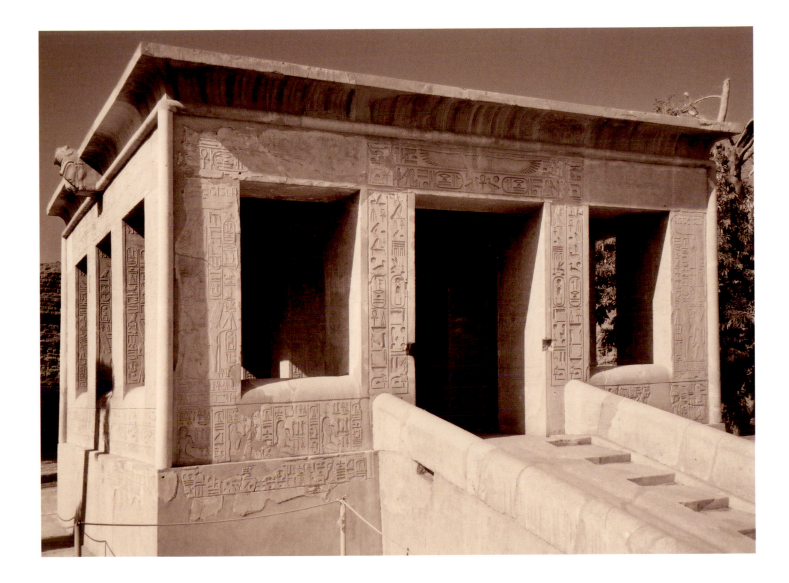

Fig. 3. The White Chapel
of Senwosret I, Dynasty
12, reign of Senwosret I,
1971–1926 B.C., Karnak.
Photograph by Lawrence
M. Berman.

brate the king's relationship with the gods, along with his own *sed*-festival, a royal jubilee to which he was entitled after thirty years of rule. The chapel's sixteen square pillars depict Senwosret I repeatedly presenting offerings to manifestations of the Theban god Amen (often with the ithyphallic attributes of the god Min, likely to stress virility to refresh the king's regency), sometimes escorted by other deities. In turn, Amen validates his divine right to rule.[23]

The inscriptions of the White Chapel also encapsulate all of Egypt into one discrete monument. The northern and southern sides of its base list the nomes in tabular form, recording for each its capital, primary deities, and the land it encompasses.[24] This royal registry reflects moves by the early Middle Kingdom kings to regain central state oversight of their provinces. They replaced uncooperative nomarchs and those with previous loyalties to the Herakleopolitan regime, as at Asyut, or confirmed accommodating governors, such as those of Deir el-Bersha, in power. The king and his court claimed the authority to reapportion the nome districts, arbitrate territorial disputes, and assess tax obligations.

According to the tomb autobiography of the nomarch Khnumhotep II at Beni Hasan, this policy was well established by Amenemhat I, who confirmed the appointment of his grandfather Khnumhotep I. Redistricting was repeated with each new reign, allowing Khnumhotep II's inscription to reference such "great favors" bestowed upon four generations of his family, from King Amenemhat I through Senwosret II. As clients of the king, they were obliged to exhibit loyalty in exchange for retaining prominence in their home districts. Yet, Khnumhotep II's inscription also cites heredity and marriage arrangements as though they still cemented entitlement to high positions within a nome or across nome boundaries.[25] The tension between royal appointment and hereditary succession was surely a prominent facet of Middle Kingdom politics. Although, technically, nomarchal tenure was subject to review and could be revoked, it was likely to be equally advantageous for pharaohs to confirm successors from within ruling family ranks in areas where their status was well entrenched. In a mutually beneficial exchange, the nomarchs oversaw district lands, channeled taxes and natural resources to the state, and assembled workforces for royal projects. For the national government, an additional means to encourage cooperation was to appoint prominent provincial heads to the highest national posts of vizier, royal steward, and royal treasurer.[26]

THE GOVERNING ELITE AND SOCIETY

The primary cemeteries of the Middle Kingdom nomarchs are concentrated in Middle Egypt, specifically in Upper Egyptian nomes at the sites of (from north to south) Beni Hasan, Deir el-Bersha, Meir, Asyut, Deir Rifa, and Qaw el-Kebir, with an outlier deep in the south at Qubbet el-Hawa.[27] The limited and geographically concentrated distribution of these attestations, and the even more limited usage of the "true" nomarchal title of Great Overlord, fuels a modern debate as to whether the office was employed throughout Egypt at this time, or if its persistence (or appearance) in certain areas was instead a measure of the power of some local families, the value of their domains, or particular royal agendas. Certainly for the first half of the Middle Kingdom, the construction of large, elaborately decorated rock-cut tombs for the most prominent families argues for equivalent power and wealth regardless of titling. Nevertheless, it is in the early Middle Kingdom climate of transition and recovery of the state that the nomarch Djehutynakht lived.

Djehutynakht was one in a family line of governors of the fifteenth nome of Upper Egypt, also known as the Hare nome. He and his wife of the same name shared tomb 10A at Deir el-Bersha in the elite necropolis of the provincial governors and their families. The hub of the province was about 10 kilometers (6¼ miles) northwest and across the Nile at its capital of Hermopolis (ancient name Khmun, or "Town of Eight"), present-day el-Ashmunein. A largely unbroken sequence of the ruling family tree at Deir el-Bersha suggests that although they were part of the Herakleopolitan kingdom earlier, they aligned themselves with the Thebans of Dynasty 11 during the unification period.[28] Their continued allegiance is unmistakable in the naming of four members as viziers by the early Middle Kingdom state.[29] Djehutynakht's appropriate placement in this family lineage is not cer-

tain, since a small number of names repeat over several generations. The primary owner of tomb 10A was either the fourth or fifth notable man out of several individuals to carry the name among those who left a record.[30] A tentative consensus now falls on the former candidate. Along with the Deir el-Bersha tombs, the primary source of information about these governors is a series of commemorative rock graffiti from the local quarries of Hatnub. One of Egypt's principal sources of travertine (Egyptian alabaster), this nearby quarrying sector of the Eastern Desert was exploited in many projects overseen by the governors and their personnel. The corpus of graffiti includes both Djehutynakht candidates.[31]

If the male occupant of tomb 10A is Djehutynakht IV, son of Ahanakht, little more is known about him than his father's name. If, rather, he is Djehutynakht V, he appears in the decoration of Deir el-Bersha tomb 4, belonging to his father, the nomarch Nehri. This filiation would identify him as a participant in a time of warfare mentioned several times in the Hatnub inscriptions.[32] However, the timing of the Battle of Shedyetsha has been a matter of disagreement, one that affects the chronological placement of both men. Whereas some historians see it as a fight for unification under Nebhepetra Mentuhotep II, others interpret it as part of the unstable changeover from Dynasty 11 to Dynasty 12, possibly under Amenemhat I.[33] If this second estimation is correct, the Djehutynakht in question governed the Hare nome sometime during the reigns of Mentuhotep III, Mentuhotep IV, and/or Amenemhat I.

As a rule, the title of Nomarch was omitted from the coffins of Deir el-Bersha's governors, and the coffins of the Djehutynakhts were among very few items from their tomb assemblage to bear inscriptions at all.[34] The male Djehutynakht's texts display the bare minimum of titles for Deir el-Bersha's elite administrators. The first title preserved for him is Governor (*haty-a* in Egyptian). It may denote specifically Djehutynakht's governance of the nome capital at Hermopolis; it is often translated as "mayor." However, it was also commonly held by regional governors as a general marker of very high status beyond the confines of just a specific town, the likely case here.[35] The contents of tomb 10A, as well as its location on the main cliff terrace of the Deir el-Bersha necropolis, leave

little doubt as to the lofty status of its occupants and Governor Djehutynakht's position in his nome.

As with most nomarchs, a high-level role at the local temple complemented his civil authority.[36] He and all the Hermopolitan nomarchs held the titles Controller of the Two Thrones and Overseer of Priests, which conferred ritual duties and identified the carrier as the temple's high priest, respectively. The primary temple at Hermopolis was dedicated to the god Thoth, whose later identification with the Greek god Hermes gave rise to Hermopolis's common name. The Djehutynakhts' name was itself in homage to the god, meaning "Thoth Is Strong." As a god of knowledge and writing, their namesake was also a divine administrator of sorts. Lady Djehutynahkt's titles are equally elevated and equally limited in the number preserved. Her coffins designate her as Hereditary Princess and Royal Ornament, neither of which necessarily denotes a royal background.

The loss of tomb 10A's superstructure from later stone quarrying is unfortunate, for with it were probably lost a fuller array of titles, an autobiographical inscription, and details about Djethutynakht's life and work, including perhaps mention of the king who validated his appointment. However, broadly speaking, the nature of a nomarch's life may be extrapolated from other nomarchal tomb scenes, including some at Deir el-Bersha, as well as fine examples of the ruling family of the neighboring sixteenth, or Oryx, nome at Beni Hasan, situated in the Eastern Desert cliffs approximately 20 kilometers (12½ miles) to the north.[37] The walls of these tomb superstructures carry scenes that, though technically exhibiting the tomb owners' ideal preparations and expectations for the afterlife, reflect the very real capabilities of their earthly estates. At the very least, captions identifying individual subordinates by name serve to anchor them as representations that approximate real life.

Judging from tomb scenes, the nomarchal estate supported a multifaceted array of industries and productive activities devoted to working the land.[38] Crafting industries were staffed by such workers as spinners and weavers, potters, carpenters, smiths, and boat builders. A nomarch's granaries are likely to have stored the largest surpluses in the region (fig. 4). Baking bread and brewing beer were

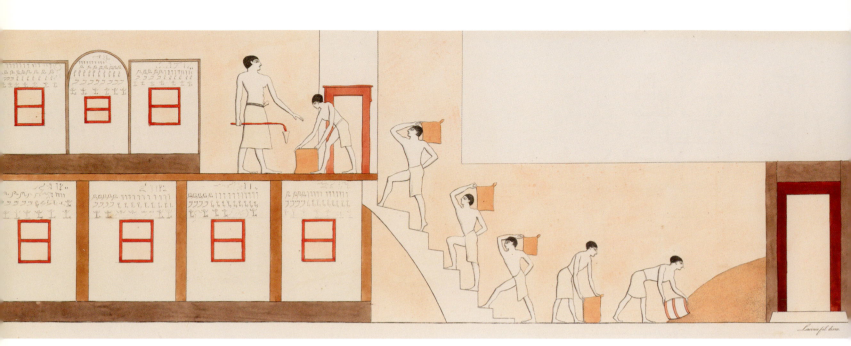

Fig. 4. Granary scene, Dynasty 12, reign of Senwosret I, 1971–1926 B.C., Beni Hasan, tomb 2 (Amenemhat). From Ippolito Rosselini, *I monumenti dell'Egitto e della Nubia*, plate 34.

daily pursuits; both products were staples alongside a more varied array of foods and beverages than many households could procure (fig. 5). Agricultural bounty was supplemented with desert game hunts, fishing, trapping of fowl, and the keeping of livestock. A skilled butchery staff was therefore necessary. Tomb scenes also depict nonproductive, yet essential, activities such as laundering. The governors' managerial tasks are portrayed in scenes of accounting at storage facilities and judgment of citizens who have defaulted on requisite payments. A sign of the times preserved in several tombs depicts a group of soldiers besieging fortified buildings, with accompanying registers displaying military training as a somewhat enigmatic survey of wrestling maneuvers. Participants sometimes number in the hundreds. In addition to a cadre of attendant personnel, including stewards, butlers, scribes, and various overseers who tended to the nomarch's estate, an armed, private militia accompanied him for protection (fig. 6).

The world depicted in the nomarchs' tombs reflects the perspective of a very small, privileged sector of Egyptian society. From the viewpoint of the ruling royal and provincial elite, every person belonged to one of only two groups: those who ruled and those who labored for the rulers. A literary composition of the Middle Kingdom (known from copies preserved due to its popularity in the Middle and New Kingdoms as a scribal teaching text) captures this view in a lighthearted, yet elitist, way. In *The Satire on the Trades*, a man named Duakhety instructs his son in the virtues of becoming a scribe as he escorts him to the royal residence, to be admitted to the scribal school with the children of Egypt's prominent families: "Since I have seen those who have been beaten, it is to writings that you must set your mind. See for yourself, it saves one from work. . . . As for a scribe in any office in the Residence, he will not suffer want in it. . . . I shall make you love books more than your mother." Duakhety then enumerates the horrid lot of those in other professions. The coppersmith suffers because "his fingers were like the claws of the crocodile, and he stank more than fish eggs." The potter "is covered with earth, although his lifetime is still among the living. He burrows in the field more than swine to bake his cooking vessels." And to tend laundry, "the washerman launders at the riverbank in the vicinity of the crocodile His food is mixed with filth, and there is no part of

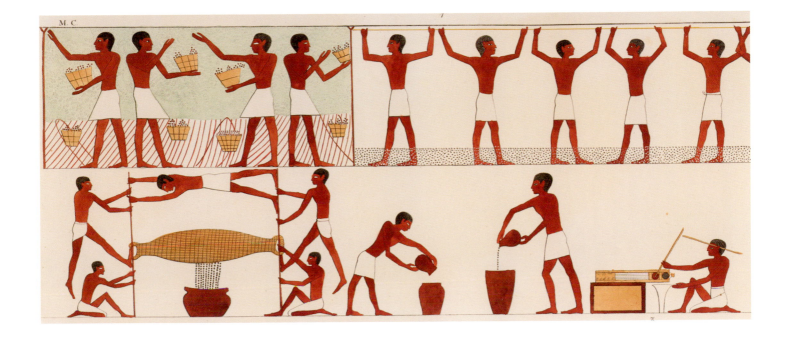

him which is clean. . . . He weeps when he spends all day with a beating stick and a stone there."[39] The element of truth to be gleaned from this father's overwrought lesson, however, is that literacy was a job-specific skill in ancient Egypt, a necessary first step to moving within the ranks of the bureaucracy.

The composition of the nomarchs' more immediate staff appears rather similar to that of the royal court, only smaller in scope. The inclusion of upper-level personnel in his tomb recalls the relationship between king and high official in the Old Kingdom, when dutiful attendance to one's office was rewarded with tomb preparations in the sacred royal necropolises. The nomarchs apparently offered a degree of similar afterlife service by commemorating names for eternity and allowing their subjects to cluster tombs near their own, but on lower ground. There are signs that nomarchs of the Middle Kingdom indeed viewed themselves as a brand of royalty, despite still posturing as loyal subjects of the king in their inscriptions. For instance, in graffito 31 from Hatnub, Djehutynakht V dates his inscriptions to his own term of office rather than the king's regnal year. Moreover, he copies a royal protocol in employing the phrase "life,

prosperity, health" after his name, while the inscription on Djehutynakht's coffin from tomb 10A includes the similarly tripartite royal expression "life, stability, dominion," three things granted to kings by the gods. These phrases are two of several royal epithets and symbols borrowed by nomarchs.[40] Royal pretenses were carried into the tomb with the use of the Coffin Texts, direct derivatives of the once exclusively royal Pyramid Texts. Though limited in scope, this borrowing must be regarded as a primary catalyst in a gradual evolution of funerary decorum that eventually permitted the spread of several royal emblems to the nonroyal domain as the Middle Kingdom progressed.[41] Elsewhere at Deir el-Bersha, in tomb 2, dating to the later Twelfth Dynasty, a scene depicts the movement of a colossal (nearly 7 meters [23 feet] tall) travertine statue of the nomarch Djehutyhotep II from the Hatnub quarries to his large chapel, proving that the nomarch attained even a royal scale of monumental display (fig. 7). Similarly, late Middle Kingdom tombs at Qaw el-Kebir adapted elements of the royal pyramid complexes for their own funerary monuments.[42]

By virtue of family history, status, and office, a governor possessed the greatest resource for generating

Fig. 5. Wine-making scene, First Intermediate Period–early Middle Kingdom, Dynasty 11, 2140–1991 B.C., Beni Hasan, tomb 17 (Khety). From Ippolito Rosselini, *I monumenti dell'Egitto e della Nubia*, plate 37.

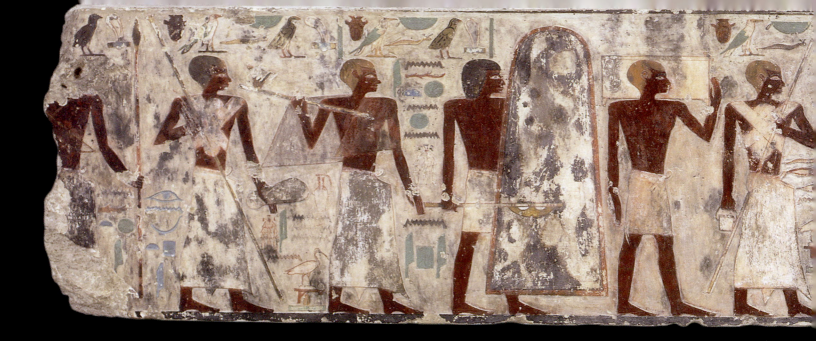

Fig. 6. The nomarch's retinue, Dynasty 12, reign of Senwosret II–Senwosret III, 1897–1841 B.C., British Museum, London, EA 1147. Image © The Trustees of the British Museum.

wealth and followers, namely land. In ancient Egypt's nonmonetary, agrarian economy, payment took the form of basic staple foods like grain, grain products (for example, bread and beer), and other commodities. Arable land was a scarce resource, limited to narrow strips along both sides of the Nile. Although the king retained a claim on all of Egypt's territory, practically speaking, farmlands were the holdings of some kind of estate, be it royal (that is, state), temple, private, or mortuary. Individuals and institutions managed sizable tracts that could be received and disbursed as grants in exchange for service and loyalty. Landholders with a surplus of fields, or those who were not in a position to till, had the option to lease out to others. Tenants ceded a pre-arranged percentage of the yield to the landlord as his due. Landowners amassed copious surpluses that became payment for the personnel of other industries and reserves for the future. As the majority of Egyptians

were peasant farmers, they could not afford to rent land outright, working instead in fields or industries or becoming household staff for those with better means in exchange for basic subsistence. Access to a small plot of land was often handed down as inheritance, and a peasant family was thus tied to both land and landholder. Their service to the household often persisted through multiple generations, and serfs were transferable along with a parcel of land or a service.[43]

Multiple channels of income enlarged the nomarchal estates. In addition to their family holdings, the nomarchs' service to the state earned them official grants of land and personnel that passed on to their professional successors irrespective of family affiliation. Revenues from these holdings could be extended to others while the nomarch lived to fulfill his responsibilities, but contractual agreements could be nullified by the next incumbent nomarch. Similarly, their duties at the temple

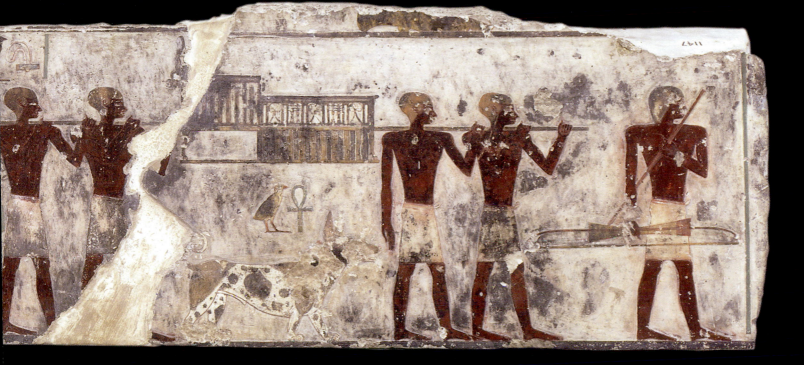

generated additional income, as a portion of offerings was converted to payment in kind. Other assets, including additional shares of temple income derived from private family inheritance, could be allocated to their heirs as desired. The nomarch Djefaihapi I captured the mechanics of this social arrangement, albeit for a somewhat more formal context, in ten contracts drafted to secure attendance on his mortuary cult by priests of his local temples of Anubis and Wepwawet. Recorded for posterity (and perhaps for insurance) on the walls of his tomb (no. 1) at Asyut in the reign of Senwosret I, the introduction to these documents instructs the mortuary priest hired to ensure the contract's terms: "Look, I have made you functional like any official of Asyut, with fields, with people [that is, serfs], with herds, with basin-lands, with everything, for the sake of your doing something for me with your heart effective. You should attend to all my things that I have put under your hands."[44] This

endowment was to be handed down to a son of the priest on the condition that he would continue service to the nomarch's *ka* statue. To guarantee these terms, the nomarch prohibited division of the property among several offspring. The contracts stipulate several kinds of goods, including bread, beer, barley, meat, as well as coals and wicks, to be presented to the temple's chief priest and his subordinates via a complex array of exchanges. Some were arranged as direct payment, and others took the form of offerings for Djefaihapi's cult statue that would later be redistributed.[45]

Once granted the rights to a plot of land, a tenant could generate additional income by taking on dependents of his own through smaller land grants or provisioning, as long as he continued to produce the requisite payments to the landlord. A series of five letters and four accounts of the mortuary priest Heqanakht, also dating from the reign of Senwosret I, present a detailed view

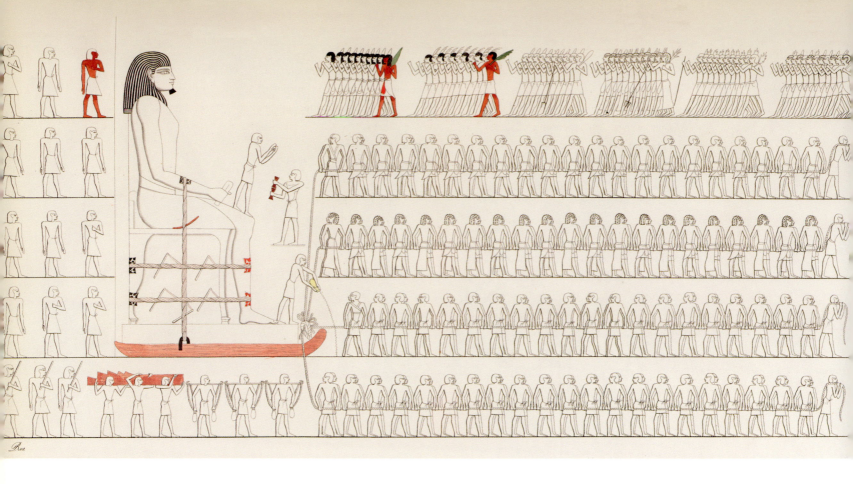

Fig. 7. Scene of moving the colossal statue of the nomarch Djehutyhotep, Dynasty 12, reign of Senwosret II–Senwosret III, 1897–1841 B.C. From Ippolito Rosselini, *I monumenti dell'Egitto e della Nubia*, plate 48.

of how the other party in Djefaihapi's agreement might benefit. Heqanakht wrote home from Thebes, where he tended to the mortuary cult of a state official, probably a vizier. The whereabouts of his residence are not yet known, but perhaps they lie well north of Thebes.[46] Aside from family matters, Heqanakht's documents concentrate on managing fields at home plus others in the Thinite nome (Upper Egyptian nome 8). The letters offer no clues as to whether the landholdings are his by inheritance or are a funerary endowment entrusted to him, but Heqanakht certainly controlled them. Through his letters he ordered the rental of additional fields and determined what crops to plant and which fields should lie fallow. As head of household, he rebuffed complaints from his sons about their rations and authorized payments for household workers. His accounts tabulated outstanding reserves and debts for staple grains, bread, cattle, and wood, while budgeting for taxes and future expenditures. Mention of

widespread crop failure suggests Heqanakht faced a greater challenge than usual in managing the estate:

> Look, the whole land is dead and [you] have not hungered. Look, before I came upstream I made your salaries to perfection. [Now,] has the inundation been very [big]? Look, [our] salary has been made for us according to the state of the inundation, which one and all bear. Look, I have managed to keep you alive so far. . . . Lest (any of) you get angry about this, look, the whole household is just like my children, and everything is mine to allocate. Half of life is better than death in full. Look, one should say hunger (only) about (real) hunger. Look, they've started to eat people here. Look, there are none to whom this salary is given anywhere.[47]

In addition to at least seven family members, Heqanakht was able to support several functionaries, including a foreman, a steward and a household scribe (both of whom doubled as field workers), maidservants, and additional field hands. At least two of these dependents supported families of their own.[48]

MIDDLE KINGDOM EXPANSION AND PROSPERITY

The wealth displayed so conspicuously by many nomarchs is an index not only of their socioeconomic positions but also of a surge in Egypt's overall wealth. Aside from land management, royal projects involving quarrying and mining, trade missions, and military campaigns shaped and propelled Egypt's economy and administrative system, guiding the country into an extremely prosperous phase of its history. Though these activities do not feature prominently in nomarchs' tomb scenes, they comprised the most intensive point of intersection between the capital and the provinces, enriching both through cooperation. The backbone of Middle Kingdom prosperity was a system of corvée labor. Provincial governors were required to supply workforces from their own districts in coordination with representatives of the state. The participation of the average citizen was not optional. Failure to report for compulsory corvée or military duty—or neglecting to pay for a dependent to go in one's place— could mean punitive labor or imprisonment for offenders and their families.

Many quarrying sites lay dormant through the First Intermediate Period, and commercial trade stalled. The kings of late Dynasty 11 resumed expeditions almost immediately after coming to power, and Dynasty 12 broadened access to desirable goods and materials. Various stones, ores, and minerals were valued for particular attributes, including color (for aesthetics as well as symbolism), density, grain, and scarcity, which suited them to specific utilitarian or ritual uses. Stone most commonly used for buildings occurs plentifully in the desert cliffs that flank the Nile Valley, and work resumed on deposits such as the fine white limestone of Tura near Memphis and the granite and quartzite of Aswan. Some domestic quarrying was planned and overseen by local administrators, and provincial elites like the Hermopolitan governors could engage in smaller extractions of their own accord. State sponsorship was required for especially large procurements and the long-distance travel they sometimes required. Royal requests often demanded substantial organization and huge labor pools, as in the case of an expedition of seventeen thousand men sent by Senwosret I to the Wadi Hammamat in the Eastern Desert with a mandate to return with a special grade of greywacke stone in quantities sufficient for 150 statues and 60 sphinxes.[49]

When resource-gathering expeditions ventured beyond the security of the Nile flood plain via desert routes or across Egypt's borders, a military escort often accompanied the labor force. When not needed for protection, they doubled as quarrymen. References to the quelling of foreigners are numerous throughout the Middle Kingdom. Hailing from all sides, common enemies included Libyan tribes of the Western Desert, seminomadic groups of the Sinai and Eastern Desert—ranked indistinguishably together by the Egyptian term *aamu*, "Asiatics"— and Nubian peoples from the south. Surely many instances were proactive strikes to smooth the way for Egyptian excursions as well as to fend off encroachments on Egypt's borders. Despite risks, operations beyond the fringes of Egypt were quite active in the Middle Kingdom. To the east, virtually all Twelfth Dynasty kings are mentioned in rock inscriptions of the southern Sinai, from which they commissioned the mining of turquoise, copper, and malachite at Wadi Maghara and Serabit el-Khadim. To the south into Lower Nubia, partly fortified encampments and a simple fortress at Wadi el-Hudi accommodated work crews who mined amethyst, one of several colorful and semiprecious stones that became popular for use in the decorative and funerary arts of the Middle Kingdom.[50]

With the progression of the Middle Kingdom, Egypt's stance toward neighboring regions transformed from one of attentive defense to aggression. Foremost among Egyptian interests in all periods were Nubian gold deposits. Gold was both a valued luxury good and a symbol of divinity. Ample supplies could be mined in outlying desert lodes accessed via the Wadi Allaqi, just over 100 kilometers (approximately 62 miles) south of Egypt. A presence in Lower Nubia also put the Egyptians in control of a commercial window to sub-Saharan Africa, from which they imported exotic goods such as ebony, ivory, incense, and animal skins. Old Kingdom policy toward Lower Nubia was restricted mostly to organized expeditions targeting areas with desired resources. These

efforts successfully depopulated the northern region of its inhabitants, but Egypt's absence in the First Intermediate Period allowed their successors to amass new populations.

Egypt did not approach its return to Nubia lightly. Nubians had a well-established reputation as expert archers and desert trackers, as large numbers of them had crossed into Egypt to become mercenaries among Egyptian troops, including those commanded by nomarchs. Late Eleventh Dynasty forays into Lower Nubia pressed back Nubian infiltrators and insulated some areas of Egyptian interest with basic fortifications. Although walled and fortified defensive structures were known from most periods of ancient Egyptian history, a tightly integrated fortress network established by Dynasty 12 became the largest military apparatus up to that point, not to mention one of ancient Egypt's most impressive achievements. The Nubian fort system also spurred the formation of the country's first professional army. Senwosret I solidified the decisive new direction by moving past border fortifications in the Aswan region to outfit a small group of fortresses just north of the Second Cataract on the Nile River and staffing them with regularly rotating troops. Probably motivated by the emerging power of Kushite Nubians farther south near the Third Cataract at Kerma, Senwosret III later seized the whole Second Cataract region, upgrading earlier installations and increasing their number to seventeen fortresses that stretched at strategic intervals across the nearly 350 kilometers (approximately 217 miles) from Aswan to the Semna Fort, a little south of the Second Cataract. Each fortress was customized intricately to its purpose (for example, supply station, trade center, defense post, river checkpoint) and topography (valley plain, desert promontory, coastal and island outcroppings).[51] Senwosret III claims in boundary stelae set up during four aggressive campaigns past the Second Cataract, "I have made my boundary further south than my fathers. I have added to what was bequeathed me. . . . I have captured their women, I have carried off their dependents, gone to their wells, killed their cattle, cut down their grain, set fire to it." Thereafter, troops and administrative personnel resided in Nubia more permanently, making it a true extension of Egypt, with a definite border such that "he who abandons it, who fails to fight for it, he is not my son, he was not born to me."[52]

The fortress system served several strategic objectives. Sealing Egypt's border with its southern neighbor, it regulated the northward passage of Nubians. It afforded protection to mining projects and trade routes so that Egypt's economic interests were not impeded. Where Nubian populations concentrated, watchmen at the forts monitored their movements, ready to broker trades or quell uprisings against the occupying Egyptians while preserving a buffer zone between Lower Nubia and the Kushites. A series of eight reports known as the Semna Dispatches (named for the newly annexed Second, or Semna Cataract, region) offers glimpses of constant close communication among the forts that was relayed back to Egypt to be logged at Thebes.[53]

Some type of monitoring facility along Egypt's northeastern boundary into western Asia, perhaps a fort or fortress system, is suggested by textual references to the "Wall(s) of the Ruler." Though this installation has yet to be substantiated archaeologically with any confidence, it is said to have been in place by the time of Amenemhat I. Across this perimeter of Egypt, kings of Dynasty 12 inserted Egypt into a trade network that extended from the Sinai Peninsula, north through the coastal Levant (including modern Syria, Lebanon, Palestinian territories, and Israel) along the eastern Mediterranean, with less frequent and indirect contacts reaching Minoan Crete, Cyprus, Mesopotamia (Iran and Iraq), and Anatolia (Turkey). Middle Kingdom goods, statues, and iconography spread even to the most distant reaches of this expansive sphere of influence. Amenemhat II displayed the reciprocal flow of trade in a votive deposit of four bronze chests buried in the foundation of a temple sanctuary of Montu at Tod, dedicated by his father, Senwosret I. Their contents were a motley assortment of items from disparate regions, including silver and gold ingots; silver metalwork; uncarved and worked Afghan lapis lazuli; Aegean, Levantine, and Mesopotamian seals and amulets; and 145 silver cups of probable Minoan design.[54]

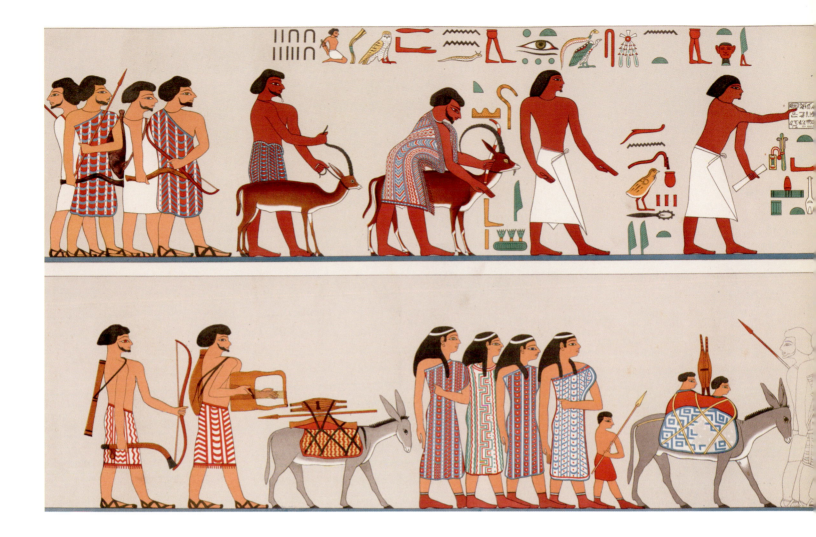

Fragmentary annals from Memphis and Saqqara that record events in the reign of Amenemhat II list multifaceted interactions with Syro-Palestinian areas that were variously militaristic, diplomatic, and commercial in nature.[55] Opinions vary as to the relationship reflected in a later tomb scene of the nomarch Khnumhotep II at Beni Hasan, which chronicles the arrival of a caravan of Asiatic nomads bearing animals and eyepaint and led by their chief, named Ibisha (fig. 8). The governor's staff receives their goods, possibly carrying out part of his role as overseer of the Eastern Desert for the state.[56] Egypt imposed tribute obligations on foreign chiefs in western Asia, as well as in both Upper and Lower Nubia,

some of which would have been reciprocated with diplomatic gifts from Egypt. At the Syrian port site of Byblos, a source of coveted cedar of Lebanon and organic resins with which Egypt kept close relations, local headmen displayed hieroglyphic writing while adopting Egyptian titles. Amenemhat II's records refer explicitly to the sacking of two Syro-Palestinian towns, from which an expedition returned with 1,554 captives destined to be given to officials as servants or pressed into labor and military service. Still others may have been hired as mercenaries. By the late Middle Kingdom, segments of this population were fully settled in Egypt. The distribution of foreign names in written documents indicates that some assimi-

Fig. 8. Scene of receiving a caravan of Asiatics, Dynasty 12, reign of Amenemhat II, 1929–1892 B.C., Beni Hasan, tomb 3 (Khnumhotep II). From Prisse d'Avennes, *Histoire de l'art égyptien*, plate 47.

lated, marrying Egyptians and establishing themselves well enough to successfully pursue administrative careers. Additional migrations and settlement in the Delta followed, a process that later contributed to dire circumstances in the Second Intermediate Period (about 1640–1550 B.C.).[57]

Egypt reestablished its contacts to the southeast as well. Probably situated along the Red Sea coast of modern Eritrea, the land of Punt was a highly valued source of incense and myrrh, essential supplies for cultic rituals. Though Egyptian expeditions traditionally disembarked for Punt via the Wadi Hammamat's outlet to the sea at Quseir, a port of choice in the Middle Kingdom lay to the north at the harbor of Mersa Gewasis, where recent excavations have uncovered pottery remains indicating contact even farther south of Punt, along the Gulf of Aden.[58]

The expansion of Egypt's territory, productivity, and population had profound effects on government and society. Several streams of change converged in the reigns of Senwosret III and his successor Amenemhat III, who enjoyed long tenures of thirty-seven and forty-seven years, respectively. If concessions to nomarchs had previously exerted a centrifugal pull of power away from the central state toward some of the provinces, a reconfiguration of the government under Senwosret III enacted an opposing, centripetal force back toward the capital. His reforms created a more pervasive, comprehensive bureaucratic system with a complex range of officials at all levels of government whose ties linked them with the state apparatus. As a result of this transformation, Senwosret III's reign is recognized as the start of the late Middle Kingdom. The nomes persisted, but larger administrative districts (warut) superseded them as the geopolitical basis of running the country. Corresponding new departments at the capital were formed for Upper and Lower Egypt, respectively, with special consideration also for the southernmost nine nomes, collectively called the Head of the South. Itjtawy retained its primacy as the capital, but Thebes functioned as a southern counterpart seat of government. Egyptian-controlled Nubia remained its own entity, but with virtually every bureau of Egypt proper visibly at work in the fort system.[59]

The palace administered the new districts through a centrally integrated system of bureaus, or ministries, the majority of which were subsumed under the vizier's office, which continued to act as the supreme executive and judiciary authority for the pharaoh.[60] These departments included the treasury, a national granary, the Offices of Fields and Cattle, and the military. A new Office of the Provider of People (literally "Office of the People's Giving") placed the coordination of the country's labor pool under the central government's control. A burgeoning hierarchy of delegated responsibilities extended the state's regulatory hand more directly into provincial and local affairs, connecting more people to the central government. Answering to the vizier were a reporter and second reporter for each district. For special commissions a council (djadjat) was designated, and a court (qenbet) monitored recurrent projects away from the capital.[61] A host of other district officials rounded out this system, which brought a corresponding profusion of new administrative titles for all levels of government, from the inner palace at the capital all the way to the provincial town. Among these were numerous positions that conferred scribal and sealing duties, emblematic of a new fervor for constant accounting and accountability in the production, storage, and transfer of goods as well as the activities of personnel.

The advent of the complex, multitiered bureaucracy of the late Middle Kingdom is accompanied in the archaeological record by the impression of a new distribution of wealth in Egyptian society. A pronounced increase in the amount of private statuary and stelae placed at local cult centers demonstrates that a broad cross-section of the populace had the financial means to obtain the services of the sculptors, scribes, and priests required to fashion and support a personal votive monument. The clearest example of this development is at Abydos, where the cult of the god Osiris made it immensely popular as a pilgrimage destination through Dynasty 12. Visitors erected chapels, stelae, and offering tables along a processional route that was the stage for an annual festival reenactment of the god's mythological story. Their hope was to participate in the festival

through the proxy of a monument and thereby gain a share of the Osiris temple offerings for their own cultic structures. A wide range of size and quality is evident among the remains, indicating a socioeconomic differentiation beyond the two-tiered social structure envisioned by the ruling elite in their own monuments. Among the dedicators were many with mid- and lower-level titles, including minor officials, artisans, and even servants. Access to space was influenced by status as well, with smaller monuments filling in spaces between larger ones that occupied prime real estate.[62] By the Thirteenth Dynasty, so many had contributed to this sacred area that a royal decree was issued to prohibit the addition of new structures and prevent them from encroaching on the processional way.[63]

That a broader range of Egyptians were increasingly able to afford such votive accoutrements has been taken as primary evidence of the emergence during the Middle Kingdom of a middle class, a segment of society situated somewhere between the wealthy ruling class and the poorest of peasant farmers. Other sources, however, suggest that this somewhat ambiguously defined component of society was merely brought into clearer view by the new government structures. The ability of the average Egyptian to live beyond a basic subsistence level varied, but historically most who could do so carried administrative, priestly, or military titles, which they invariably recorded on their monuments to indicate the profession from which they made their fortune. There is no denying that the larger bureaucracy offered more opportunities for advancement and profit. Yet, even earlier textual sources include individuals of demonstrable financial means who held no titles linking them to the bureaucracy.[64] Moreover, comparable socioeconomic differentiation is visible in the burial types and grave goods through much of the Middle Kingdom, especially when studied as gauges of differential access to space, skilled labor, and valuable materials. This gives rise to the proposition that rather than being a product of the late Middle Kingdom, this pattern of distribution evolved from developments of the late Old Kingdom and First Intermediate Period, the era of nomarchal florescence.[65]

CLOSURE FOR THE NOMARCHS, CLOSURE FOR THE KINGDOM

Where, then, did the nomarchs fit within these emerging social and governmental conditions? In fact, Senwosret III's reign ushered in the terminal phase of the nomarchs. The title of "true" Nomarch disappeared, and the sequences of large nomarchal tombs of Middle Egypt did not outlast the subsequent reign of Amenemhat III. Though it was once believed that Senwosret III ousted the remaining nomarchs forcibly, it is now understood that less confrontational, more gradual processes were at work. In short, powerful provincial families were absorbed into the national bureaucracy, with their inflence and wealth redirected from their home districts to the residence at the capital.

The naming of nomarchs to high positions of state very early in the Middle Kingdom may have presaged this practice. Probably implemented opportunistically, the phasing out of the nomarchs was under way by the reign of Amenemhat II. Where provincial elite power was not problematic, the king could just deny the confirmation of the next nomarch in the hereditary line.[66] Where governing families were strong or their territories important, young nomarchs-to-be could be taken into the care of the palace and raised and educated as courtiers, possibly alongside royal children who were heirs to the kingship. When of age, they were assigned state-level offices, and returned either to their homelands or other regions as trained officials of state but no longer titled as nomarchs. Their fortunes and loyalties now were directed toward the center of the administrative system rather than to their home provinces, divesting their families of the nomarchal office estate and some of their hereditary holdings as well.[67] The national treasury, with representatives more active in the provinces, now controlled the stores that had formed the basis of much nomarchal wealth.[68] The classic case study for this phenomenon is Khnumhotep III, son of Governor Khnumhotep II of Beni Hasan. Having been educated at the palace in his youth under Senwosret II, he advanced to the office of High Steward under Senwosret III. Rather than construct a tomb in his

ancestral necropolis, he commissioned one at Dahshur in the environs of Senwosret III's pyramid. Whether due to similarly realigned loyalties or diminished local resources, the last large tomb at Beni Hasan (no. 4), that of his half-brother, Khnumhotep IV, was left unfinished.[69]

Along with the gradual diminution of the power of the provincial governors, a concurrent process through the Twelfth Dynasty was the constriction of the primary area of local government from the nome district to the town. The chief local office, then, became that of mayor, which was still designated by the title *haty-a*, but to which was appended the name of a specific settlement. The transition to local governance by township may relate to a propensity of Twelfth Dynasty kings to found new, state-planned towns and to remodel several existing ones to suit an emerging administrative structure.[70] Where known or surmised archaeologically, the residences of Middle Kingdom mayors are palatial buildings composed of a relatively modest, central residential apartment (sometimes with an ancillary apartment), surrounded by blocks of special-function rooms furnished for some of the productive activities that would have taken place on the nomarchal estates.[71] Mayoral estates, however, were certainly smaller than those of their gubernatorial counterparts, and their management was a more closely integrated component of the state's administrative infrastructure rather than part of a loosely tied provincial regime.

The last great king of Dynasty 12, Amenemhat III, enjoyed the fruits of his predecessors' labors. His reign seems to have benefited from peace with Egypt's foreign contacts and subjects, as references to military activity under him are few. Thus his lengthy reign was one of development and display. He shored up Egypt's borders and the Nubian fortresses, and showed not only continued but intensified interest in the Fayum agricultural zone, where much of his construction activity concentrated. An increase in the output of fields was achieved by reclaiming land through large irrigation projects, a process begun in earnest earlier

by Senwosret II. Quarrying and mining expeditions were a clear priority during Amenemhat III's reign. His constructions and statuary exhibited a new trend toward the colossal and creative, some garnering attention as late as the Roman occupation of Egypt approximately a millennium and a half later.

Probably already of advanced age following the long reign of Amenemhat III, the fourth Amenemhat continued to pursue quarrying projects, exploit the Fayum, and promote trade across well-monitored borders. His decade as king was a continuation of the years of his predecessor, only without similar monuments that might have established a prominent place for him in later memory. The close of Dynasty 12 was met with a lack of a viable male heir, bringing the female pharaoh Nefrusobek to power for fewer than four years. She was probably the daughter or granddaughter of Amenemhat III, thus sister to Amenemhat IV, but her tendency to associate her building activities with those of the former king may suggest the need to validate her legitimacy. Though details of her reign are few, its end does not seem to have been marked by upheaval.

Dynasty 13, which historians still sometimes include as part of the Second Intermediate Period (about 1640–1550 B.C.) rather than the Middle Kingdom, was accompanied initially by little detectable change in the day-to-day administration of Egypt. Some top state officials even remained in office through the changeover. However, patterns of royal succession altered dramatically and suggest an equally stark change in royal politics. In contrast to the tight succession of the Twelfth Dynasty's eight rulers over two centuries, about sixty names fill the roster for the Thirteenth Dynasty's span of barely a century and a half. A core group of around thirty kings are among the better-known ones, but their precise ordering is disputed, even with respect to the founder of the dynasty.[72] Individual reigns show a staggering disparity in length, one lasting as long as twenty-four years and others as

short as a few months or even weeks. Cases in which the kingship was transferred from father to son, or sometimes from brother to brother, are few. The overall picture, then, is of a period devoid of a single royal family. Rather, influential families with ties to the court vied for control and put forward candidates for king from their own ranks, with high positions sometimes filled by other family members.[73] The mechanisms of transition are unknown. Depending on the reign, these prominent families may have held the real political power, reducing kings to mere figureheads.

A few kings were able to build large burial monuments, including five stone pyramids (two at Saqqara, two at Mazghuna, and one at Dahshur). Other possible pyramids have been suggested, but their attributions remain speculative pending further investigation.[74] Many kings of this dynasty probably constructed smaller monuments of less-enduring mud brick.[75] An overall shift to Abydos's more southerly burial site may relate to its importance to the god Osiris or may reflect political changes later in the dynasty. Whereas the early dynasts continued to rule from the Twelfth Dynasty capital of Itjtawy and sited their burial places in the Memphite region, later kings, many of whom reigned less than a full month, found themselves pushed southward to Thebes as the Nile Delta came under the control of a people of northern Canaanite origin now known as the Hyksos.[76] Egypt was once again divided. The southern Egyptians found themselves pinched between these foreign rulers of the north and the now quite powerful Kushites from Upper Nubia, whose coordinated efforts severed Egypt's commercial ties and suppressed attempts at unified Egyptian rule for approximately two and a half centuries. Two Theban brothers, Kamose and Ahmose, eventually expelled the Hyksos and drove the Nubians deep into their homelands, and in so doing gave rise to the Eighteenth Dynasty and the New Kingdom.

NOMARCHS AS BENEFICIARIES AND CASUALTIES

Although the nomarchs of ancient Egypt were the beneficiaries of circumstance during the state's meltdown of the late Old Kingdom and First Intermediate Period, they were also the casualties of the state's growth and success during Dynasty 12. These provincial governors indeed occupied a pinnacle of Egyptian society, but it was a society in flux. As put by one scholar, by the late Twelfth Dynasty, the few remaining nomarchs were "living fossils even during their lifetime. And—as we know—the dinosaurs died out, because they lived in unfavourable surroundings."[77] Through a give-and-take dynamic with Egypt's pharaohs, nomarchs affected the social and administrative shape of Egypt from the late Old Kingdom through the late Middle Kingdom. Although their claims to the trappings of royal status may have resonated with citizens in their provincial spheres, their fortunes throughout the Middle Kingdom moved in contrast with those of Egypt's pharaohs. As the capital's business of managing an expanding and prospering nation transformed government bureaucracy into a growth industry, the nomarchal office became regarded as an unsustainable level of middle management, and its responsibilities were redistributed. Concurrently, Egypt's kings reestablished their claim to divinity, some being worshiped as gods perhaps before they died, but certainly for many centuries thereafter in response to their accomplishments. Ironically, the desire of later regents to build upon their foundations—literally and figuratively—led to the loss of most of the structures they had built, thus reducing the detail now available to us for many of those reigns. Yet, several Middle Kingdom kings were granted places of pride in the ancient Egyptians' historical annals. Though the opposing trajectories of kings and governors intersected in ways that can be documented or inferred from fragmentary material, many questions remain open concerning the sociopolitical fluctuations between state and province. As the case of Deir el-Bersha illustrates, both ongoing research and renewed study of past excavations offer exciting possibilities to enhance our current understanding of every level of ancient Egyptian society.

FUNERARY BELIEFS AND PRACTICES IN THE MIDDLE KINGDOM

DENISE M. DOXEY

FOR THE ANCIENT EGYPTIANS, the tomb was not simply a place to bury the dead but a location where the living and dead could continue to interact. Surviving death to be reborn in the afterlife was thought to be a complicated process requiring a group effort on the part of the gods, the king (who served as an intermediary between the gods and humans), mortuary priests, the deceased, and their survivors. A great deal of work was involved. The body had to be preserved through mummification. A person's life force, known to the Egyptians as the *ka*, required ongoing sustenance in the form of food, beverages, and clothing. The *ba*, an aspect of the human spirit believed to move back and forth between the worlds of the living and dead, needed guidance to navigate the dangerous roads to the afterlife and to appease hostile beings guarding the route. The living were expected to maintain their ancestors' memory by visiting their tombs, bringing them offerings, repeating their names, and reciting prayers for the blessing of the king and the gods. None of these responsibilities could be taken for granted, and wealthy Egyptians made elaborate and expensive provisions to guarantee their eternal lives by building, decorating, inscribing, and furnishing their tombs, in some cases even drawing up complex legal contracts with the priests who would look after their cults.

Although many elements of Egyptian burial practices and the fundamental beliefs underlying them remained more or less the same over three thousand years, some significant changes occurred over time, and the First Intermediate Period and Middle Kingdom experienced some of the most dramatic developments in the history

of Egyptian funerary religion. The most important change involved the context and content of funerary texts. In the Old Kingdom, at the end of Dynasty 5 (2465–2323 B.C.), the world's oldest preserved religious inscriptions, known today as the Pyramid Texts, first appeared on the walls of the burial chambers of King Unas at Saqqara.[1] The texts combined spells protecting the body, hymns to various deities, requests for offerings, and elaborate passages describing the king's ascension into the heavens, where he was welcomed by the gods and became a star in the night sky. Particularly important in the events described were the sun god Ra, who presided over the sky by day, and Osiris, who ruled the netherworld below the earth. At the end of the Old Kingdom the Pyramid Texts also began to appear in the tombs of royal family members. For the most part, nonroyal tombs from this period included only requests for offerings and biographies demonstrating the virtues of the deceased.

By the early Middle Kingdom, when large-scale royal tomb building resumed after the disruption of the First Intermediate Period, funerary texts were no longer included in royal monuments; they were instead inscribed on the interiors of coffins and burial chambers of elite, but nonroyal, officials. The practice gave them their modern name, the Coffin Texts. While incorporating many elements of the Pyramid Texts, the Coffin Texts added important new features. Among the most notable was an increased focus on the dangers of descending to the afterlife through the earth, as opposed to ascending to the sky, and a related increase in the importance of Osiris relative to Ra.[2] This shift in emphasis toward the

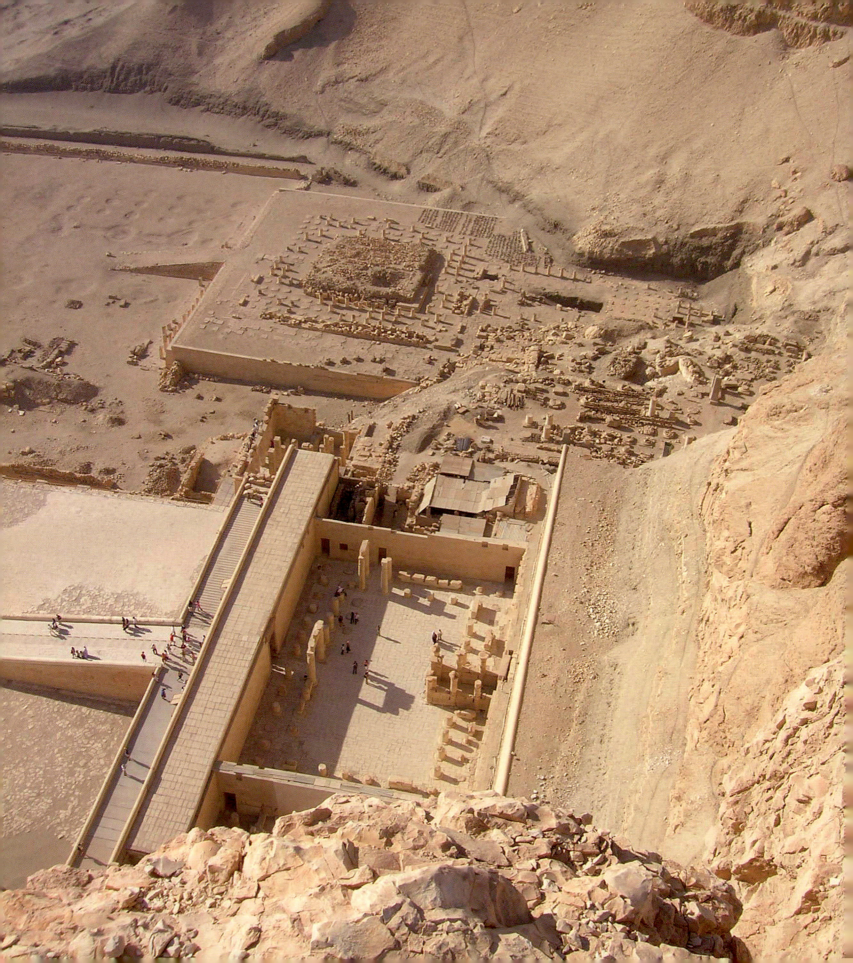

underworld may also be reflected in an increase in the number and variety of offerings placed in the subterranean burial chambers of tombs at this time. Alongside the Coffin Texts, burials sometimes included a map that outlined potential routes to the afterlife. The map is known today as the Book of Two Ways (fig. 80, p. 127). Central Egypt, the region of Deir el-Bersha in particular, played a crucial role in the development of both the Coffin Texts and the Book of Two Ways. Eventually the Coffin Texts would form the basis of the New Kingdom Book of the Dead, and the Book of Two Ways would evolve into the so-called Underworld Books, which decorated the New Kingdom royal tombs in the Valley of the Kings.

ROYAL TOMBS AND MORTUARY TEMPLES

Royal tombs and their adjacent temples also underwent significant changes during the Middle Kingdom as kings alternately experimented with innovative architectural designs and returned to centuries-old traditions from the Old Kingdom. In Thebes the kings of Dynasty 11 inherited a local tradition of building what are known today as *saff* tombs, from the Arabic word for "row." Carved into the cliffs of el-Tarif on the northwest bank of the Nile, the tombs consisted of a series of chambers with subterranean burial shafts behind long, pillared facades opening onto courtyards. As Middle Kingdom founder Mentuhotep II consolidated his power, he used his increasing wealth and prestige to transform the design into a unique multilevel complex set into the imposing cliffs of Deir el-Bahri, slightly south of his ancestors' cemetery (fig. 9). Unlike the tombs of his immediate predecessors, it incorporated both his burial place and his mortuary temple, along with burial chambers for his wives and other women associated with his court.

Mentuhotep's mortuary temple took a previously unknown form. At the foot of the cliff were the temple gardens. From there, a ramp led to a terrace surrounded by a colonnade, in the middle of which stood a rectangular building. Although the complex is now largely destroyed, surviving elements of the decoration show the king in the company of deities, including the Theban warrior god Montu, to whom the kings of Dynasty 11 were especially

devoted (fig. 34, p. 67). By Dynasty 12, another Theban god, Amen, would replace him in prominence. Figures of the king as Osiris reflect his growing association with the popular funerary god (fig. 35, p. 68). Sunk into the temple garden was a tomblike chamber—possibly a symbolic tomb of Osiris—that housed a seated statue of the king in the garments of his *sed*-festival. The festival was a jubilee typically held in the thirtieth year of the king's reign and was intended to rejuvenate him, just as Osiris was rejuvenated after death to become the king of the afterlife.

Little remains of the other royal tombs of Dynasty 11. Amenemhat I apparently began a tomb near Deir el-Bahri at the onset of Dynasty 12, but abandoned it when he moved the capital to Itjtawy.[3] At nearby Lisht, he built a mortuary complex that combined most elements of late Old Kingdom pyramids with certain Theban features.[4] Senwosret I's better-preserved pyramid at the same site adhered to a stricter Old Kingdom model, in which the pyramid was entered from the north and the mortuary temple stood on the east, facing the rising sun (fig. 10).[5] The design suggests an effort by the kings to identify themselves with illustrious predecessors at a time when they were still solidifying their rule in early Dynasty 12. Although only fragments of the temple's

Fig. 9. View of Deir el-Bahri. Photograph by Lawrence M. Berman.

Fig. 10. View of Lisht, Pyramid of Senwosret I, Dynasty 12, reign of Senwosret I, 1971–1926 B.C. Photograph by Nicholas S. Picardo.

relief have survived, the decoration probably included scenes of the king performing rituals for various deities, as had been the case in Old Kingdom mortuary temples. Two walls surrounded the complex. The inner one was decorated with 150 massive panels in the form of *serekh*s, representations of the palace facade topped by the falcon god Horus (fig. 11). The *serekh* symbol dates to the earliest years of Egyptian kingship and identifies the king as the living Horus. The causeway that connected the desert complex to a second temple at the edge of cultivated land was once lined with statues of Senwosret I in the pose of Osiris. Unfortunately, the

pyramid's burial chambers are now filled with groundwater, the pyramid temple is poorly preserved, and the remains of the valley temples lie beneath modern occupation, so it is impossible to know what these structures looked like or whether the burial chambers were inscribed.

The reign of Amenemhat II was a time when funerary beliefs seem to have been undergoing changes in both the royal and nonroyal realms. Mid– to late–Dynasty 12 rulers began to depart from Old Kingdom models and to experiment with a variety of plans and locations for their pyramids. Amenemhat II's pyramid at Dahshur was set in a long enclosure with a massive entrance pylon. Its burial

chamber was uninscribed, indicating that by this time at least the Pyramid Texts were no longer in use. Senwosret II's massive mud-brick pyramid at el-Lahun, near the entrance to the Fayum Oasis, incorporated a new design for its interior, possibly in an unsuccessful attempt to thwart grave robbers. The burial chamber was reached through a vertical shaft located outside the pyramid and connected to it by a tunnel, rather than having the traditional entrance in the pyramid's north wall. Another innovation in the design has no practical purpose and must have a religious explanation: an interior passage loops around the burial chamber from south of the entrance, with a reentry point from the northwest. Scholars have argued that this feature both reflects the deceased king's circumnavigation of the stars, an allusion to the Pyramid Texts, and creates a subterranean island, a feature associated with the myth of Osiris.[6]

Senwosret II's pyramid, like that of all Middle Kingdom rulers, was robbed almost completely, but surviving grave goods from surrounding tombs hint at the spectacular wealth of its burials. Excavating the graves of the royal family in 1913, Sir William Flinders Petrie and Guy Brunton opened the disturbed burial shaft of Princess Sithathoryunet.[7] In a small mud-filled niche in the wall of the burial chamber, they uncovered a magnificent cache of jewelry and cosmetic equipment of gold and semiprecious stone, along with remains of the superbly crafted boxes of inlaid ebony and ivory that had originally held them. The jewelry is among the finest preserved from ancient Egypt. Among the collection is a matching ensemble of girdle, bracelets, and anklets, all made of amethyst and gold, including amuletic beads in the form of lions and other wild felines (fig. 12). Amulets of dangerous animals were believed to protect the body of the deceased on the journey to the afterlife. The exquisite craftsmanship and costly materials can only hint at the extravagant wealth the pyramids and surrounding tombs must once have held.

During the course of his long reign, Senwosret III experimented more dramatically with the traditional mortuary complex than any of his predecessors.[8] Returning to Dahshur, he originally built a pyramid

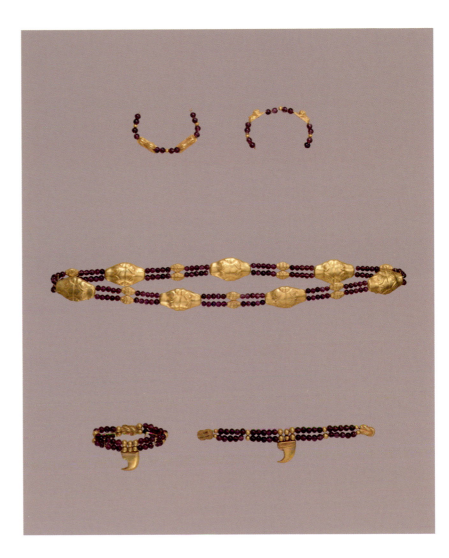

with a traditional temple arrangement. At a later date, the complex was significantly enlarged to the north and south, and a new mortuary temple was built in the southern enclosure. Although smaller in scale, the southern temple and enclosure mimic the layout of the earliest stone pyramid, which was built at Saqqara by King Djoser some seven centuries earlier. The decoration, although fragmentary, also includes elements not seen since Djoser's time, such as the king's *sed*-festival. Senwosret seems to have been seeking a connection to Egypt's ancient past by associating himself not just with the kings of the Old Kingdom but also with its founders.

Fig. 12. Leopard-head girdle, pair of claw anklets, and lion bracelets of Sithathoryunet, Dynasty 12, reign of Senwosret II–Amenemhat III, about 1897–1797 B.C., The Metropolitan Museum of Art, New York, Purchase, Rogers Fund and Henry Walters Gift, 1916, 16.1.6–7, 16.1.14a–15a. Image © The Metropolitan Museum of Art.

In building a second tomb and temple complex at Abydos, Senwosret III took his association with the past even further, returning to the cemetery of his earliest royal predecessors.[9] At the same time, he expanded and renovated the cult center of Osiris, whose tomb was believed by the Middle Kingdom Egyptians to lie at the site. He cut his own enormous subterranean tomb into the cliffs at the foot of a natural pyramid-shaped feature known to the Egyptians as Anubis Mountain, named for the god whose role was to protect the dead and guide them to the afterlife. A long curved shaft reached beneath the mountain, with the royal burial chamber at its central point. The current excavator of the site, Josef Wegner, has identified the design as a precursor of the New Kingdom royal tombs in the Theban Valley of the Kings. The mortuary temple, with its associated industrial facilities and a planned town for those involved in the cult, stood at the edge of the cultivated land. The complex is the earliest known example of a type of temple that would become standard in the New Kingdom, by which time it would be known as the king's Mansion of Millions of Years.

Like his father, Amenemhat III built two funerary complexes. The earlier, at Dahshur, featured an unusually complex array of internal tunnels, chambers, and chapels, including a series of royal burial chambers, a *ka* chapel, and tombs intended for Amenemhat's queens.[10] Construction of the pyramid was stopped due to structural difficulties, and a second pyramid was begun at Hawara. Although there were fewer chambers and corridors than at Dahshur, the pyramid housed burial chambers for at least two queens as well as for the king. The most remarkable feature of the complex was the massive pyramid temple, the plan of which was so complicated that later Greek travelers dubbed it the Labyrinth and described it as more impressive even than the Great Pyramid at Giza.[11] Almost nothing remains of the temple today, but the ground plan suggests it was modeled after Djoser's funerary complex, with a series of mock palaces and other ceremonial structures. Amenemhat III's was the last major pyramid to be constructed in the Middle Kingdom.

NONROYAL TOMBS

Just as royal tomb complexes incorporated both hidden burial chambers and visible temples for the worship of deceased kings, tombs for people of high but nonroyal status included a chapel set at ground level, where survivors could make offerings to dead relatives, and a subterranean burial chamber intended to protect the body and grave goods. In the Memphite cemeteries, where the tombs stood in the desert near the kings' pyramids, these tombs took the form of solid rectangular structures built of mud brick with interior chambers lined with limestone. This type of tomb is known today as a *mastaba*, from the Arabic word for "bench." The burial chambers below could also be lined with stone and decorated, sometimes with Coffin Texts and the Book of Two Ways. The Memphite cemeteries have produced relatively little Middle Kingdom material when compared with those in the Nile Valley, but today archaeologists are discovering new tombs and producing important new information about officials who were buried there, including relatives of nomarchs from Middle Egypt who went on to serve in the central administration at Itjtawy.[12] In central and southern Egypt, where the Nile Valley was relatively narrow, the tombs were cut into the surrounding cliffs and consisted of an entrance court (sometimes preceded by a causeway), a pillared hall decorated with scenes and inscriptions relating to the life and afterlife of the deceased, and one or more subterranean shafts for the burial of the tomb's owner and his family (fig. 13). The Djehutynakhts' tomb at Deir el-Bersha was originally of this type. Unfortunately, the upper hall collapsed as a result of quarrying in the surrounding hills, destroying the decoration and virtually all the evidence the tomb might have provided about its inhabitants. Only the underground shafts survived.

The chapels of large elite tombs like the one Djehutynakht must have commissioned featured elaborate decoration (figs. 4–5, pp. 26–27). From the Old Kingdom onward, they almost invariably showed scenes of the deceased seated at a table eating, with copious amounts of food and beverages depicted beside and beneath the table, and inscribed offering lists to expand

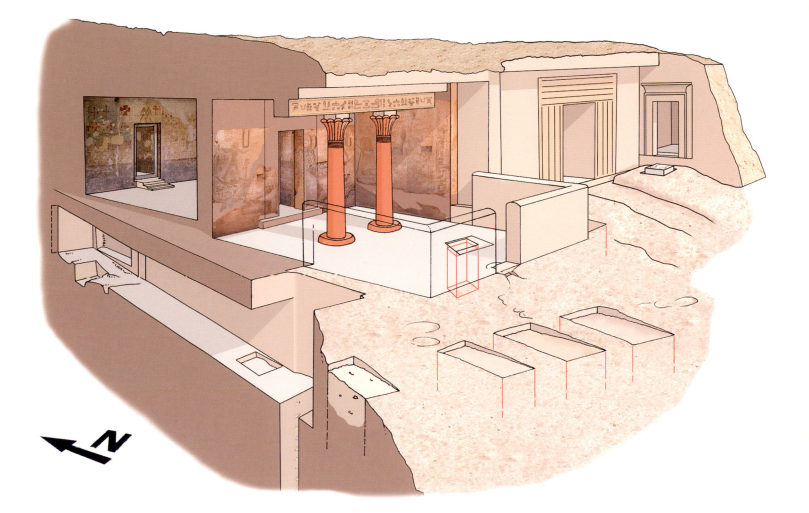

N

the menu. Processions of offering bearers approached the table bearing cuts of meat and other provisions for the feast. Symbolically, such scenes were meant to furnish eternal sustenance for the *ka*. By the late Old Kingdom, the repertoire of representations on tomb chapel walls had become increasingly complex. They included scenes not only of food and beverages for the deceased, but also of food production and other activities, such as the manufacture of goods. The tomb owner was shown hunting wild animals with his sons in the desert and fishing and hunting marsh birds from a boat with his wife and children of both genders.

The *ka* statue, located in a niche opposite the tomb's entrance, was the focal point of the mortuary cult. On festival days, family members and friends entered the chapel to present offerings and recite prayers for the deceased. This practice was not exclusively for the benefit of the dead. Believing that *ba*s could intercede in the world of the living and with the gods, Egyptians left letters seeking assistance with problems such as illnesses, legal entanglements, and financial woes. In some cases the requests were written on the very vessels in which they brought their offerings, where the dead could hardly miss them. A letter on the outside of a bowl, for exam-

Fig. 13. Reconstructions of rock-cut tomb 2 (Djehutyhotep) and tomb 3 (Amenemhat) at Deir el-Bersha. Image courtesy of Katholieke Universiteit Leuven Mission to Dayr al-Barshā.

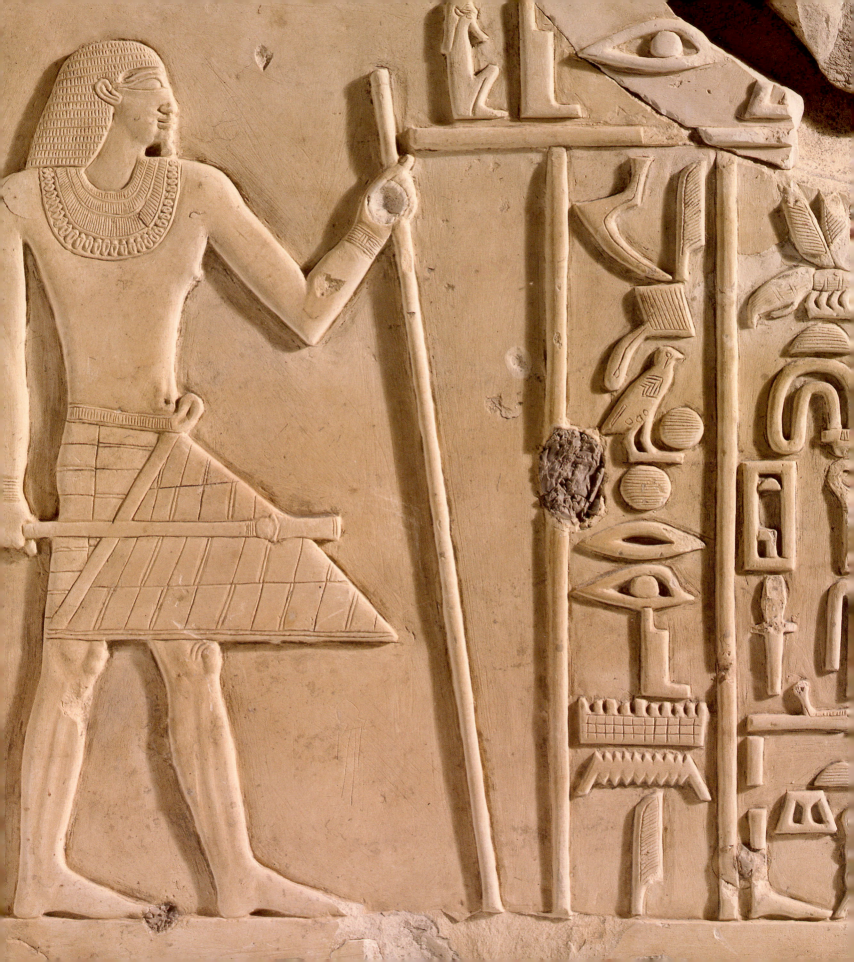

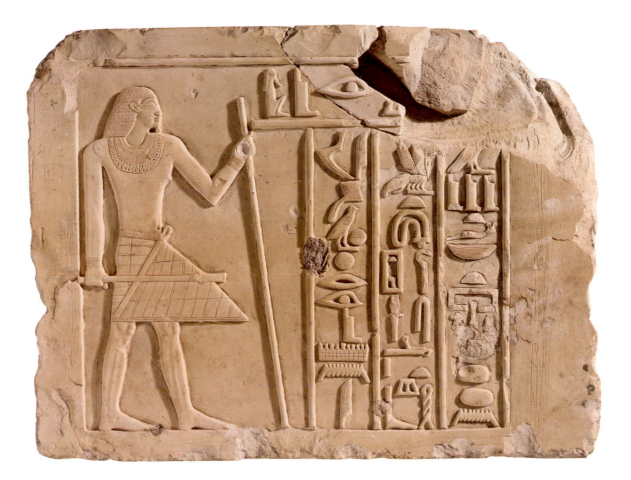

ple, was addressed by a woman named Merti to her dead son Mereri. Evidently the mother believed that a malevolent spirit was to blame for her family's hardships. She exhorts her son:

> stand up to your enemies, male and female, who are ill disposed to your mother and your brother. . . . In your own interests, be the most favorable of my dead, male or female. You know what he told me: "It is I who will bring action against you and your children." Bring action yourself since you are in the place of vindication."[13]

The words "in your own interests" politely suggest that further offerings could be withheld if the sender's wishes went unmet.

The only tomb chapel at Deir el-Bersha to survive in relatively good condition belongs to the nomarch Djehutyhotep, who lived during the reigns of Senwosret

II and III, several generations after the Djehutynakhts. Djehutyhotep's tomb is justifiably famous for its decoration. Along with the traditional subjects, the tomb shows the transport of a colossal statue of Djehutyhotep (fig. 7, p. 30). The massive size of both the statue and the crew charged with moving it reflects the prominence of Djehutyhotep in his own district and gives him almost royal attributes. A fragmentary scene showing Djehutyhotep's entourage, including soldiers who may have formed his bodyguard, also emphasizes his local importance (fig. 6, pp. 28–29).[14] An archer leads the procession, followed by four men with the nomarch's carrying chair, officials, and additional soldiers. Walking beneath the chair and identified by name is Djehutyhotep's dog, Ankhu. The procession reminds one of the three-dimensional procession models from the tomb of Djehutyhotep's ances-

Fig. 14. Stele of Meny, First Intermediate Period, Dynasty 9, about 2100 B.C.

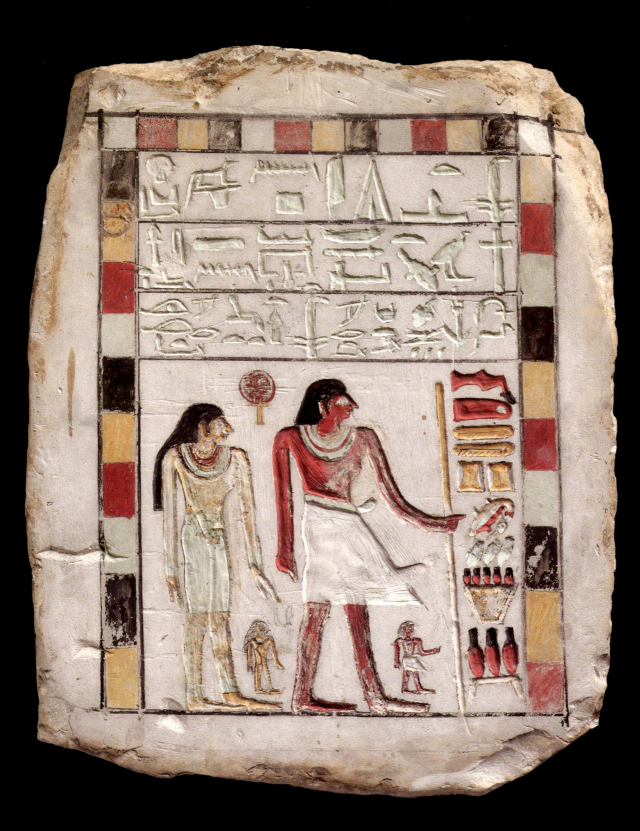

tor, Djehutynakht, whose chapel may well have included scenes of his own subordinates.

*Mastaba*s and rock-cut tombs were available only to the wealthiest Egyptians. For those in the next tier of society, the chapel was replaced by a single stele, or stone slab, containing only the essential elements necessary for the mortuary cult, namely an image of the deceased, his or her names and titles, pictures of food for the *ka*, and an offering formula. Throughout the First Intermediate Period and Middle Kingdom, these basic features remained remarkably stable despite dramatic changes in society and artistic conventions. Over time, however, certain less-obvious developments took place, including an increase in the importance of Osiris and a growing elaboration of the offering formula. Three stelae serve to illustrate this phenomenon (figs. 14–16). A First Intermediate Period stele from Mesheikh in central Egypt depicts an official named Wadjsetji and his family, whose figures fill most of the stele (fig. 15). They face a tall pile of food offerings, and the text above them bears an offering formula that reads:

> An offering that the king gives, and Anubis, who is upon his mountain, who is in the embalming place, the lord of the necropolis, invocation-offerings for the sole companion Wadjsetji and his wife, his beloved, the sole royal ornament, Merirtyfy.[15]

The stele of Meny, from Dendara in southern Egypt, also dates to the time before the reunification (fig. 14). The rectangular stele shows Meny standing at the left, and a brief offering formula occupies the rest of the stele.

> An offering that the king gives, and Osiris, in all his places, invocation-offerings for the seal-bearer of the king of Lower Egypt, estate manager, sole friend and lector priest, one honored before Osiris, Meni.[16]

The text illustrates that by this time in southern Egypt, Osiris had replaced Anubis as the principal funerary deity. The round-topped stele of Seniankhu and his wife Iy, from Sheikh Farag near Mesheikh, dates from late in the reign of Amenemhat III, some three centuries after the burials of Meny and Wadjsetji (fig. 16). Although the relief style is that of the late Middle Kingdom, the scene is essentially unchanged from the time of Wadjsetji. Seniankhu and Iy stand on the left, before a mound of offerings. The offer-

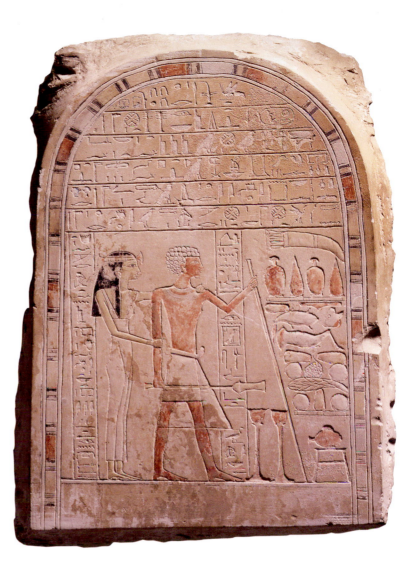

ing prayer includes the same fundamental elements as those from centuries earlier, but by this time new epithets of Osiris and an expanded list of offerings had been added.

> Year thirty under the majesty of the king of Upper and Lower Egypt, who lives forever, Nimaatra [Amenemhat III]. An offering that the king gives and Osiris, the lord of Busiris, the great god, lord of Abydos in all his places, invocation-offerings of bread and beer, beef and fowl, clothing and alabaster, a thousand food offerings and every divine offering for the ka of . . . the guardsman Seniankhu, vindicated, born of Weserhathor, vindicated, the son of Ik, vindicated, and his favorite beloved wife, the honored one, the mistress of the house, Iy, born of Dedetnebu, vindicated.[17]

Fig. 15. Stele of Wadjsetji and Merirtyfy, First Intermediate Period, Dynasties 9–11, about 2100–2040 B.C.

Fig. 16. Stele of Seniankhu and Iy, Dynasty 12, reign of Amenemhat III, 1844–1797 B.C.

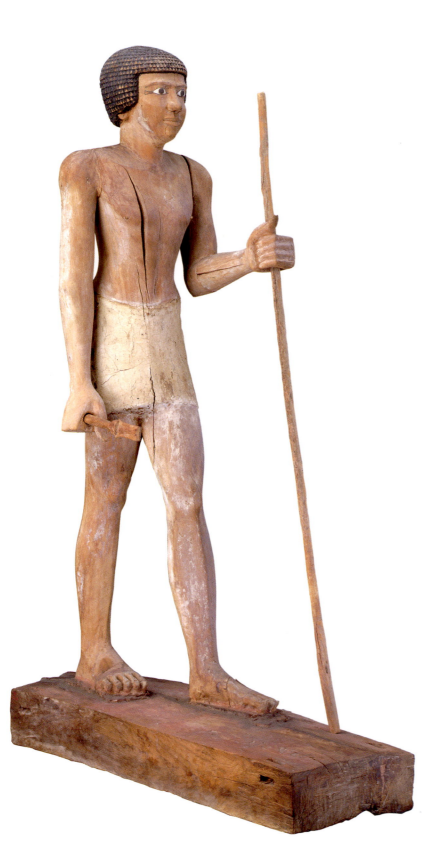

TOMB EQUIPMENT OF THE EARLY MIDDLE KINGDOM

The ancient Egyptians assumed that the necessities of life on earth, particularly food and drink, would continue to be needed in the afterlife. Accordingly, the actual items, models, depictions, and/or textual references to them were included in burials. Just as it was believed that the body would be reborn if the proper conditions were met, so the accompanying material would also magically provide sustenance and enjoyment in perpetuity.

During the early years of the Middle Kingdom, when the Djehutynakhts were buried, an extensive number and variety of grave goods accompanied wealthy burials. Among them were objects used in life, such as walking sticks, jewelry, clothing, mirrors, and cosmetic equipment, as well as items made specifically for the tomb, such as models of offerings, food, tools, weapons, servants, craftsmen, boats, houses, granaries, and agricultural activities. Many of these possessions were arranged on top of and around the coffins in positions that held significance in the burial ritual. The thieves who plundered the Djehutynakhts' burial chamber ransacked it and left the grave goods scattered, but the position in which the models were found suggests that many of them had once stood on top of the nomarch's coffin. Despite the theft of the jewelry and precious metals, the tomb attests to the complexity of the early Middle Kingdom burial assemblage.

The purpose of the models, like the scenes of similar activities in the tomb chapel, was to provide magically for the *ka* of the tomb owner in eternity and to provide transportation on the route to the afterlife.[18] Old Kingdom burial assemblages occasionally included limestone models of people engaged in activities such as grinding grain, baking bread, and brewing beer. Such statues were the precursors of wooden models that reached their high point of creativity, quantity, and variety in the early Middle Kingdom. By the late Eleventh Dynasty or early Twelfth Dynasty, models depicting agricultural activities expanded in both number and type. Scenes of animal husbandry were especially popular in Middle Egypt,

where Deir el-Bersha is located and where the Nile Valley is at its widest and best suited to farming.[19]

Just as the models in the burial chamber duplicated scenes and activities portrayed in the tomb chapel, statues of the tomb owners in the burial chamber reinforced the function of their statues and depictions in the chapel above. Like the models, these burial chamber statues were typically made of wood. The figure of Wepwawetemhat from Asyut exemplifies the type of statue produced in central Egypt in the beginning of the Middle Kingdom (fig. 17). Wepwawetemhat stands with his left foot forward, wearing a short kilt and holding the long staff and scepter that identify him as an official. The pose and accoutrements, in fact, duplicate in three dimensions the hieroglyphic symbol for the word *official*. The short wig and kilt show that he is a young man. A smaller and somewhat later wooden statue of an official named Nakht, also from Asyut, is of a man of more advanced years, as indicated by his long kilt and bald head (fig. 18). His plump physique demonstrates his prosperity. Like Wepwawetemhat, he stands with his left leg forward. The carving of the statue is particularly fine, and the inlaid eyes set into copper frames give the man a strikingly lifelike appearance.

Coffins from the late First Intermediate Period and early Middle Kingdom, like those of the Djehutynakhts, were rectangular, made of wood, and fairly plain on the outside. Typically, a single line of hieroglyphic text around the sides contained an offering formula identical to those inscribed on grave stelae, requesting the necessary provisions for a good burial from the king and funerary gods (fig. 19). On the left side of the coffin, at the end where the head of the mummy would have rested, was a pair of sacred *wedjat* eyes representing the eyes of the falcon god Horus. In addition to being protective symbols, the eyes were believed to allow the mummy resting on its side with its face immediately behind the eye panel to "see" into the afterlife. The coffins' interiors were often more elaborately decorated, bearing representations of offerings and items required for the afterlife. It is here that the Coffin Texts typically occurred as

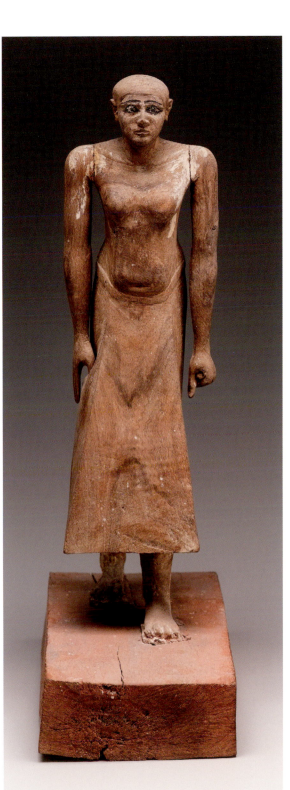

Fig. 17. Statue of Wepwawetemhat, First Intermediate Period–Middle Kingdom, probably late Dynasty 11, 2140–1991 B.C.

Fig. 18. Statuette of Nakht, late Dynasty 11 or early Dynasty 12, 2040–1878 B.C.

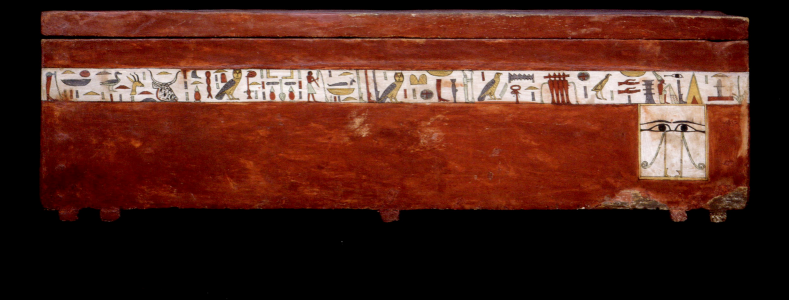

Fig. 19. Coffin of Menqabu, First Intermediate Period, probably early Dynasty 11, 2140–2040 B.C.

Fig. 20. Plaster form of the mummy of Wah, Dynasty 12, reign of Amenemhat I, about 1975 B.C., The Metropolitan Museum of Art, New York, Rogers Fund, 1940, 20.3.203. Image © The Metropolitan Museum of Art.

well. The coffins of Djehutynakht are among the best examples of interior decoration to have survived from ancient Egypt.

Middle Kingdom mummies were wrapped in successive layers of bandaging that give them a characteristically fat appearance. In 1935 the Metropolitan Museum of Art unwrapped the mummy of Wah, a near contemporary of the Djehutynakhts from Thebes, and found that it had been enveloped in more than 375 square yards (313.5 square meters) of linen (fig. 20).[20] Jewelry and amulets adorned the bodies of even relatively minor individuals, as exemplified by the impressive assortment of jewelry found in a single burial at Naga el-Deir in central Egypt (fig. 21).[21] The deceased wore a silver pendant in the form of a *uraeus* cobra, and necklaces, armlets, bracelets, and anklets of carnelian, amethyst, quartz, jasper, faience, shell, silver, and ivory. Among the jewelry were amulets intended to protect the body, such as claws on the anklets and abstract lion and crocodile amulets on the

faience girdle, which also contains an amulet of the hippopotamus goddess, Taweret. Taweret was the protector of pregnant women and children and, by association, those hoping to be reborn in the afterlife. The collection offers a hint of what the Djehutynakhts' jewelry and amulets may have been like.

During the Middle Kingdom, traditionally royal accoutrements became part of nonroyal grave assemblages. These included items such as scepters, maces, cobras like the example from Naga el-Deir, and false beards associating the deceased with Osiris. A new element of burial equipment at this time was the funerary mask, which was designed to cover the mummy's head and shoulders and give it a lifelike appearance (fig. 22).[22] Masks were made of wood or cartonnage (layers of linen soaked in plaster and painted). For the wealthiest individuals, like Djehutynakht (whose mask was destroyed by grave robbers), the facial area was gilded to represent the gold flesh of the gods, with whom the deceased

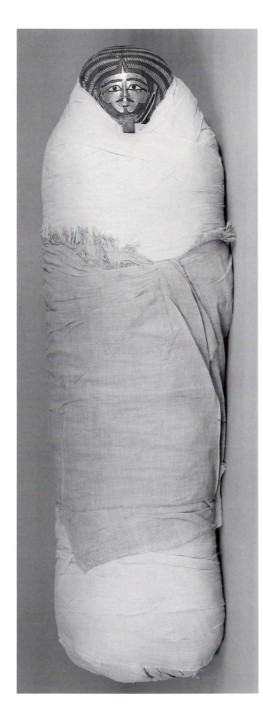

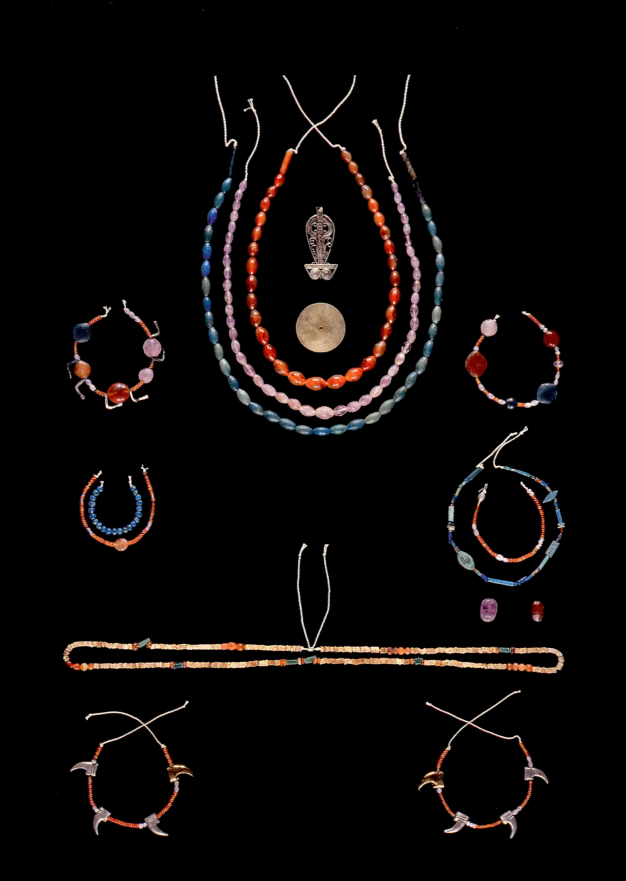

were now identified. More often, masks were merely painted yellow in imitation of gold. The eyebrows and other facial hair were rendered in blue because the Egyptians believed that the hair of the gods was made of lapis lazuli. The painted details also included elaborate jewelry such as diadems and broadcollars. A long, plain front panel would have been hidden in the wrappings, and the face was left exposed.

During the mummification process, the lungs, liver, stomach, and intestines were removed from the body, mummified separately, and placed in specially designed containers known today as canopic jars. Prior to the Middle Kingdom the jars had simple, flat lids, but in the Middle Kingdom lids took the form of human heads (fig. 23). The boxes housing the canopic jars carried interior and exterior decoration identical to that of the coffins, including Coffin Texts in some cases. They were probably manufactured in the same workshops that produced the coffins.

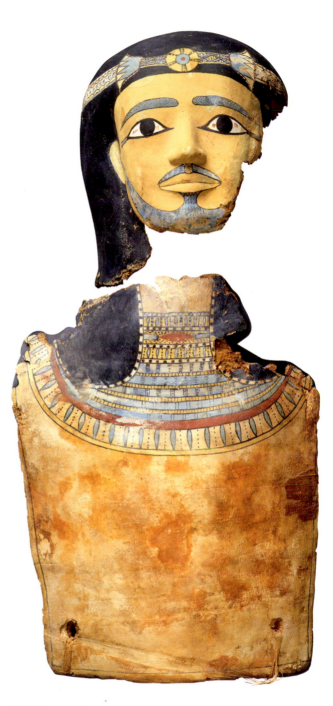

Fig. 22. Mummy mask, Dynasty 11 to early Dynasty 12, 2140–1926 B.C.

Fig. 23. Canopic jar lid, late Dynasty 12–early Dynasty 13, 1820–1740 B.C.

Fig. 21. Set of sixteen articles of jewelry, Dynasty 11, 2140–1991 B.C.

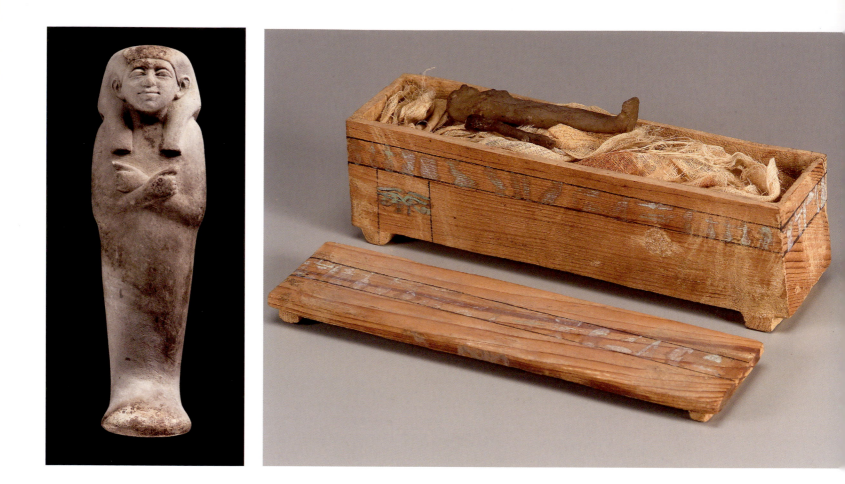

Fig. 24. *Shawabty*, late Dynasty 12 to Dynasty 13, 1878–1640 B.C.

Fig. 25. *Shawabty* of Queen Neferu with miniature coffin, Dynasty 11, reign of Mentuhotep II, 2040–2010 B.C.

TOMB EQUIPMENT OF THE LATER MIDDLE KINGDOM

During the second half of Dynasty 12, just as royal monuments began to exhibit major changes, nonroyal funerary offerings also changed dramatically.[23] The most obvious manifestation of this process was the abandonment of large elite tombs in most areas of Middle Egypt, including Deir el-Bersha, in favor of burials closer to those of the kings. Burial goods also underwent notable transformations. The number and variety of models placed in tombs were drastically reduced, and eventually only model boats were continued.[24] Instead of models of agriculture and craft production, the Egyptians introduced a figurine type known as a *shawabty* as a new means of providing for the dead in the afterlife (fig. 24). Named for the ancient Egyptian word for "answerer," *shawabty*s were

intended to work on behalf of their owners when called upon to perform agricultural labor in the underworld. The earliest *shawabty*s were merely wooden or wax pegs, sometimes inscribed with spells and placed in miniature coffins (fig. 25). In the second half of the Middle Kingdom, they began taking the form of mummies equipped with agricultural tools. *Shawabty*s would continue to appear in Egyptian tombs for the remainder of the pharaonic era.

Coffin decoration also evolved as the dynasty advanced, becoming increasingly standardized during the reign of Senwosret III and later.[25] Added to the relatively plain exterior decoration favored in earlier times were vertical columns of text containing prayers to various funerary deities, including the four sons of Horus, who protected the internal organs and represented the four pillars believed to support the heavens. Later, coffins

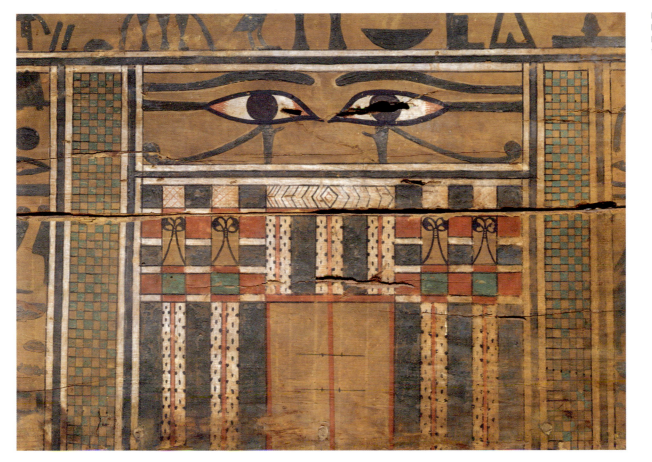

Fig. 26. Coffin of the Lady of the House Neby, Dynasty 12, 1991–1783 B.C.

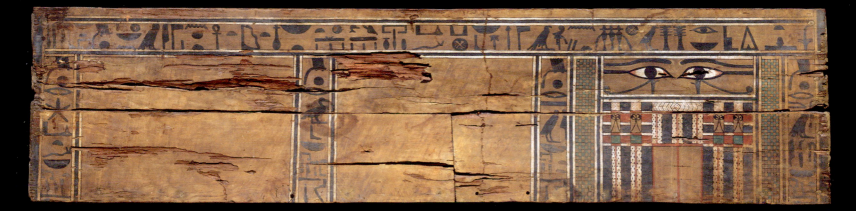

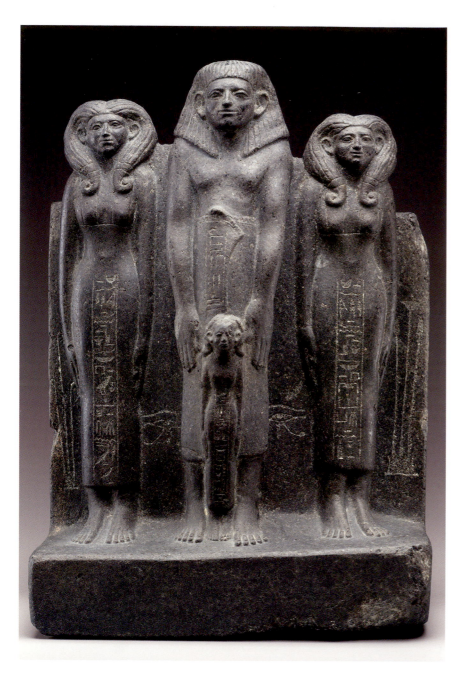

Fig. 27. Group statue of Ukhhotep II and his family, Dynasty 12, reign of Senwosret II or III, 1897–1841 B.C.

began to incorporate palace facade decoration, as seen on the example belonging to the lady Neby from Beni Hasan (fig. 26). By the end of Dynasty 12, decoration covered the entire coffin exterior. Meanwhile, the object friezes and Coffin Texts on the interiors disappeared. Also in late Dynasty 12, coffins in the form of a mummified body came into use, and full-body cartonnage covers were sometimes used in place of mummy masks.

In the second half of Dynasty 12, wooden tomb statues of officials frequently were replaced by small-scale statues in hard stone. Often the deceased is shown in a long cloak or wrapped as a mummy, which suggests that the statues' function was related to that of *shawabtys*. Although individual figures continued to be placed in tombs, statues of family groups became increasingly popular, as exemplified by a statuette of the nomarch Ukhhotep II of Meir and his family dating to the reign of Senwosret II or III (fig. 27).

At the same time, a number of new magical devices appeared, including wands and rods, female figurines, and faience models. Such items were absent from earlier tombs like those of the Djehutynakhts, although they did appear in offering friezes on coffins. Based on the appearance of these items just as the Coffin Texts ceased, some scholars have argued that they replaced some of the texts' functions in offering protection.[26] Ivory wands are among the most distinctive classes of such objects found in late Middle Kingdom burials (fig. 28). The curved wands retain the shape of the hippopotamus tusks from which they were carved, with one side usually flat and the other convex.[27] The decoration on a wand now in Boston includes a procession of protective deities and real and fantastical animals bearing knives. The face of a feline appears on the curved end, and the pointed end displays that of a canine accompanied by a lotus blossom, an Egyptian symbol of rebirth. The other creatures include a lion, a cat, a frog, the hippopotamus goddess Taweret, a composite feline deity, a winged griffin, and a seated jackal-headed god. The last figure is a sun disk with legs carrying the symbol of life. Taweret and the god behind her lean on

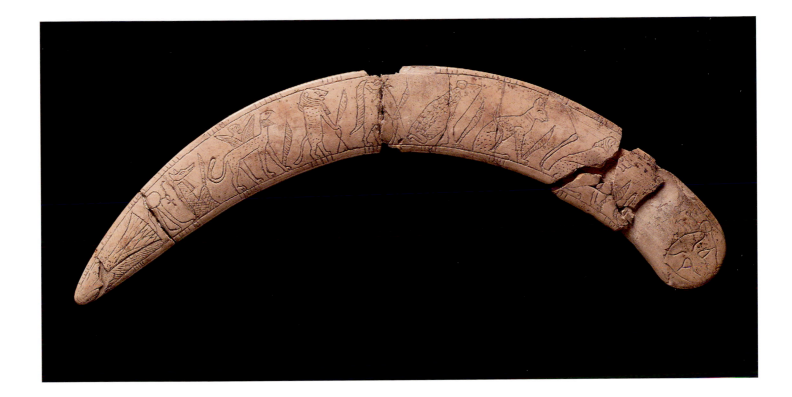

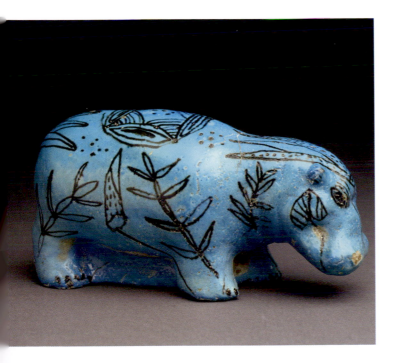

the hieroglyph for "protection"; the symbol explains the function of the wand. Scholars believe that the wands were used in life to draw protective circles around a person's bed, in order to magically ward off snakes and scorpions, as well as to offer protection to women and babies during pregnancy and childbirth. In the Middle Kingdom, this protection was extended to the deceased, ensuring a safe rebirth in the afterlife.

Also joining the repertoire of grave goods during the second half of the Twelfth Dynasty were figurines of hippopotami made of blue faience and decorated in black with representations of aquatic plants and creatures associated with the marshes in which hippopotami dwell (fig. 29). The function of these objects is not fully understood. Because both the color blue and the marsh environment symbolized fertility, some scholars have suggested that the figurines were intended to aid in the rebirth of the deceased.[28] It is also possible that they

Fig. 28. Ivory wand, Dynasty 13, 1783–about 1640 B.C.

Fig. 29. Hippopotamus figurine, Dynasty 11–13, 2040–about 1640 B.C., Musée du Louvre, Paris, E 7709. Photograph Hervé Lewandowski / Réunion des Musées Nationaux / Art Resource, New York.

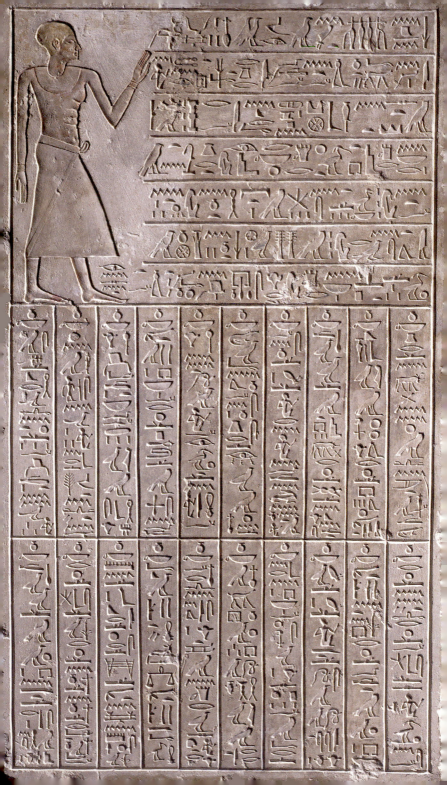

served a protective function. The hippopotamus was a creature associated with the chaotic forces of nature and the storm god Seth. By harnessing its dangerous powers for their own use, the Egyptians believed they could offset the very threats it represented. Interestingly, many of the figurines had at least one leg broken, perhaps to render them powerless to cause harm in the burial chamber.

ABYDOS AND THE CULT OF OSIRIS

As evidenced by both the Coffin Texts in nonroyal tombs and representations of kings in royal temples, Osiris rose during the early Middle Kingdom to become the supreme funerary deity throughout Egypt at all levels of society (fig. 37, p. 69). Tradition held that Osiris, Egypt's original king, brought fertility and civilization to the Nile Valley before being murdered and dismembered by his jealous brother, Seth, the god of chaos. Osiris's wife and sister, Isis, recovered and reassembled Osiris's body parts, reviving him in the process and conceiving a son, Horus, who would avenge his father and claim the throne of Egypt. Resurrected, the mummified Osiris became ruler of the afterlife, and Horus reigned on earth. In the Old Kingdom, kings already envisioned themselves as the embodiment of Horus on earth and of Osiris after death, but in the Middle Kingdom nonroyal individuals also hoped to merge with Osiris in the afterlife. Just as Horus had to prove himself worthy of his father's throne, the deceased were required to prove that they deserved to become an Osiris. They did this by both demonstrating good behavior in life and facing judgment at the entrance to the afterlife. Biographies in tomb chapels provided evidence of the former, and the Coffin Texts addressed the latter. Those who succeeded in showing that they were "true of voice" (as described in the Coffin Texts) gained admittance to the afterlife and became effective spirits known to the Egyptians as akhs.

By at least the early Middle Kingdom, the Egyptians identified the First Dynasty tomb of King Djer at Abydos as the burial place of Osiris himself, and Abydos became a sanctuary of national importance. In the early Twelfth

Dynasty, Senwosret I undertook a major expansion of the cult center, prompting a building boom in which officials constructed mud-brick chapels along the processional route from a temple enclosure known as the Terrace of the Great God to the early dynastic cemetery.[29] The chapels' interiors, lined with elaborately inscribed limestone panels, housed cult statues of their owners (fig. 42, p. 75). Although they were not the actual burial places of those who commissioned them, the chapels' decoration in many ways mirrored that of tomb chapels.

Perhaps the finest example of such a chapel is that of Intef, son of Sobekwenu and Senet. It was built when Intef made a pilgrimage to Abydos in the thirty-ninth year of Senwosret I's reign.[30] Three large stelae formed the walls of the statue chamber, the inscriptions of which are masterpieces of both art and literature. The central panel contains an offering scene identical to the type found in the chapels of actual tombs. On one side panel, Intef stands in the upper corner facing a seven-line poem that describes the consecration of his chapel and calls Abydos "a seat blessed since the time of Osiris, settled by Horus for the forebears, served by the stars of heaven" (fig. 30). The biographical inscription occupying the rest of the stele is arranged in uniform vertical segments, each containing a phrase introduced by the words "I am" and describing Intef as the epitome of the civil servant: patient, polite, calm, friendly, generous, intelligent, eloquent, faithful, and honest. The text borrows directly from a popular literary genre of the age comprising instructional treatises that advised readers on how to live a moral life and earn the right to a happy and successful afterlife.[31] The stele's unique combination of visual and verbal symmetry has led it to be considered the culmination of Egyptian autobiography.

Just as group statues became popular in tombs during the later Twelfth Dynasty, at Abydos large stelae bearing the image of a single official gave way to those featuring groups, which included both families and colleagues.[32] The inscriptions on such stelae took on a strictly religious character as hymns to the king or Osiris or simple offering prayers largely replaced biographies. The most complex cenotaphs took the form of minia-

Fig. 30. Stele of Intef, Dynasty 12, reign of Senwosret I, 1971–1926 B.C., British Museum, London, EA 581. Image © The Trustees of the British Museum.

Fig. 31. Carved slab from the funerary chapel of Sehetepibra, Dynasty 13, about 1783–about 1640 B.C., The Metropolitan Museum of Art, New York, Rogers Fund, 1965, 65.120.1. Image © The Metropolitan Museum of Art.

Fig. 32. Carved slab from the funerary chapel of Sehetepibra, Dynasty 13, about 1783–about 1640 B.C., The Metropolitan Museum of Art, New York, Rogers Fund, 1965, 65.120.2. Image © The Metropolitan Museum of Art.

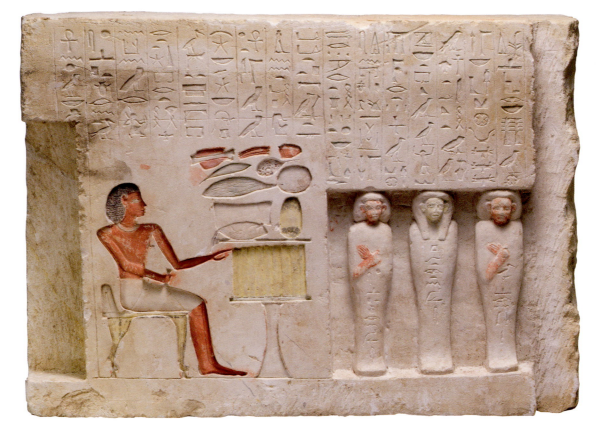

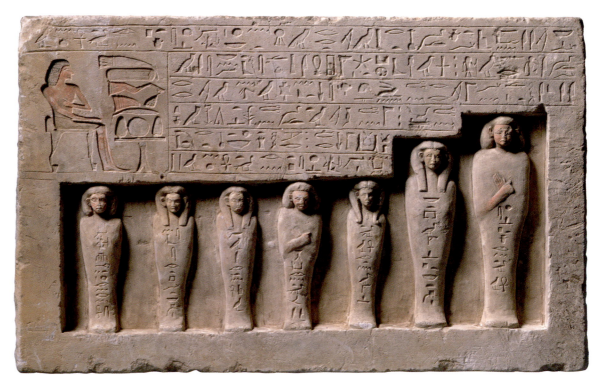

ture tomb chapels for entire families. As time progressed and access to the Terrace of the Great God became more widespread, an increasingly larger segment of the population dedicated stelae and small statues, some merely rough limestone fragments with ink inscriptions.[33]

A highly unusual pair of Thirteenth Dynasty stelae formed two sides of an offering chapel (figs. 31–32). They include several members of a family standing in niches, and a seated figure of the chapel's owner, an official named Sehetepibra, is rendered in relief at the left before a table laden with offerings. The texts contain an offering formula, an appeal to visitors to maintain the cult, and a brief description of the dedication of his monument at the Terrace of the Great God. A unique feature of the stelae is that the individuals are shown mummified, like a series of shawabtys. Each is identified by name, and the artist has even taken pains to portray them as distinct individuals. With these stelae, the connection between developments in late Middle Kingdom burial practices and the cult of Osiris is illustrated with particular clarity.

The Djehutynakhts and their Middle Kingdom contemporaries witnessed revolutionary changes in many aspects of funerary beliefs and practices. Royal pyramid complexes, a hallmark of the Old Kingdom, underwent changes both subtle and profound until, by late Dynasty 12, kings began to experiment with subterranean tombs that would later become the norm in the New Kingdom. The decoration of elite nonroyal tomb chapels adhered in many ways to Old Kingdom precedents, but the contents of the burial chambers were modified repeatedly over the years as the Egyptians revised their thinking on the requirements for an ideal afterlife. Wooden models, for example, entered the repertoire of grave goods,

became ubiquitous, and then all but disappeared. Only model boats, whose function related to travel to the afterlife rather than sustenance for the *ka*, would continue in the New Kingdom.

The funerary priests of the Middle Kingdom reinterpreted the ancient Pyramid Texts, editing and expanding them into the body of work we know as the Coffin Texts. The concept of providing a map to the afterlife in the form of the Book of Two Ways was entirely new. In the Middle Kingdom, such maps first appeared in nonroyal coffins and burial chambers, but they would eventually reemerge in the New Kingdom as a primary element of royal tomb decoration in the Valley of the Kings. Although the Coffin Texts decreased in popularity in late Middle Kingdom coffins, they must have survived in more perishable media, for they formed the basis of the New Kingdom Book of Going Forth by Day in the Underworld, better known today as the Book of the Dead. Written mainly on papyrus and mummy wrappings rather than coffins, the texts would, over the course of the New Kingdom, reach a far wider audience than the Middle Kingdom Egyptians could have imagined.

With the growing importance of the cult of Osiris, a divine afterlife became possible for a larger segment of the population than ever before. Whereas the Coffin Texts of the early Middle Kingdom were restricted to only the wealthiest burials, the humble stelae set up at Abydos by the end of the Middle Kingdom indicate that even those of modest means aspired to benefit from Osiris's largesse. The prominence of Osiris would only grow during the New Kingdom, as the decoration of both royal and nonroyal tombs increasingly focused on the journey to the afterlife.

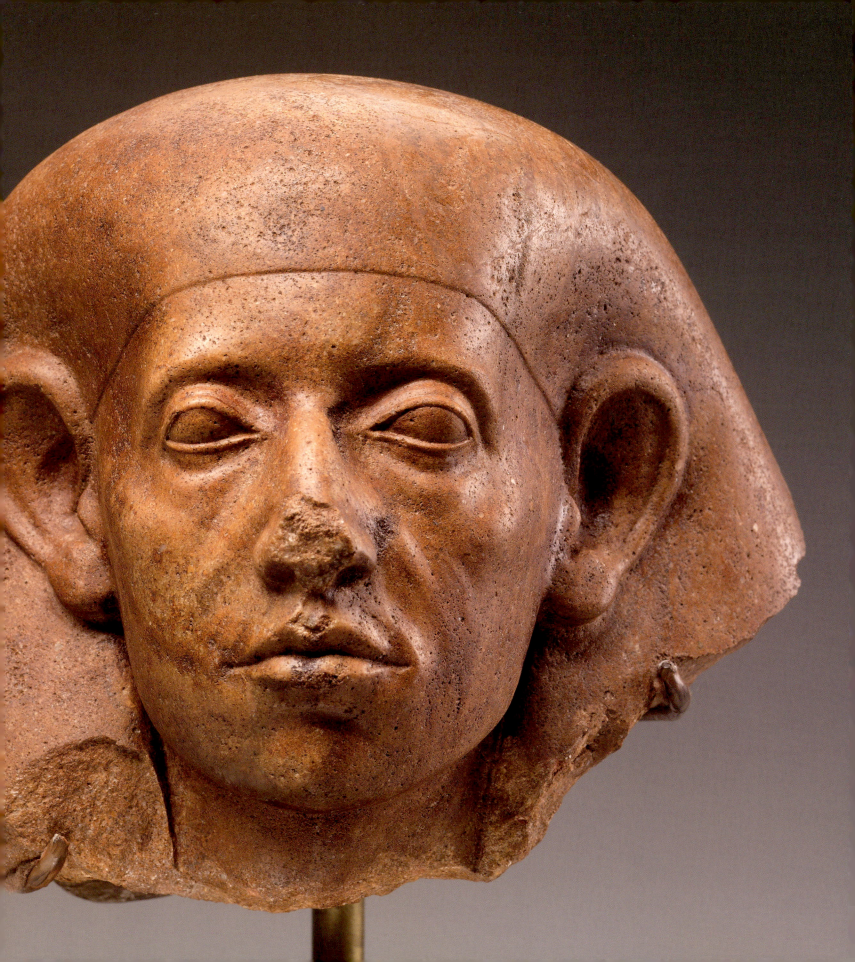

ART OF THE MIDDLE KINGDOM

RITA E. FREED

AFTER THE TURMOIL of the First Intermediate Period, the long and prosperous reigns of the Middle Kingdom brought the domestic stability and international contacts that allowed the arts to flourish. Anonymous artists from this period of Egyptian history produced some of the most sophisticated, creative, and technically complex works the world has ever known. Undoubtedly, a dynamic tension between the restored central authority and still-powerful provincial nomarchs contributed to this creativity. Material from the tomb of the nomarch Djehutynakht and his wife at Deir el-Bersha shows, on the one hand, the sophistication of royal art of the beginning of the Twelfth Dynasty and, on the other, the individual local preferences of the region. Understanding the art of the Middle Kingdom will shed light on the broader framework of the era in which the Djehutynakhts lived and showcase the marvelous achievements of this brief and underappreciated chapter in Egyptian culture.

ART OF THE EARLY MIDDLE KINGDOM

The reign of Nebhepetra Mentuhotep II is key to an understanding of early Middle Kingdom art. As the king gradually increased his power base over the course of fifty-one years, he altered the spelling of his name and related epithets to reflect his new authority. At the same time, he enlarged and modified his funerary temple in his home city of Thebes, on the western side of the Nile, in a bay of cliffs known today as Deir el-Bahri. Because the relief decoration created for the different phases of the temple and its accompanying tombs for royal family members features the different forms of his name, scholars today are able to determine a relative chronology for the art.

Art at the start of the Eleventh Dynasty and into the early years of Mentuhotep II's reign, particularly relief carving, was heavily influenced by the Dendara style of the preceding First Intermediate Period. Dendara was typical of the period's regional centers, each of which developed its own local style prior to the establishment of a strong centralized bureaucracy. Its relative proximity to Mentuhotep II's homeland of Thebes, the broad appeal of its local goddess Hathor, and its unbroken artistic output from the Old Kingdom were the likely reasons for its influence on his artists. The Dendara style is characterized by high raised relief with smoothly rounded edges and skillfully incised details and hieroglyphs (see fig. 14, p. 47). A notable degree of modeling gives figures an almost three-dimensional, lifelike appearance.

The influence of the Dendara style may be seen clearly in reliefs from the earliest elements of Mentuhotep II's funerary complex: six tombs constructed simultaneously for six young women. They were all priestesses of Hathor and probably minor queens; four bear the epithet Royal Wife. A relief from one of the tomb chapels identifies its owner as Kemsit. She is shown seated, wearing a dress, shawl, broadcollar, and bracelets as she sniffs a jar of scented unguent (fig. 33). Underneath the considerable amount of paint that still covers her figure, each separately carved, tiny curl of Kemsit's wig, each bead on her multi-strand broadcollar, and each feather on her dress may be observed. In all, six different levels of relief were necessary to accommodate the garment's complexity, a sophisticated

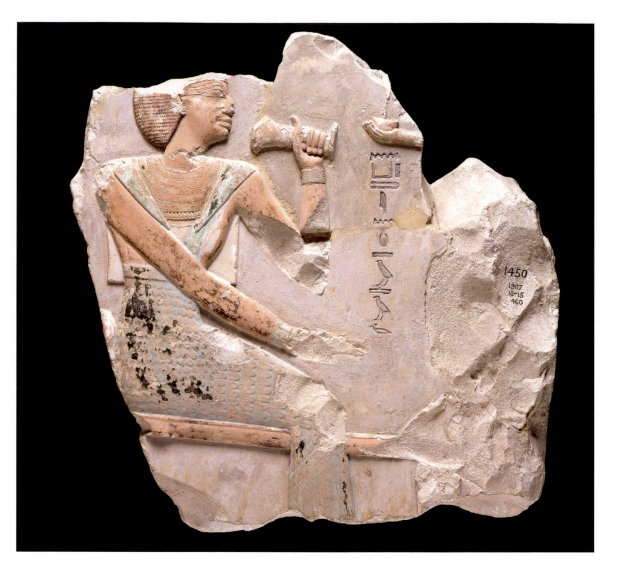

accomplishment for which the cutting back of layer after layer of limestone had to have been planned in advance. Kemsit's high raised relief and patterning borrow a great deal from the Dendara style, but at no time did Dendara artists achieve such intricacy of detail or sculptural quality. Kemsit's overly large and prominent facial features also distinguish her from Dendara reliefs, as do the features of the other royal wives. They are typical of the Theban style and appear to have been copied from tomb to tomb irrespective of how each owner looked in life. The presence of a pre-reunification form of the king's Horus name *neter-hedjet*, "God of the White Crown," in the tombs tells us

that they were constructed while Mentuhotep II was still struggling to consolidate his control over Egypt. Nevertheless, the quantity and sophistication of the relief sculpture (including decorated sarcophagi) clearly show that there was already a dedicated group of artists at Thebes supported by the growing power and wealth of its leader.

A fragment from the tomb of Mentuhotep II's chief queen Neferu contains another form of the king's titulary, the Horus name *sema-ta(wy)*, "One Who Unites the Two Lands." The epithet suggests that Neferu's tomb was made after the king had completed his conquest of an opposing dynasty based in Herakleopolis in the north and

reunited the country, an event that took place no later than his thirty-ninth regnal year.[1] Stylistically, the reliefs in Neferu's tomb, carved in both raised and sunk relief, continue the style of the minor queens' tombs with some modifications. The raised relief is not quite as high, and bolder, less fussy decoration replaces the jewel-like incised detail of the earlier work. The deliberate simplification of detail is accompanied by an exaggerated attenuation of shapes, most noticeably in Neferu's limbs and facial features, including her overly large, fleshy ears.

Both Neferu's and the minor queens' reliefs share the elongated legs, high waists, and small heads that characterize First Intermediate Period material from Dendara and elsewhere. These qualities change in the next and last phase of Mentuhotep II's funerary temple construction, which is marked by the final form of the king's name and clear attempts to reproduce the Old Kingdom canon of proportion. Under royal sponsorship and based largely in the Memphite area, artists of the Old Kingdom had developed a carefully controlled way of reproducing the human figure in both statuary and relief. Works from that period retain evidence that bodies were conceived around a central vertical axis intersected by horizontal lines. Middle Kingdom artists required more guidance to re-create the earlier proportions, so they developed a full eighteen-square grid that accommodated a standing figure from the hairline to the bottom of the foot.[2] The more minute divisions made it easier to make precise copies of Old Kingdom examples, and thereby associate the king with the unquestioned power and divinely given authority of the earlier age.

Examples of works from this phase of early Middle Kingdom art come from the colonnaded halls and sanctuary at the rear of Mentuhotep II's funerary complex, all decorated with relief. In true propagandistic fashion, the subject of the colonnades is the king overcoming enemies, whereas the chapel features intimate scenes of the king received by the gods.[3] One relief fragment from the sanctuary shows Mentuhotep II embraced by Montu, a local god associated with war (fig. 34). Typical of the relief style at the end of the king's long reign, the carving is exceedingly low and flat, with details supplied in paint rather than with the chisel.[4] Compared with ear-

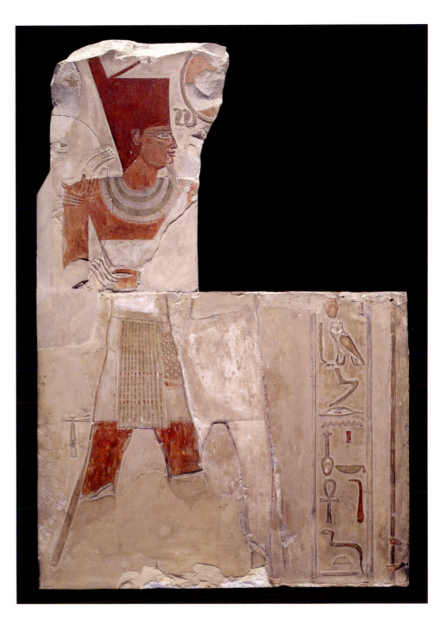

lier reliefs from the reign, the heads are larger, the waists lower, and the legs not as long; in fact, the carving and the proportions of the figures bear a close resemblance to Old Kingdom works from the Memphite region. The similarity can only be a result of Mentuhotep II's artists having traveled north to observe the Old Kingdom material directly, or artists from the Herakleopolitan area coming south to work. Neither would have been possible prior to the reunification of the country.[5] Private, nonroyal reliefs from this

Fig. 34. Mentuhotep II embraced by Montu, Dynasty 11, reign of Mentuhotep II, 2040–2010 B.C., British Museum, London, EA 1397. Image © The Trustees of the British Museum.

Fig. 35. Mentuhotep II
as Osiris, Dynasty 11,
reign of Mentuhotep II,
2061–2010 B.C., The
Metropolitan Museum
of Art, New York, Rogers
Fund, 1926, 26.3.29.
Image © The Metropolitan
Museum of Art.

Fig. 36. Seated statue of
Mery, Dynasty 11, reign of
Mentuhotep II, 2061–2010
B.C., British Museum,
London, EA 37895. Image
© The Trustees of the
British Museum.

time follow the king's example of emulating the Old Kingdom style.[6]

With the exception of small wood pieces, there is little sculpture in the round from the end of the Old Kingdom until the reign of Mentuhotep II. He revived the tradition of life-size royal sculpture, probably after reunifying the country and after his artists viewed the Djoser funerary complex of Dynasty 3 at Saqqara. Like Djoser, Mentuhotep II is depicted throughout his funerary temple complex as Osiris in an enveloping garment with hands crossed over the chest.[7] In just one example of a standing Osiride figure from the Mentuhotep II temple, one may see how the artists preserved the pre–Old Kingdom manner of hardly differentiating the body from the stone (fig. 35).

Mentuhotep II's reunification of the country could not have been accomplished without the aid of trusted military and administrative officials, some of whom were granted the privilege of burial near their monarch. One of these officials was Mery, the king's steward. He held one of the most important offices of the time and was in charge of the royal estate. Mery's two statues bear a striking resemblance to Mentuhotep II's own, although on a smaller scale (fig. 36).[8] They may even have been made by the same artists. Mery's face is as square as his sovereign's and has similarly large and awkwardly carved features. The lack of definition in his arms and torso makes it appear as if the body has no skeletal structure. Mery also has the high waist of figures in early Mentuhotep II reliefs.

The heavy volumes and exaggerated shapes of the Mentuhotep II years gave way to a refined delicacy during the reign of Mentuhotep III. A comparison of an Osiride sculpture of the successor with that of the predecessor reveals how an elegant elongation of the figure replaced stocky mass (fig. 37). Also, in contrast to the knee-length garment of Mentuhotep II and his Old Kingdom predecessors, Mentuhotep III is completely enveloped in the costume associated with the jubilee festival of rejuvenation. Despite the differences, both kings' features are delicately carved upon the face, not organically integrated into it. Mentuhotep III's sculpture comes from the Montu temple at Armant, the only site at which statues of this king have been found.

Fig. 37. Osiride statue of Mentuhotep III, reinscribed for Merenptah, Dynasty 11, reign of Mentuhotep III, 2010–1998 B.C.

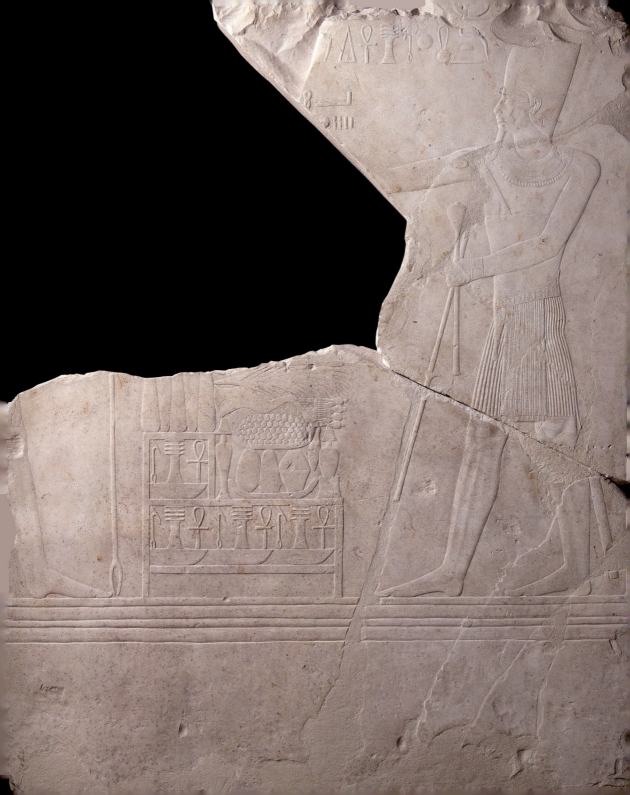

The low, flat relief style seen at the end of Mentuhotep II's reign becomes even lower and flatter—almost paper-thin—during the reign of Mentuhotep III. Remarkably, details that were added only in paint during the previous reign are now precisely and intricately carved, making them some of the most beautiful reliefs Egyptian artists ever produced. One relief from Tod, located across the river from Armant, shows Mentuhotep III beside a table piled with food offerings (fig. 38). His pleated kilt is overlaid with a beaded apron, and a dagger inserted under his belt hangs in front. His belt, bracelet, and multistrand broadcollar are likewise made of individually incised beads. All the contrasting patterning, as well as the highly modeled muscles of the legs, fit harmoniously together and bear testimony to the increasing skills and sophistication of the court artists.

By the time of Mentuhotep III's reign, the king's body proportions reproduced those of the Old Kingdom exactly. Clearly, a unified Egypt provided ready access to the Memphite area's monuments. Itinerant artists from the north may well have found employment in or near Thebes and instructed their counterparts there. Reliefs of Mentuhotep III, like those of Mentuhotep II, have been discovered in temples from Abydos south to Elephantine.[9] Whereas Mentuhotep II's reliefs differ from site to site, those of Mentuhotep III display a remarkable uniformity. This consistency of style indicates that there was a talented, centrally supported artistic school producing a single image of the king.

A NEW DYNASTY

Thebes remained the center of power until a man named Amenemhat, the vizier of Mentuhotep IV, became Amenemhat I, the first king of Dynasty 12. Internal troubles may have forced him to move the capital north to virgin territory on the border between Upper and Lower Egypt, close to the mouth of the Fayum Oasis.[10] Amenemhat I constructed his funerary complex there outside what is now the village of Lisht, but most of the work probably took place under his son and successor, Senwosret I. The two may have ruled jointly for a period of ten years.[11]

Although Amenemhat I's reign lasted three decades, he left remarkably little royal sculpture or relief, perhaps

because he was focused on quelling internal turmoil. The difficulty of evaluating his legacy is compounded by that of isolating his commissions from those of his son. From among the period's scattered fragments, which have been found as far south as Armant, as far east as Sinai, and as far north as the Nile Delta, only two well-preserved, dated statues of Amenemhat I are known. They come from the Delta sites of Tanis and Khatana.[12] One is approximately life-size, and the other, at 2.7 meters (nearly 9 feet) tall, is colossal. Both feature a compact upper body, well-defined musculature, and body proportions that conform to the traditional canon of the Old Kingdom. The head and facial features, in contrast, show a closer affinity to the Theban area's Eleventh Dynasty material, particularly in the way the facial planes lack modeling.[13]

Due to the lack of firmly attributable royal material, much of what we know about the art of this period comes from the private sphere. As before, artists working for the elite are believed to have followed the royal practice of copying Old Kingdom styles. Models were readily available to them near the capital at Saqqara. Two private tombs located north of the Teti Pyramid at Saqqara feature techniques (such as the use of raised and sunk relief in the same composition) and clever details (such as figures carrying two animals or birds bound together in a basket) that occur only in these two tombs and in the Old Kingdom tombs in the immediate vicinity.[14] The owners, Ihy and Hetep, were priests who served the cults of both King Teti of Dynasty 5 and Amenemhat I. In addition to the artistic borrowing, such dual service lends support to the idea that there was a desire to establish continuity with the past and to recapture its ideals.

Reliefs dating from the period are often characterized by a careful balance of food offerings under, beside, and sometimes on top of the main offering table, such that the integrity of an individual item is sacrificed in favor of overall balance or spatial organization (fig. 140, p. 184). This forced grouping of offerings occurs in Ihy's tomb, as well as on contemporary stelae found throughout Egypt. Once again an official style, transmitted by artists accompanying administrators from the capital, supplanted local preferences.[15]

The tombs of Ihy and Hetep also introduce a new sculpture type.[16] Each tomb contained two statues that

Fig. 38. Relief of Mentuhotep III, Dynasty 11, reign of Mentuhotep III, 2010–1998 B.C., Musée du Louvre, Paris, E 15113. Image © 2009 Musée du Louvre / Angèle Dequier.

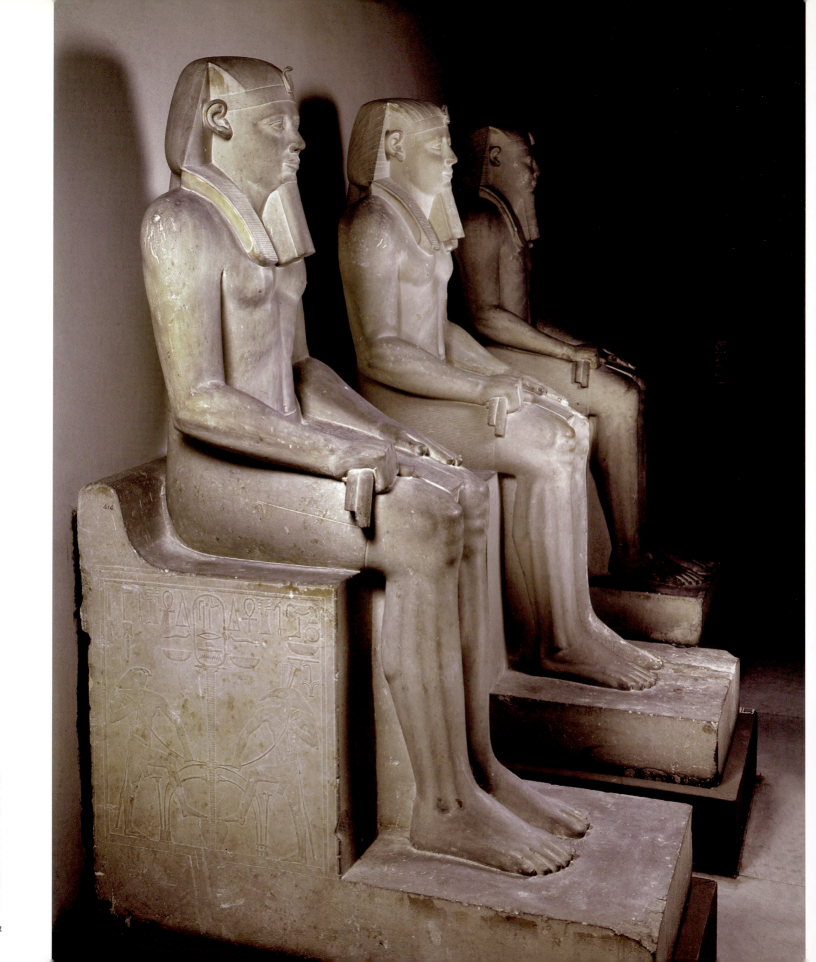

depict the owner seated on the ground with his legs drawn up close to his body and his hands crossed over his knees. Known by Egyptologists as a block or cube statue, this may represent a man seated in a carrying chair, a translation into three dimensions of relief representations abundant in nearby Old Kingdom tomb chapels. It may at the same time signify rebirth: the curved back of the chair represents the horizon, and the round head of the statue resembles the sun emerging from it at the dawn of a new day. Later in the Twelfth Dynasty, this statue type, like others, developed a more abstract form.[17]

In contrast to Amenemhat I's limited building activity, son and successor Senwosret I's was prolific and widespread, extending not only countrywide but also beyond Egypt's borders. We know from textual evidence that the goal of just one of his many far-flung quarrying expeditions was to retrieve sufficient stone to carve 150 statues and 60 sphinxes.[18] Numerous temples and statues from Elephantine to the Delta bear his name. One statue is more than 4 meters (13 feet) tall; a number of others extend over 3 meters (nearly 10 feet); and most stand more than 2 meters (6½ feet) high. Although Senwosret I ruled for forty-five years and his sculptures show significant variation, unfortunately none includes a year date. It is therefore impossible to tell if the various styles artists employed for his commissions changed with time or with an object's location or intended function.

Senwosret I was the first king to build extensively at Karnak, which would become Egypt's largest and most important temple. Given the presence of the many statues of Mentuhotep II at Deir el-Bahri across the river and toward which Karnak was oriented, it is not surprising that Senwosret I's sculptural contributions to Karnak, which include a sphinx and standing statues, continue the tradition of the Eleventh Dynasty. Like the statuary of Amenemhat I, the sphinx and standing statue feature a broad rectangular facial structure with high cheekbones, large flat eyes with thick straight brows and cosmetic lines, firm chins, and unsmiling mouths. Senwosret I's body, with its well-defined pectorals, small waist, abdominal muscles, depressed navel, and median line extending upward, shows a mastery of anatomical detail not seen since the Old Kingdom. Similar statues of the king are known from

Memphis, Tanis, and Alexandria.[19] Osiride statues of the king from Karnak and Abydos, however, differ from the sphinx and standing statues in the slender elongation of their torsos, their oval rather than square heads, and their deeply cut facial features. In its massive breadth and lack of modeling in the midtorso, the example from Abydos is closest in style to the Osiride statues of Mentuhotep II.[20]

Nowhere is the Middle Kingdom attempt to emulate the Old Kingdom clearer than in a group of ten sculptures found buried in the courtyard of Senwosret I's funerary temple at Lisht (fig. 39). The facial features and torsos are well modeled and conform to the canon of proportion, but overall the figures appear cold and lifeless. Their gaze is neither formal nor endearing, and their bodies lack an understanding of skeletal structure. In short, they demonstrate superficial mastery of the Old Kingdom style, but without the inner strength and nobility of spirit that are the hallmarks of the Pyramid Age.

Whereas the sculptures of Senwosret I show an array of styles, most reliefs from his many monuments depict

Fig. 39. Seated statue of Senwosret I, Dynasty 12, reign of Senwosret I, 1971–1926 B.C., Egyptian Museum, Cairo, CG 414. Photograph © Jürgen Liepe.

Fig. 40. Relief fragment depicting foreigners and a battle scene, Dynasty 12, reign of Senwosret I, about 1971–1927 B.C., The Metropolitan Museum of Art, New York, Rogers Fund, 1913, 13.253.3. Image © The Metropolitan Museum of Art.

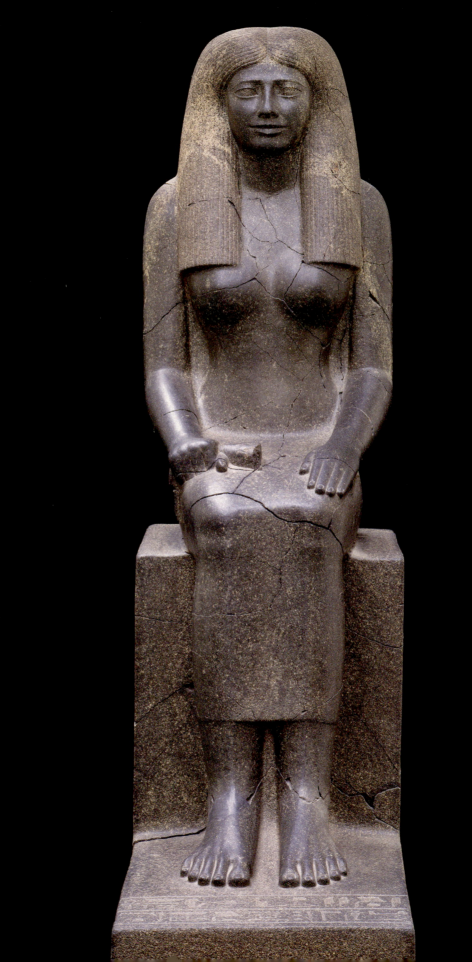

Fig. 41. Statue of Lady
Sennuwy, Dynasty 12, reign
of Senwosret I, 1971–1926
B.C.

Fig. 42. Seated statue of
Intef, Dynasty 12, reign of
Senwosret I, 1971–1926
B.C., British Museum,
London, EA 461. Image ©
The Trustees of the British
Museum.

him in a homogeneous manner.[21] Because refurbishing temples to local gods was part of the king's program to consolidate power, he deployed artists to carve his likeness as far north as his funerary temple at Lisht and as far south as the Satet Temple near the border at Elephantine.[22] Raised reliefs from his reign are higher, with more incised detailing and greater surface modeling than in previous reigns. Mentuhotep III's artists had made use of intricate incised detailing, but the paper-thin depth of their carving limited their ability to render subjects with naturalism or three-dimensionality. Working in high raised relief, Senwosret I's artists were able to go far beyond what Mentuhotep III's had achieved. One example from the king's funerary temple at Lisht depicts what may be a skirmish between Egyptians and Bedouins (sand dwellers) or "Asiatics" (*aamu*; fig. 40).[23] The artists have superbly captured the Egyptian idea of these strangers with their thick, curled hair and aquiline noses, and in the case of the male warrior, a long, pointed beard. Beyond that, they have also captured the fierce dignity of a man and hopelessness of a woman and child seeking mercy from their captors. Even in the most formal of royal reliefs, including those of the White Chapel at Karnak, there are an animation and strength of character that demonstrate how far the royal artists have gone beyond copying, having truly mastered the medium. The same spirit is generally evident in sunk relief representations.

With the increase in royal building activity, private arts also flourished, as highly placed administrators commissioned their own funerary monuments, perhaps from the king's own sculptors. Qubbet el-Hawa and Asyut are two of a number of sites where large tombs bear testimony to the continued importance of the regional governors and Senwosret I's support of them. South of Asyut and north of Thebes, Meir, Beni Hasan, and Deir el-Bersha also feature large, painted or relief-decorated tombs of early Dynasty 12 officials. They display the influence of a peaceful, reunified Egypt in which artists had access to models outside their local areas.

The statue of Sennuwy, wife of Djefaihapi of Asyut, may represent direct royal beneficence toward a regional leader (fig. 41). The figure is the first over-life-size sculpture of a woman known since the end of the Old Kingdom.

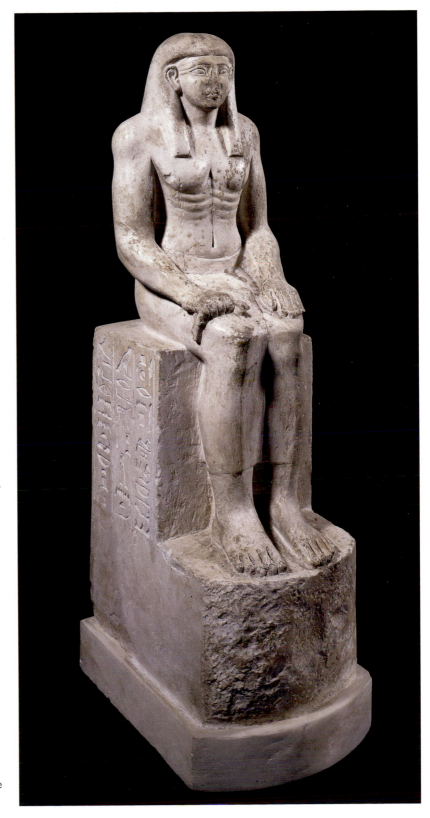

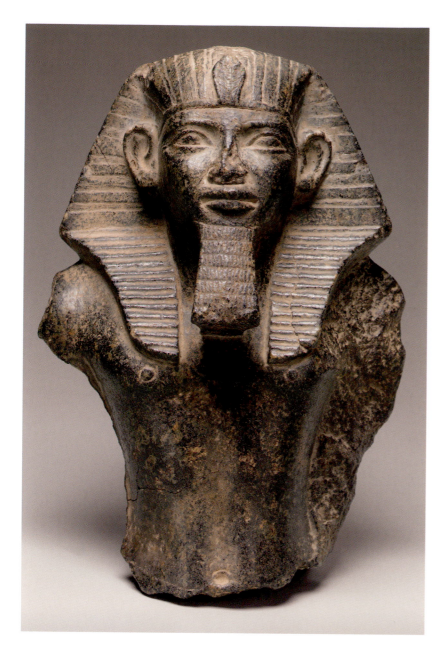

Fig. 43. Statuette of Amenemhat II, Dynasty 12, reign of Amenemhat II, 1929–1892 B.C.

Fig. 44. Seated statue of the steward Sehetepibra-ankh, Dynasty 12, reign of Amenemhat II, 1929–1892 B.C., The Metropolitan Museum of Art, New York, Rogers Fund and Edward S. Harkness Gift, 1924, 24.1.45. Image © The Metropolitan Museum of Art.

Djefaihapi was nomarch of Asyut during the reign of Senwosret I, and his large, decorated tomb, from which the sculpture is thought to originate, was a gift from the king.[24] The size and quality of Sennuwy's statue support the claim that Djefaihapi enjoyed royal favor. With its large, well-formed body and sweet, placid face, it compares favorably with sculptures of the king from the royal residence.

Compared with Sennuwy, a statue of Overseer of Chamberlains Intef represents a more angular, awkward style from the same period. Intef has an unmodeled face with large eyes, which are made more prominent by thick brows and cosmetic lines. Concentric scallops bisected by a deep vertical furrow on Intef's chest extend from his pectorals to his navel. They are probably meant to represent rolls of fat, but because his torso is so thin they look more like ribs, making him appear gaunt instead (fig. 42). On three stelae he dedicated to Osiris at Abydos, pendulous breasts and parallel notches on his belly are clearly meant to indicate corpulence (fig. 30, p. 60). Intef desired to live for eternity as a fat man, a situation made possible only by prosperity. He may have chosen to depict himself in this manner because of a long-lasting famine that began about the twenty-fifth year of Senwosret I's reign. We cannot be sure if he was truly fat during his lifetime.[25]

When Senwosret I died, he left behind a stable and prosperous country. Throughout Egypt new or renovated temples to local gods bore his name. By the end of the reign, artists who carved relief for the king and his high officials had largely succeeded in their quest to reclaim the artistic legacy of the Old Kingdom. On the basis of style alone, it is sometimes difficult to distinguish between reliefs from the two different periods. Sculptors who produced three-dimensional work during this reign, on the other hand, clearly copied Old Kingdom forms but never quite reproduced their inner strength of character.

Amenemhat II succeeded Senwosret I as king, most likely as his son. Despite thirty-seven years of rule, and in stark contrast to his father, remarkably little royal material may be irrefutably dated to his reign, even though inscriptions mention his building activity.[26] Recent work on one of a pair of colossal sphinxes found at Tanis has convincingly demonstrated that traces of Amenemhat II's

cartouche appear on the front of the mane, making it the only fully preserved, dated sculpture from that time.[27] All royal sculpture attributed to Amenemhat II, therefore, is based on this example.

The face of the sphinx is unquestionably broad. The unmodeled expanse of the cheeks contributes to its massiveness. Prominent features include arched eyes with nearly horizontal rims continuing in a wide cosmetic line, thick brows that parallel the eyes and cosmetic lines, a broad nose with nasolabial folds, a philtrum, and straight lips highlighted by a thin raised line. Although on a much smaller scale, a bust of a king in Boston has all of these hallmarks and so may be attributed to Amenemhat II (fig. 43). The harsh, almost brutal quality of these sculptures bears no relation to the sweet idealized faces from the end of Senwosret I's reign.

Although it is not specifically dated, based upon its style the splendid seated statue of the steward Sehetepibra-ankh is likely to have been made during the reign of Amenemhat II (fig. 44). It was found at Lisht, which continued to be used for private burials throughout the Middle Kingdom despite the location of royal burials elsewhere after Senwosret I's reign. Sehetepibra-ankh's features are the same as those found on the king's sphinx. His solid, muscular body is more naturalistically sculpted than those of the previous reign. His wig, which envelops his shoulders and tapers to points above his breasts, represents a new fashion of the time and may subtly mimic the royal *nemes* headcloth. It is masterfully rendered, with modeled waves and incised individual curls carefully tied off at the forehead and lower edge.

Amenemhat II was buried at Dahshur in a pyramid that has not yet been properly explored.[28] A few fragments of royal relief survive from Dahshur and elsewhere, but they are of little value for art historical analysis. Private stelae from Abydos provide the greatest body of material dating from Amenemhat II's reign.[29] The democratization of religion at the sacred site continued the trend begun in the previous reign, which saw an explosion in the number of nonroyal stelae dedicated to Osiris there.[30] The increased demand for monuments was met by a local school of artists. Compared with works created in the time of Senwosret I, they are formulaic. Most are in sunk relief,

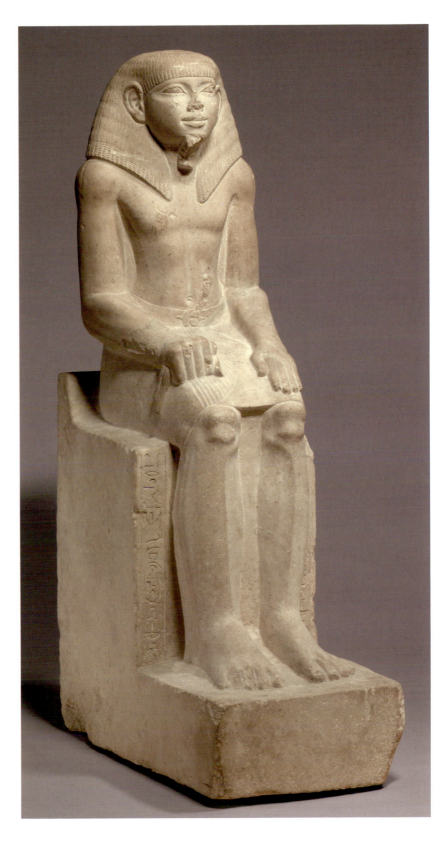

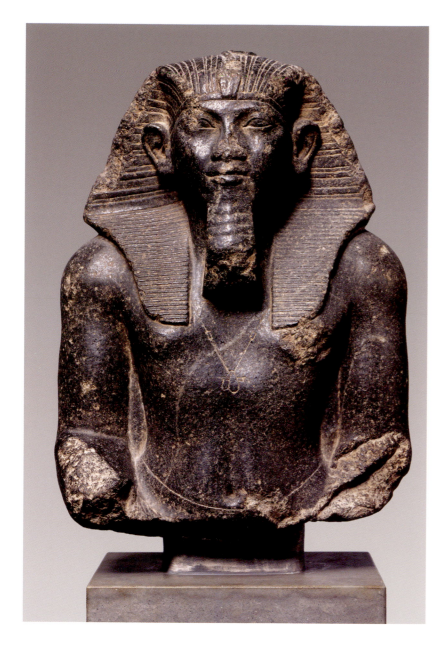

Fig. 45. Senwosret II,
Dynasty 12, reign of
Senwosret II, 1897–1878
B.C., Ny Carlsberg
Glyptotek, Copenhagen,
ÆIN 659. Photograph by
Ole Haupt.

which generally requires less skill to execute than raised relief. Thin, elongated figures of family members stand stiffly in registers facing the dedicant, who is usually seated at an offering table, now devoid of the rich variety of goods seen previously. Although the same artists' hands may be identified on many of them, in no instance is the artist identified.[31]

MATURITY AND A NEW DIRECTION

Although the reign of the next king, Senwosret II, was relatively short (eight to nine years) and little from it has survived, there is evidence that it was one of the most artistically and culturally innovative periods in Egyptian history. Continued economic prosperity, internal stability, exploration of new areas within Egypt, and increased contact with surrounding countries must have contributed to such a flowering. Unfortunately, at least three (and possibly more) colossal images of Senwosret II were altered almost beyond recognition and perhaps moved from their original locations by Ramesses II in Dynasty 19, and then taken to Tanis by another king in Dynasty 22. Other statues of Senwosret II have been found at Karnak, Medamud, and Memphis. No sculpture and relatively few fragments of low, flat, raised relief have thus far been discovered at his funerary complex at el-Lahun, located near the entrance to the Fayum.[32]

Even though they are few in number, the surviving images of Senwosret II clearly show a movement away from youthful idealization toward more psychologically powerful images of maturity and character. A bust of the king said to be from Memphis and originally part of a seated statue has large eyes depressed under strong, overhanging brows (fig. 45). His thick lower lip protrudes downward in a scowl. Pronounced cheekbones and receding cheeks draw attention to nasolabial furrows. Ears pushed artificially forward by the *nemes* headcloth draw even more attention to the face. Regardless of whether it represents a true portrait, the result is a much more stern, unforgiving countenance than previously seen on royal sculpture. Ironically, the king's torso retains the youthful, idealized modeling of earlier statues, but the

beaded chain with a double-lobed pendant he wears is new. The necklace shows both the prosperity and internationalism of the times. Mining operations during this reign produced such exotic and colorful stones as amethyst, turquoise, obsidian, and carnelian, all of which were incorporated into the exquisite and complex jewelry and cosmetic vessels left in tombs associated with the pyramids of Senwosret II and his father.

Sculptures of royal women from Senwosret II's reign are both more numerous and greater in size than those of earlier times. This situation may reflect a larger role for queens in both the political and religious spheres. Two over-life-size images from Tanis of a Queen Nofret have faces that are similar to the king's.[33] The voluminous tripartite wig of both sculptures is similar to the one worn by the great mother goddess Hathor; it pushes her large ears forward, giving her even greater presence. A statue of a queen named Weret, who bears the title Great Royal Wife, has a rounder face but comparable eyes.[34] Similar eyes also lead to the identification of a queen in Boston as Weret (fig. 46).[35] Narrow shoulders and the angle of the break at the neck suggest she came from a sphinx, the ultimate symbol of power in Egypt previously reserved for men. Another sphinx, one representing a daughter of Amenemhat II, was found in the Levant, where it may have been sent as a diplomatic gift or a reminder of Egyptian power. Its style leaves no doubt that it was made in Egypt.[36]

By this time the regional lords were at the peak of their power, as the quantity and quality of their tombs attest. In one painted relief from the tomb of the nomarch Djehutyhotep at Deir el-Bersha, no fewer than 172 men drag a colossal travertine statue of their lord (fig. 7, p. 30). It is a perfect example of the tremendous resources at the nomarchs' disposal and the large building projects they undertook in their homelands as a result. From another nomarch's tomb of this period, one belonging to Sarenput II and located at Qubbet el-Hawa opposite Aswan, we have the first known image of a private individual depicted as Osiris, a privilege previously reserved for royalty.

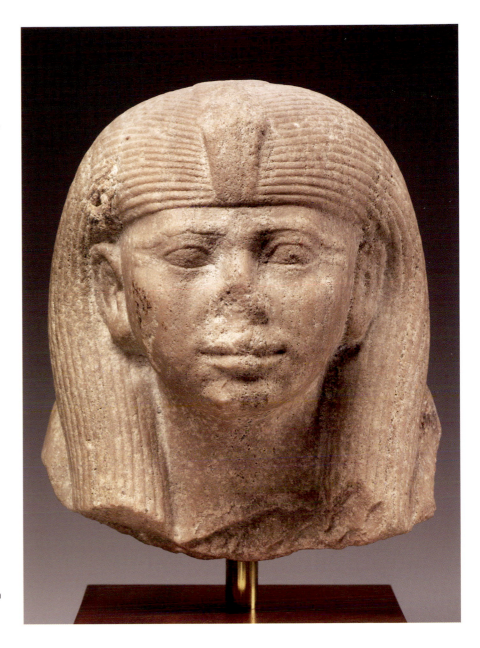

Fig. 46. Head of a female sphinx, mid–Dynasty 12, 1897–1878 B.C.

Fig. 47. Sphinx of Senwosret III, Dynasty 12, reign of Senwosret III, 1878–1841 B.C., The Metropolitan Museum of Art, New York, Gift of Edward S. Harkness, 1917, 17.9.2. Image © The Metropolitan Museum of Art.

ART OF THE LATER MIDDLE KINGDOM

According to recent discoveries, Senwosret III, son and successor of Senwosret II, may have ruled for close to forty years.[37] He left many monuments, some colossal in scale: sixty-eight statues and statue fragments throughout Egypt, as well as in Nubia and Sinai.[38] Karnak, Deir el-Bahri, and Medamud have thus far yielded the most impressive examples. Sculpture and relief made for this king and his highest administrators followed the Twelfth Dynasty's trend toward depicting advanced age, maturity, and wisdom. Many of these superbly crafted images succeed in imbuing hard stone with a lifelike appearance and human character. Nowhere is the divine power of kingship better expressed than in the gneiss sphinx of Senwosret III, thought to originate from Karnak (fig. 47). His distinctive face could be identified immediately even if his name were not inscribed on the mane. The iconography of age, wisdom, and strength of character hinted at during the reign of his predecessor is now overt, even to the point of

exaggeration. Hooded eyes protrude outward from sunken sockets, which are further emphasized by pronounced pouches beneath, and parallel sets of diagonal grooves extend from the inner corners of the eyes to the cheeks, from the nostrils to the corners of a tight-lipped, frowning mouth, and from the corners of the mouth to the chin. As in the previous reign, overlarge ears are pushed outward by the *nemes* headdress. The taut modeling of the lion body, further enhanced by the variegated stone, meld beast and man together into a creature worthy of reverence if not fear.

At Deir el-Bahri, Senwosret III identified with an illustrious predecessor and served up powerful propaganda for the populace in the process by placing images of himself at the funerary temple of the Middle Kingdom's founder, Mentuhotep II. The powerful and over-life-size sculptures, all carved from granodiorite, stood between columns of the colonnade. Six remain; two are headless. Many scholars have speculated on what additional mes-

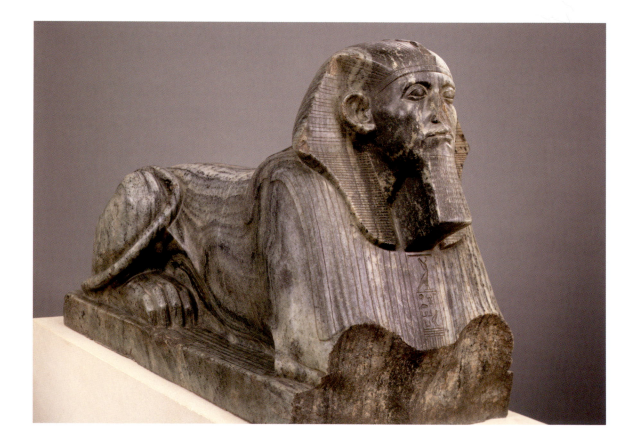

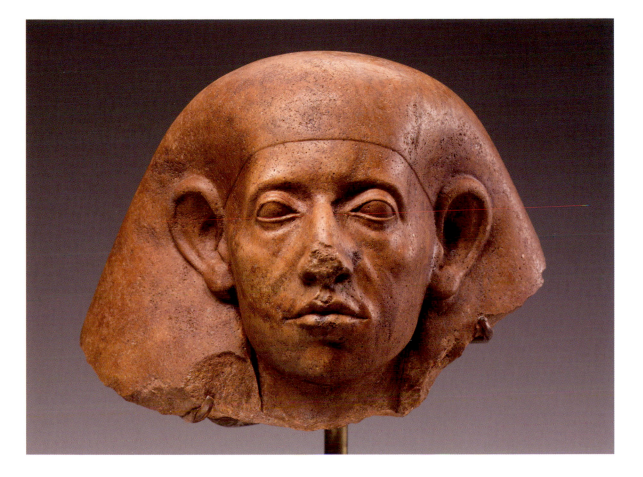

sages the king wished to convey with his aged, haggard, and stern visage here and at other locations. Some of those suggested include the king's desire to elicit fear, reveal his awesome divinity, generate respect (by showing him to be deeply in prayer to the god in whose temple his statues were erected), and show himself to be the concerned care-taker of his people referenced in contemporary literature.

The full range of facial modeling exhibited by a group of what were at least twenty seated statues of granodio-rite, as well as by a number of sphinxes from the Montu temple at Medamud, suggests that the king's artists delib-erately intended to show him at various stages of life throughout the realm.[39] The signs of age are particularly noticeable in the three-dimensionality of the eyes and the depth of vertical furrows of the cheeks and chin. In all cases, whether youthful or aged, the body displays the idealized muscular form of a man in his prime.

Ongoing excavations at Senwosret III's tomb complex-es at Dahshur and Abydos are continuing to yield more material. Reliefs of the king found at both places, and at Medamud as well, show sophisticated modeling of both main figures and hieroglyphs.[40] For example, on a lintel from Medamud, Senwosret III is represented twice, on the left side with a youthful unmodeled face offering to the falcon-headed local god Montu and in a mirror image with a subtly furrowed face and hooded eye offering to falcon-headed Horus, god of kingship.[41]

Although Senwosret III is known for administrative reforms that ultimately diminished the power of the nomarchs in favor of more centralized control, his reign was a time when sculptures and reliefs of important pri-vate officials maintained the same fine quality as royal art. A quartzite head of such an official, known today as the Josephson Head, for example, is carved with such sensitiv-

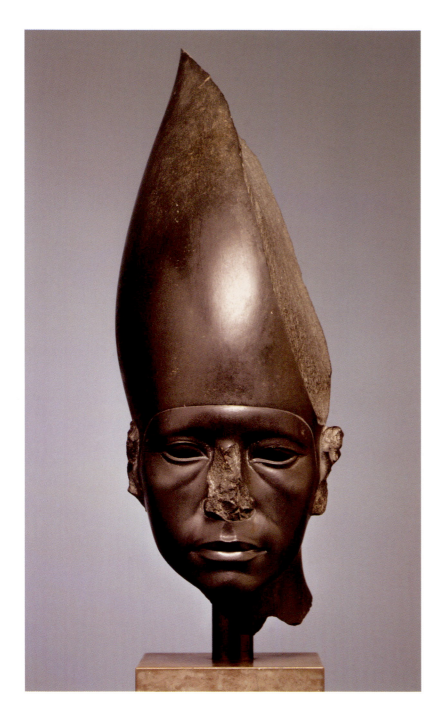

Fig. 49. Head of Amenemhat III, Dynasty 12, reign of Amenemhat III, 1844–1797 B.C., Ny Carlsberg Glyptotek, Copenhagen, ÆIN 924. Photograph by Ole Haupt.

ity that the hard stone reads as flesh (fig. 48). Although the facial features bear the unmistakable stamp of the time of Senwosret III, details like the bump just below the bridge of the nose and the finely chiseled cheeks suggest that the head has the characteristics of a portrait. Whereas the shape of the nose is unique among sculptures of its time, the deeply grooved, fleshlike furrows on the face and delicate modeling of the lips (particularly the way they are slightly pursed in the corners) are comparable to the way they appear on one of the Senwosret III heads from Medamud. Surely one of Senwosret III's own sculptors must have carved the Josephson Head, perhaps in the Theban area.

The number of smaller-scale sculptures and reliefs of officials of lower rank increased dramatically during Senwosret III's reign, especially at Abydos, where many private stelae bearing his name have been found. Some are innovative in their form and skilled in their execution, but most show large numbers of family members and coworkers carved in rote, cookie-cutter fashion and arranged in repetitive rows or framed in squares.[42] Carved in sunk relief, they give the impression that they were mass-produced for low-ranking bureaucrats who were now also entitled to participate in the drama of Osiris's rebirth.

At the end of his long and stable reign, Senwosret III may have shared a coregency of perhaps as long as nineteen years with his son Amenemhat III, after which Amenemhat III continued to rule for at least another sixteen to nineteen years.[43] The superb sculptural achievements of the previous reign continued during his. At least seventy images of Amenemhat III are known.[44] In most instances, representations of Amenemhat III may be distinguished easily from those of his father. The stern-visage type continued, but the hooded eyes and deep diagonal furrows that marked the face of Senwosret III are less severe. A jutting chin with a pouting mouth, often including a protruding lower lip, becomes the face's focus. As with Senwosret III, images of Amenemhat III vary from youthful and idealized to more mature, and they all have an emphasis on the lower part of the face (fig. 49).[45] Whereas the younger-looking images have the appearance of a spoiled adolescent, the mature ones project a haughty confidence. The consummate skill of the artists is beauti-

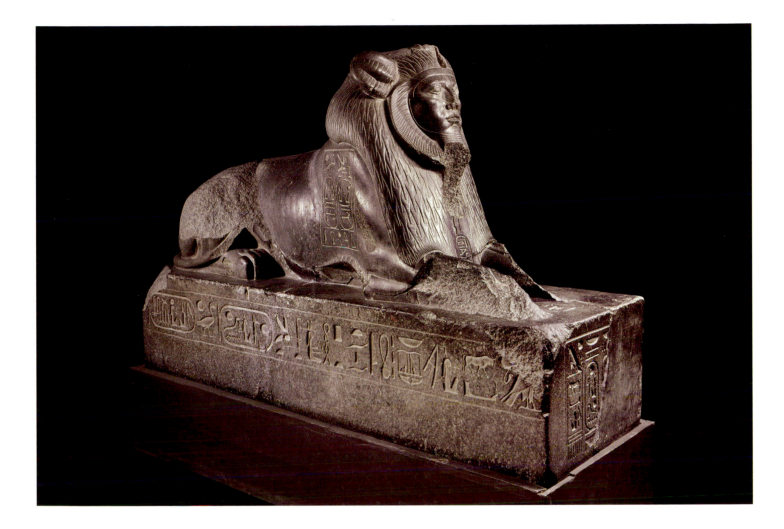

fully expressed in masterpiece after masterpiece of royal sculpture in hard stone.

Based on the number of quarry inscriptions from Sinai to Nubia that bear his name, we can also assume that quarrying activity was greater in the time of Amenemhat III than in that of any king before him.[46] With ample resources, artists were able to produce numerous colossal images of their king. A head from one of two seated statues from Bubastis is over three-quarters of a meter (two and a half feet) high. With once-inlaid eyes, the statues must have formed an awesome pair outside the temple to Bastet, where they served as intermediaries between the populace and the divinity at home inside the temple. Two other seated statues of the king used to preside over

the banks of Lake Moeris at Byahmu in the Fayum. Although only their pedestals remain, fragments of the sculptures found nearby suggest that statue and pedestal together were over 18 meters (60 feet) in height.[47] At the time they were made, they were Egypt's tallest freestanding statues, and surely served as the models for Amenhotep III's so-called Memnon colossi at Thebes in the New Kingdom.

Variety also distinguishes the sculpture of Amenemhat III from that of his predecessors. In their dress, pose, and attributes, some statuary is purely traditional, whereas other images display a creativity unsurpassed by any previous monarch. Good examples are the many sphinxes from the Delta. Some are sleek, beautiful animals in the traditional style of Senwosret III, and others move in a new

Fig. 50. Sphinx of Amenemhat III, Dynasty 12, reign of Amenemhat III, 1844–1979 B.C., Egyptian Museum, Cairo, CG 394. Photograph © Jürgen Liepe.

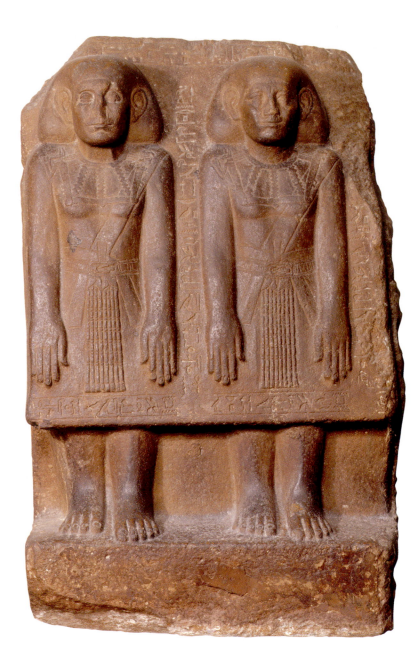

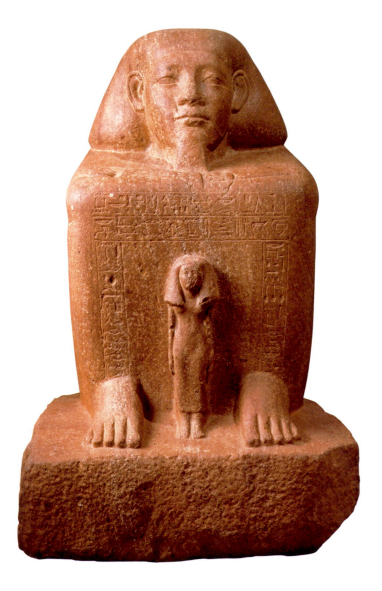

Fig. 51. Double statue of the high priests of Ptah, Sehetepibra-ankhnedjem and his son, Nebpu, Dynasty 12, reign of Senwosret III, 1878–1841 B.C., Musée du Louvre, Paris, A 47. Photograph Hervé Lewandowski / Réunion des Musées Nationaux / Art Resource, New York.

Fig. 52. Block statue of Senwosretsenebefny, Dynasty 12, reign of Senwosret III–Amenemhat III, about 1878–1797 B.C., Brooklyn Museum, New York, Charles Edwin Wilbour Fund, 39.602. Photo courtesy of Brooklyn Museum.

direction, melding man and beast by means of a leonine mane framing the face.[48] The surrealistic image is carried through to the torso, with massive and powerful muscles enhanced by stylized grooves in imitation of hair (fig. 50).

Amenemhat III probably used the Step Pyramid precinct of King Djoser of Dynasty 3 as a model for his funerary complex at Hawara.[49] His interest in Egyptian antiquity and tradition explains why a number of his statues from the Fayum Oasis, an area on which he focused extensively, wear the long ringlets and full beards known only from Egypt's first few dynasties.[50] One of these statues shows him with the accoutrements of a high priest, including a leopard skin, a *menat* necklace, and standards bearing divine heads.[51] Although the king's role as high priest may have been understood in the past, this sculpture represents the first time a king is specifically shown in this role.

The innovation that characterizes royal sculpture from Amenemhat III's reign extended into the private sphere as well. An example of a new form is the now twin but once triple statue of the Memphite high priests Sehetepibra-ankhnedjem and his son Nebpu (fig. 51). They share a base and back slab, as well as a continuous triangular kilt that extends directly outward, creating the impression that the statue is as much a relief as a three-dimensional work. Its inscription states that Nebpu commissioned this statue for his father. Sehetepibra-ankhnedjem's facial features exhibit the deeply hooded eyes and diagonal furrows of Senwosret III, and Nebpu's emphasize the pouting mouth of Amenemhat III. This difference may have been a conscious effort to acknowledge change in the official physiognomy from reign to reign. The trend toward representing more than one family member in a single sculpture may also be seen in a block statue of Steward of the Counting of Cattle Senwosretsenebefny and his wife, Itneferuseneb, who stands between his feet (fig. 52). Block statues including more than one person are rare, and this one is among the first. When the sculpture is seen from the front, wig, lap, legs, and base meet at right angles, forecasting a trend toward simplification and reduction to geometric forms. When viewed from the side or at an angle, however, the statue displays a sophisticated melding of curvilinear, organic forms.

Amenemhat III's reign was the last of the lengthy and productive periods of Dynasty 12. His son or possibly grandson succeeded him, but Amenemhat IV's ten-year reign may have included a several-year-long coregency.[52] A square pedestal decorated with friezes of uraei bearing Amenemhat IV's head in a *nemes* is the only royal sculpture with his name that bears his unrecarved image.[53] The faces, although small in scale and very damaged, exhibit hooded eyes similar to those of Senwosret III. This is the first time the king's face adorns a uraeus, and in that respect his reign continued the trend of creating new forms. Amenemhat IV completed several temples begun by his father in the Fayum, most notably Medinet Madi, which was built to honor the goddess of the harvest, Renenutet. Large-scale, flat, and unmodeled reliefs of the king and gods cover the walls.

Little private material is specifically dated to the reign of Amenemhat IV, although a few private stelae from Abydos bear the cartouches of both Amenemhat III and Amenemhat IV. Overall, the second half of Dynasty 12 produced very little in the private sphere that is comparable in scale or skill to private works from the first part of the dynasty. They are offset by countless examples of small-scale statues and stelae made for minor officials. Often depicting entire families, they make up in charm for what they lack in sophistication. In nearly every case, a specific date is difficult, if not impossible, to assign without additional information. Found at Abydos, throughout the country, and into the Levant and the Sudan, they are often crudely proportioned, lopsided, and downright amusing. Nevertheless, whether from tombs or temples, the statues served their purpose of representing the owner's eternal presence and giving him or her access to the necessities of life in the netherworld. In the stelae, the depiction of a private individual worshiping a god directly (without the king as intermediary) represents a major innovation of this time and is in keeping with the greater access to and popularization of religion at the end of the dynasty.

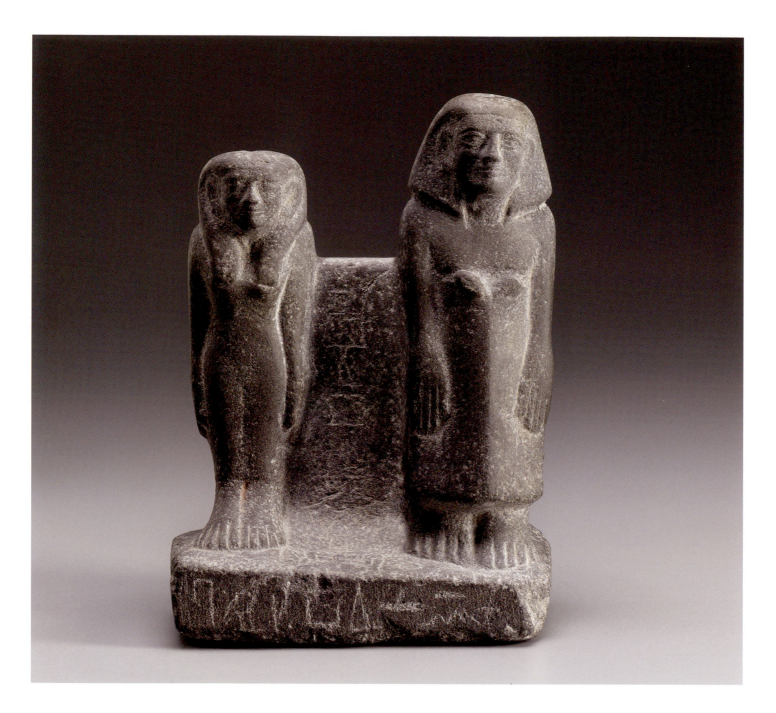

Fig. 53. Statuette of a man
and his wife, Dynasty 13,
1783–about 1640 B.C.

THE END OF THE MIDDLE KINGDOM

Nefrusobek, the wife of Amenemhat IV (and his sister as well, according to the historian Manetho), was the last king of Dynasty 12.[54] After her, perhaps as many as fifty to sixty kings, mostly unrelated to each other, ruled in the approximately 150-year period that marks the Thirteenth Dynasty, a sharp contrast to Dynasty 12, in which a single family enjoyed long reigns in a stable and prosperous country for almost two hundred years. With some reigns lasting less than a year, it is no wonder that the period is enigmatic and royal remains relatively scarce. In all, just over forty statues of Thirteenth Dynasty kings are known, and of those only seventeen retain their heads.[55] The majority of them come from Thebes and farther south; they display a tendency toward a bland continuation of tradition rather than any bold attempts at innovation. In a few, however, Thirteenth Dynasty artists' mastery over their medium achieves a level not seen before. Some of the Thirteenth Dynasty's finest works belonged to high-ranking bureaucrats, whose power must have rivaled the king's.[56] However, perhaps because so many ruled for such short periods of time, the administrative elite seldom placed a sovereign's name on their statues or stelae. The omissions make it difficult for scholars to trace the artistic trajectory of private works. By their sheer numbers, it is the proliferation of small-scale, often awkwardly proportioned statuary and stelae of low-level officials that characterize the end of the Middle Kingdom, rather than the few works of high quality representing highly placed bureaucrats or royalty (fig. 53). Most works of this type probably originated in Abydos. Many of the stelae simply repeat the layout and subject matter typical of late Dynasty 12, including the dedicant making offerings directly to funerary gods, and others reinterpret the standard iconography in their own charming manner. Some Thirteenth Dynasty officials wear three overlapping skirts rather than the two common in the Twelfth Dynasty; gross obesity appears in a way that exceeds all previous known attempts; and tiny heads stand on top of mannerist and elongated, often exceedingly thin torsos.[57] These lower-level bureaucrats assume the prerogatives of royalty and the nobility by sitting on fancy high-backed chairs or including in their private spheres the flail or *shen* sign (symbol of eternity)

previously restricted to kings and gods.[58] In at least one instance, an artist signed a stelae he made, certainly an expression of pride in his work and a rare attempt to assert creative ownership.[59] Given the age-old push to recapitulate the past, these expressions of individuality suggest that the culture provided more opportunity for personal expression within these lower levels of society. The bold usurpation of royal symbols hints at a weakness of central authority and a redirection of focus toward individual regions and away from the capital.

The Middle Kingdom was a time of rapid and dramatic change, particularly at the beginning of Dynasty 12 under Amenemhat I, whom the nomarch Djehutynakht probably served. Literary records tell us that the king had some difficulty establishing and maintaining his authority and was perhaps even murdered. One of the reasons Amenemhat I moved the capital north from Thebes to Lisht must have been to consolidate his power.[60] The support of nomarchs in areas like Deir el-Bersha must have been critical to that effort, and the king may have rewarded them with gifts and other forms of royal favor. Governor Djehutynakht's outer coffin and superb model of a procession may be examples of such favor. They stand out dramatically from the rest of the material in the tomb in terms of their quality and the care involved in their manufacture. It is possible that royal artists created them. They show a deliberate attempt to recapture the ideal of beauty of the Old Kingdom, while the other material from the tomb varies tremendously in style.

Overall, the tomb is very much a product of the private sphere, particularly of Middle Egypt, where funerary arts flourished without break from the Old Kingdom to the Middle Kingdom despite the lack of a central authority. In fact, it is perhaps because of the lack of central authority that provincial artists, forced to use resources close at hand, were able to take liberties. With the return of a central government, their innovations gave impetus to the development of the new iconography and style for the Middle Kingdom. This pull between innovation and a return to the past, and between central authority and the provinces, was at its height when the Djehutynakhts lived—an exciting time indeed.

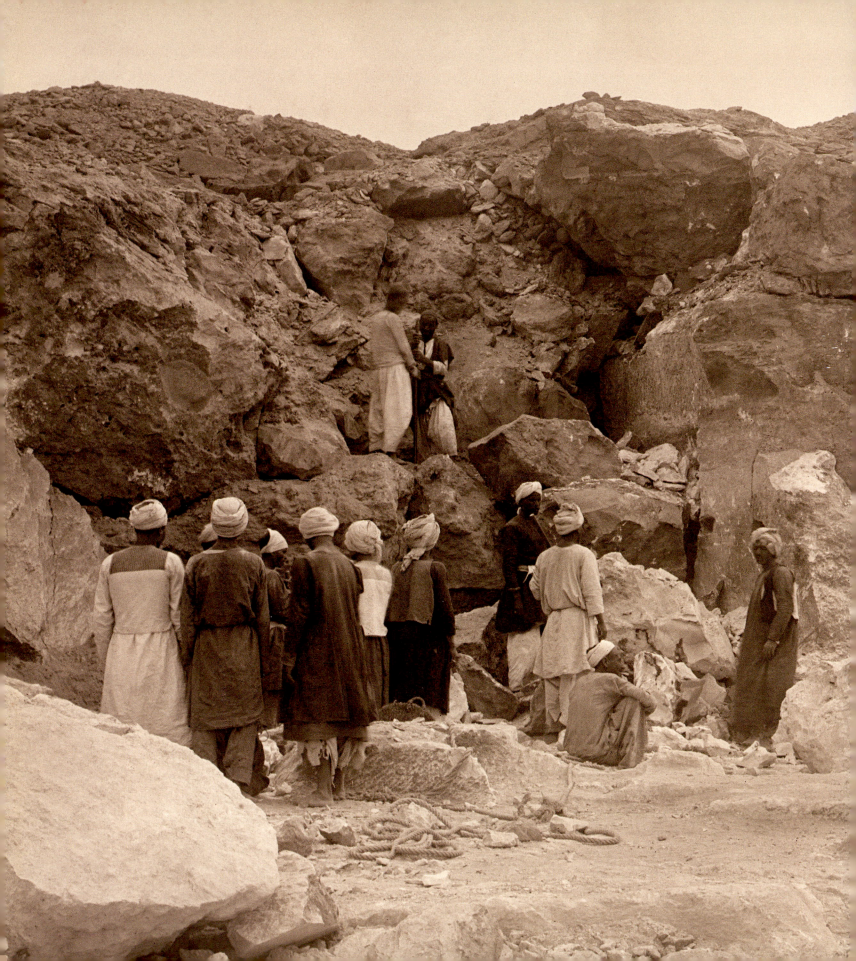

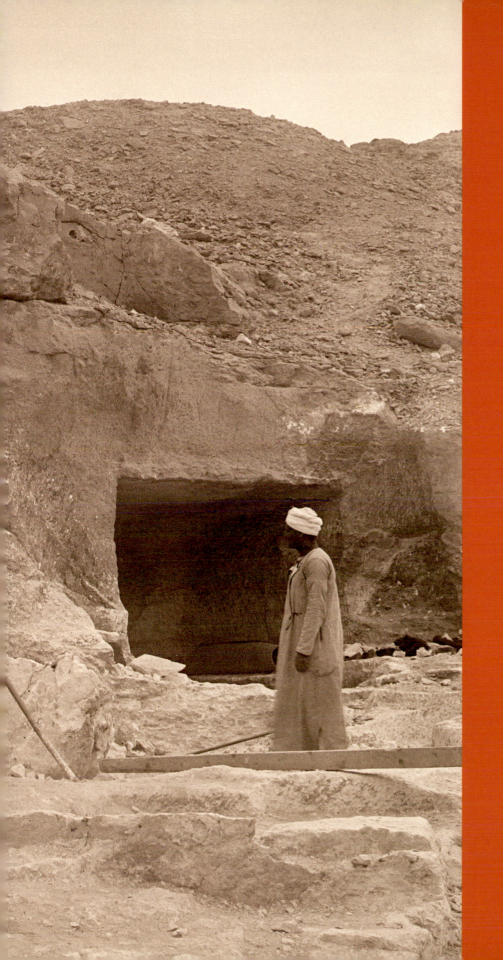

DISCOVERING DEIR EL-BERSHA

LAWRENCE M. BERMAN, DENISE M. DOXEY, AND HARCO WILLEMS

THE NOMARCHS' CEMETERY of Deir el-Bersha is located high on the desert cliffs overlooking the valley on the east bank of the Nile, about 280 kilometers (175 miles) south of Cairo. The capital of the Hare nome was Hermopolis, present-day el-Ashmunein, on the opposite side of the Nile; its major deity was Thoth, god of wisdom and writing. The area was prosperous from of old. The Hare nome is personified as a woman with a hare on a standard on top of her head; she appears alongside the Old Kingdom's King Menkaura and the goddess Hathor in a triad of King Menkaura, Hathor, and the Hare nome (fig. 54).[1] In the mid-fourteenth century B.C. during the New Kingdom, the Hare nome became, albeit briefly, the seat of royal power when Amenhotep IV, better known as Akhenaten, founded the city of Akhetaten (present-day el-Amarna), south of Deir el-Bersha, as his residence. Toward the end of the New Kingdom period, the dismantled blocks of Akhetaten were used in the foundations of Ramesses II's new construction at Hermopolis.

Hermopolis flourished during the Ptolemaic Dynasty, when Thoth was worshiped by Greeks and Egyptians alike as Hermes Trismegistos (Hermes-thrice-great). The principal cemetery at that time was Tuna el-Gebel, just west of the town. The tomb of Petosiris, with its wonderful paintings combining Greek and Egyptian styles of representation from about the time of Alexander the Great, is still a major tourist attraction. In A.D. 130 the Roman emperor Hadrian founded a city on the east bank of the Nile opposite Hermopolis, called Antinoopolis after his lover Antinous, who had drowned there. As one of the four Greek cities of Egypt, its residents enjoyed special privileges. In the Byzantine Period, the area around Hermopolis was a center of Coptic Christianity with numerous convents and churches; the monks used the tombs of the nomarchs high up in the cliffs as places of retreat, painting crosses over the pagan wall paintings.

EARLY DISCOVERIES

The first European visitor to Deir el-Bersha of whom we know was Johann Michael Vansleb, a Dominican friar who traveled to Egypt in 1672 to collect manuscripts and coins for the library of Louis XIV. Vansleb (also known as Wansleben) left an account of the tombs, where he was taken by the Copts. The hieroglyphs in particular excited his imagination:

> The first remarkable thing that I saw, was the Hieroglyphick Cave, which the Country people commonly call the Church. I conceive this mistake proceeds from the Crosses which are painted every where within. . . .

> This Cave is full of images in the Walls, and above, which represent their Sciences by Emblemes, and Hieroglyphick Figures, with very little Characters in their Language round about. The colours of them are so beautiful and lively, that I could not but wonder how they continue so fresh, during so many Ages. . . .

> Besides this great number of characters there painted, are to be seen some lines of the same little Characters very clean carved in the Wall, some reaching from one end to the other, others from the top to the bottom. These Characters, and Figures, are so numerous, that they are not to be drawn by any in less than a Months time.[2]

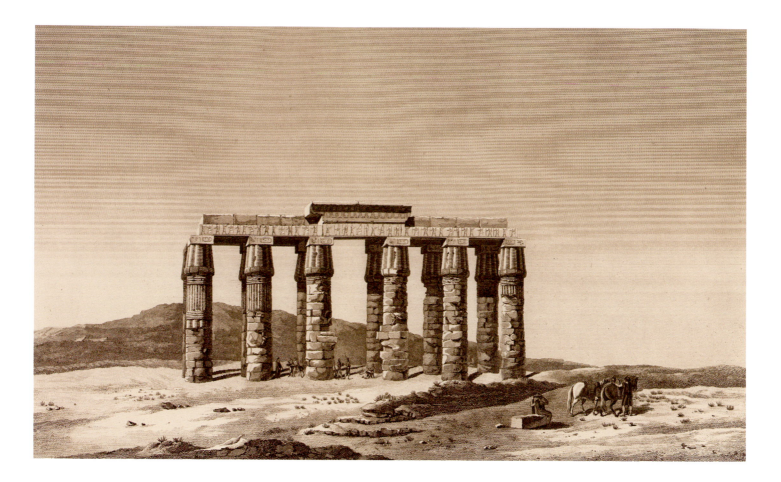

Fig. 54. King Menkaura, the goddess Hathor, and the deified Hare nome, Old Kingdom, Dynasty 4, reign of Menkaura, 2490–2472 B.C.

Fig. 55. View of the portico of the temple of Thoth at Hermopolis (el-Ashmunein) as it appeared in 1798. From *Description de l'Égypte*, plate 51.

Vansleb also left a map of the area showing the villages and monasteries ringed by cliffs dotted with tombs.[3] Yet his account did not garner much attention, and the nobles' tombs were not among the sites visited by the members of Napoleon's Egyptian Expedition when they stopped there in full view of the cliffs in December 1798.[4] Instead, they devoted their attention to the more conspicuous monuments in the valley: the majestic portico of the temple of Thoth at Hermopolis and the ruins of Antinoe with its colonnades and triumphal arches like those of a Roman city (fig. 55).[5]

Not until nineteen years later did a pair of British travelers first see the tomb that was to make the cemetery of Deir el-Bersha famous in Egyptological literature. Charles Leonard Irby and James Mangles were sea captains in the Royal Navy who retired in 1815 after having

seen action in the Napoleonic Wars. Still eager for adventure, they embarked on what was to become a four-year tour of the Middle East. Seeming to be always in the right place at the right time, Irby and Mangles had the good fortune to participate in a number of important and exciting discoveries. On March 21, 1817, they observed the vernal equinox from the descending passage of the Great Pyramid, which had just been cleared. The following August 1, they were present at the opening of the temple of Abu Simbel. On August 26, on their way back from Abu Simbel, they stopped at el-Rairamun, near Hermopolis, the site of a sugar refinery—the first in Egypt—operated by Charles Brine, a British subject friendly to travelers. Doubtless it was Brine who pointed out to them the way to a tomb in the cliffs:

We have been so fortunate as to discover an interesting tomb opposite to Mr. Brine's at [el-Rairamun]; the sides are covered with paintings, amongst which are two groups, of a description very rarely, if ever, to be met with; one of them represents the removal of a colossus between 30 and 40 ft. high, seated on a chair; upwards of a hundred labourers are employed to move it. . . . Mr. Bankes and Mr. Beechey are the only travelers who have visited this tomb since we discovered it: the former has made accurate drawings of all its contents.[6]

It was the tomb of Djehutyhotep, better known as the Tomb of the Colossus. All the early travelers in Egypt—mostly young men of independent means and the artists in their employ—hastened to see it, but it was not easy; the tomb was hard to find. The first drawing of it in print appeared in 1823 in the magisterial publication of Ippolito Rosellini, head of the Tuscan expedition, who traveled with Jean-François Champollion, the decipherer of hieroglyphs, on his first and only trip to Egypt (fig. 7, p. 30). Champollion himself never saw it, however. Even John Gardner Wilkinson, the founder of British Egyptology, who lived in Egypt for twelve years (1821–33), visiting practically every known ancient site, was frustrated. Yet he added to its fame by publishing a drawing of it based on a lithograph by John Bankes in his immensely popular work *Manners and Customs of the Ancient Egyptians,* which appeared in 1837 and earned him a knighthood.[7] Not until his second trip to Egypt in 1843 did Wilkinson succeed in finding the tomb. He gives the precise coordinates in his guide for travelers *Modern Egypt and Thebes*:

> In my previous visit to Egypt I could not succeed in finding this tomb: and as others have also had some difficulty discovering it, I had better describe its position. It is at the left hand of the ravine, behind the convent and village of Dayr e' Nakhl, near the top of the hill, and a little way to the right of a sort of road, which is seen from below running to another grotto. The following are the bearings of the principal objects from its entrance:—Antinoë 332½°; Reramoon 276°; Dayr e' nakhl 288°, three quarters of a mile; and El Bersheh 236° 2 miles.[8]

Wilkinson's *Modern Egypt and Thebes* was the basis for Murray's *Handbook for Travellers in Lower and Upper Egypt*, the most popular guidebook for English-speaking

travelers to Egypt well into the 1890s, where these coordinates are repeated.[9]

By the 1890s, however, there was little left to see. In 1887 a singular discovery was made at el-Amarna that affected all the monuments in the area. It seems (there are various accounts of the story) that a farmer's wife digging for fertilizer in the mud-brick ruins of Akhenaten's capital came across a trove of cuneiform tablets. Naturally she had no idea what they were, but as they were so strange, she showed them to a friend, who took them to the dealers in Luxor, who sent them out to be examined. Some thought they were forgeries, but others, more knowledgeable, surmised what they were: the diplomatic correspondence of Amenhotep III and Amenhotep IV with their allies and vassals in the ancient Near East. We know the corpus today as the Amarna Letters. News of the discovery traveled fast; by the time the Egyptian government arrived on the scene and attempted to confiscate the tablets, most had already been sold. Meanwhile, the local residents had become aware of their value. Either out of greed, according to some reports, or out of anger at the government for having deprived them of a ready source of income, they decimated the walls of the tombs in order to pass off the inscribed fragments as tablets.[10]

We can place the vandalism according to a photograph taken in 1889 that shows the scene intact.[11] By 1890, the damage was done. On January 21, 1891, American Egyptologist Charles Edwin Wilbour, making his annual tour of the Nile on his houseboat, the *Seven Hathors*, visited the tomb and was shocked at the devastation:

> We went up and saw the ruins of the Colossus tomb behind Bersheh. . . . It is sickening. Great portions are cut away and all the rest hammered except two strips about two feet wide which having been exposed to a fall of dust are so faded that the marauders did not think them worth destroying. The little but quite perfect tomb of Mr. Fight-Strong [Ahanakht] of which I once copied one side, has shared the same fate. We copied a large part of Thoth-nekht's tomb, too much ruined by the fall of its roof to invite modern depredation. A guardian, No. 31, assured us that he left the place only to get his food.[12]

Meanwhile, the newly established Archaeological Survey of the London-based Egypt Exploration Fund had arrived on the scene to conduct the first scientific work at Deir el-Bersha. The expedition was led by British Egyptologist Percy E. Newberry; assisting him was the young Howard Carter, just beginning his long and eventually famous career in Egyptology. Although it was too late to save the colossus on a sledge, there were new discoveries to be made. As Newberry reports:

> Within a quarter of an hour of my arrival at El Bersheh, however, I had the good luck to discover ten more inscribed tombs, all of about the twelfth dynasty, and containing many lines of inscriptions. It is simply extraordinary that these should never have been noted before, as they all lay within one hundred yards of the tomb of Tahutihotep, and six of them were actually on the same level.[13]

The two volumes on Deir el-Bersha written by Newberry with illustrations by Carter represent a milestone in the archaeological history of the site.[14]

The Egyptian Antiquities Service excavated at Deir el-Bersha in 1897 under the direction of Georges Daressy and in 1900 under Ahmed Bey Kamal.[15] The result was a splendid series of Middle Kingdom coffins for the Egyptian Museum.[16] At around the same time, both the British Museum and the Louvre acquired decorated coffins from Deir el-Bersha.[17] In 1902 Brine's successor at the sugar refinery, Signor Antonini, obtained permission to excavate there.[18] Although these finds were not particularly rich, it was enough to suggest to George A. Reisner that much remained to be found at Deir el-Bersha.

— L. M. B.

THE HARVARD UNIVERSITY—MUSEUM OF FINE ARTS, BOSTON, EXCAVATIONS

The success of the Egyptian Antiquities Service's excavations brought about certain unintended consequences. Deir el-Bersha had suffered from illicit digging since antiquity, but in the early years of the twentieth century the problem worsened. Increasingly concerned, Ahmed Bey Kamal sought an expedition to excavate the site scientifically, and in 1914 he approached one of the most highly regarded archaeologists working in Egypt, George Andrew Reisner of the Harvard University–Boston Museum of Fine Arts Expedition (fig. 56).

Reisner had begun excavating in Egypt in 1899 on behalf of the University of California at Berkeley, with financing provided by newspaper heiress Phoebe Hearst. He immediately started developing and refining techniques for surveying, excavating, and recording that would later lead him to be heralded as the Father of American Egyptology. In 1902 he was awarded a permit to excavate at one of Egypt's most coveted sites, Giza, home to the great pyramids of Dynasty 4, where he would continue to make remarkable discoveries until his death at the site in 1942.

The failure of one of her family's gold mines in 1904 forced Mrs. Hearst to withdraw her funding, creating an opportunity for the Museum of Fine Arts, Boston. It could inherit a well-established archaeological project led by the preeminent American excavator of his day, thereby receiving a substantial percentage of the objects discovered. At the same time, Harvard University began courting Reisner to induce him to join its faculty. Ultimately, the trustees of Harvard and the MFA offered to combine their efforts, and the Harvard University–Boston Museum of Fine Arts Expedition to Egypt was born. Reisner was appointed as Harvard's first (and, to date, last) professor of Egyptology, as well as curator of Egyptian art at the Museum. His team would go on to excavate at more than twenty sites throughout both Egypt and Sudan.

Within only a few years of Reisner's arrival, the excavations at Giza had given the MFA a collection of Egyptian Old Kingdom art unparalleled outside Egypt. Other eras of Egyptian art, however, were less well rep-

Fig. 56. George Andrew Reisner, June 26, 1933

resented, and art from the Middle Kingdom was the weakest area of the Museum's collection. This lack was especially poignant in that the Museum's chief rival, the Metropolitan Museum of Art in New York, was strong in Middle Kingdom material. The first change in the MFA's fortunes occurred in 1914, when Reisner undertook excavations at the Sudanese site of Kerma, capital of ancient Kush, and, much to his surprise, discovered a trove of superb Egyptian sculpture from the Middle Kingdom, notably the over-life-size statue of Lady Sennuwy, one of the greatest masterpieces of the early Twelfth Dynasty (fig. 41, p. 74). Reisner, misinterpreting Kerma as an Egyptian outpost in Nubia, hoped that continuing work there would soon remedy the Museum's shortcomings in this area.

The first shipment of material from Kerma had barely arrived in Boston when the opportunity to excavate at Deir el-Bersha arose, and the Museum's trustees welcomed the chance to expand the Middle Kingdom collection further. Reisner was normally opposed to sel-

ecting sites primarily on the basis of potential acquisitions of art, but he was convinced by the ongoing destruction of the site and agreed to conduct a brief season of what amounted to a salvage excavation. There was a problem, however. Reisner was already fully extended by his simultaneous work at Giza and Kerma, and his chief assistant, Clarence Fisher, had just resigned so he could excavate on behalf of the University of Pennsylvania Museum in Philadelphia. As a result, nobody was available to attend to the day-to-day running of the Egyptian Department, much less to lead the expedition to Deir el-Bersha. Reisner wrote to Boston seeking a replacement for Fisher, and at the trustees' meeting in October 1914, the Museum decided to assign the task to its newly appointed registrar, Hanford Lyman Story.[19] Story had worked at the Museum for a year longer than Reisner and had experience at the American School of Archaeology in Athens, but he was formally trained in neither archaeology nor Egyptology. Yet, he readily accepted the chance to assist the Egyptian Department, and the Museum's trustees agreed to grant him a leave of four to six months to learn his new field by working with Reisner in Egypt. The 1915 season would prove to be a trial by fire.

In Egypt, Story met up with Reisner who, en route from Sudan to Cairo, stopped at Deir el-Bersha to get the excavation under way. He was to be assisted in the field by Reisner's very capable Egyptian *reis*, Said Ahmed Said, who had already worked extensively with the Harvard–MFA Expedition and whom Reisner later described as "the most gifted foreman who ever worked for the expedition" (fig. 57). Said came from a family of trained excavators from the village of Quft, a town that had provided workmen for foreign excavations since the nineteenth century (and continues to do so today). Given Story's complete lack of experience in Egypt, Said's presence at the site proved to be invaluable.

When the team arrived at Deir el-Bersha on March 17, 1915, they were met with a discouraging state of affairs. Reisner later wrote, "The southern cemetery and that in the plain were found systematically cleared by thieves from end to end, while the terrace of the tombs of the princes was a wilderness of dump heaps. I esti-

Fig. 57. Said Ahmed Said
and son at Gammai

and Story made the dubious decision to employ a local explosives expert to blast the rock apart, a procedure they hoped would give access to any burial shafts the robbers may have missed.

The harsh environment was hardly Story's only problem. Only a week into the excavation, he learned a painful lesson in Egyptian village politics.[21] On March 24 one of the workmen arrived at the site to find that all the expedition's tools and baskets were missing. Initially suspecting theft, Said sought the aid of the village mayor, who proved to be less than helpful. While acknowledging that he knew who was responsible, he suggested paying the presumed thief, the leader of a Bedouin group camped near the cemetery, to "find" the equipment. In the end it proved unnecessary when the tools were discovered thrown into a deep tomb shaft high on the cliff. It seems that the Bedouin sheikh was expressing his displeasure at having been removed from his position as guard of the site and at having failed to be hired to provide donkeys for the expedition's use. Previous excavators, both legal and illegal, had hired the inhabitants of the camp, and they felt slighted at being ignored by Story's team. The village mayor, for whom they routinely performed what Story termed "his dirty work (theft, assault and battery, etc.)," was loath to do anything about it. Outraged, Story made it clear that he would never employ any of them and wanted them to stay away from the excavation. The following day, Said hired armed guards.

Also of concern to Story was a much larger and more serious political crisis. World War I was raging in Europe, and the shipping lanes to North America were becoming increasingly dangerous, with the threat of their being closed altogether. The 1914 shipment of objects from Kerma would prove to be the last one to arrive in Boston before 1919. While Reisner was content to wait out the war in Egypt or Sudan, Story wondered anxiously whether he would be able to get home to Boston.

By late April, the expedition had excavated some fifteen elite burial shafts, and although numerous objects of archaeological significance had surfaced, the team had recovered virtually nothing that the MFA's trustees would consider worthy of display. Several of the Egyptian exca-

mate that over a thousand important tombs have been plundered, and. . . no adequate record exists for even a single tomb."[20] After two days of surveying the area, they set up camp at the mouth of the wadi and began the tedious and laborious task of clearing debris from the terrace in front of the elite tombs, all but two of which had been destroyed by ancient quarrying or by nineteenth-century plunderers (fig. 58). Only the subterranean burial chambers remained. Massive limestone blocks and mounds of debris had made the site all but unintelligible. For thirty-eight days, the excavators worked through scorching heat, sandstorms, and infestations of insects, only to find burial shaft after burial shaft almost completely emptied by grave robbers. In an effort to remove the fallen limestone blocks brought down by the quarrying, Reisner

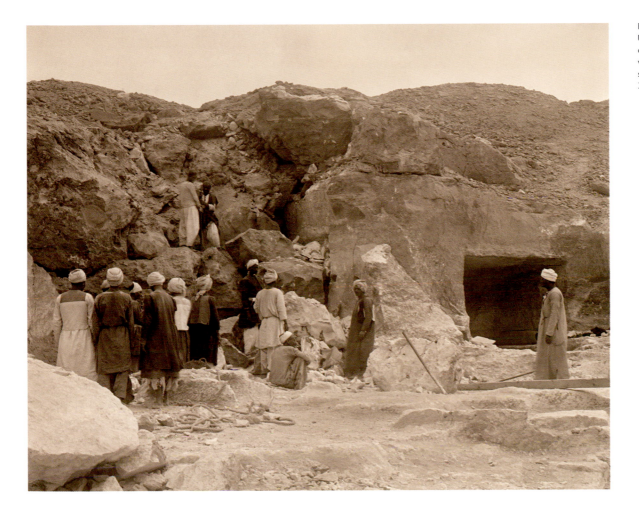

vators were falling ill, and the rigorous work of clearing the terrace was leaving them exhausted. Reisner was due to arrive in early May to evaluate the situation, and it seemed to Story that the project would be likely to end at that point. The only place that still appeared to offer any hope was an area where they had removed tons of fallen rock and where large boulders and low overhanging rock ledges continued to make digging extremely difficult.

In this area, where tomb 10 once stood, a burial shaft appeared (fig. 59). Said, whose experienced eye told him that the soil had not been disturbed since ancient times, was encouraged. It might still be possible for Story to return to Boston with significant finds for the Museum. On April 26, excavations began in the shaft, numbered 10A, which had originally been located in the now-destroyed tomb chapel. Although the sandy fill did not appear to have been disturbed recently, it was mixed with objects, such as fragments of rope, pieces of wooden models and other damaged grave goods, indicating that the burial chamber had been robbed. After continuing down more than 9 meters (30 feet), the excavators reached the bottom of the shaft and found that one of the limestone slabs blocking the entrance to the burial chamber had been pulled aside. Ash and soot, along with fragments of human remains and mummy wrappings, suggested that the body of the tomb owner had been pulled into the shaft and set on fire. The tomb was definitely not intact.

Story had had enough. Describing his deflated emotions in a later report, he wrote:

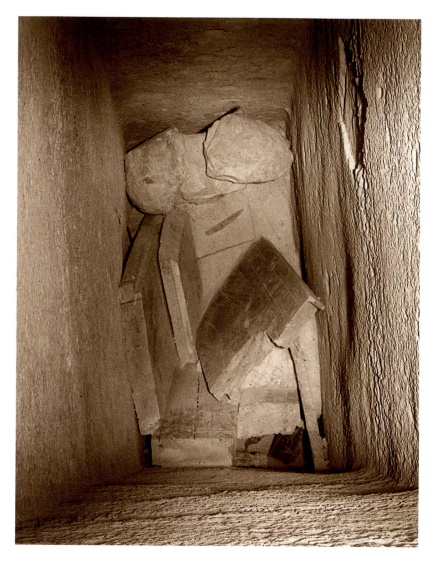

word that the chamber looked promising. Story was lowered down the shaft and handed a candle. By its light, he saw that the expedition had at last met with success. At the same time, he was appalled by the ruthlessness of the grave robbers who had preceded him.

Immediately inside the entrance to the chamber was a massive cedar coffin (fig. 60). The robbers had pulled off the end board in order to extract the body, but the lid remained in place. Inside was a slightly smaller coffin with an elaborately painted interior. A second set of coffins lay disassembled against the far wall of the chamber. The rest of the small chamber was a scene of utter chaos, crammed with hundreds of objects strewn about by the robbers (fig. 61). These included dozens of wooden models of boats, animals, craftsmen, and offering bearers, as well as sticks, staves, boxes, headrests, and stone vessels. A unique canopic jar in human form rested on top of the coffin, along with a gruesome remnant of the robbers' work, the head of one of the mummies, which had been ripped from the body in a search for precious amulets among its wrappings. Thrown into the far corner of the chamber was a human torso, stripped of its wrappings, head, and limbs (fig. 62). The thieves had taken virtually everything made of gold and other precious materials, but among the many wooden objects they left behind were masterworks of Egyptian art. That these items had survived the violence of the thieves and the fire they had set, along with the effects of four thousand years underground, was nothing short of miraculous. Still, more hazards were to be faced.

Story immediately sent news of the discovery to Reisner, who arrived at Deir el-Bersha on May 1, three days before Story had hoped to shut down the excavations. Clearly additional time was needed to clear the chamber. Reisner cabled Boston: "Musart Boston. Most important continue work Bersheh. Story's departure before May 26th upsets whole plan. Please reconsider order. Reisner."[23] The MFA's director, Arthur Fairbanks, agreed. Story's departure would have to wait.

The removal of the objects from the Djehutynakhts' burial chamber took just over two weeks, and while clearing the area in front of the tomb, the excavators discovered a second shaft, which they labeled 10B.

Fig. 59. View down the shaft of tomb 10A, April 30, 1915

Then tomb numbered 10, pit A, was found and cleared in high hopes; but when the top of the entrance was reached at the bottom of a forty-foot [sic] shaft, the entrance was found open. That seemed the last straw. A number of the workmen were sick, the weather was almost unbearably hot, and answering the pleas of the men I telegraphed Dr. Reisner to ask if I should not stop the work. I received no reply. He told me afterwards that he threw my telegraph in the wastebasket.[22]

As the following days would prove, Reisner was once again demonstrating his uncanny ability to anticipate a major discovery. Only hours after Story sent his telegram, Said summoned him to the tomb shaft with

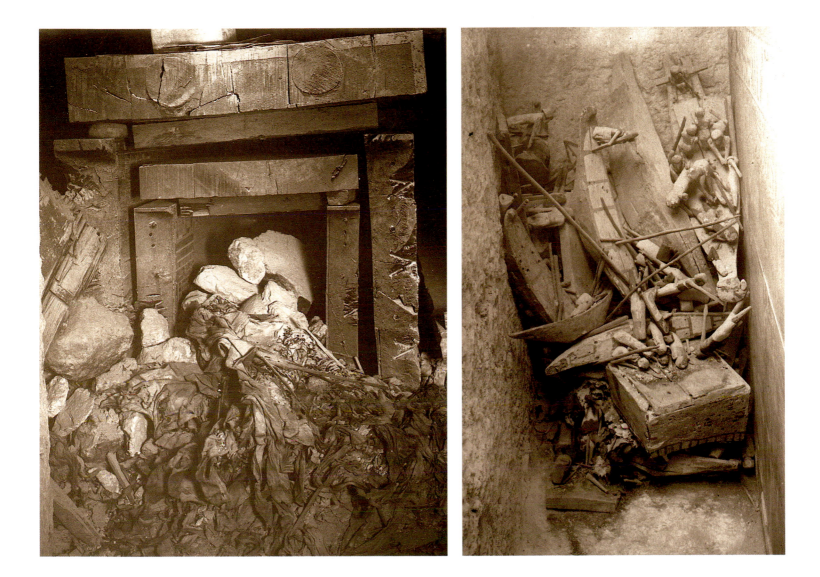

Originally located in the courtyard of tomb 10, it housed the burial of a woman named Satmeket, whose relationship to the Djehutynakhts remains unclear. The tomb was far more heavily robbed and damaged than 10A but nevertheless contained parts of a decorated coffin and other well-preserved artifacts.

The depth of the shaft and the low overhang of the fallen rock above it rendered the excavation of the contents of chamber 10A, particularly the coffins, highly precarious. This became most apparent on May 12, when the workmen failed to maneuver the lid of Governor Djehutynakht's outer coffin under the overhanging rock, causing damage to the inscribed surface. Story was mortified, writing to Reisner, "Said is in tears and has been showering curses on the men. Everyone feels very badly about the accident to the cover. . . . The rest of the coffin will be boxed before being taken from the chamber, which may be another case of locking the stable door after the horse has been stolen."[24] Said was more sanguine, noting in his journal, "the cover was slightly scratched."[25]

The excavations concluded on May 29, and carts carried the Djehutynakhts' possessions to the Nile for their

Fig. 60. Cedar coffin in the entrance to the burial chamber of tomb 10A (viewed from shaft), May 2, 1915

Fig. 61. Pile of models and other objects in situ, found between the east wall of tomb 10A and the outer coffin of Governor Djehutynakht, May 11, 1915

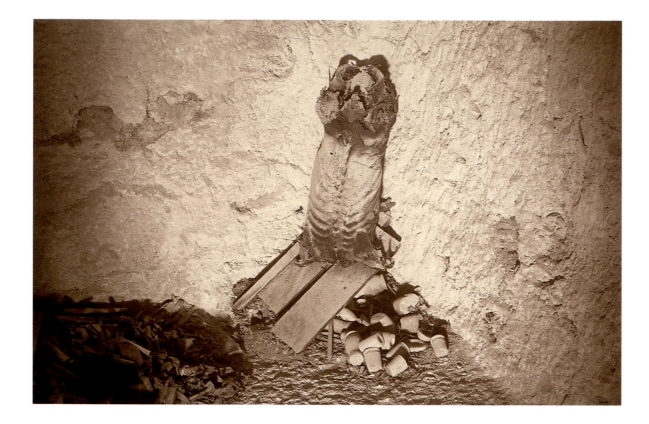

Fig. 62. Remains of a human torso in the southwest corner of the burial chamber of tomb 10A, May 7, 1915

journey to- Cairo. Story returned to Boston, but the threat of German attacks halted further shipments of artifacts to Boston for four more years. Even with the war over, Reisner worried about the safety of the coffins at sea, recalling an earlier incident in which a shipment from Giza had been damaged by a fire on the ship carrying it to Boston. He scarcely knew how to place an insurance value on Governor Djehutynakht's outer coffin, noting in his packing instructions, "It is worth a fortune, the finest [Middle Kingdom] coffin in the world." In the margins, he scribbled, "P.S. I shall die of anxiety while the boxes are at sea."

Reisner did not die of anxiety, but his fears were hardly unfounded. As the vessel *Clan Murdoch* neared the United States with its precious cargo, a fire broke out on board. Although the fire was contained, the crates were drenched with water. The ship was diverted to New York, and its contents hastily unloaded. The Metropolitan Museum sent staff members to help inspect potential damage. Fortunately, the packing crates proved sufficient to protect

their irreplaceable contents. Again, the Djehutynakhts' coffins had escaped a brush with disaster.

Once safely in Boston, the coffins of Governor Djehutynakht assumed a place of pride in the MFA's galleries (space did not permit the remaining coffins to be displayed at that time), and the Museum's Middle Kingdom collections reached a new level of quality and importance. The conservation and reconstruction of the many wooden models damaged by the grave robbers would wait for almost a century. Despite Reisner's hope that the Museum would continue work at Deir el-Bersha, no further excavations would be conducted until the 1990s, when its staff returned to the site for a joint survey with the University of Pennsylvania and Leiden University in the Netherlands. Today, new excavations under Harco Willems of the Katholieke Universiteit of Leuven, Belgium, continue to shed light on the remarkable cemetery at Deir el-Bersha.

— D. M. D.

RECENT RESEARCH AT DEIR EL-BERSHA

After George Reisner left Deir el-Bersha, research there ceased for a long time. Between 1988 and 1992, the Museum of Fine Arts, Boston, Leiden University (including the present author), and the University of Pennsylvania briefly attempted to create a joint project there but realized only one mission in 1990. In 2002 I succeeded in mounting a long-term project, which so far has resulted in seven campaigns. Rather than confining itself to decorated tombs alone, this undertaking has the aim of understanding the site as a whole within its geographic context.

For much of their existence, the Deir el-Bersha cemeteries seem to have offered last resting places to the population of the provincial metropolis of el-Ashmunein, located some 10 kilometers (about 7 miles) farther west on the west bank of the Nile. Although the site is best known for its monumental Middle Kingdom tombs, we now know that it was intensively used between the early Old Kingdom and the early New Kingdom. After that, the intensity of use dropped significantly, with Tuna el-Gebel becoming the main burial ground of the town.

Most Old Kingdom tombs are situated north and south of the mouth of the Wadi el-Nakhla. The tombs of the northern group have been severely damaged, but the state of preservation of those on the southern slope is much better. The many dozens of tombs have hardly been investigated before. It is here that the mission in 2007 made its most publicized find: the entirely undisturbed tomb of Henu. Henu was not a major official, but a mere "estate manager" (heqa-hut), who must have worked for the local governor, Djehutynakht, son of Teti, who lived late in the First Intermediate Period. Despite Henu's lesser title, the tomb's funerary models are of a superb quality.

The locations of the tombs of this Djehutynakht and others from the First Intermediate Period are still unknown. However, a barely investigated area in the village square of Deir el-Bersha also contains tombs. Egyptian archaeologists opened several of them in the early 1970s. When we reexcavated there in 2006, it became clear that at least some tombs date to the First Intermediate Period. They were very well built. Textual

Fig. 63. The Middle Kingdom cemetery at Deir el-Bersha today. Photograph courtesy of Katholieke Universiteit Leuven Mission to Dayr al-Barshā

remains from one of them shows that a man of no lesser rank than a vizier was buried there—a crucial find, as no other First Intermediate Period viziers were hitherto known. Clearly the site was of major importance during the period.

In the early Middle Kingdom, the tombs of the highest elite were moved to the top of the Wadi el-Nakhla's north slope (fig. 63). Until the late Twelfth Dynasty, nomarchs built an uninterrupted series of tombs there for themselves and their retinues. They are severely damaged, in many cases almost beyond recognition as tombs, as a result of quarry activity that took place in antiquity. We are trying to reconstruct these buildings on the basis of detailed analyses of the fragmentary remains (fig. 64; fig. 13, p. 45).

It seems that the first monumental tombs were made in this area just after King Mentuhotep II reunited Egypt. Middle Egypt, to which the Deir el-Bersha region belongs, had theretofore formed part of the Herakleopolitan kingdom that had opposed Mentuhotep II. In the appeasement period that followed Egypt's unification, a local ruler named Ahanakht seems to have played a

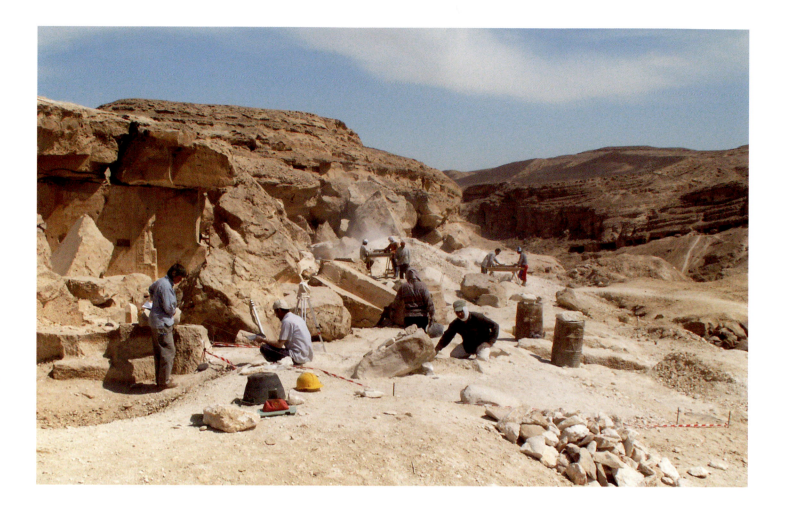

Fig. 64. Archaeological work in progress at Deir el-Bersha by members of the Katholieke Universiteit Leuven Mission team. Photograph courtesy of Katholieke Universiteit Leuven Mission to Dayr al-Barshā

crucial part. He was named vizier, and his tomb autobiography suggests he played an important role in aligning the provincial rulers of Middle Egypt with the new central government.

Ahanakht's rise to power seems to have been signaled by a number of privileges accorded to him. He was the first to build a rock tomb at a commanding position overlooking the Hare nome. At the same time, the cemetery on the desert plain below vastly expanded, covering an estimated surface of about a square kilometer (approximately four-tenths of a mile square). Almost all the tombs investigated here seem to date from the early Middle Kingdom, and this situation may be explained by assuming that the Hare nome had evolved into an administrative center of national importance.

Our research has revealed that the tombs in the plain are neatly arranged around an east-west road, a part of which is preserved. When projecting the orientation of the road at each end, it becomes clear that it must have formed the connection between the town of el-Ashmunein and the nomarchal tombs (fig. 65). The entire mortuary landscape appears to have been created around a processional axis leading to the tombs of the regional elite.

On the way to these tombs, the participants in the processions had to cross the river Nile from the west. We know from textual evidence that a group of mortuary chapels for the governors stood close to the harbor. The most impressive of these must have been that of the last Twelfth Dynasty governor, Djehutyhotep. His tomb

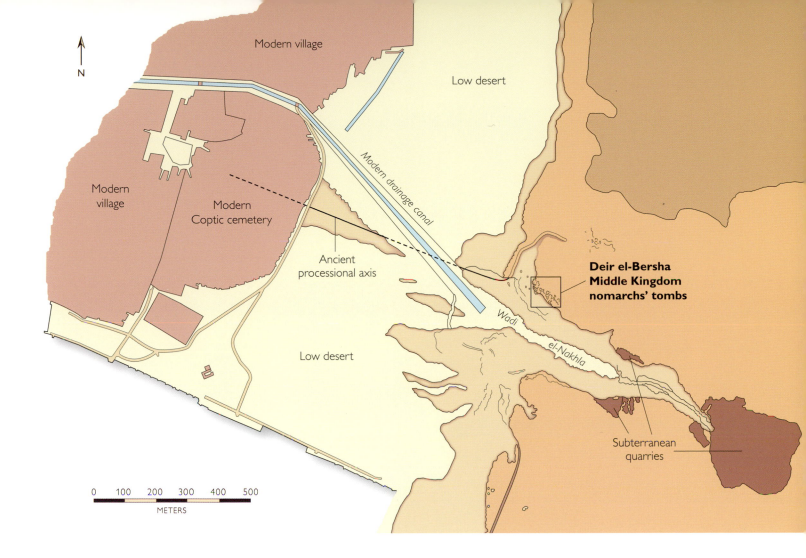

N

Modern village

Low desert

Modern village

Modern Coptic cemetery

Modern drainage canal

Ancient processional axis

Deir el-Bersha Middle Kingdom nomarchs' tombs

Wadi el-Nakhla

Low desert

Subterranean quarries

| 0 | 100 | 200 | 300 | 400 | 500 |

METERS

still contains the well-known scene depicting the transportation of his colossal statue (fig. 7, p. 30), which on internal evidence seems to have stood at the harbor of Deir el-Bersha. Researchers are still looking for its location, but geomorphological studies have already shown that ancient beds of the river Nile may have passed almost 2 kilometers (1¼ miles) farther east than today. It is therefore likely that the chapels still lie hidden somewhere under the modern village of Deir el-Bersha.

The entire cemetery layout creates a ritual landscape linking the nomarchs' chapels on the riverbank with the tomb chapels of the same officials. This design underscores how important the cult of the local ruler must have been in the Middle Kingdom. The nomarchs' status is also manifest in the decoration of their coffins.

Middle Kingdom coffins from Deir el-Bersha are renowned for their lavish decoration and the enormous amount of religious texts (Coffin Texts) written on their insides. Although similar coffins have been found elsewhere, those from Deir el-Bersha contain far more decoration and inscriptions than was customary in other parts of Egypt. The coffins at the Museum of Fine Arts, Boston, are exceptionally good examples of this. However, contrary to what is often believed, such coffins were very rare. At Deir el-Bersha, Coffin Texts are hardly ever attested outside the plateau where the nomarchs and their families were buried. It seems that the religious veneration they already received during life in their chapels formed the starting point for their funerary cult.
— H.W.

Fig. 65. Modern map of Wadi el-Nakhla and environs, created by Mary Reilly after an image provided by Katholieke Universiteit Leuven Mission to Dayr al-Barshā

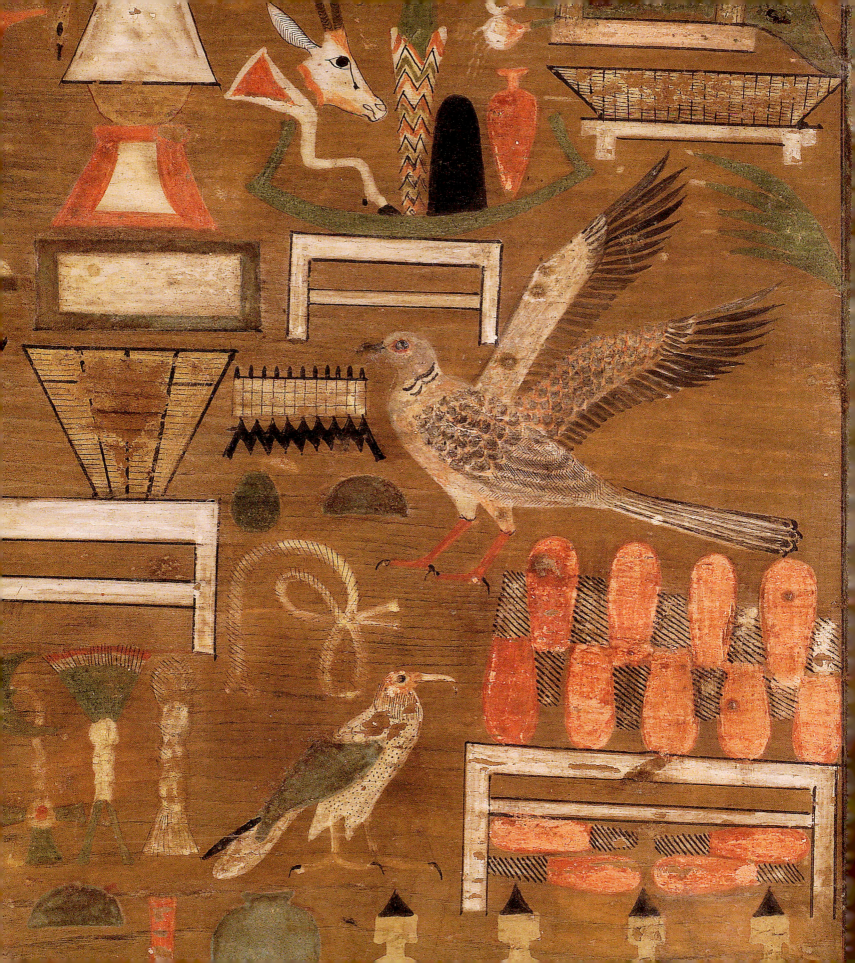

THE COFFINS AND CANOPIC CHESTS OF TOMB 10A

LAWRENCE M. BERMAN

A COFFIN WAS THE MOST important item of a person's tomb equipment. The Egyptians had many terms for *coffin*, one of which was *neb ankh*, "lord of life." More than just a container for the body, this simple oblong box with lid, by virtue of the texts and images carved and painted upon it, was a record and reenactment of the funeral rites, a map of the cosmos, and a vessel that guaranteed passage to the afterlife.[1] A coffin, particularly a decorated one, was expensive. It is estimated that only 2.8 percent of the population of Upper Egypt during the Middle Kingdom possessed decorated coffins.[2] Persons with coffins inscribed with Coffin Texts formed an even more exclusive group, perhaps 0.68 percent.[3] Made of imported coniferous wood, decorated inside and out, and amply furnished with texts, the Djehutynakhts' coffins were the best that wealth and position could buy.[4]

The texts on the coffins are strictly funerary; they are concerned with the afterlife. They tell us nothing about the Djehutynakhts' personal lives. Any such information would have appeared in the tomb chapel inscriptions, which have not survived. The traditional funerary spells have been customized only to the extent of inserting the Djehutynakhts' names and a few titles in appropriate places, and even these are reduced to a bare minimum. A man in Djehutynakht's position would have boasted an impressive array of titles and epithets, but on his coffins we see only two: *haty-a*, "Governor," and *kherep-nesty*, "Controller of the Two Thrones." The latter is obscure but is believed to be connected to his religious duties as nomarch. Lady Djehutynakht is *iret-pat*, "Hereditary Princess" or "Member of the Elite," and *khekeret nesut*, "Royal Ornament." The last of her titles is an old courtly one, which at this point in Egyptian history did not by itself indicate a personal relationship with the king (though it would not exclude such a relationship).

CONSTRUCTION

The coffins are made of thick boards of imported cedar of Lebanon (*Cedrus libani*) doweled together. Elegant lozenge-shaped repairs mask imperfections in the wood. Each coffin consists of a box and a lid. The box has five sides: two long sides (front and back), two short sides (head and foot), and the floor or bottom. The sides have beveled edges fastened together by dowels and copper ribbons and fitted together at the top by butt joints. The lower edges are rabbeted and held to the bottom by dowels and copper ribbons that also passed through the ends of four battens or cross-pieces fitted to the underside. Thus secured, it would have been no easy task to break the coffin apart (which has not deterred people from doing so, be they tomb robbers looking for treasure or Egyptologists wishing to copy the inscriptions).[5] The massive lids were lifted into place using two integral lugs at each end, which were afterward sawed off to make the sides flush.[6] All these construction details, as well as the damage inflicted by the grave robbers who prized off the ends, are visible in the excavation photographs (fig. 66). The whole ensemble rested on a wooden sledge for dragging the coffin to the tomb.

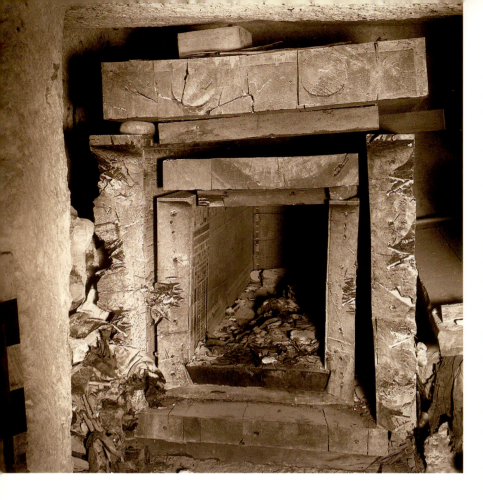

Fig. 66. Inner and outer coffins of Governor Djehutynakht in situ (viewed from the burial shaft), tomb 10A, May 3, 1915

EXTERIOR DECORATION

The decoration of the exterior is simplicity itself (fig. 67). A single band of inscription runs just below the rim on each side and down the center of the lid. The hieroglyphs were incised and filled with blue paint, which has since turned dark green. The background was painted white. The remaining surfaces were left bare except for a pair of sacred eyes on one side. The eyes are incised and painted and set within a rectangular frame. The eyes (the proper left one here is badly damaged) mark the front of the coffin. The mummy was placed in the coffin lying on its left side, with its head facing east. The eyes were supposed to enable him to look out of the tomb and see the rising sun as it set forth on its journey across the sky.

The layout of the texts and decoration reflect the position of the mummy. All the inscriptions read from head to foot, the hieroglyphs facing in the direction of the mummy's head in order to make them easier for him or her to read. In this way, the coffin was complete only with the mummy inside it.

Each side of the coffin bears a spell for offerings appropriate for the direction it was supposed to face. Taken together, the inscriptions provide for a proper burial (front and back) and a successful journey to the afterlife (lid). These benefactions are said to be provided by the king and the funerary gods Osiris, god of the dead, and Anubis, guardian of the cemetery. The inscription on the front of the coffin is a prayer for offerings and provisions: "An offering that the king gives, and Osiris, lord of Busiris, foremost of the westerners, lord of Abydos: invocation-offerings of bread, beer, oxen, and fowl in all the beautiful places of the necropolis to the honored one, governor and controller of the two thrones, Djehutynakht."

The back of the coffin bears a prayer for a good burial in the west: "An offering that the king gives, and Anubis, foremost of the divine booth, he who is in the place of embalming, he who is on his mountain, lord of the cemetery: a good burial in the western desert to the honored one, Governor Djehutynakht." Ideally, Egyptian cemeteries were located on the west bank of the Nile. In Middle Egypt, however, the eastern desert hills came up to the river, whereas on the other side the fertile plain extended far into the west, so the practical advantage of an accessible location and the allure of a commanding view made the east bank more desirable as a place of burial for the citizens of Hermopolis. Nonetheless, "a good burial in the west" retained its symbolic value. The cemetery always maintained its association with the place where the sun set, the kingdom of Osiris, "lord of the westerners."

The lid inscription reads: "An offering that the king gives, and Anubis, lord of Sepa, that he may be followed by his *ka* to the pure places of the necropolis and walk well on the good roads on which the honored ones walk." The inscriptions on the head and foot are brief. "Governor and controller of the two thrones, Djehutynakht" is called "the one honored by Osiris, the great god," on the head end and "the one honored by Anubis" on the foot.

INTERIOR DECORATION OF THE OUTER COFFIN OF GOVERNOR DJEHUTYNAKHT

The decoration of the coffin's interior is as lavish as the outside is austere. It is the most elaborately decorated of all the Deir el-Bersha coffins, celebrated since its discovery for the altogether exceptional quality of its paintings.[7] Texts and images combine to form a meaningful inter-related whole.

There are essentially three types of inscriptions on the interior: ornamental hieroglyphs, Coffin Texts, and edge inscriptions. The ornamental hieroglyphs are elaborately painted texts laid out in horizontal and (occasionally) vertical bands on the sides. These are mainly offering spells beginning with the words "An offering that the king gives." Each hieroglyph is a painting in itself, a perfect example of the unity of art and writing.

The Coffin Texts are laid out in vertical columns, the signs outlined in black and then incised. The Middle Kingdom Coffin Texts are the largest body of ancient Egyptian funerary texts. There are 1,185 officially identi-fied Coffin Text spells (some are no more than captions, and others are several columns in length) compared with some 800 Old Kingdom Pyramid Text spells and 200 New Kingdom Book of the Dead spells.[8] Not included in this count of Coffin Texts are some 270 older spells already known from royal tombs of the Old Kingdom and therefore classified as Pyramid Texts.[9] The Egyptians, however, would not have made this distinction; for them it was all part of one living tradition. Most individual coffins, however, have fewer than 200 spells. The Djehuty-nakhts' coffins are abundantly inscribed with Coffin Texts: the nomarch's outer coffin has 175 spells, and his inner coffin has 201; Lady Djehutynakht's outer coffin has 92 spells, and her inner coffin has 127.[10] Altogether, they fill 2,807 columns of text.

Edge inscriptions, the third type of inscription found on the coffins, barely qualify as decoration at all, for they are not visible when the coffin is assembled. These inscriptions are crudely painted or incised on the beveled edges of the four side walls and on the top edges of the

Fig. 67. Front panel (exterior view) of Governor Djehutynakht's outer coffin, late Dynasty 11–early Dynasty 12, 2010–1961 B.C.

Fig. 68. An edge inscription on the head panel of Governor Djehutynakht's inner coffin, late Dynasty 11–early Dynasty 12, 2010–1961 B.C.

Fig. 69. Head panel (interior view) of Governor Djehutynakht's outer coffin, late Dynasty 11–early Dynasty 12, 2010–1961 B.C.

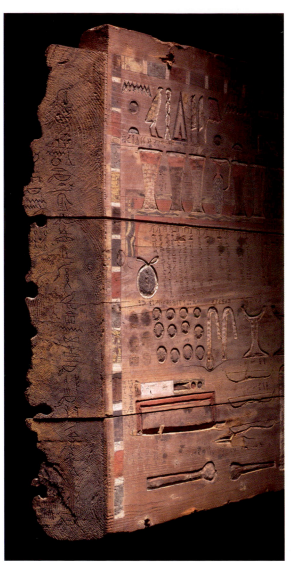

A few examples illustrate the graphic intensity of these spells. On the head end of Governor Djehutynakht's inner coffin (fig. 68), it says:

Words spoken: I am Horus. I have come to you, my father Osiris Djehutynakht, that I may rejoin your bones for you, that I may strengthen your two arms. . . in your place of eternity.
Words spoken: O mother of this Djehutynakht, come to him, remove his mummy bandages.

HEAD

The head side of the outer coffin is a perfect example of how texts and images correspond (fig. 69).[13] At the top are two lines of painted hieroglyphs: "Open the chest and bring ointment for the honored one before Anubis, Governor Djehutynakht."[14] Cosmetic oils and unguents offered to the deceased during the funeral rites are pictured in the object frieze just below them. Represented are, from left to right, the "seven sacred oils" in their prescribed order—setj-heb, heknu, sefeti, ni-chenem, tewat, best ash, and best tjehenu—and in containers of various shapes. The first six are of cream-colored travertine (Egyptian alabaster), and the last of hard mottled stone, perhaps diorite. We should picture the vessels as small, since the oils are precious. All are tightly sealed to keep their contents fresh and prevent evaporation. Next come bags of green and black eye paint, which also have their place in the offering ritual. In keeping with the extravagant decoration of the rest of the coffin, the object frieze is padded with extra items, including two bows, a pillow (?), a headrest of ebony, and pellets of incense.

The incised texts below, excerpted from the Pyramid Texts, make clear that the function of the oil is to transform the deceased into a blessed spirit, or akh, literally an "effective one," one whose spiritual parts have been reunited to enable him or her to function forever in the afterlife.

Ointment, ointment, where should you be? You on Horus's forehead, where should you be? You were on Horus's forehead, but I will put you on this Djehutynakht's forehead.
You shall make it pleasant for him, wearing you; you shall akhify him, wearing you; you shall make him have control of his body; you shall put his ferocity in the eyes of all the akhs who shall look at him and everyone who hears his names as well. First-class cedar oil.[15]

bottom where the side walls are fixed to cover them.[11] Sometimes they even occur on the dowels. The two coffins of Governor Djehutynakht are richly furnished with these inscriptions, more than any other known coffins, and include texts that are found nowhere else.[12] Although hidden from view, they are powerful spells that surround the deceased with the deities Horus, Nut, Geb, Isis, and Nephthys. They restore to him his head and his limbs; they revivify him, just as they did for Osiris in the story that serves as the background for the funeral ceremony.

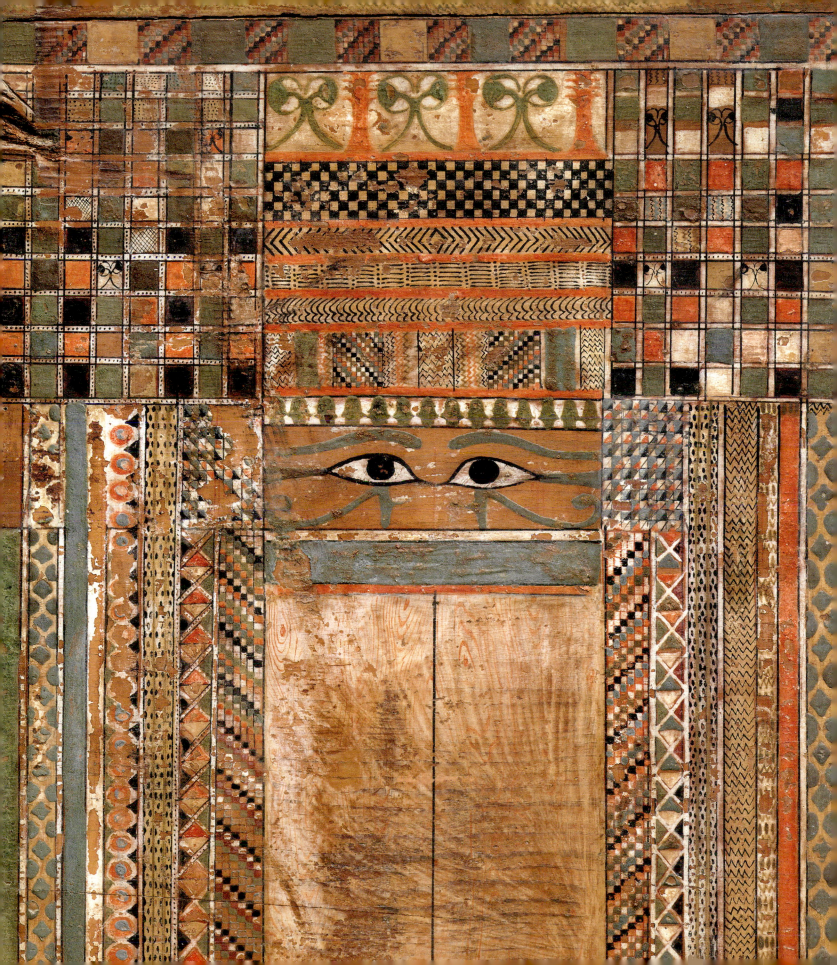

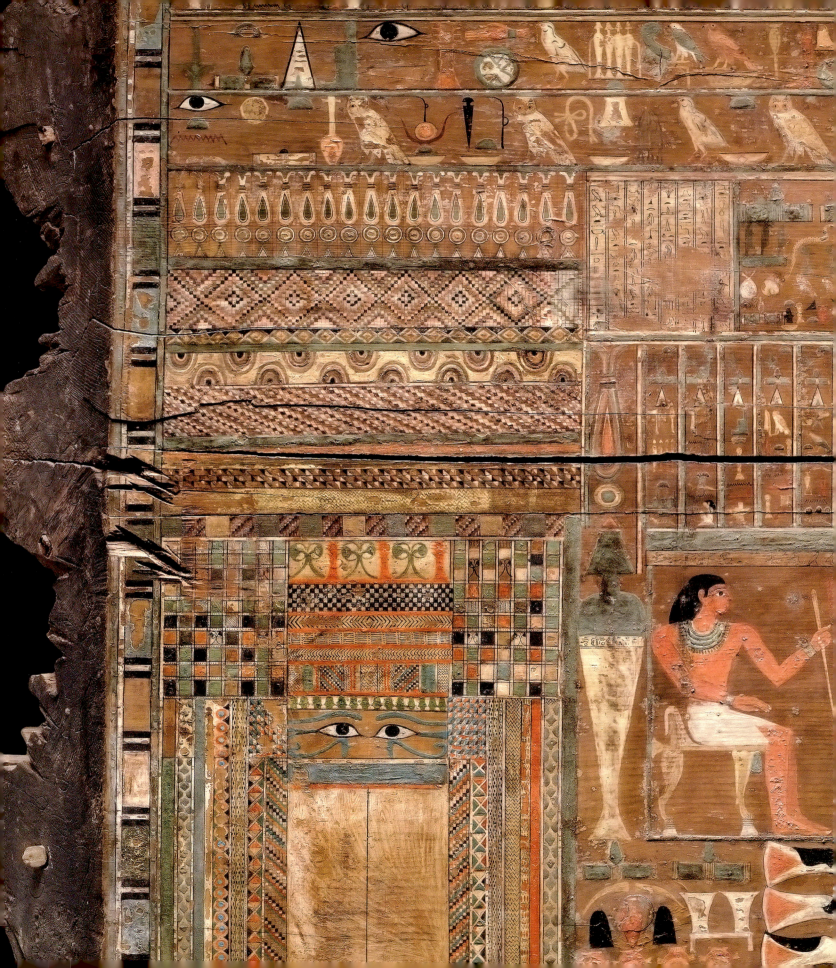

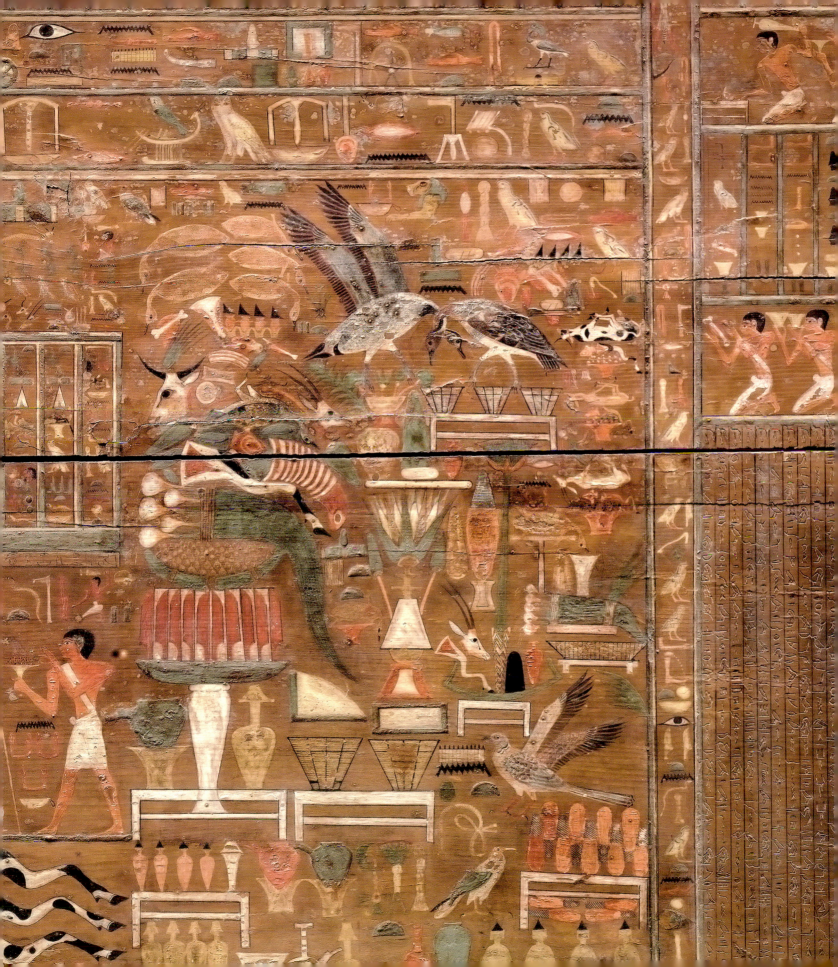

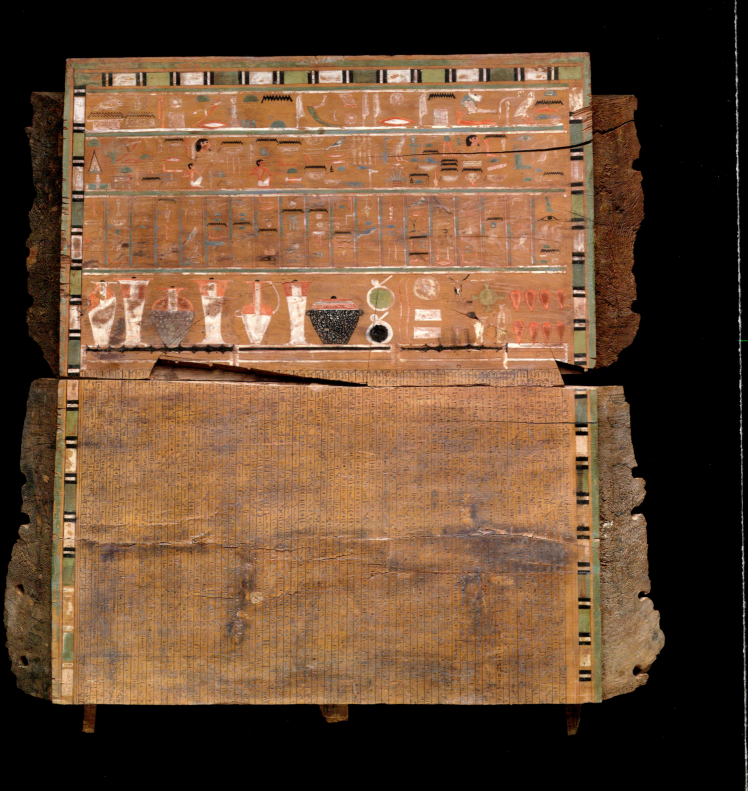

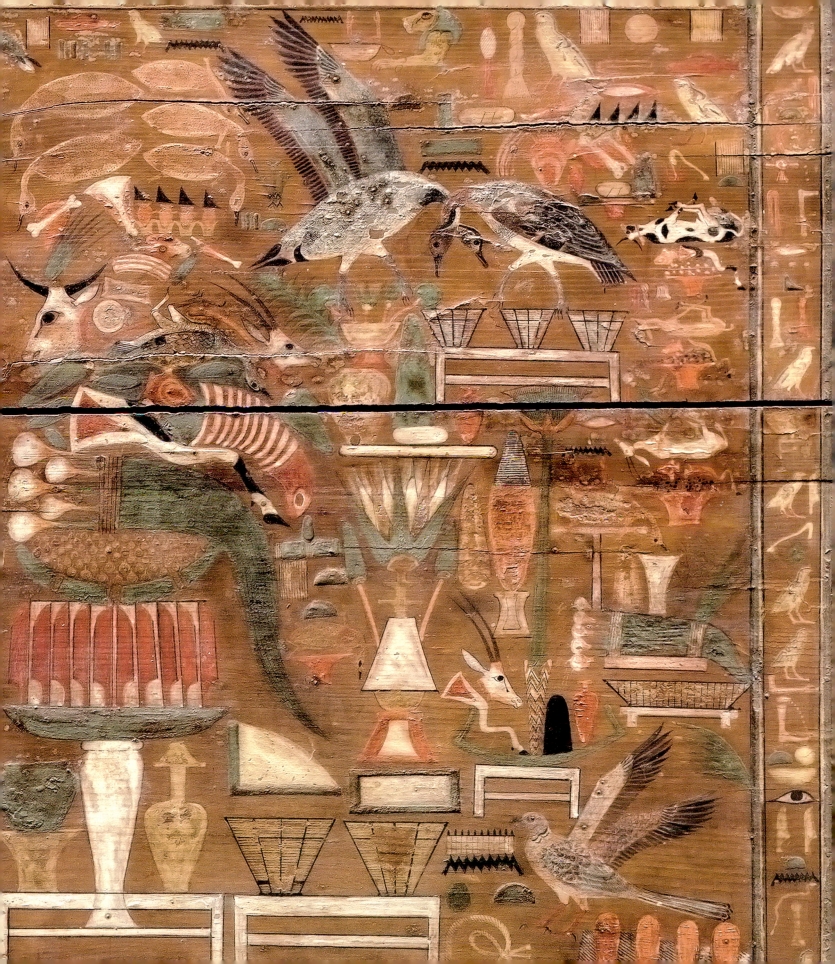

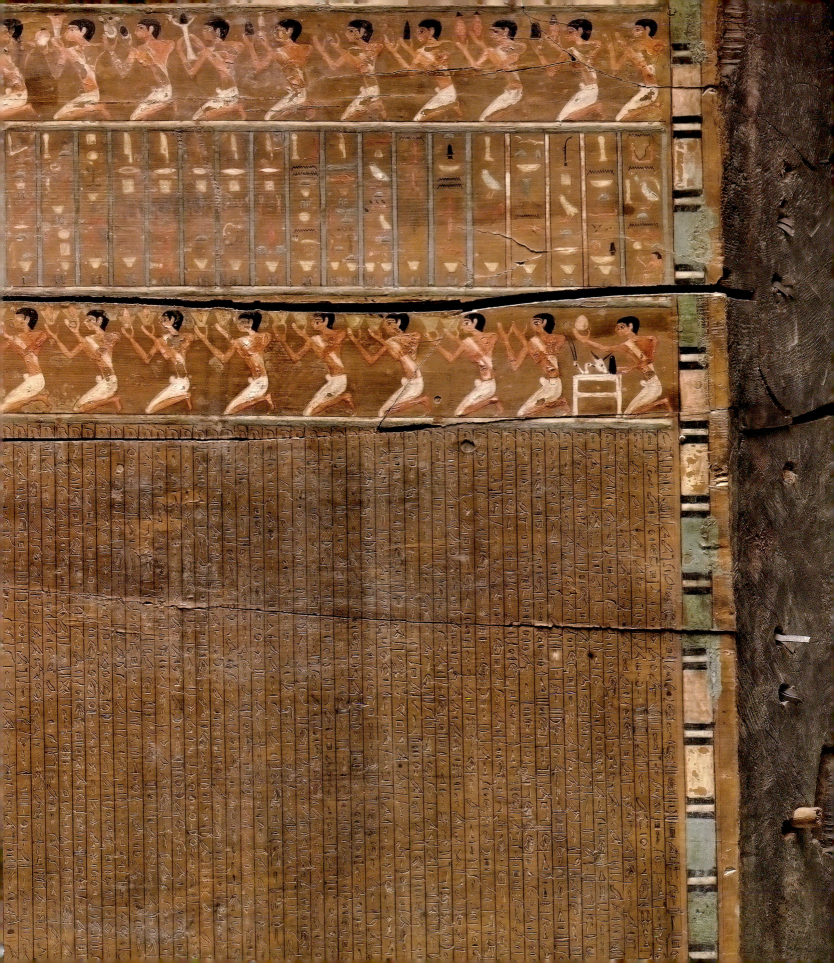

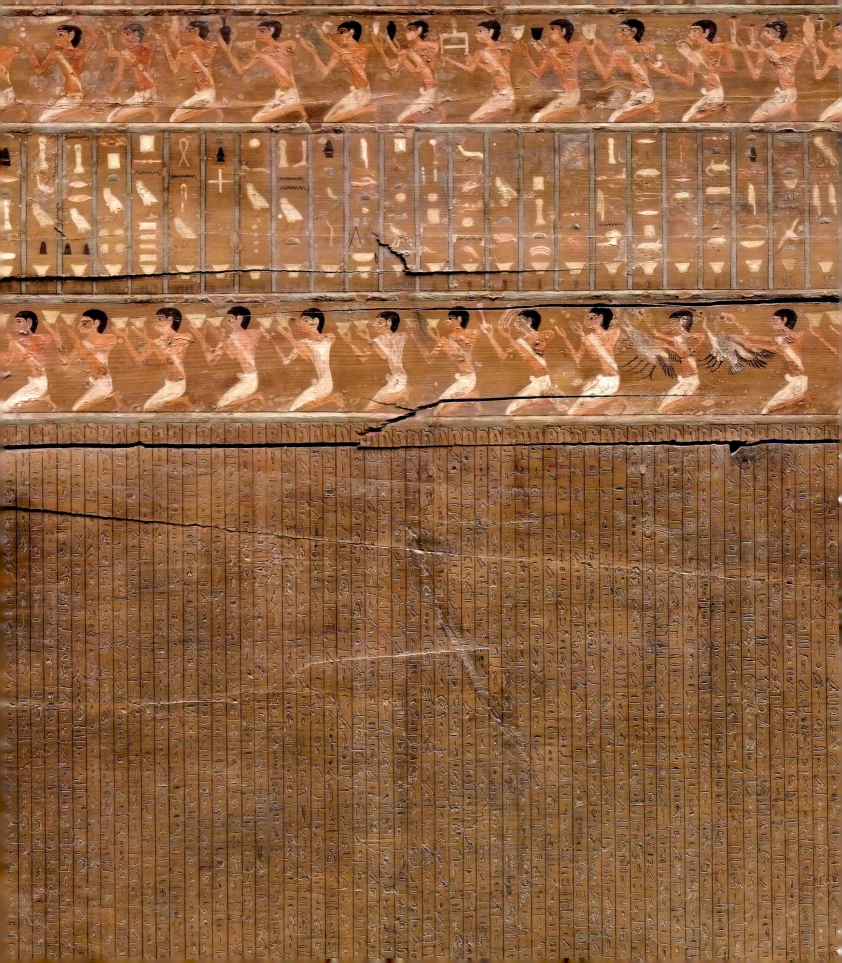

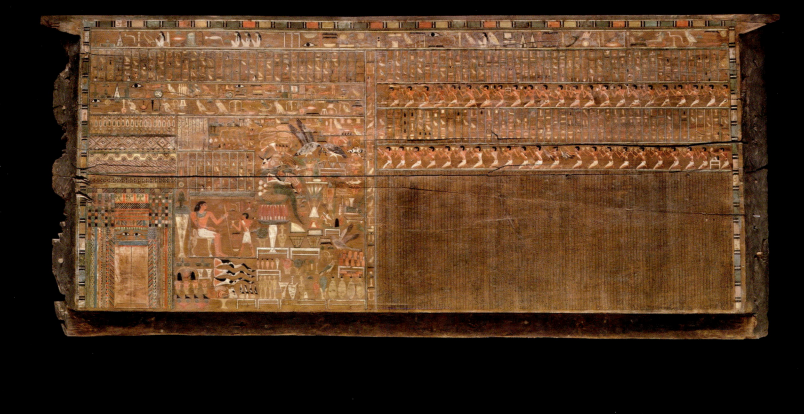

Fig. 70. Front panel (interior view) of Governor Djehutynakht's outer coffin, late Dynasty 11–early Dynasty 12, 2010–1961 B.C.

Fig. 71. Detail with false door, front panel (interior view) of Governor Djehutynakht's outer coffin

FRONT

The band of ornamental hieroglyphs across the top of the front side of the coffin contains a prayer to all the gods that effectively serves as a heading for all the offerings and inscriptions below (fig. 70):

> An offering that the king gives, and Thoth, the Two Conclaves, the Great Ennead, and all the (other) gods, that they might perform rituals for you in accordance with this writing of divine words made by Thoth in the house of writing, which they have given to the one honored before the great god, lord of the sky, Governor Djehutynakht.

A vertical column of hieroglyphs runs down the middle of this side dividing it in two halves: "Words spoken by the lector-priest: 'I purify all offering tables with burning incense and libation. This is pure, everything that is done for Djehutynakht and his *ka*.'"

The area to the left of this column contains the most wonderful painting on the coffin. On the far left is a "false door" imitating a palace facade hung with brightly colored reed matting (fig. 71). In a tomb chapel the false door serves as the interface between the worlds of the living and the dead, the focal point of the offering cult of the deceased. On coffins the false door serves a similar purpose, for the design always incorporates a pair of sacred eyes to enable the deceased to look out toward the rising sun with its promise of rebirth.

The painting is a triumph of delicacy and precision. There is a dazzling combination of linear and geometric patterns—checkerboards, chevrons, triangles, and lozenges. The kaleidoscopic effect is all the more remarkable considering the limited range of pigments employed: black (carbon black), white (calcium carbonate), red (a mixture of iron oxide and calcium carbonate), yellow (orpiment),

blue (Egyptian blue), and green (a mixture of Egyptian blue and atacamite, a copper chloride).[16]

The door leaves are painted red over white to imitate the natural veining of wood. Pairs of bound papyrus plants appear near the top of the lintel, where they alternate with *djed*-pillars (poles with crossbars near the top, the hieroglyphic sign for stability). Bound papyrus plants appear on palace facade decoration on coffins as early as Dynasty 4.[17] This is one of the earliest instances in which bound papyrus plants are combined with *djed*-pillars on false doors, both motifs being associated with Osiris.[18] Tiny bound papyrus plants also appear in some of the squares of the checkerboards on both sides.

The door and its surrounds occupy only about 60 percent of the total height. Above the lintel are contrasting patterned bands. The row of staggered semicircles represents sawed-off ends of roof beams. The top is embellished with a row of *kheker* signs, their form derived from the tufted ends of reeds knotted together, frequently used as a crowning element in architecture.

To the right of the false door, Djehutynakht sits on a lion-legged chair holding a staff in his left hand, a classic image of an Egyptian dignitary (see p. 2). Figures of the tomb owner appear regularly on stelae and tomb chapel walls but only rarely on coffins.[19] His appearance here, in addition to the false door, gives this side of the coffin the appearance of a tomb chapel wall in miniature.

Standing before the tomb owner, a priest drops a pellet of incense onto a dish heaped with burning coals from which smoke rises. The hieroglyphs read, "Burning incense for your *ka*s two times." It is rare for something as elusive as the texture of smoke to be represented in Egyptian painting. Indeed, the most remarkable aspect of the decoration on Governor Djehutynakht's outer coffin is its painterly quality. Most Egyptian painting is linear; color is applied in flat tones. Although this artist is clearly a master of outline, he often eschews it, relying on color as well as line to suggest form. Here, for example, the artist has used different shades of red to distinguish the seated tomb owner's legs. The right leg is painted the same shade as the rest of his body, but the left leg, partly overlapped by the right one and theoretically farther away, is a darker red.

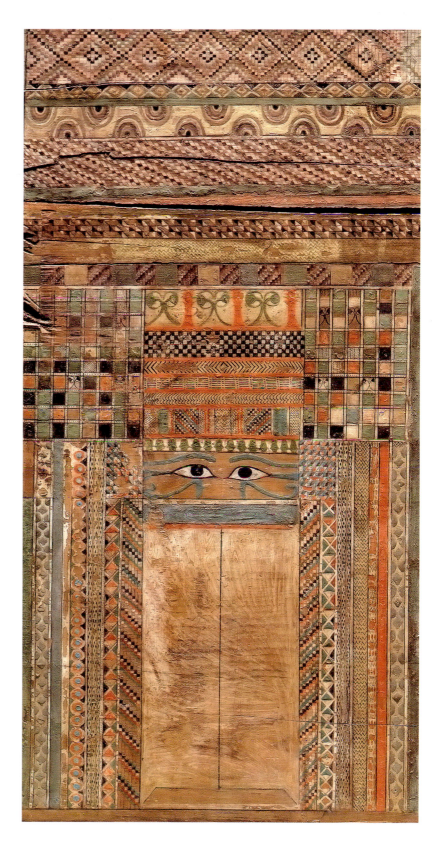

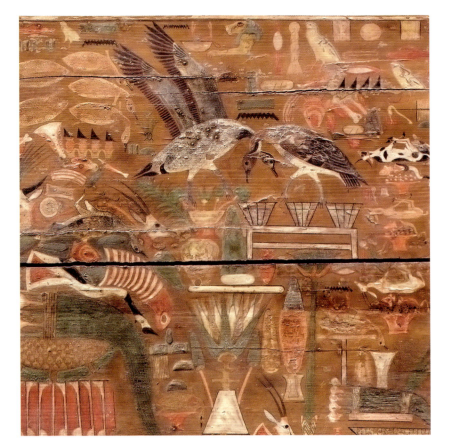

on the bone, and, at the very top, five plucked fowl labeled "five ducks, whose necks have been wrung."

The space to the right of this enormous pile of food has tables, baskets, and potted plants rising up into the air. At center height are a lotus blossom between two buds, and a tall papyrus plant. Crowning this section is an arch formed by the intertwined necks of two ducks, the left one with outspread wings, the right with wings folded (fig. 72).

At the far right, near the top, one above the other, are three trussed animals—an ox, a gazelle, and an oryx. The hides and horns of each species are accurately rendered. Below each are a heart and a foreleg roasting on braziers. One brazier has dead white coals, the others have a mixture of live red, unburned black, and dead white coals—such is the artist's care for detail. Animal sacrifice was an essential part of every funeral. Heads, hearts, forelegs, and feet of cattle were presented to the deceased to sustain him in the afterlife. For that reason, these cuts of beef figure prominently below the seated figure of Djehutynakht. It may seem surprising to find wild desert animals alongside domesticated cattle, but gazelle bones recently identified in tombs at Deir el-Bersha tell us that such game was included among the funerary offerings.[21]

The pièce de résistance is the dove at the lower right (p. 104). Although the bird is shown with one folded wing and two unfolded wings, the artist has used this convention of Egyptian art to show off his virtuosity. He gives us three different views of a bird's wing: one from the side, one from the top extended, and one from below, the different types of feathers clearly and correctly distinguished.

To the right of the lector-priest's recitation is a list of offerings itemized as a table two rows deep and forty-five columns across. On most coffins the names of the items are written in black and incised, but on the outer coffin of Governor Djehutynakht they are polychrome, in keeping with the overall deluxe standard of its decoration. The names of the objects are accompanied by small kneeling figures of offering bearers presenting the items named in the text columns above—libations, incense, tables, vessels of various shapes, onions, live ducks. Although the kneeling figures are nearly identical, the different individual offerings add variety and—especially in the wriggling

Fig. 72. Detail with ducks, front panel (interior view) of Governor Djehutynakht's outer coffin

Behind the seated tomb owner is a gigantic water jar inscribed with his name. Above him, prayers for offerings are written in colored hieroglyphs arranged in neat vertical columns. The prayers call for a thousand portions of bread, beer, oxen, fowl, and everything good and pure for Djehutynakht.

There was never such a scene of plenitude. It is a banquet fit for a god. Behind the priest is an offering table with stylized reed leaves standing on end, symbolizing the Field of Reeds, the plot of land assigned to the deceased for his eternal sustenance in the afterlife, the Egyptian Elysium.[20] On top of the reed leaves a large basket of figs is shown in section to reveal its contents, and above that is an enormous bunch of onions, highlighted in orange and looking truly bulbous. On top of the onions are a leg of beef, a section of ribs, a heart, a duck lying upside down between an ox head and an oryx head, sections of meat

birds in the bottom row—a certain liveliness to the composition (fig. 73).

Below the offering list, occupying roughly the lower right quadrant, are the Coffin Texts. These begin with a spell known only from Deir el-Bersha: "To become Hetep, Lord of the Fields of Offerings." *Hetep* (plural: *hetepu*) is the Egyptian word for "offering," as in "an offering that the king gives" and also "offering table." The Fields of Offerings is the Egyptian Elysium, where the deceased does whatever he likes and no one interferes with him. Appropriately, this spell occurs directly opposite the offering table scene, so the Coffin Text complements the visual imagery.

> Men carouse and this Djehutynakht carouses in it, men eat and this Djehutynakht eats in it; men drink and this Djehutynakht drinks in it, men plough and this Djehutynakht ploughs in it, men reap and this Djehutynakht reaps in it. . . . This Djehutynakht will not be apprehensive in it.[22]

Having told us what he wants to do, Governor Djehutynakht then tells us what he does not want to do in the afterlife. He does not want to eat feces, and he does not want to stand upside down. He wants to eat only good food.

> What I doubly detest, I will not eat. Feces is my detestation and I will not eat. . . . I go upstanding, for to be upside down is my detestation. . . . Impurities are my detestation, and I will never eat them. . . .[23]
>
> What will you live on? say the lords of Pe.
>
> I will live on what they live on, I will eat of what they eat. . . . I will live on that pleasant tree which is in his shrine, on which the Followers of Re live, for I indeed dwell in his shrine, being pure.[24]

The spells that follow are concerned with (in the order in which they occur) not letting a man's magic be taken from him in the land of the dead, receiving gifts in the land of the dead, not eating feces or drinking urine, not working, not rotting and not working, again not eating feces or drinking urine, and a man having power over his foes.[25] To sum up:

> A man does what he wishes in the realm of the dead. I am a lion who eats what is pure in the field, for whom is done what he wishes; I will be there, for I have seen with my own eyes.[26]

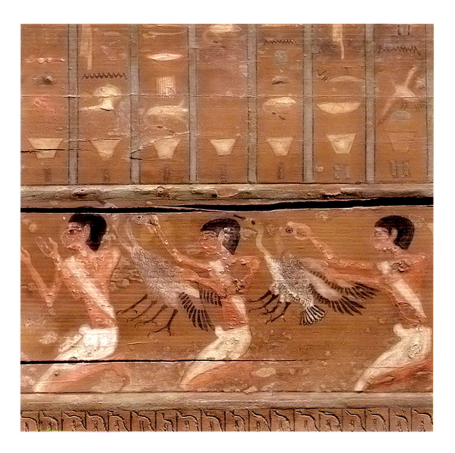

Fig. 73. Detail with offering bearers holding live ducks, front panel (interior view) of Governor Djehutynakht's outer coffin

FOOT

The foot of Governor Djehutynakht's outer coffin has only Coffin Texts. There is not even a band of ornamental hieroglyphs across the top. Interestingly, the texts end with a long and triumphant variant of spell 468, a description of the Fields of Hetep. Thus this side ends where the Coffin Texts on the front began, with the Egyptian Elysium.

BACK

At the top of the coffin's back side are three lines of ornamental hieroglyphs with a version of Pyramid Text spell 592, a prayer to Geb, the earth god, for Djehutynakht's protection. The text here is somewhat garbled despite the beautiful hieroglyphs (fig. 74). If one substitutes Djehutynakht's name for the king's in the original (written on the walls of the Old Kingdom pyramid of King Merenra [2255–2246 B.C.]), one reads:

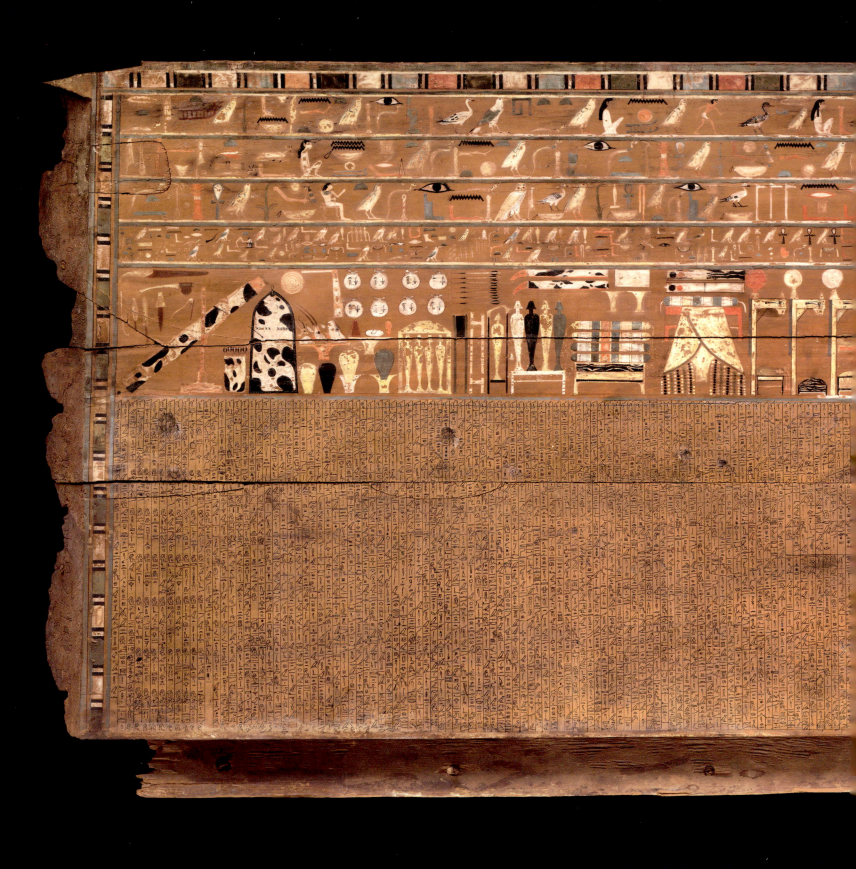

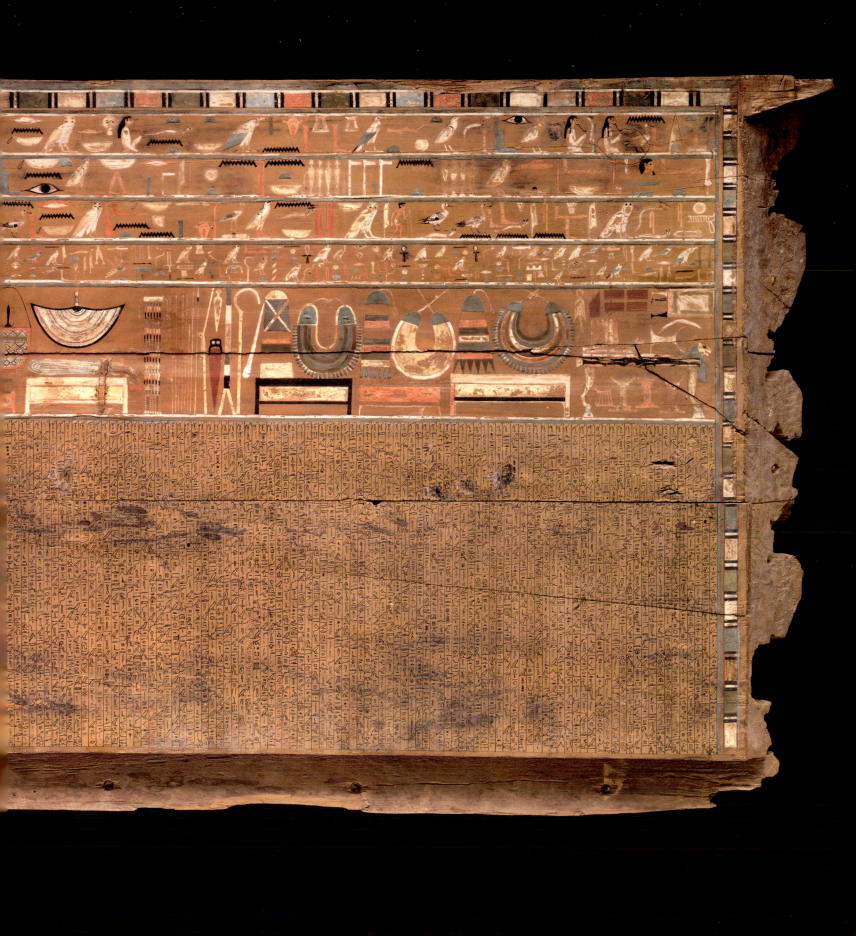

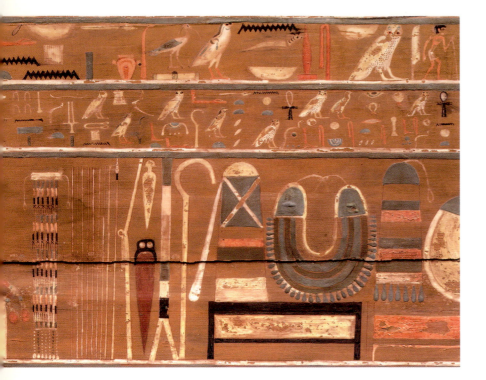

frieze and the mummy in the coffin. Thus, headrests, mirrors, and necklaces appear nearest the head, tools and weapons within arm's reach, and sandals by the feet.

Governor Djehutynakht's object frieze is the most elaborate and exquisitely detailed of all extant examples. So many items are depicted that not all are mentioned in the inscription above, and the descriptions of the objects do not always correspond to the way they appear in the frieze. Text and image should not be seen as contradictory; rather they complement one another, each supplying its own version of the information. The frieze begins with an assortment of bedroom equipment—not just a headrest, but a whole bed. The bed is made of wood (specified as ebony in the inscription) and has a lion's head and lion's legs and feet resting on inverted cones. A linen sheet is placed upon the bed. A headrest lies on its side on top of the sheet. The lion-headed board with vertical uprights is an object of unknown use. It is not named in the inscription. The crescent-shaped object above the headrest appears to be an ivory wand.[28] Four more headrests of different types and materials—including one, apparently of wood, with six struts supporting the top—are placed under the bed. At the top are razors with handles of different materials protruding from a case, and five razor blades.

Next come three broadcollars and their counterpoises, each standing upright on a table (but to be thought of as lying flat upon it). The middle one is described as gold with a counterpoise of gold and lapis lazuli, and the one on the left as lapis lazuli with a counterpoise of precious stones. An assortment of scepters, weapons, and staves follow. The inscription mentions forty walking sticks; only eight are shown, but many more were found in the tomb. Plain wooden walking sticks were obviously of no value to the robbers, who ransacked the tomb in search of burial ornaments fit for a king. Next is an elaborate apron of colored beads (fig. 75).

The frieze continues with a fan, a mirror in its beadwork case with shoulder strap, and more tables with necklaces lying on them. Three mirrors follow, their disks made of gold, silver, and copper according to the inscription, perched on tall wooden stands embellished with

Fig. 74. *(previous spread)* Back panel (interior view) of Governor Djehutynakht's outer coffin, late Dynasty 11–early Dynasty 12, 2010–1961 B.C.

Fig. 75. Detail of a lapis lazuli broadcollar with counterpoise, scepters, weapons, staves, and a beaded apron from the object frieze on the back panel (interior view) of Governor Djehutynakht's outer coffin

An offering that the king gives: Geb, this Osiris Djehutynakht is Shu's son. The heart of your mother flooded up with joy over you, in your identity of Geb. You are Shu's eldest and senior son, his firstborn.

Ho Geb! This is Osiris Djehutynakht. Gather him to you, that what is against him might end.

You alone are the great god, for Atum has given you his inheritance. He has given you the Ennead gathered, and Atum himself as well amongst them, gathered for his senior son's son in you, for he has seen you effective, your heart big with pride; persuasive in your identity of the persuasive mouth, the god's elite one; standing on the earth and judging at the fore of the Ennead, your fathers and your mothers. Come to their fore, more controlling than any god, and come to this Osiris Djehutynakht and defend him from his opponent.[27]

This spell introduces the frieze below, which depicts the objects presented to the deceased during the offering ritual. Each item is named in the hieroglyphs directly above it. Object friezes are a standard part of the decoration of Middle Kingdom coffins. There is often a logical connection between the position of the objects in the

sacred eyes. Next come scribe's palettes of ebony and ivory, a royal kilt, bracelets lying on a table, tall jars (some standing on tables, others in shrines), arrows (six are shown, but the inscription directly above tells us there are 73,311), offering tables (one with heads of animals), ewers and basins, and eight small pouches of linen labeled "king's equipment." The frieze ends with a shield, a quiver of arrows, a spear case of dappled animal hide, and, in the upper corner, a set of carpenter's tools. It is not always clear what these objects signify or why they are placed where they are. We do not know, for example, what the sacks of "king's equipment" were thought to contain, nor do we know why carpenter's tools are placed at the feet. The presence of objects associated with royalty, however, does not indicate any presumption on the part of the deceased. Rather, it serves to underscore his or her identification with Osiris, king of the underworld.[29]

TOP

The underside of the lid has Coffin Texts framed top and bottom by two broad bands containing some of the most beautiful painted hieroglyphs of all (fig. 76). The delicacy of the hare (just left of center in the top band), the finesse and precision of the owls (to the left), and the adept placement of the downturned arms and hands (introducing the phrase *n mwt.f ḏt*, "that he not die forever") with the fingers separated in white, make this section "a kind of microcosm of what we admire so much in Middle Kingdom painting: the superb drawing, the softness and clarity of the coloration, the clean spatial organization."[30] These Coffin Texts begin with an abridged version of the guide to the underworld known as the Book of Two Ways (represented by a fuller version on Djehtuynakht's inner coffin), followed by miscellaneous spells.

Fig. 76. Lid (underside view) of Governor Djehutynakht's outer coffin, late Dynasty 11– early Dynasty 12, 2010– 1961 B.C.

Fig. 77. Inner coffin of
Governor Djehutynakht
(frontal view), late Dynasty
11–early Dynasty 12,
2010–1961 B.C.

Fig. 78. Detail of front
panel (interior view) of
Governor Djehutynakht's
inner coffin

BOTTOM

The bottom of the coffin is covered with Coffin Texts
except for a small panel in the center with the remains
of an inscription, apparently an offering formula in blue
but now mostly illegible.[31] The Coffin Texts begin with
a sequence of six spells concerned with the god Shu.[32]
These are some of the most sophisticated texts in the
whole corpus of Egyptian funerary literature. Their sub-
ject is the creation of the world; they tell how the pri-
mordial god Atum brought the world into existence
alone, or how one being differentiated himself into many—
what James Allen calls the "splitting of the Atum."[33]

In the beginning, Atum existed by himself in the
primeval waters. The first thing he did was to create a
void, like a bubble. That bubble is the atmosphere, Atum's
firstborn son, the god Shu. As a female counterpart for
Shu, he created Tefnut. This process, whereby a single being
was able to give birth, is expressed in the Egyptian texts
by punning on the words for "sneezing," *i-shesh*, and "spit-
ting," *tef*, which sound like Shu and Tefnut. Metaphorically,
Atum is said to have created Shu by sneezing and Tefnut
by spitting. This bubble in the ocean, the atmosphere, has
a bottom and a top. These are the earth, personified by
the god Geb, and the sky, by the goddess Nut. Geb and
Nut are the children of Shu and Tefnet, and also the first
children born of sexual union. Just as the air separates the
earth and the sky, in Egyptian mythology, Shu separates
Geb and Nut, thus creating the conditions in which life in
all its manifestations can develop. Geb and Nut give birth
to Osiris, Isis, Seth, and Nephthys. These nine gods are the
Ennead, the "first corps" of gods.

Shu represents the principle of all life, which was cre-
ated out of Atum, the self-developing god. By identifying
himself with Shu, the deceased Djehutynakht identifies
himself with life itself.

I am Life, lord of years,

Life of Eternal Recurrence, lord of Eternal Sameness—
the eldest that Atum made with his efficacy,
when he gave birth to Shu and Tefnut in Heliopolis,
when he was one and developed into three,
when he parted Geb from Nut,
before the first Corps was born,
before the two original Enneads developed

and were existing in me.
It is in his nose that he conceived me,
it is from his nostrils that I emerged. . . .

I will fix the head of Isis on her neck,
and assemble Osiris's bones.
I will make firm his flesh every day
and make fresh his parts every day—
falcons off birds, jackals off prowling,
pigs off the highlands, hippopotami off the cultivation,
men off grain, crocodiles off fish,
fish off the waters in the Inundation—
as Atum has ordered.
I will lead them and enlighten them,
through my mouth, which is Life in their nostrils. . . .

I will enliven the little fish and the crawling things on
Geb's back.
I, in fact, am Life that is under Nut.[34]

INNER COFFIN OF GOVERNOR DJEHUTYNAKHT

The exterior of Governor Djehutynakht's inner coffin
is decorated according to the same layout as his outer
coffin, with horizontal bands of hieroglyphs along the
top of all four sides and down the center of the lid with
offering formulas invoking Osiris and Anubis and a pair
of sacred eyes on the front (fig. 77). The main difference
is on the interior, and it is a matter of technique. Rather
than being simply painted, the major decorative elements
have been carved out in sunk relief and then painted.
The paintings themselves, however, though colorful, are
not nearly as refined as on Djehutynakht's outer coffin
and are obviously by a different hand.[35]

The interior front side of Djehutynakht's inner coffin
lacks the profusion displayed by his outer coffin (fig. 78).
It is limited to a band of ornamental hieroglyphs across
the top, an altogether plainer false door (though the
leaves of the door and door bolt are nicely detailed),
and an incised offering list with a single row of kneeling
figures. There is no tomb owner, no offering table, and
no piles of offerings.

The incised texts, nearly half of which are Pyramid
Texts, compensate for the absence of pictures. These
texts are all borrowed from the royal offering ritual. First
the deceased is censed, and his mouth is cleansed with
saltwater. Next, the table is prepared for him, and he is
offered bread and onions, beef and poultry, drinks, fruits,

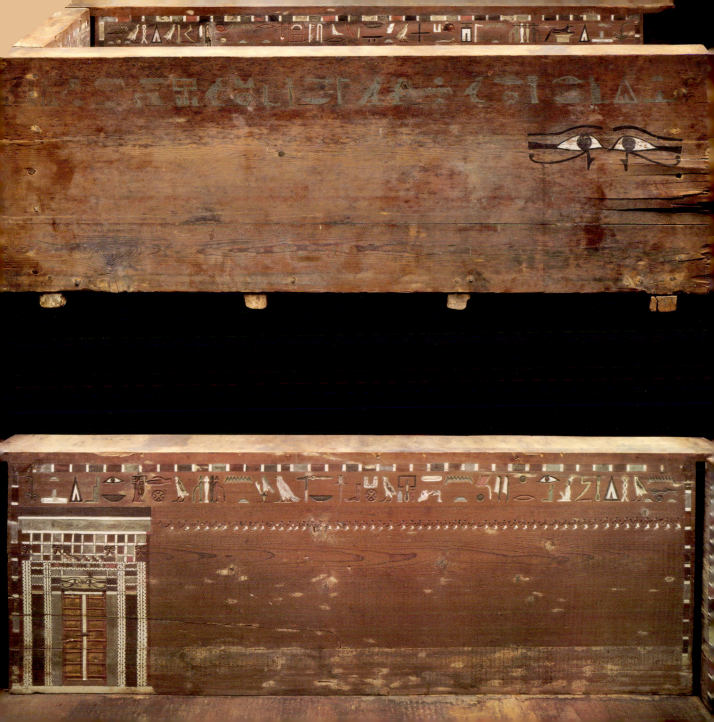

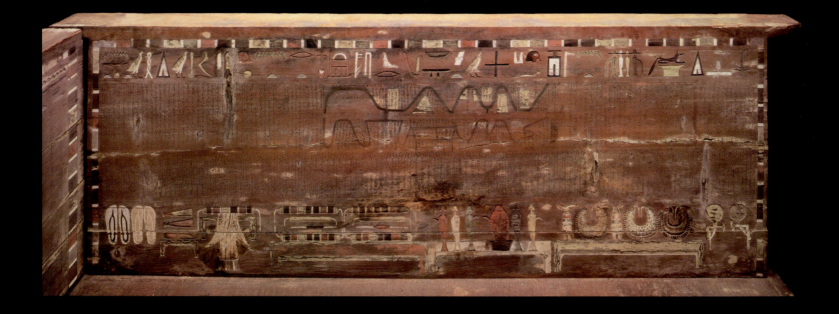

Fig. 79. Detail of back panel (interior view) of Governor Djehutynakht's inner coffin

and vegetables. Each item on the menu is presented with the words "Accept the eye of Horus." In Egyptian mythology, the left eye of Horus was torn out by Seth and given back to him by Thoth. Identifying the food with the eye of Horus, therefore, magically enhances its restorative power. Finally, the deceased sits down to his meal.[36]

The Coffin Texts are similar to those on the front of Djehutynakht's outer coffin and express the same concerns. There are spells for not dying again, for driving away vultures and poisonous snakes, for not having to eat feces and drink urine, for not having to walk upside down, for not having to work, for having power over the four winds and over water, and for driving off pigs and crocodiles who steal one's magic.[37]

> As for any god or goddess, any spirit or dead person, or any snake in heaven or earth who shall go to and fro, my magic will drive them off. . . . I will not die, and in fact I will not die a second time on earth.[38]

BACK WITH THE BOOK OF TWO WAYS

The most striking feature of Governor Djehutynakht's inner coffin is the Book of Two Ways on the back (fig. 79). The Book of Two Ways is an illustrated guide to the underworld known almost exclusively from Deir el-Bersha, but only from eighteen out of some fifty known coffins with Coffin Texts. The Djehutynakhts account for three of these: one on the lid of Governor Djehutynakht's outer coffin, one on the back of his inner coffin, and one on the floor of Lady Djehutynakht's inner coffin.[39] Only the version on Governor Djehutynakht's inner coffin, however, includes the map; the others are not illustrated, bearing only texts.

The book opens with a magnificent, awe-inspiring sunrise, the heavens all astir as the sun god, likened to a mummy resting in his coffin (thus identified with the deceased), wakes up, enters his boat, and sets sail across the sky.

Trembling falls on the eastern bark of the horizon at the voice of Nut, and she clears the paths of Re before the Great One when he goes around.

Raise yourself, Re; raise yourself, you who are in your shrine; may you snuff the air, swallow the backbones, spit out the day, and kiss Maet; may the Suite go about, may your bark travel to Nut, may the great ones quake at your voice, may you count your bones and gather your members together, may you turn your face to the beautiful West and return anew every day. . . . Sky and earth fall to you, being possessed with trembling at your traveling around anew every day. The horizon is joyful and acclamation is at your tow rope.[40]

The goal is eternal life spent sailing with the sun god in his day and night boats or resting in the netherworld with Osiris. The spells show the way and equip the deceased with the information needed to reach his goal unharmed. Passing through the "circle of fire" indicated by a faded white rectangle, we reach the black semicircle of "the gate of fire and the gate of darkness," which lead to the two winding paths that give this group of funerary texts its modern name.[41]

The two ways—one by water, one by land—describe the circular passage of the sun god and his bodyguard by boat from east to west across the sky by day (the upper way, originally colored blue) and back through the underworld by night (the lower way, painted black).[42] A faint red band separates the two: "Its name is 'The lake of fire of the knife-wielders.' There is no-one who knows how to enter the fire, for he is turned back from it." The upper path, labeled "the path to the abodes of those who live on sweet things," passes by tall mounds that appear on the map as white patches of various shape, guarded by fearsome demons with names such as "Scowler. Those who are in it are: He whose face is hot; He of the loud voice; Oppressor; Monster; Trembler"; and "He who swallows; He who is alert; He who is vigilant; He who is sharp-sighted; He who listens."[43] On some coffins, such as that of the physician Gua, the demons are pictured on the map: animals, human-headed mammals, or mammal-headed serpents, some bearing knives, resembling the figures that appear soon after on ivory wands (fig. 28, p. 59).[44] One beautifully preserved and decorated wand is inscribed "protection of night" and "protection of the day" in reference to the sun god's journeys across the sky and the underworld.[45] Some of these demons resurface in the New Kingdom Book of the Dead.[46]

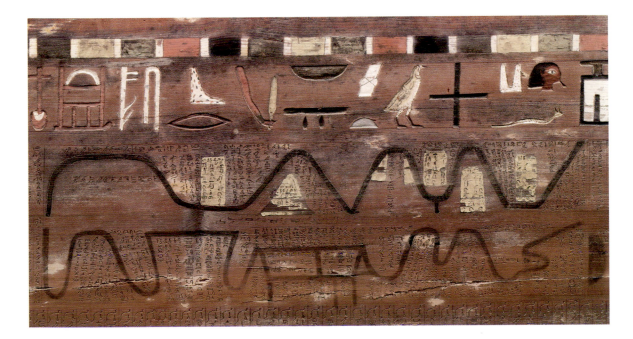

Fig. 80. Detail of the Book of Two Ways, back panel (interior view) of Governor Djehutynakht's inner coffin

Fig. 81. Head panel (interior view) of Governor Djehutynakht's inner coffin, late Dynasty 11–early Dynasty 12, 2010–1961 B.C.

Djehutynakht is undeterred: "I am a spirit and a lord of spirits; the spirit whom I will create will indeed exist; the spirit whom I hate will not exist. . . . I circle around with the Eye of Horus at hand; Thoth crosses the sky in my presence, and I pass safely."[47] Returning through the lower path, he has to negotiate tortuous bends in the road guarded by still more powerful demons: "He who is driven off with two faces in dung," "Dog-face, whose shape is big," "Protector-of-the-two-gods," "He of the sharp knife," and "Great-face who repels the aggressors."[48] But armed with the proper spells, Djehutynakht passes by safely.

Open, O sky and earth; O western and eastern horizons; open, you chapels of Upper and Lower Egypt; open, you doors; open you eastern gates of Re, that he may issue from the horizon. Open to him, you double doors of the Night-bark; open to him, you gates of the Day-bark, that he may kiss Shu, that he may create Tefenet. Those who are in the Suite will serve him, and they will serve me like Re daily.[49]

At this point, Djehutynakht reaches Rostau. Rostau, or Ra-setjau, means literally "place of ramps," referring to the ramp or subterranean passage cut in the floor of the tomb for dragging the coffin down to the burial chamber. The cemetery would have been riddled with these ramps. Rostau therefore can refer to the cemetery itself or by extension to the underworld pictured as a maze of intersecting ramps, where Osiris reigned as king of the dead.[50] Here, the roads crisscross: "These paths here are in confusion; every one of them is opposed to its fellow. It is those who know them who will find their paths. They are high in the flint walls which are in Rostau, which is both on water and on land."[51]

The proper spells allow the deceased to pass through Rostau and achieve his goal to be with Ra and Osiris for eternity. The longest spell of all—seventy-four lines—has Djehutynakht sailing with the sun god and fending off his enemies:

I am this one who travels around the sky to the West [and] I will not be opposed I will go aboard your bark, I will occupy your throne, I will receive my dignity, I will show the paths of Re and the stars. I am he who opposed the destroyer who came setting fire to your bark on the great polar quarter. I am he who knows them by their names, and they shall not attack your bark while I am in it.[52]

The book inscribed on the back of the inner coffin ends before reaching the last spell. Coffin Text spell 1130, the great conclusion to the Book of Two Ways, is, however, included in the otherwise greatly abridged Book of Two Ways on the lid of Governor Djehutynakht's outer coffin. There, the sun god speaks of his "four good deeds."

Words spoken by Him-whose-names-are-hidden, the All-Lord, as he speaks before those who silence the storm, in the sailing of the court:

Hail in peace! I repeat to you the good deeds which my own heart did for me from within the serpent-coil, in order to silence strife. I did four good deeds within the portal of lightland:

I made the four winds, that every man might breathe in his time. This is one of the deeds.

I made the great inundation, that the humble might benefit by it like the great. This is one of the deeds.

I made every man like his fellow; and I did not command that they do wrong. It is their hearts that disobey what they have said. This is one of the deeds.

I made that their hearts are not disposed to forget the West, in order that sacred offerings be made to the gods of the nomes. This is one of the deeds.

I have created the gods from my sweat, and the people from the tears of my eye. . . .

As for any person who knows this spell, he will be like Re in the eastern sky, like Osiris in the Netherworld. He will go down to the circle of fire, without the flame touching him ever![53]

The placement of the Book of Two Ways near the top of the back wall of the inner coffin forces the object frieze to the bottom (figs. 79 and 80). All essential elements are presented in logical order, though with none of the elegance of the object frieze on the outer coffin. Nearest the head are two mirrors. Besides their obvious connection with the face, mirrors are also highly symbolic in Egyptian art, as their reflective surface likens them to the sun; therefore mirrors are a symbol of rebirth. The Egyptian word for "mirror" as it appears in the object frieze is *ankh*, the same as the word for "life." This would have been significant for the Egyptians, who "believed that words with similar sounds had an underlying connection."[54] Next, arranged on tables, come collars and counterpoises, vessels for ablutions, bracelets, a royal kilt, razors, and two pairs of sandals.

The head end of Governor Djehutynakht's inner coffin has a very different layout from that of his outer coffin (fig. 81). Near the top is a single band of colored hiero-

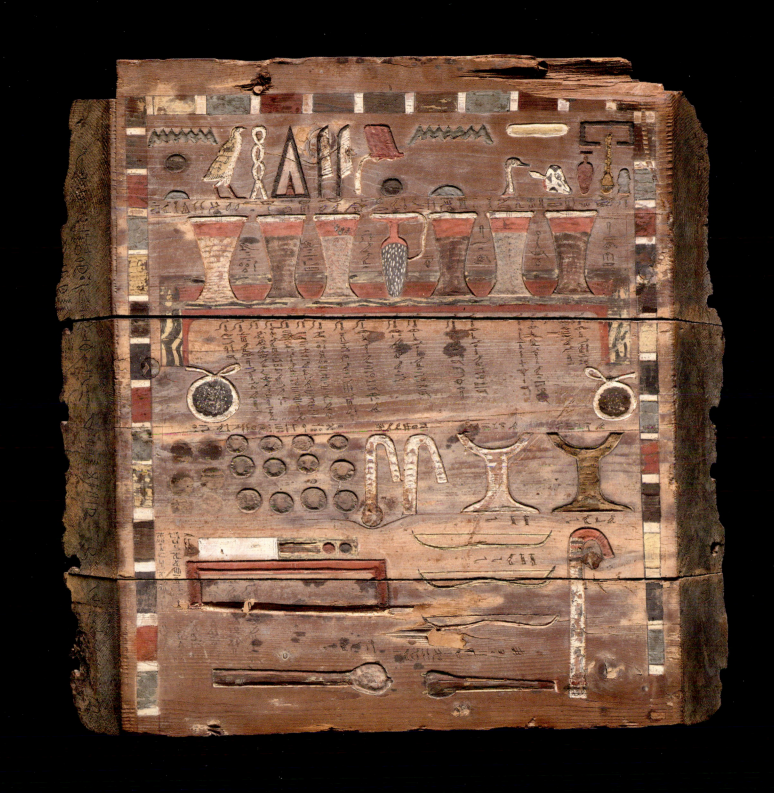

Fig. 82. Disassembled panels of the middle and inner coffins of Lady Djehutynakht in situ, May 5, 1915

Fig. 83a. Middle coffin of Lady Djehutynakht (interior view of the front panel with false door), late Dynasty 11–early Dynasty 12, 2010–1961 B.C.

Fig. 83b. Middle coffin of Lady Djehutynakht (interior view of the back panel with object frieze)

Fig. 83c. Inner coffin of Lady Djehutynakht (interior view of the back panel), late Dynasty 11–early Dynasty 12, 2010–1961 B.C.

glyphs: "Invocation-offerings for the honored one, Djehutynakht." Below that, the seven jars of sacred oils are arranged in a row. The jars rest on one long wooden table. Beneath the legs of the table are bags of eye paint, green on the left, black on the right. Between the bags of eye paint are incised Pyramid Text spells for anointing and censing the deceased.[55] Below are two headrests, two folded cloths, and balls of incense and myrrh. At the bottom are a staff, three bows, two maces, and a scribe's palette lying flat on a table.

The foot end of the coffin has a band of colored hieroglyphs across the top exactly like the head end; incised Coffin Texts fill the rest of the space. The lid and bottom of the coffin are also covered with incised texts. Those on the lid include passages from the royal resurrection ritual.

> You will go up and go down: you will go down with the sun, one of the dusk with the One Who Was Cast Down.
>
> You will go up and go down: you will go up with the sun and rise up with the One of the Great Reedfloat.
>
> You will go up and go down: you will go down with Nephthys, one of the dusk with the Nightboat.
>
> You will go up and go down: you will go up with Isis and rise up with the Dayboat.[56]

The Day of Judgment in the land of the dead is the subject of a sequence of Coffin Text spells incised on the bottom of the coffin. Here, the deceased is identified with Horus, whose claim against Seth is recognized by the divine tribunal, and his mother, Isis, plays the sistrum elatedly in joy over his victory. These spells, which enabled the deceased to assume his rightful inheritance in the afterlife, were recited on the solemn night before the funeral.[57]

> The vindication of a man against his foes is brought about in the realm of the dead. The earth was hacked up when the Rivals [Horus and Seth] fought, their feet scooped out the sacred pool in On. Now comes Thoth adorned with his dignity, for Atum has ennobled him with strength, and the Two Great Ladies are pleased with him. So the fighting has ended, the tumult is stopped, the fire which went forth is quenched, the anger in the presence of the Tribunal of the God is calmed, and it sits to give judgment in the presence of Geb. Hail to you, magistrates of the gods! Djehutynakht is vindicated before you on this day, even as Horus was vindicated against his foes on that day of accession. May he be joyful before you even as Isis was joyful in that her happy day of playing music, when her son Horus had taken possession of his Two Lands in triumph.[58]

THE COFFINS OF LADY DJEHUTYNAKHT

The texts to be recited the night before the funeral are also found on the coffins of Lady Djehutynakht. She originally had a set of three nested coffins, but the outer one was broken apart by tomb robbers and thrown out of the burial chamber into the tomb shaft. The pieces were found at the bottom leaning against two side walls and the entrance to the burial chamber (fig. 59, p. 98). Not surprisingly, they were in poor condition and were not sent to Boston.

Lady Djehutynakht's middle and inner coffins had also been taken apart but were in much better condition, as the disassembled sides had been left in the tomb chamber, either on the floor or stacked one against the other against the wall (fig. 82). The two coffins are very similar to one another. The exteriors have the usual offering formulas invoking Osiris and Anubis on the sides and down the center of the lid, and a pair of sacred eyes on the front. The horizontal and vertical edges of the exterior sides and lids were framed with narrow bands of gold

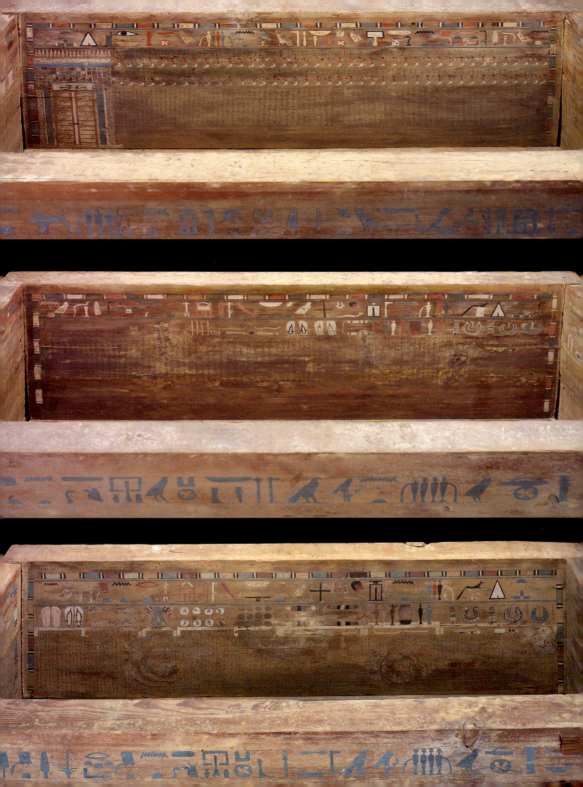

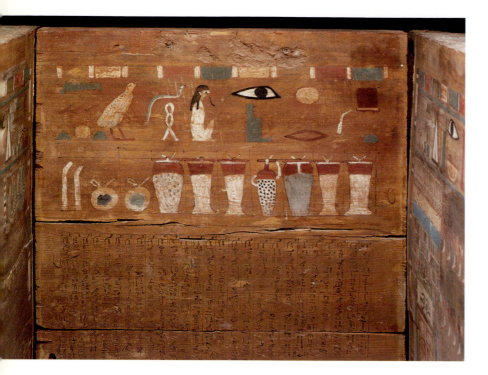

Fig. 84. Detail of the head panel (interior view) of Lady Djehutynakht's middle coffin

leaf. This added touch of luxury was not missed by the tomb robbers, who scraped most of it away. Enough remains to be clearly visible on Lady Djehutynakht's coffins. Traces suggest that Governor Djehutynakht's outer coffin received the same treatment, but no gold may be seen. Like Governor Djehutynakht's inner coffin, the interior sides of Lady Djehutynakht's coffins are carved and painted. The fronts are virtually identical, with ornamental hieroglyphs along the top, false doors, offering lists in double file, and incised texts (fig. 83a).

The object frieze on the back of Lady Djehutynakht's middle coffin is quite basic, even skimpy (fig. 83b): we see collars and counterpoises, vessels for ablutions, bracelets, two pairs of sandals, and weapons (two bows, arrows, and a mace), and staffs. The objects take up only about two-thirds of the available space, so that the sandals, instead of being at the far end by the mummy's feet, end up in the center. The items are not labeled and do not sit on tables.

The items missing from the middle coffin's object frieze are supplied on the back of Lady Djehutynakht's inner coffin (fig. 83c). Here we have bags of cloth, a royal

kilt, and razors, in addition to collars and counterpoises, vessels for ablutions, bracelets, and two pairs of sandals. These objects are placed on tables. The objects' names do not appear in a separate register above but are incised alongside them. Under the first table is a scribe's palette; under the second and third tables are weapons. Two mirrors on stands are depicted in a separate panel below the head end of the frieze.

The object frieze on the head end of Lady Djehutynakht's middle coffin depicts only the essential elements called for in the offering ritual: the seven sacred oils, two bags of eye paint, and two rolls of cloth, arranged in a single register (fig. 84). The original head end of Lady Djehutynakht's inner coffin was not found; it has been replaced by a modern wooden board.

In the disposition of their Coffin Texts, Lady Djehutynakht's coffins are more typical of Deir el-Bersha coffins than those of her husband. Both middle and inner coffins have Coffin Text spells 1 to 17 on the lid rather than on the bottom (as on Governor Djehutynakht's inner coffin), and the inner coffin has the Book of Two Ways on the bottom, where this sequence of spells most often occurs, rather than on the lid (as on the governor's outer coffin) or the back (as on his inner coffin). Unfortunately, Lady Djehutynakht had to find her way through the underworld without the benefit of a map, as her guidebook is not illustrated.

CANOPIC EQUIPMENT

Presumably, Governor and Lady Djehutynakht would have had one canopic chest each for housing their mummified internal organs, but only one canopic box and two lids could be reconstructed out of the numerous fragments recovered from their tomb. Made of cedar and decorated to match the coffins, the box bears ornamental hieroglyphs below the top of each exterior side and Coffin Texts on the interior. The hieroglyphs were originally painted blue, but the pigment has all but disappeared, leaving only shadows (fig. 85). Still, enough remains to indicate that "the honored one Djehutynakht" mentioned in the inscription is Lady Djehutynakht, as the word for "honored one" has the feminine ending

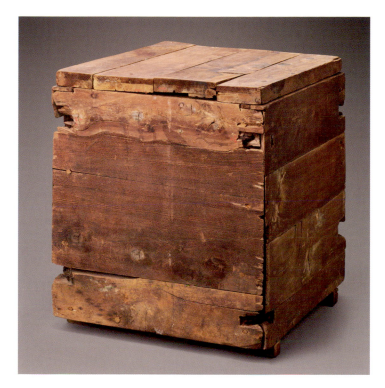

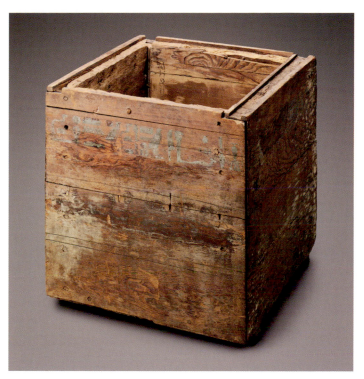

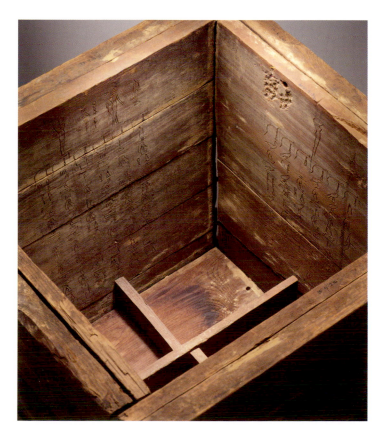

Fig. 85. Canopic box and lid of Lady Djehutynakht, late Dynasty 11–early Dynasty 12, 2010–1961 B.C.

Fig. 86. Canopic box with preserved hieroglyphs, late Dynasty 11–early Dynasty 12, 2010–1961 B.C.

Fig. 87. Interior of Lady Djehutynakht's canopic box

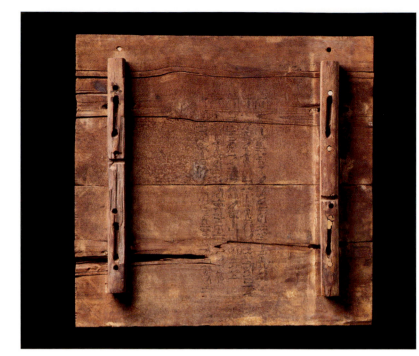

Fig. 88. Canopic box lid
of Lady Djehutynakht
(underside view), late
Dynasty 11–early Dynasty
12, 2010–1961 B.C.

and Qebehsenuef—who represent the four cardinal points.[61] These deities are charged with protecting the internal organs. The Coffin Texts on the interior are speeches by these deities, who are represented standing on top of their speeches as falcon-headed mummies. Hapy (north) is paired with the goddess Neith; opposite them are Imsety (south), who is paired with the goddess Selqet. To the right of Hapy is Duamutef (east), who stands across from Qebehsenuef (west). The intersection of Hapy and Duamutef, therefore, points symbolically northeast. The canopic chest is a model of the universe, a microcosm. By placing the organs in the charge of the Four Sons of Horus, the deceased's body is anchored to the cosmos and made fast and permanent.

Qebehsenuef appears again on the bottom of the box. His speech, an example of the other deities' speeches, makes it clear that the function of the canopic deities was to keep the body safe and whole.

> I am Qebehsenuef, and my father Horus said to me: Come, refresh my father, betake yourself to him in your name of Qebehsenuef. You have come that you may make coolness for him after you, and do not be far from him; join him up, put him together, knit him up as regards his bones. . . . O Qebehsenuef, come, betake yourself beneath this Osiris Djehutynakht and refresh him.[62]

One of the lids is inscribed on the interior with a Coffin Text spell known only from this lid and the canopic box lid of Deir el-Bersha nomarch Amenemhat, who lived one or two generations later (fig. 88).[63] The inscription is painted but not incised. Drawings and photographs taken during the excavations show painted figures of the sky goddess Nut and Dewenanui, god of the eighteenth Upper Egyptian nome, to the north of Deir el-Bersha, who appears as a falcon with outstretched wings. As sky goddess, Nut is often identified with lids. Dewenanui is seldom encountered at Deir el-Bersha but, interestingly, also appears on the canopic lid of Amenemhat.[64] The other lid is inscribed on the exterior with a band of hieroglyphs for "the one honored with Anubis, [Lady] Djehutynakht." No inscription is visible on the underside of this lid, although there may have been one in paint.

Only one canopic jar was found in the tomb, resting

(imakhyt). The canopic box from tomb 19B, with its well-preserved pigment, shows what Lady Djehutynakht's canopic box would have looked like (fig. 86).

The painted and incised Coffin Texts on the inside are well preserved (fig. 87). Here, the use of the feminine demonstrative pronoun "this" in "this Osiris Djehutynakht" confirms that the box belonged to Lady Djehutynakht. Strangely, both lids are inscribed for a female, and both fit on the box.[59]

Although the canopic box is decorated to resemble the coffins, it is neither as elaborate nor as sturdily constructed. Each side wall consists of a double layer of wooden planks.[60] Cedar was expensive, and the best timbers were reserved for the coffins. Canopic chests, being smaller, could be constructed from planks. Two intersecting pieces of wood divide the interior crosswise into four compartments, in which (presumably) the jars containing the organs were stored.

The ornamental inscriptions on the exterior side walls are brief, merely mentioning the deceased alongside one of the Four Sons of Horus—Hapy, Imsety, Duamutef,

on top of Governor Djehutynakht's outer coffin, near the foot end of the lid. Most canopic jars in the Middle Kingdom were made of pottery, wood, or stone, and took the form of tall, shouldered jars.[65] This one is unusual in being made of cartonnage—a material like papier-mâché, but using linen instead of paper—and also in having a pair of human legs and feet (the right foot is restored), the toes indicated in black paint (fig. 89). A pair of arms was painted at the sides of the jar. Arms and feet were adorned with bracelets and anklets painted with green and black stripes. An inscription on the chest identifies the deity as Qebehsenuef. This Son of Horus is usually associated with the intestines.

A cartonnage lid was also found. It was not found with the jar, although it could very well have belonged to it. The lid takes the shape of a human head. The top of the head and upper part of the face are missing, and the rest is in poor condition, but we can see that the hair or wig was painted blue and the face yellow, and that the neck was adorned with a broadcollar painted blue, red, and yellow.

A COMPLETE COSMOS

The coffins and canopic equipment from tomb 10A form a wonderfully complete and self-contained set. The outer coffin of Governor Djehutynakht stands out as a masterpiece of Middle Egyptian painting. The beautiful paintings on the inside, however, were never intended to be admired purely as works of art. The Egyptians welcomed visitors into their tomb chapels aboveground to stop in, say a prayer, and admire the decoration. Graffiti left by later well-wishers tell us as much: "The scribe Bak came to see this tomb of the time of Sobekneferu," writes one New Kingdom visitor to a Middle Kingdom tomb. "He found it like heaven in its interior."[66] Coffins, however, were different. Although there cannot be any doubt that Governor Djehutynakht was proud of his beautiful painted outer coffin, once his mummy was placed inside and the coffin was sealed, the pictures were hidden from sight for four thousand years. To appreciate the coffins properly, we have to consider the famous coffin along with the others, and the texts along with the pictures,

because they function together. They tell us not so much about the day-to-day world of the Djehutynakhts and their peers, but about their cosmos and how they perceived their place in it. The coffins reveal their hopes and fears, from the most mundane—such as not having to eat excrement in the afterlife or stand upside down, and not having one's magic taken away—to their most sublime visions of an eternal afterlife spent in the company of Osiris, king of the dead, or sailing across the sky with the sun god. Only then can we begin to understand why the Egyptians called the coffins *neb ankh*, "lord of life."

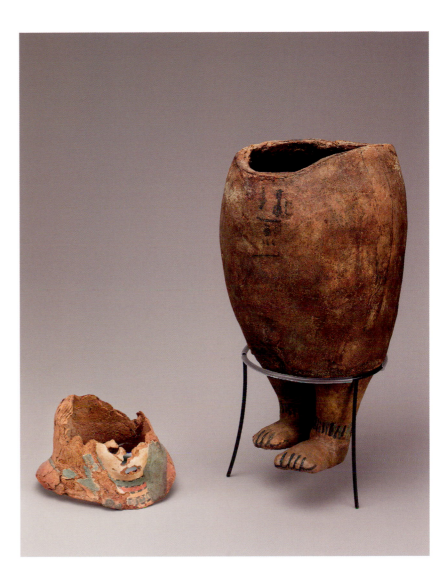

Fig. 89. Canopic jar and lid, late Dynasty 11–early Dynasty 12, 2010–1961 B.C.

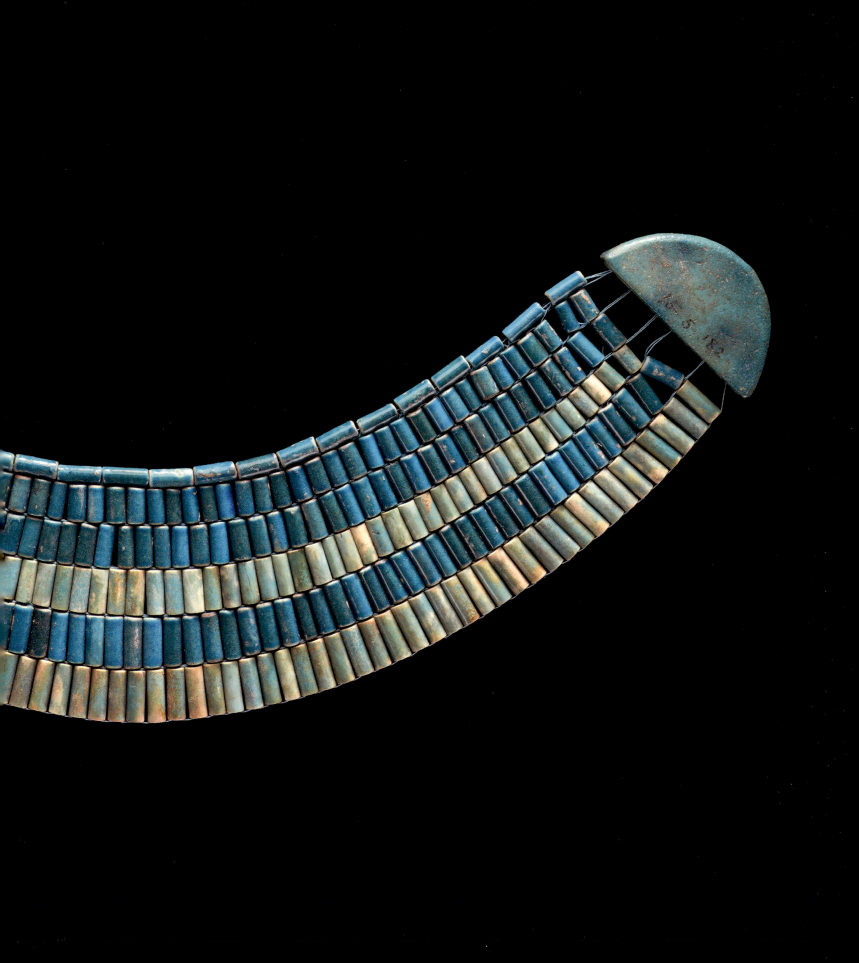

THE DJEHUTYNAKHTS' BURIAL GOODS

DENISE M. DOXEY

FOR THE DJEHUTYNAKHTS and many of their early Middle Kingdom contemporaries, it was impossible to be overly prepared for the afterlife. For reasons that present-day scholars do not fully understand, Egyptians of the era sought redundancy in providing for their *kas*, by depicting food, clothing, and other provisions in tomb chapels, on coffins, and in three-dimensional representations in the burial chamber. In addition to the representation of objects on their coffins, the Djehutynakhts' burial included full-scale, usable items and small-scale models of exactly the sort of grave goods shown in the object friezes. Although many items survived in remarkably good condition, the destruction wrought by early grave robbers has made it impossible to accurately assess the entire assemblage. The thieves also succeeded in stealing virtually all the precious metals and even most of the copper in the chamber, as well as almost all the semi-precious stones. Fragments of gold suggest that the Djehutynakhts' burial was originally richly furnished, but exactly how much so will never be known. The majority of surviving objects were made exclusively for the tomb and would never have been used by the Djehutynakhts in their lifetime.

Among the worst damage caused by the thieves was the destruction of the mummies themselves. In accounts of tomb-robbery trials preserved on papyri from the late New Kingdom, such thieves confessed to stripping the mummies in search of jewelry and amulets adorning the body, and then burning the human remains. This appears to be exactly what happened to the Djehutynakhts. Only remnants of the mummies survived the harsh treatment, including Lady Djehutynakht's torso and leg (the latter

recovered by Belgian excavators only in 2009), and the still-unidentified head of one mummy, which the robbers left on top of the governor's coffin (figs. 62 and 137, pp. 100 and 181).

The remarkably well-preserved mummified head has features that hearken back to the Old Kingdom, before the advent of the funerary mask when the mummies themselves were made to appear as lifelike as possible. They include padded lips, painted eyebrows, and eyes that are both padded and painted, plus a cap. However, in contrast with this adherence to an older tradition for the mummy's exterior decoration, the Djehutynakhts' embalmers performed the relatively uncommon procedure of removing the brain. That procedure was not a regular occurrence in Egypt's mummification process until the New Kingdom.

Only fragments of the Djehutynakhts' funerary masks survived the robbery. Sections of one cartonnage mask, found in close proximity to the governor's coffin, probably belonged to him. The back of a wooden mask found near his wife's coffin probably belonged to her. The governor's mask features a long front tab (popular in the early Middle Kingdom) adorned with a painted broadcollar. Gilded fragments, including an ear, suggest that the face was originally covered in gold to identify the deceased as a deity. A pair of eyes formed by copper frames inlaid with stone probably also came from one of the funerary masks. These rich materials suggest that the Djehutynakhts' funerary masks were of the highest quality available at the time.

The burial contained only a small amount of pottery relative to some other Middle Kingdom tombs. A niche

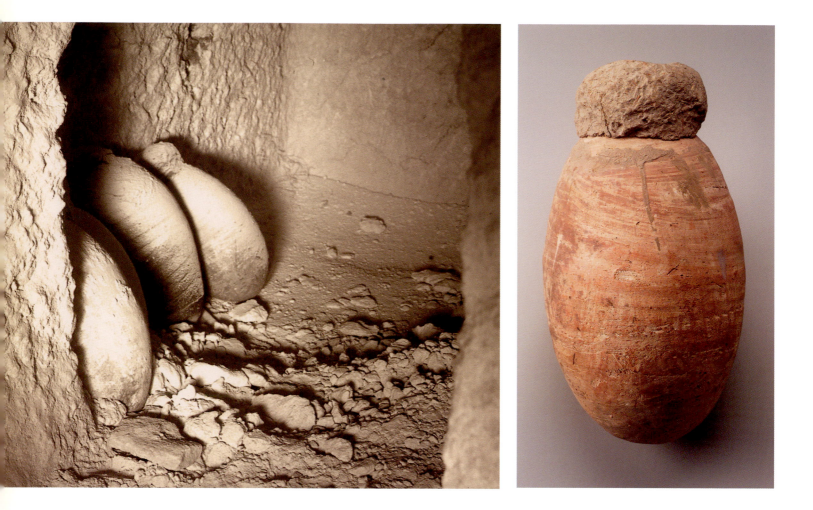

Fig. 90. Stoppered storage jars in situ, eastern niche of tomb 10A, May 2, 1915

Fig. 91. Storage jar with mud stopper, late Dynasty 11–early Dynasty 12, 2010–1961 B.C.

at the entrance to the burial chamber contained four large food-storage jars with intact mud seals and undisturbed contents (figs. 90–91). The same type of jars, with seals painted black to represent mud, are among the piles of offerings shown on the coffins and in the wooden models of breweries and kitchen boats, where they were presumably intended to be beer jars. In the tomb chamber itself were two shallow bowls that may also have contained food offerings. The pottery is the product of a local workshop and differs from types found in other parts of Egypt, but the style is closest to that known elsewhere from the beginning of Dynasty 12.

Along with actual food offerings that have not survived, the tomb held models of food and beverages that

the Egyptians believed could magically sustain the *ka*s of the Djehutynakhts. Small vases of various sizes made of travertine, wood, and faience take the form of water or wine jars known in ancient Egyptian as *hes* jars (fig. 92). Jars of this type appear in ritual contexts, such as the pouring of libations for gods and deceased relatives, and are seen being carried in model offering processions. One such jar is depicted behind the seated figure of Governor Djehutynakht on his outer coffin. Several sets of model jars and bread loaves, also made of travertine, were set into rough wooden stands. These included five sets composed of four shouldered jars each, two sets containing only three jars, two individual jars on their own planks, two sets of four bread loaves, and three

individual bread loaves (figs. 93–94). Two rather crudely made travertine offering tables set in wooden stands accompanied the group.

Numerous tables appear on the coffins, where they are shown holding a variety of items, most often food and beverages, but also jewelry and cosmetics. Five model tables made of white-painted wood and found broken in pieces duplicate the small tables that appear on the governor's outer coffin, where they are shown supporting a set of *hes* jars. The model tables have anywhere from four to six dowel holes in their tops for the placement of faience model cups and *hes* jars (fig. 95). It has been suggested that these sets may have been related to the Opening of the Mouth ceremony, which enabled the mummy to speak and breathe in the afterlife.[1]

What must originally have been a colorful assortment of model offerings made of painted cartonnage survives in generally poor condition, but certain items are relatively intact (fig. 96). The models were made by wrapping linen around a core of mud or string and covering it with plaster, and then painting over it. Originally the group included representations of two plucked geese, two loaves of bread, a "pottery" bowl and stand, folded bolts of cloth, red and yellow onions, garlic, figs, and lotus blossoms. Numerous cartonnage leaves, painted green, may come from model vegetables that are now lost. Fragments of

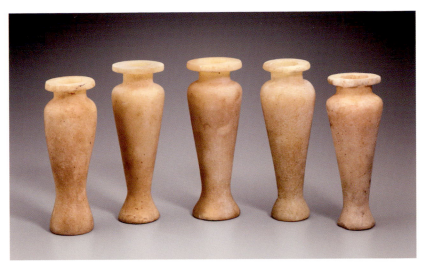

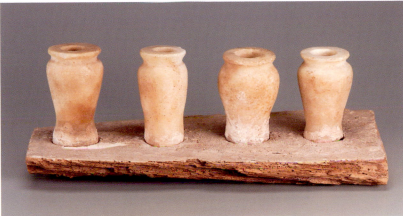

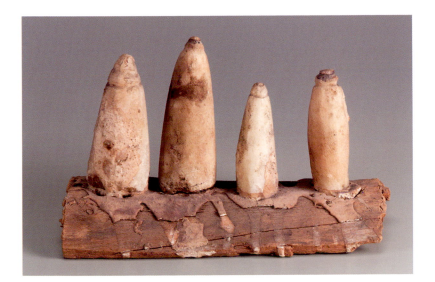

Fig. 92. Model *hes* jars, late Dynasty 11–early Dynasty 12, 2010–1961 B.C.

Fig. 93. Model *hes* jars on a wooden base, late Dynasty 11–early Dynasty 12, 2010–1961 B.C.

Fig. 94. Model conical bread loaves on a wooden base, late Dynasty 11–early Dynasty 12, 2010–1961 B.C.

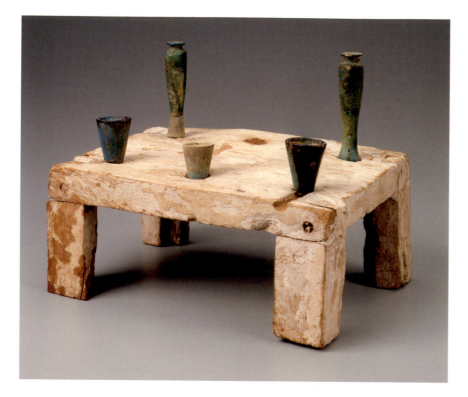

cartonnage painted white with brown linear decoration probably come from a basket that once held the models. When intact, the group would have borne a striking resemblance both to the food depicted in the offering scene on Governor Djehutynakht's outer coffin and to the provisions carried by the figures in the model offering processions. At least five other sets of cartonnage food models are known from Deir el-Bersha; they range in date from late Dynasty 11 to the reign of Senwosret III in mid–Dynasty 12.[2]

A niche at the entrance to the burial chamber opposite the one containing the storage jars housed bundles of sticks tied together with string (fig. 97). Bundles of sticks were a common tomb offering in the early Middle Kingdom, but their significance remains uncertain.[3] Because of the placement of the bundles of twigs opposite the food jars, it is tempting to think that they may have been intended as kindling for an eternal cooking fire. Including the bundled sticks, the Djehutynakhts' grave contained more than 250 sticks and staves of various

Fig. 95. Model table and five model vessels, late Dynasty 11–early Dynasty 12, 2010–1961 B.C.

Fig. 96. Model food, produce, and bowl, late Dynasty 11–early Dynasty 12, 2010–1961 B.C.

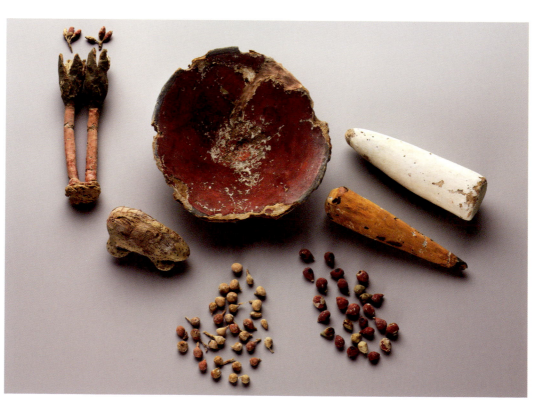

Fig. 97. Cache of sticks in situ, western niche of tomb 10A, May 2, 1915

Fig. 98. Model mace, late Dynasty 11–early Dynasty 12, 2010–1961 B.C.

Fig. 99. Model *was*-scepter, late Dynasty 11–early Dynasty 12, 2010–1961 B.C.

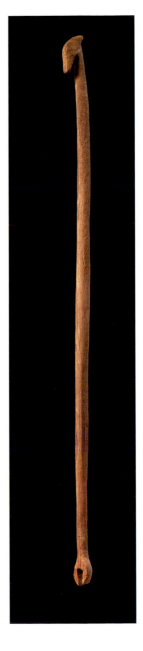

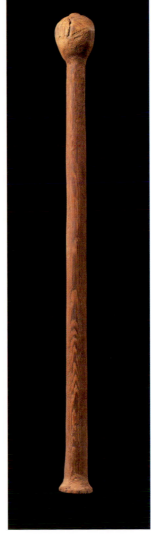

types, from functional walking sticks to simple, unfinished branches.

The most distinctive of the sticks and staves are replicas of scepters and insignias of office that had ritual significance. Originally, such objects would have had a practical function, but by the early Middle Kingdom they had come to have symbolic meanings. Coffin Text 75 invested the deceased with various divine insignias, and the types of scepters found in the tomb closely parallel those represented in the object friezes on the coffins.[4] Among these is a model mace, typically associated with a deity known as the Opener of the Ways and the power of the king to defeat enemies (fig. 98).[5] Actual maces seem to have been used as weapons far earlier, during the Early Dynastic Period (2960–2648 B.C.), and they retained their symbolic value as such throughout ancient Egyptian history. By including such a royal emblem among their grave goods, the Djehutynakhts were not claiming royal status in life, but were associating their *ka*s with the divine powers of kingship and, by association, with Osiris. Another divine accessory was the *was*-scepter, which featured the head of an animal (perhaps the god Seth) and was the hieroglyphic symbol for dominion. Its forked base might reflect an original function of restraining serpents.[6] As an attribute of the gods, the scepter, like the mace, may reflect the concept of deification in the afterlife (fig. 99). The burial chamber also housed a group of staffs squared at one end and

Fig. 100. *Iryt-r* staffs, late Dynasty 11–early Dynasty 12, 2010–1961 B.C.

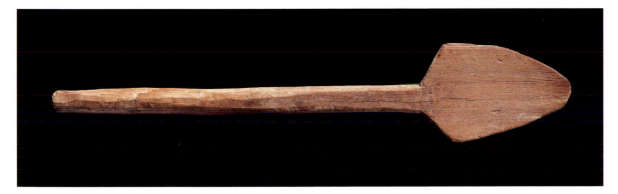

Fig. 101. Two jointed or bent staffs, late Dynasty 11–early Dynasty 12, 2010–1961 B.C.

Fig. 102. One of a pair of wooden paddles, late Dynasty 11–early Dynasty 12, 2010–1961 B.C.

rounded at the other, with a groove near the rounded end (fig. 100). Staffs of this type are often shown bound together in coffin friezes, where they are known as *iryt-r* staffs, although their exact function is unclear.[7] The staffs also resemble the *mdw* staffs used by heralds to pound the floor for attention.[8] Two enigmatic bent or jointed staffs might relate to a type of staff mentioned in the Pyramid Texts and associated with the bows of the funerary god Wepwawet (fig. 101).[9] A pair of rough, clublike staffs may have been intended to represent the curved shepherd's poles shown in tomb statues, possibly for use on the deceased's journey across the Western Desert.[10]

To assist the Djehutynakhts in their voyage to the

afterlife, which was perceived as a journey by boat, the tomb contained a pair of wooden paddles, perhaps one for each burial (fig. 102). They were also intended to serve the Djehutynakhts on their journeys with the sun god on his daily circuit across the skies. Paddles of this type are found in graves through the New Kingdom, including a set found in the burial chamber of Tutankhamen.

The head end of Governor Djehutynakht's inner coffin and the object frieze of the outer coffin show headrests made of both wood and travertine. Four wooden headrests were found in the burial chamber, including one in Governor Djehutynakht's coffin, where it must have supported the head of the mummy. Along with the functional

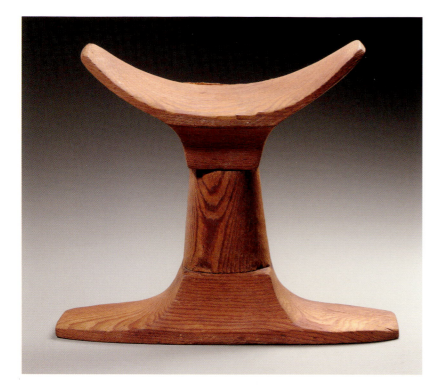

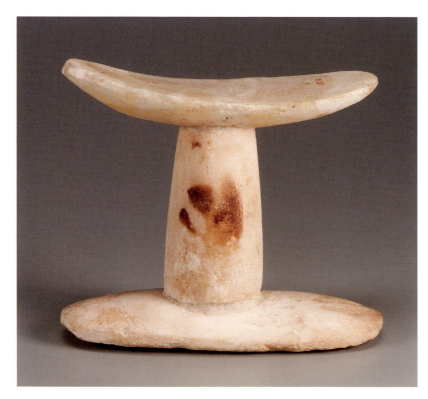

headrests was a pair of model headrests made of travertine, intended to symbolically protect the head of the deceased (figs. 103–104).

Two small boxes, the larger of which was in pieces and both of which were devoid of their original contents, were discovered on top of Governor Djehutynakht's coffin (fig. 105).[11] They were crudely made of wood, covered by gesso and painted white. In intact tombs, such boxes sometimes contained jewelry or model tools. Representations of similar boxes in association with jewelry painted on Governor Djehutynakht's outer coffin suggest that this may have been the case in tomb 10A as well, although coffin friezes also show boxes with their contents labeled as linen and other materials.

The tomb robbers stole almost all of the Djehutynakhts' jewelry, much of which would have been on the mummies themselves. Jewelry, including amulets, served both as adornment for the living and as magical protection for the dead. Fragments from tomb 10A, including beads made of gold, silver, copper, carnelian, amethyst, lapis lazuli, glazed steatite, and faience, hint at the tomb's original wealth and suggest that the jewelry in the tomb once resembled the collection of adornments portrayed on the coffin friezes.[12] Three beads, including a cylinder bead of lapis lazuli, a carnelian barrel bead, and a decorative seal of glazed steatite, were found on their original string. Broadcollar terminals, cylindrical beads, and drop-shaped pendants of faience and glazed steatite derive from what must have been a number of broadcollars, one of which has been reconstructed (fig. 106). A gold band with rounded ends pierced for stringing may have been part of a bracelet. Other elements seem to have come from bracelets, anklets, necklaces, and possibly a beaded kilt similar to one pictured on Governor Djehutynakht's outer coffin and another found in the burial of Senebtisi at Lisht.

The early Middle Kingdom was a period when military prowess was a necessary attribute for governors and other officials, and so it is likely that the tomb once contained assorted weapons. Only a single copper spearhead has survived. Indeed, weapons and model weapons were popular grave goods even for people who were not war

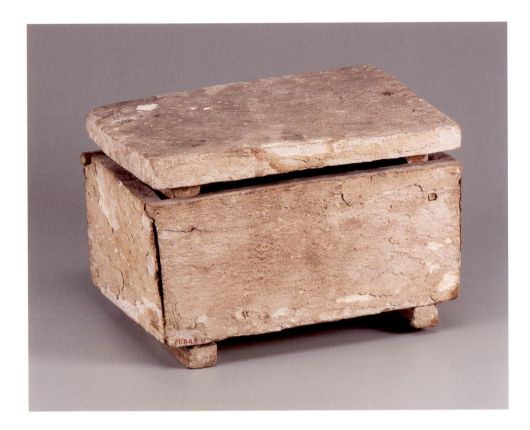

Fig. 103. Headrest, late
Dynasty 11–early Dynasty
12, 2010–1961 B.C.

Fig. 104. Model headrest, late
Dynasty 11–early Dynasty
12, 2010–1961 B.C.

Fig. 105. Box, late Dynasty
11–early Dynasty 12,
2010–1961 B.C.

Fig. 106. Broadcollar, late
Dynasty 11–early Dynasty
12, 2010–1961 B.C.

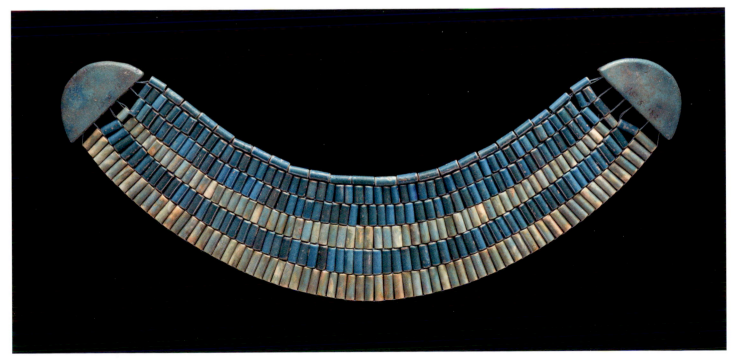

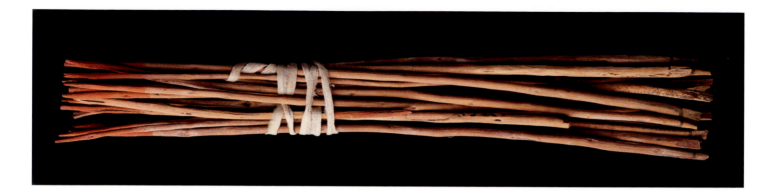

Fig. 107. Bundle of model arrows, late Dynasty 11–early Dynasty 12, 2010–1961 B.C.

Fig. 108. Model shields, late Dynasty 11–early Dynasty 12, 2010–1961 B.C.

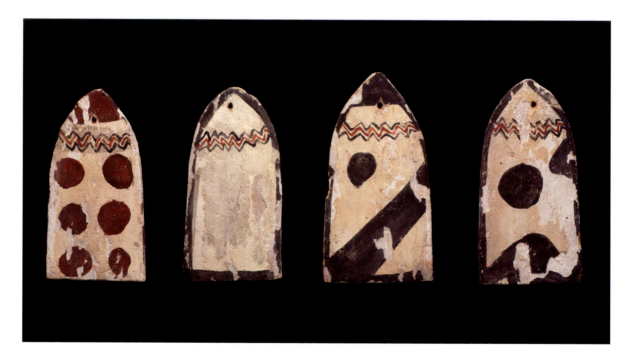

riors, and may have been intended for the defense of the deceased against the many threats encountered on the way to the afterlife. The Djehutynakhts were buried with a selection of model weapons. Certain rough sticks in the tomb may represent clubs. Model arrows were found in several bundles, including examples made of wood with copper tips and others entirely of wood, with tips painted red in imitation of copper and representations of feathers painted in black at the ends (fig. 107). For defensive purposes, the tomb contained a large number and variety of wooden model shields (fig. 108). They are painted to rep-

resent the same type of trapezoidal ox-hide shields shown in model boats and military processions. Some of the shields may derive from model soldiers, but the largest, at least, seem to have been individual models. Similar model shields, in a range of sizes, have been found in many Middle Kingdom burials, especially in central Egypt. A pair of model axes, one of which retains its copper blade, may represent weapons but may also have been carpenter's tools (fig. 109). Both weapons and tools appear in the Djehutynakhts' coffin friezes, and a complete set of model carpenter's equipment was found in

the burial chamber of Satmeket (tomb 10B), located in what would have been the outer courtyard of tomb 10.

Among the model tools in tomb 10A are two well-made and well-preserved model hoes (fig. 110). Hoes of this type, with a sharpened wooden blade attached at an acute angle to a wooden handle and bound with cords, were versatile agricultural tools used for digging, tilling, weeding, and covering sown seeds with soil.[13] In the afterlife, such tools were useful in the Field of Reeds and situations in which the deceased was called upon to perform agricultural labor. Such activities are mentioned in the Coffin Texts, and hoes and other agricultural equipment are shown both in coffin friezes and in tomb models. The model tools were undoubtedly intended as magical replacements for actual hoes, to facilitate the Djehutynakhts' farming pursuits in the hereafter. By the late Middle Kingdom, *shawabty*s would carry exactly the same type of hoe.

Just as the contents of the Djehutynakhts' burial chamber and those of their contemporaries duplicated offerings, tools, and activities portrayed elsewhere in the burial chambers, they included wooden statuettes intended to represent the *ka*s of the tomb owners, which would also have appeared in the aboveground chapel of the tomb (figs. 111–112). The Djehutynakhts' statuettes are no larger than many of the models found in the cham-

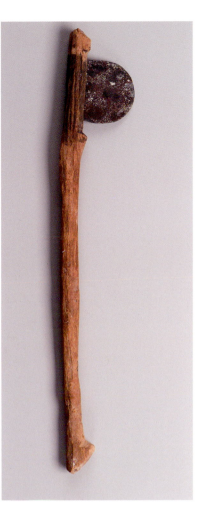

Fig. 109. Model axe, late Dynasty 11–early Dynasty 12, 2010–1961 B.C.

Fig. 110. Model hoe, late Dynasty 11–early Dynasty 12, 2010–1961 B.C.

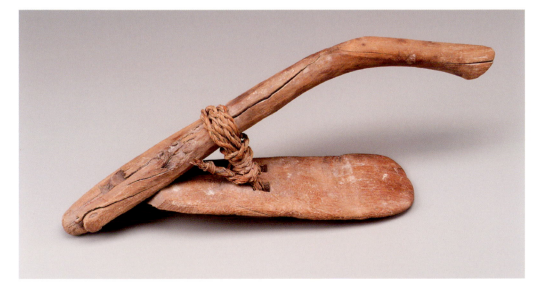

Fig. 111. Statuette of
Governor Djehutynakht,
late Dynasty 11–early
Dynasty 12, 2010–1961
B.C.

Fig. 112. Statuette of Lady
Djehutynakht, late Dynasty
11–early Dynasty 12,
2010–1961 B.C.

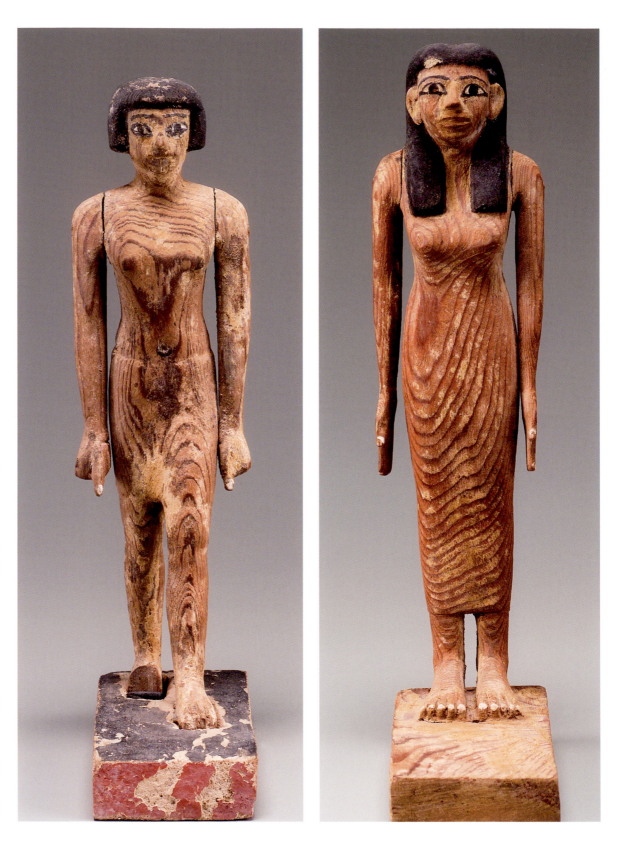

ber and are not inscribed with their names, but their poses, along with the superior quality of their carving and the hard wood from which they are made, indicate that they portray the tomb owners. In fact, although many wooden *ka* statues are quite large and bear the names and titles of the deceased, it is not at all unusual for such figures to be small and uninscribed (fig. 18, p. 51). They were not intended to be portraits of the tomb owners, and they could be purchased in generic form and later inscribed to identify them as particular individuals.

The figure of the governor stands in the typical pose of an Egyptian official, with his left foot forward and his hands clenched at his sides, as if holding the staff and scepter associated with his high rank. He is shown as a slender young man with a short-cropped black wig and knee-length kilt, both symbolic of youth. His wife, whose statuette is slightly larger than his but otherwise very similar in technique, is also depicted as young and slender, with a long black wig parted in the middle and a tightly fitting, calf-length sheath dress. Her pose, with feet together and both hands hanging open at her sides, is standard for three-dimensional representations of Egyptian women. Both figures have lost most of their paint, with the exception of their black hair, large and slightly startled-looking eyes, and white fingernails. The base of the governor's statuette retains red and black paint, and red paint remains on his right foot, indicating that the skin was once painted red, as is typical for depictions of Egyptian men. Lady Djehutynakht's statuette must have once had yellow skin, as traces of yellow paint survive on various parts of her body.

Despite the fact that the full extent of the Djehutynakhts' burial assemblage will never be known, it is clear from what remains that their tomb was exceptionally well furnished. Even compared with their contemporaries, who lived and died at a time when tomb chambers typically featured large and varied assortments of grave goods, theirs stands out. In addition to what must have been a grand chapel decorated with scenes and inscriptions meant to ensure a successful afterlife, an outstanding collection of coffins inscribed with texts and offerings unrivaled by their peers, and the largest corpus of models known from the Middle Kingdom, the Djehutynakhts felt the need to add further insurance in the form of three-dimensional representations of food, furnishings, tools, and weapons, as well as statuary. Ironically, their concern was not unfounded, since their decorated chapel collapsed, the tomb was robbed at least once, and, worst of all, their mummies were destroyed by thieves. Yet, their extensive collection of burial goods, along with their models and coffins, has succeeded in giving them a certain degree of immortality.

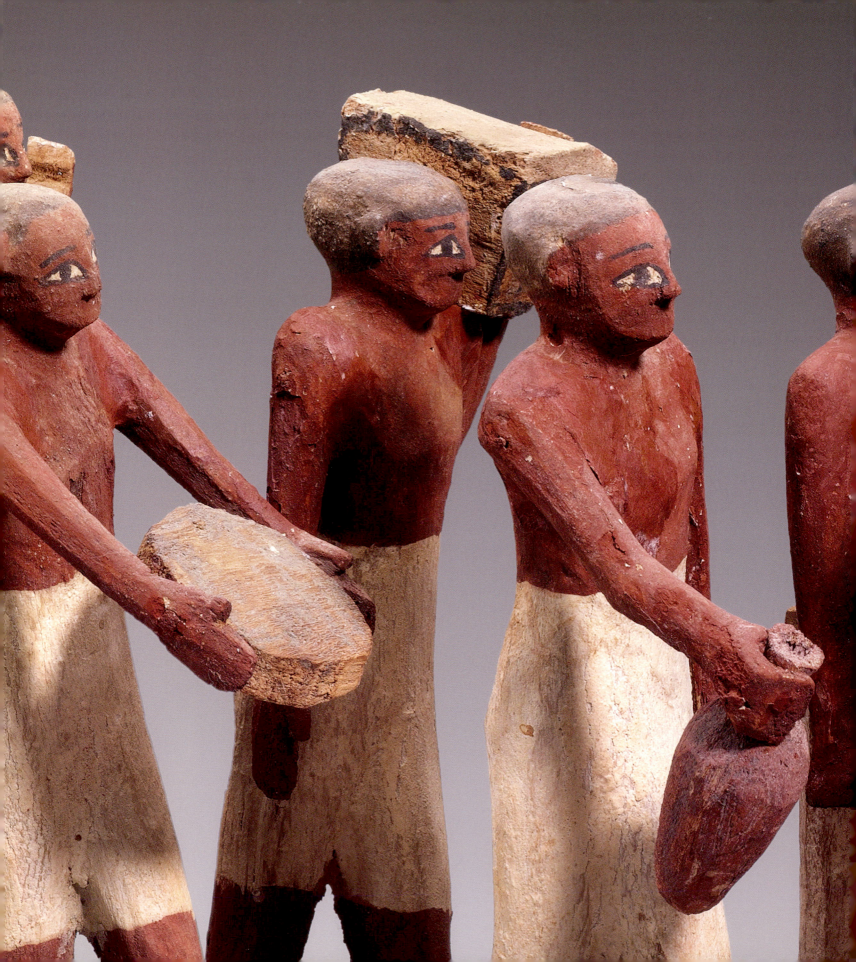

THE DJEHUTYNAKHTS' MODELS

RITA E. FREED AND DENISE M. DOXEY

OF ALL THE EGYPTIAN tombs found with wooden models, none contained more than the Djehutynakhts' of Deir el-Bersha. Its corpus falls squarely into the period between the Eleventh Dynasty and the beginning of the Twelfth, when Egyptian model production reached a high point in creativity, quantity, and variety.[1] In the Djehutynakhts' tomb and in others from that period, models were intended to provide symbolically for the owners' *kas*. They therefore represented an ideal or anticipated living standard for the afterlife, rather than an inventory of people and possessions on the tomb owner's estate. Although this ideal may or may not have conformed to anyone's reality, it is safe to assume that gender roles and hierarchies from this life were to be maintained in the next.

The practice of being buried with wooden figures engaged in agriculture, industry, or river activities began in the Old Kingdom, but at that time models were usually made as single figures performing a few restricted tasks. As the importance of regional centers grew during the First Intermediate Period, the number and geographic spread of tombs containing models increased. Model types, particularly those related to agriculture, also expanded at that time. Those showing animal husbandry were concentrated in areas like Deir el-Bersha, where the Nile Valley was at its widest, with space for animals to graze. Eventually tombs with models encompassed the entire Egyptian Nile Valley.[2] Middle Kingdom founder Mentuhotep II was the first king to include wooden models in his tomb.[3] Because the tombs of subsequent Middle Kingdom monarchs were thoroughly plundered in antiquity, we cannot determine whether they originally contained models.

Following Mentuhotep II, the area from which most models originate narrows to the region between Saqqara and Asyut. The tombs of nomarchs contained the greatest number, but the tombs of lesser officials also contained models, only in smaller quantities.[4] Although models continued to be included in tombs after the reign of Amenemhat I, their frequency, types, and geographic distribution declined dramatically. This drop corresponds to a trend toward building larger tombs that featured the same subjects carved in relief or painted on wall surfaces.[5]

As in other tombs from the same period, the Djehutynakhts' models were found in the underground burial chamber, where originally they had been placed atop and around the coffins. Within the Djehutynakhts' collection, boats make up the largest number of models (58), followed by offering bearers (8 individuals and 4 groups), and then granaries (8). Aside from the boats, the majority of models deal with food production, including 9 examples of force-feeding cattle, 3 of baking/brewing, 1 of cattle herding, and 1 scene of plowing and another of sowing seeds, in addition to the granaries. The industrial activity of the estate is also represented in models of brick makers (2), weavers (2), and carpenters (1), as is its protection and oversight with 3 processions of soldiers, 1 of scribes, and 1 of overseers.

The two tomb occupants are thought to have had separate corpora, but it is largely impossible to tell which models belonged to Governor Djehutynakht and which to Lady Djehutynakht. Given the governor's administrative function, one might guess that the warrior, overseer, carpentry, and scribal models belonged to him. The same

logic would suggest that both brickmaker models were his and that both weaving models were hers. However, a number of approximately contemporary male-owned tombs included spinning and weaving models, so we know that gender roles did not necessarily determine the type of models included for burial.[6] Moreover, since Lady Djehutynakht probably was buried first, it is likely that the models were made over a period of years. The couple may have intended to share the models in the afterlife, just as they shared an estate on earth.

Most of the models were executed with a minimum of detail and care, which was in keeping with an overall focus during the period on quantity versus quality. A general approximation of form was believed to be sufficient for models to function properly in the afterlife; in this they may be compared to model stone vessels in which the insides were left solid. The heads, torsos, and legs of the model figures were made as one, with arms made separately and pegged into place. A layer of plaster and paint covered the joinery and added detail. Figures were attached by means of dowels set into planks recycled from a previous use, judging from dowel holes and slots that bear no relation to their function as bases. Small elements, such as items carried by figures or the ears and horns of cattle, were made separately and also fixed in place with pegs. Most models lack feet, which were probably made of painted plaster applied separately to the bottom of the leg.

The torsos and arms of the straight-armed standing or seated figures found on many models, including the boats, appear to be generic. Yet in other examples of specialized tasks, such as herding and plowing, the positions of the figures show that the parts were specifically made for that job and could serve no other. Given the hundreds of bodies (and twice as many arms) made for the Djehutynakhts' tomb alone, it is tempting to imagine a vast production studio. However, their striking similarities to one another, both in terms of carving and painted details, suggest that the Djehutynakhts' large model corpus was the work of only a few craftsmen.

THE BERSHA PROCESSION

One model grouping stands out from the others. Widely recognized as the finest model of any kind discovered at any site, the Bersha Procession, as it has come to be known, depicts four individuals carrying ritual offerings (fig. 113). The quality of carving, complexity of construction, subtlety of detail, state of preservation, and overall sophistication justify its reputation. Compared with the other models in the Djehutynakhts' tomb, and indeed with most other models from any tomb, the figures have far more delicately carved and painted facial features and finely carved bodies made of a denser, finer grained, and accordingly more precious wood.

A man carrying a ritual *hes* vase on his left shoulder and a censer in his right hand leads a procession of three women, each of whom carries something different into the tomb. The ritual items held by the lead figure and his close-cropped hairstyle suggest that he is a priest. His skin is pale pink, suitable for an official who spends most of his time out of the sun, and his hair is yellow, a rare occurrence in Egypt. He wears a long belted kilt with a triangular front projection and sandals, all symbols of high status. Additionally, the greater space he occupies—he has a wider stride and the distance separating him from the women is greater than that which separates them from one another—places him hierarchically above the others.

All three women have similar torsos with narrow shoulders, small breasts, elongated waists, and garments so impossibly tight that the ridge of the pubic bone and division of the buttocks are revealed beneath. The women are the epitome of feminine beauty in their time. The first two balance similarly shaped and decorated boxes on their heads with their left hands. The bottoms of both boxes were made separately. Cleverly, the artist has made the first box from solid wood except for the bottom, because there was no need for it to be hollow. Its lid is a tray turned upside down and firmly pegged in place. Thin parallel black lines and sharp corners represent fine wooden slats. The bearer's upraised left forearm was made separately and attached to the upper arm by means of a peg below the elbow. Her long, elegant fingers extend just above the tray.

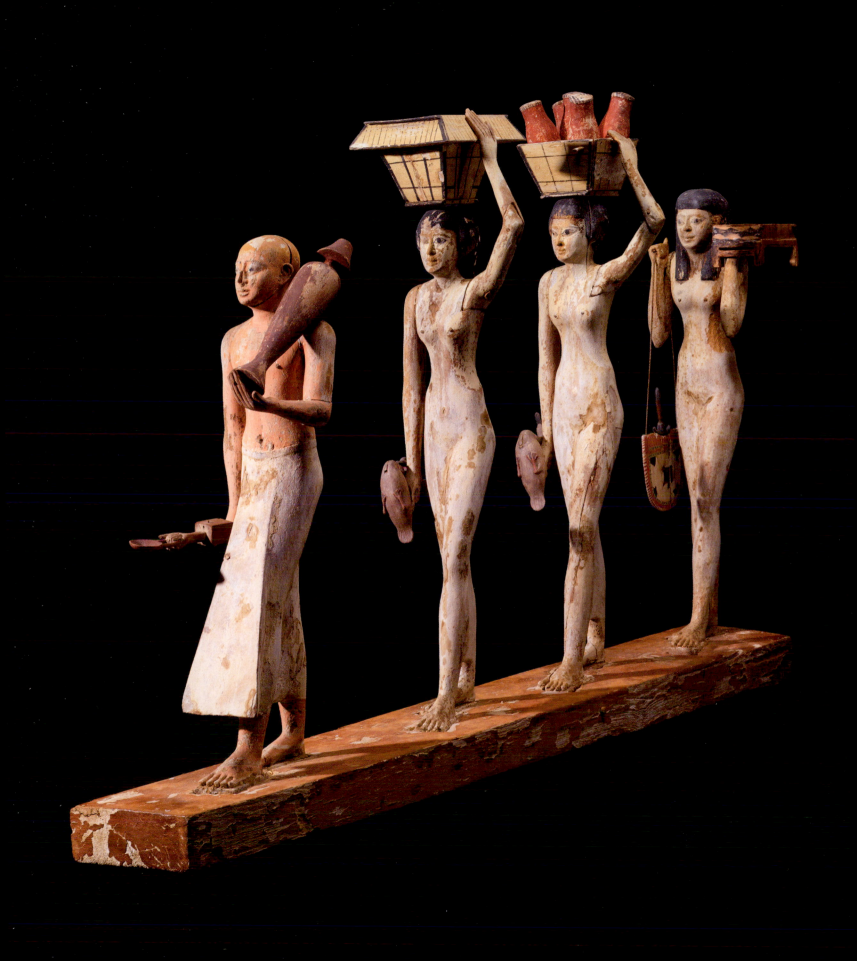

The sides of the box carried by the second woman were made individually and pegged together to the separate bottom. It is slightly larger than the first woman's box in order to accommodate its contents, five beer jars painted red and individually carved with rounded bottoms, elongated necks, and flat, black-and-white-striated tops. The second woman's left forearm is pegged to her upper arm just above the elbow, and her fingers, also elegantly elongated, curl around the top of the box.

The artists' attention to detail and variation also extended to the ducks carried in the right hands of the two women in the middle. Each small bird is a work of art in itself. In both cases the ducks are held by wings that were made separately and joined to the rest of the body. Their heads were also doweled into place. The neck of the first duck curls around so that its beak touches its body, but on the second, the head points up, so the thin beak had to be made separately and attached. Eyes, beaks, and webbing between the tiny, perfectly carved feet were painted black. The legs, held close to the duck's bodies, are painted red.

The final figure in the Bersha Procession is another unique creation. Her arms, bent at the elbow with hands holding objects, were each beautifully modeled from a single piece of wood and pegged into the body at the shoulder. Her open left hand rests on her left shoulder to steady a four-legged, braced stool painted on the top and sides with black-and-white markings to look as if it were upholstered in leopard skin. Except for her thumb, which points upward, the fingers of her right hand wrap around a linen cord to which is attached a large semicircular mirror case and mirror. The case was painted to look as if made from two pieces of wood bound together. The green strips with black dots surrounding a white area with large black spots suggest that the case was decorated with a riveted copper band framing a cowhide skin. Another strip of riveted copper forms an upper border. The decoration is the same on both sides, despite the fact that the side closest to the woman's body is largely hidden. A depression in the top of the case ensures that the convex top of the papyrus-umbel handle of the mirror fits precisely. The end of the handle and the papyrus umbel are both painted black, perhaps in imitation of ebony or obsidian. Papyrus was often associated with Hathor, goddess of fertility and motherhood.

As a composition, the Bersha Procession is quite complex. Many individual, tiny pieces had to be carved separately and then fitted together precisely, with no two elements the same. There is also a cleverly conceived rhythm and balance to the arrangement. All the figures are the same height, including the priest, and yet the eye is led upward by the diagonal of the *hes* jar carried by the priest to the baskets atop the middle two women and then back down to the final woman, who carries nothing on her head.

No other Egyptian procession model approaches this one in sheer beauty or complexity of craftsmanship. The Bersha Procession is the product of an experienced master or masters, depending on whether the carver and painter were the same person. The carver produced none of the many other models from the Djehutynakhts' assemblage, which are charming but naive by comparison. It is possible that several wooden statuettes from other tombs at Deir el-Bersha are by the same hand, for they are as finely modeled as these procession figures.[7] The overall delicacy of line and similarity of specific details make it likely that the same painter decorated both the Procession and the offering scene and ornamental hieroglyphs of Governor Djehutynakht's outer coffin, although he did nothing else in the tomb as we know it.[8]

OTHER OFFERING BEARERS

Compared with the Bersha Procession, the Djehutynakhts' other models of offering bearers are much more summarily executed, though they are charming in their awkwardness. Female offering bearers make up the majority, including six individual statues of women transporting boxes of provisions (fig. 114). Each of these statues has its own base, and each base appears to have been painted black on top and red on the sides. They are not intended to depict actual individuals on the estate. Rather, they symbolize the steady and perpetual flow of produce thought to be necessary for a comfortable afterlife. The figures vary in height from 35 to 41 centimeters (about 14 to 16 inches). As village women in Egypt do today, they balance the boxes on their heads and steady them with their upraised left hands, while their right hands hang open at their sides. Large eyes, stubby noses, and slit mouths

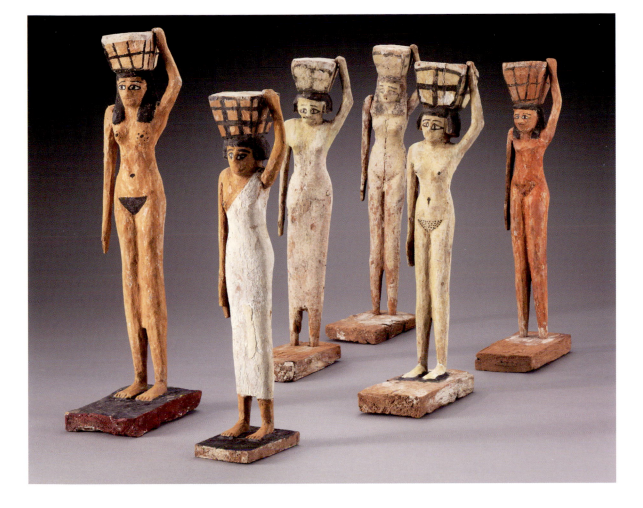

Fig. 114. Models of female offering bearers, late Dynasty 11–early Dynasty 12, 2010–1961 B.C.

adorn all. Based on their similar facial features, body proportions, and details of the torsos, they all appear to have been carved by the same hand.

Despite their similarities, one significant detail divides these figures into two subcategories: three are clothed and three are naked. Of the clothed women, one appears to have had her dress painted on as an afterthought, because the separation of her legs and pubic area are carved as if she were intended to be nude. Two of the figures wear long sheath dresses covering both breasts. A single diagonal strap on the third figure exposes the right breast. Two of the nude figures have breasts with black dots that emphasize their nipples; on one, the breasts are further highlighted by a circle of smaller black dots around the nipples. These figures also have navels prominently highlighted in black.

The presence or absence of clothing may signify different functions for these offering bearers. The clothed figures may represent estates bearing goods to the deceased. A nomarch's estates, namely his fields and other properties, were often personified and represented in tomb reliefs by clothed female figures. The nude figures may have been viewed as ensuring the rejuvenation and perpetual youth of the deceased, as well as providing him or her with sustenance for eternity.

In addition to the individual females, the Djehutynakhts' burial assemblage included three processions of exclusively female offering bearers in their tomb. One procession features two women standing with feet together on a common base; they each wear a long dress with a single diagonal strap. Both balance on their left shoulders rectan-

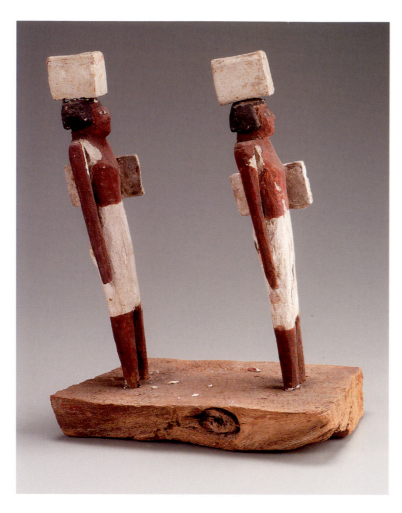

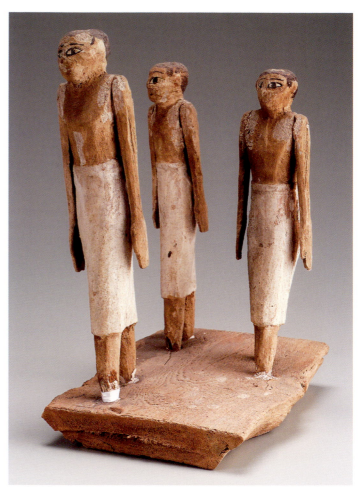

Fig. 115. Model of two scribes, late Dynasty 11–early Dynasty 12, 2010–1961 B.C.

Fig. 116. Model of a procession of three overseers, late Dynasty 11–early Dynasty 12, 2010–1961 B.C.

gular boxes of the type used to store jewelry, clothing, and personal effects, as shown on the Djehutynakhts' coffins. The woman in front, whose skin is paler, wears a long wig, and the woman in the rear has a short wig.

A second procession features five women arranged in two rows of two, with the fifth (at the back) a full head taller than the others (see fig. 147, p. 202). Whereas the paired women have their hands open and empty at their sides, the final figure balances on her left shoulder a rectangular box similar to those carried by the other procession. All the women wear single-strap dresses that leave their right shoulders and breasts bare. Based on the similarity of their torsos, facial features, and hands, all the figures also appear to have been carved and painted by the same artist.

Different hairstyles adorn the women in this procession, which provides variety to the group if not a broader significance. The two in front have tripartite wigs that cover their ears and fall just below their shoulders in front and back. The two behind them have short, squared wigs reaching to chin level in the front and a pigtail in the back carved as part of the torso. The last woman has a wig similar to the second pair, but her pigtail is twice as long and made out of a separate piece of wood so that it hangs freely.

The third female procession is the least well preserved. Nine women stand single file with feet together on a long, reused plank. All have short-cropped, cheek-length black hair and white dresses that extend just below their knees. Where the paint is preserved, it is clear that the dresses

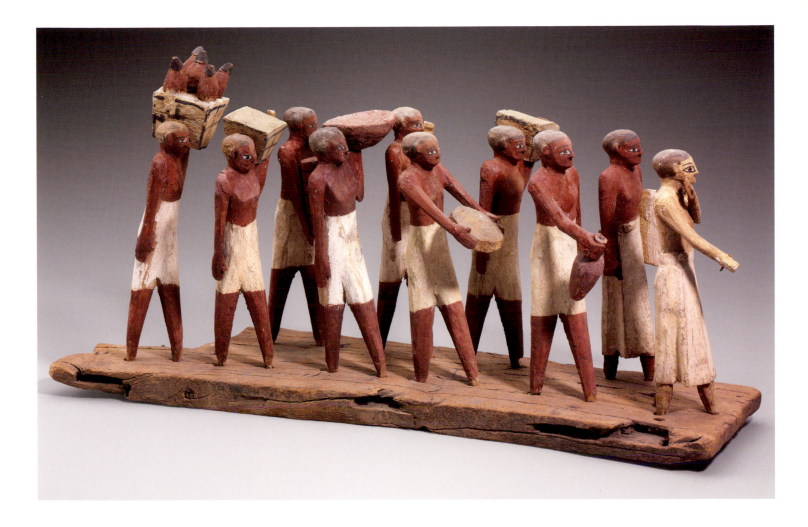

had single straps, which left the right shoulder exposed but covered both breasts. The skin color is deep beige. The bent left elbow on two of the women supported an offering, one of which is a red-painted box with a triangular top held in place by a peg joining the side of the box to the head.

No male offering bearers were depicted individually, but some form processions of multiple figures. Two male scribes, identified as such by the writing boards they carry under their left arms and the narrow rectangular scribal kits balanced on their heads, stand with both feet together on a common plank (fig. 115). Their exposed skin is the deep red ochre characteristic of models representing working males. Record keeping was an essential part of administering both the temples and the secular elements

of the Djehutynakhts' estate, so these scribes must have been included to perform that function in the afterlife.

Oversight was another critical aspect of Governor Djehutynakht's responsibilities, and three striding male figures on a common base were probably intended to represent his top administrators (fig. 116). They differ from the scribes in their yellow skin (in keeping with males who did not work outside), longer skirts (which would make manual work difficult), empty hands hanging at their sides, and short-cropped hair rather than chin-length wigs.

One procession includes a lively and varied group of ten men—an unusually large number for models of this type (fig. 117). They transport a rich array of food, drink, and perhaps cloth into the Djehutynakhts' tomb. An

Fig. 117. Model of a procession of male offering bearers, late Dynasty 11– early Dynasty 12, 2010– 1961 B.C.

Fig. 118. Model of a
procession of soldiers,
late Dynasty 11–early
Dynasty 12, 2010–1961
B.C.

overseer may be recognized in the lead position by his yellow skin and long, wrapped, and knotted kilt. Originally he held something on his right shoulder, perhaps a vessel or large writing board, and balanced it with his left hand. To the left and slightly behind the overseer, a scribe is similarly dressed but has reddish skin. Tucked under his left arm is a writing board and scribal kit consisting of a palette with depressions for black and red ink, and a rectangular compartment that holds two black-tipped red brushes. He may have carried a staff in his right fist, which is pierced. Behind the officials are two columns of men dressed in short kilts. In the right column, the first man carries a long-necked wine vessel in his right hand, and behind him a man holds a round, flat object in front of him, perhaps bread or a tray of food. The next three men on the right carry offerings on their left shoulders: first, a man with a bowl of individual small fruits or vegetables, next a man carrying a basket whose white upper surface suggests it contained folded cloth, and, finally, a man balancing a basket of five beer jars with conical tops. On the left side behind the scribe are three additional men: the first carries a basket that also may have contained cloth; next is a man who also once transported an offering, now lost, on his left shoulder; the final man on the left side balances a pile of eight round, flat, dark-grained breads or cakes in the palm of his right hand while using his left forearm as a dowel to hold seven white breads with holes in the center (the ancient equivalent of bagels). Today bread sellers in Egypt carry thin sesame-covered breads of similar shape in the same way.

This model is more detailed than any other from the tomb except the Bersha Procession, though it is not as refined or finely crafted as that work. In many ways it repeats the Bersha Procession's themes of offerings, and so it may have been made for Lady Djehutynakht, whereas the finer one belonged to the governor (based on the similarity between its painting and the painting on his outer coffin). If that is the case, it is interesting that his procession consists primarily of women and hers exclusively of men, although whether this fact is meaningful in any way is not known.

SOLDIERS

Given the political turmoil at the beginning of Dynasty 12, security was critical to the Djehutynakhts, both in life and for the ideal afterlife.[9] Their tomb includes models of soldiers, armed boats, and additional weaponry. With three processions of infantry, the tomb had more armed groups than any other found to date.[10] In the first of the Djehutynakhts' processions, four soldiers march single file with their right arms swinging forward (fig. 118). The first and third carry large body shields on their left shoulders and once held implements, perhaps bows, in their right fists. The left hands of the second and fourth men hold quivers, painted like the shields to look like they are covered in ox hides. It does not appear that they were carrying anything in their right hands, because the hands are not differentiated from the rest of the arms. The last soldier is almost a head taller than the rest.

The other two infantry models are substantially less well preserved. With ten men each, however, both were significantly larger in their original condition. In one model, two columns of five men stride forward holding what appear to be quivers and bows, perhaps alternately, in their left hands. The other is led by a figure (now missing) with feet together, perhaps a standard-bearer or officer. A column of four men marches behind him in tandem with a column of five on the opposite side. A sufficient number of bent arms are preserved from the tomb to suggest they held shields similar to the one shown on Governor Djehutynakht's coffin.

LIFE ON THE ESTATE

In agrarian economies from antiquity until the present, cattle have symbolized wealth. In addition to meat, which was probably available only to the nobility, they provided milk and labor as draft animals. Moreover, to the Egyptians they had religious significance; the right foreleg of a bull was the choicest temple offering. One model from the Djehutynakhts' tomb shows three men herding two black-spotted cattle. The two men in front, bent over as if they were trudging through a swamp, each lead an animal by a rope. To keep their kilts from getting wet and to facilitate their own movement, they have hiked up their kilts above the knees and thrown the ends over their shoulders.

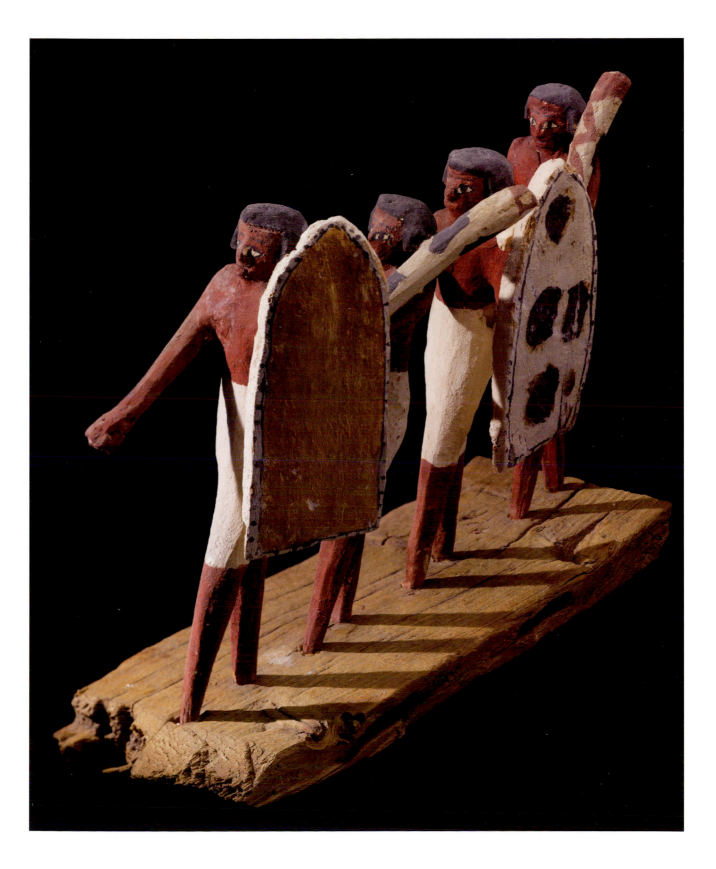

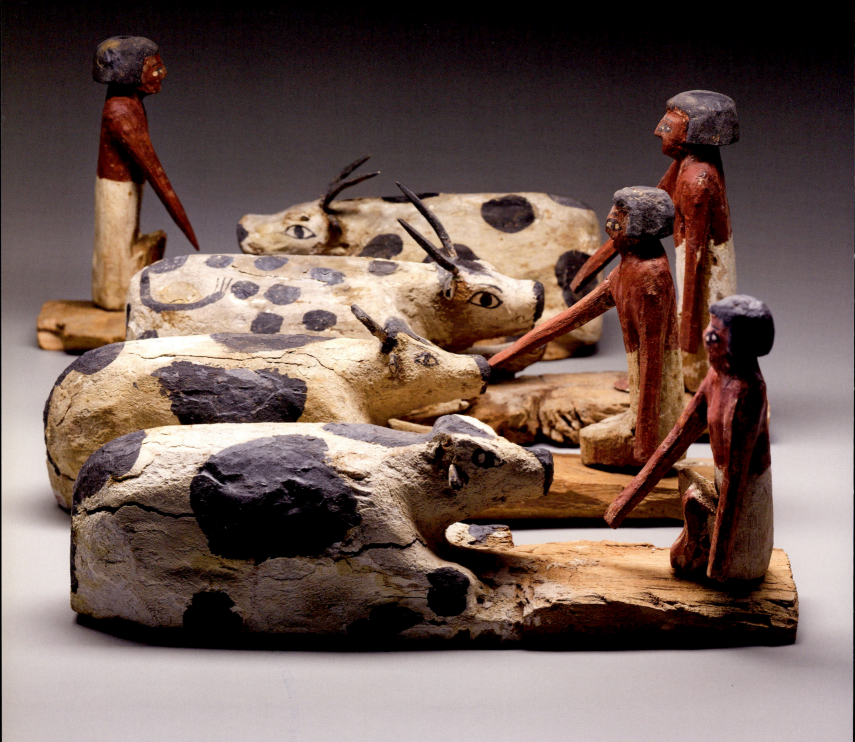

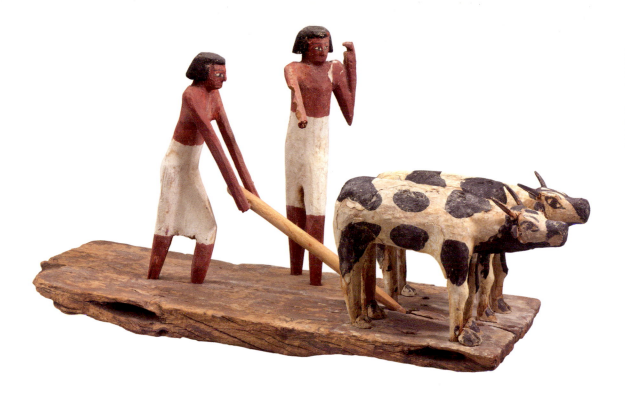

Fig. 119. Models of cattle
being fed by hand, late
Dynasty 11–early Dynasty
12, 2010–1961 B.C.

Fig. 120. Model scene of
workers plowing a field, late
Dynasty 11–early Dynasty
12, 2010–1961 B.C.

The lead man has a chin-length wig, and the second exhibits a bald pate, possibly an indication of his age. In their bent right arms both men hold sticks for prodding the animals. The third figure stands behind the animals to prod from the rear. Because he is upright and his kilt falls just below his knees, it appears that he has not entered the swampy area.

In their present state, the bodies of the cattle are hardly more than logs tapered at the head end. Roughly hewn, tapered sticks form the legs, which were slotted into the bodies. In a nice touch, a bulge at the back of the hind legs represents the joint and hints at the cattle's resistance to being forced to move. Originally, much of this model's roughly carved surface would have been masked by modeled plaster and paint.

Nine other models show an already large bull being fattened through hand-feeding, even though the rich and fertile lands of the Djehutynakhts' Hare nome provided ample room for grazing (fig. 119). The practice of hand-feeding a variety of animals was frequently represented in relief and painting on tomb walls beginning in the Old Kingdom. In each instance of this practice represented in model form, a squatting man extends his right hand to the mouth of a recumbent bull whose girth is so large that it occupies the entire width of the board that forms its base.[11] In some cases the animals appear to have been carved together with the board, but in others it is clear that they were carved separately and attached. Each bull extends his left foreleg while tucking the right one underneath his body. Some of the animals are modeled quite well, especially in the heads that strain forward to receive the offered victuals. The cattle also differ in the size and number of black spots and the shape and placement of their painted tails. As in the case of cattle in other models, horns and ears were made separately. After the cattle were fattened to capacity, presumably they were led off for slaughter. Many model corpuses included slaughter scenes, although in the Djehutynakhts' they are notably absent.[12]

After the yearly Nile floodwaters receded, leaving behind fertile black soil, plowing and seeding began. In another model, two bulls strain forward to pull a heavy wooden plow (only partly preserved), guided by a man who leans into it to steer (fig. 120). His legs sink deep

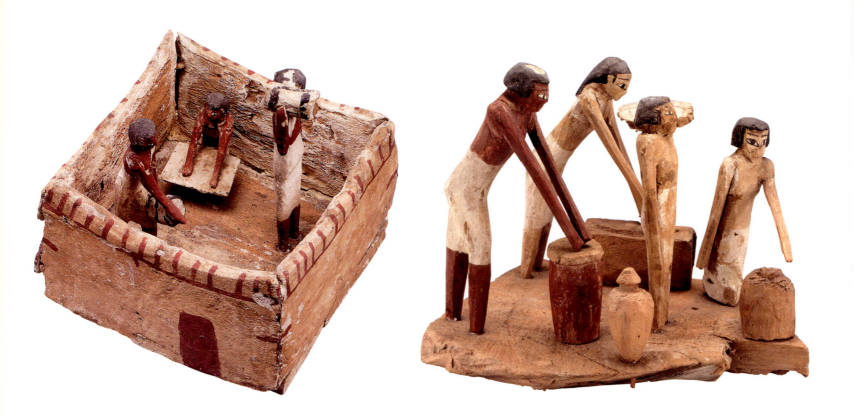

Fig. 121. Model of a granary, late Dynasty 11–early Dynasty 12, 2010–1961 B.C.

Fig. 122. Model scene of bakers and brewers, late Dynasty 11–early Dynasty 12, 2010–1961 B.C.

into the freshly plowed earth. Beside him, a man who originally had a bag on his left shoulder extends his right hand to scatter seed. Similar scenes may still be seen in Egyptian villages today. Except for its missing implements, the model is in an excellent state of preservation. The junctures of the legs with the body are completely masked by painted and modeled plaster. Delightful touches, such as the painted plaster cloven hooves, animate this model. The animals' alert heads extend beyond the front edge of the base, and their knees bend slightly as if to emphasize the difficulty of their labor. The upper surface of the base was painted a chocolate brown in imitation of the earth.

Once the harvest was collected, it had to be stored. Granaries kept grain safe and away from floodwaters for use as both a food and a commodity for payment and exchange. As early as Dynasty 1, Egyptians included model granaries in their tombs and often depicted them on tomb walls or coffins. Other than boats, more grana-

ries are known than any other type of Egyptian tomb model.[13]

The Djehutynakhts' tomb contained eight granaries, an indication of the owners' high status (fig. 121). Five of the granaries were found disassembled. Family members who buried the governor probably dismantled the granaries belonging to his wife and possibly some of his to make space for other objects in the tomb. Compared with other known granary models, the Djehutynakhts' are of the simplest type in terms of size, architectural complexity, and number of workers.[14] Each consists of a roughly square, roofless building with peaked corners, a shape that also signifies a granary in hieroglyphs. They are relatively small, but populated by the three people (possibly four in one case) necessary to carry out the work: one carries in a sack of grain, a second bends over to scoop it into a circular grain measure, and a seated scribe records the count on his tablet. To facilitate their movement, the men who transport and measure the grain have

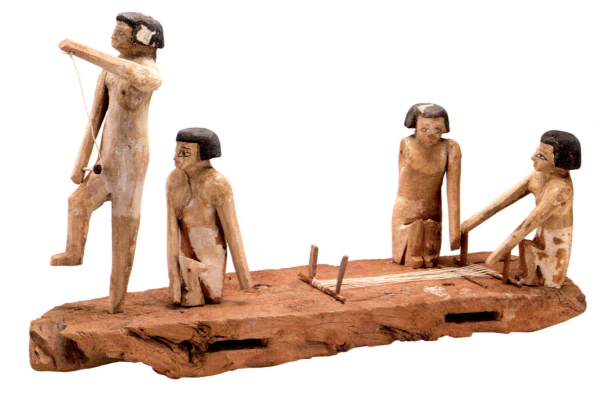

the ends of their kilts hiked up and draped over their left shoulders, whereas the seated scribe is shown with his kilt wrapped in a normal fashion. All men have red skin. The outer walls of the granary are painted beige. The upper borders are highlighted with vertical striations in red, a common upper border design known as a *kheker* frieze, which represents bound reeds. Each granary has a plain red door painted about a third of the way down on one side and red-painted clamps securing each corner. It is possible that the structures on which the models were based were made of reeds tied together at the top and plastered with mud for stability.

Bread and beer, both made from grain, were staples in the Egyptian diet. In the absence of coinage, they also served as payment for work. Bread was so important to the Egyptians that by the New Kingdom they had developed about forty different terms for it and depicted the variety of bread shapes on tomb walls. Bread was usually made from emmer wheat but could also be made from

barley. Beer was made from barley bread, and for this reason the two processes were often depicted together.

The Djehutynakhts' tomb had three bread-making/ beer-brewing models, two of which are in sufficient condition to be able to provide information about these industries (fig. 122). In both models, women prepare bread and a man makes beer, which indicates different gender roles. One woman bends at the waist to grind emmer on a grindstone, and another brings the leavened loaf to a baker, also female, who sits beside a low conical oven. A man pushes fermented barley bread through a sieve into a container to make beer, which is then stored in the jar placed in front of him with the conical top.

Different details provide a glimpse of how the industries were conceived at the time. On one model, the woman grinding grain has her long hair pushed behind her ears to keep out flour dust. All the women are shown topless with the exception of one porter, who has a single strap on the shoulder on which she balances bread.

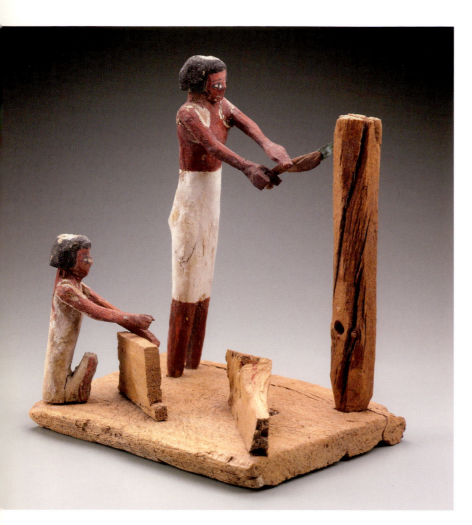

Fig. 124. Model scene of carpenters, late Dynasty 11–early Dynasty 12, 2010–1961 B.C.

depictions from the Middle Kingdom show only women engaged in spinning and weaving, and always with a horizontal ground loom. With the advent of the upright loom in the New Kingdom, men came to be depicted taking part as well.

On the Djehutynakhts' spinning and weaving model, activity proceeds from left to right, following the dominant rightward orientation of relief scenes (fig. 123). At the left end, a squatting woman feeds flax to the woman standing in front of her. The latter raises her left arm to shoulder height and extends the right slightly forward. Originally she held a spindle in each hand. Raising her right thigh to set the right spindle in motion, she would have pulled flax from the upraised spindle (now missing) in her left hand, transforming it into thread in the process. The spinner alone wears a skirt held up by a diagonal strap that runs between her breasts, thereby permitting her complicated action. Both nipples are shown as black dots, perhaps to emphasize her traditional female role.

Behind the spinning scene but on the same board, women weave. One squats at the end of the board in front of a loom installed on the ground. Two large pegs and a perpendicular rod on each end anchor the warp threads. A second woman, squatting, works the heddle to create woof threads and form the woven cloth. The women wear simple skirts and have hair of chin length, except for the spinner, who has a long ponytail hanging down her back. The wood that forms the base of the Djehutynakhts' spinning and weaving model has horizontal slots that serve no function cut into the sides. It clearly had an earlier use and was recycled for this purpose.

Wood was essential for buildings, furniture, farm equipment, boats, and burial goods, and so a fully functioning carpentry shop was an important feature of any large estate. Nevertheless, as models, they were relatively rare.[16] An ideal toolbox included copper-bladed pullsaws (Egyptian saws only pulled, unlike those of today), adzes, axes, chisels, and knives, all hafted on wooden handles.[17] The Djehutynakhts' tomb included a relatively small carpentry model (fig. 124). One man bends slightly as he uses both hands to pull a saw through a thick upright log. A shallow cut indicates his work has barely started.

Unlike the female offering bearers, who are either naked or wear single-strap dresses, in no instance on these workers are breasts or navels highlighted. A strip of linen cloth is wrapped around a kneeling baker, but her painted skirt may still be seen underneath. These baking/brewing models were the only ones whose activities did not require a rectangular base, so the wood was cut to a shape that exactly accommodates the figures. Such economies reflect just how precious wood was.

Of all the manufacturing activities of the estate depicted in model form, spinning and weaving are shown with the greatest frequency. Cloth, primarily linen, was extremely important for both secular and sacred purposes.[15] Tomb

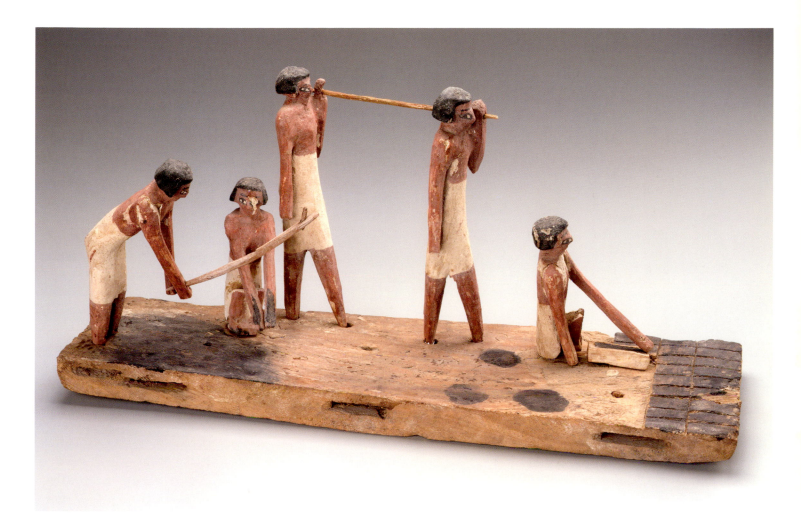

Beside him, a squatting man uses an adze (now missing) to plane a narrow upright board with projecting ends, perhaps intended as the side of a box. Also included in the model is the next project, a plank of irregular thickness already marked with a red guideline for sawing.

The basic building material for all domestic and administrative purposes in ancient Egypt was brick, which was made of clay mixed with an organic material like straw and then molded into a rectangular shape and dried in the sun. Given its importance, it is surprising that models of brick making occur infrequently in tombs.[18] The Djehutynakhts had two. On the most elaborate example, the process begins at the left (like the model of spinning and weaving)

as one man uses a hoe to break up clods of earth, while another seated beside him mixes it with an organic material to aerate it (fig. 125). Two men transport the mix in a container (now missing) suspended from a carrying pole to an area near a squatting man, who uses a rectangular mold to shape the bricks. Two finished rows consisting of carefully delineated raised rectangles are already drying as he works on a third. The second model of brick making lacks the figure who is hand mixing the clay, and the finished bricks, larger in every dimension, are incised only on the surface of the board. Like the spinning and weaving models, the slots on the base were cut into the sides for a previous use.

Fig. 125. Model scene of brick-makers, late Dynasty 11–early Dynasty 12, 2010–1961 B.C.

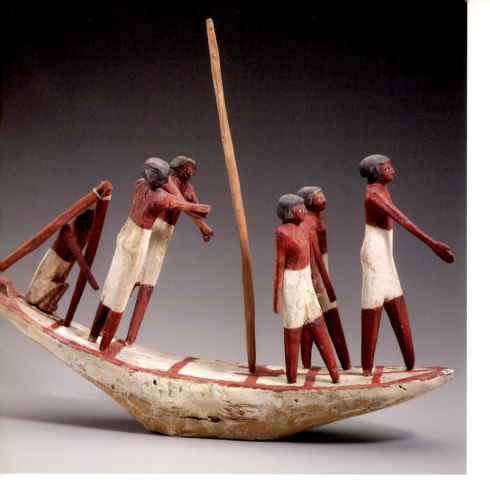

Fig. 126. Model of a boat under sail, late Dynasty 11–early Dynasty 12, 2010–1961 B.C.

BOATS

All aspects of life on the Djehutynakhts' estate, as well as of Egypt's overall economy, depended on the Nile River, Egypt's agricultural lifeblood. In addition to providing water and a source of fertile silt, it served as the country's main highway and means of communication. Travel by boat was faster and more efficient than travel by road; on water, passengers and products could move relatively easily between Egypt's capital and outlying provinces and even to Nubia and western Asia. The concept of travel by boat therefore permeated all aspects of Egyptian life and religion. Even the sun god Ra was believed to travel across the heavens by day and through the underworld by night in a boat.

The decoration of nonroyal elite tombs from the late Old Kingdom onward regularly included scenes of boats. Wooden models of boats also became a standard part of the funerary equipment at that time, and, like other mod-

els, they were placed in the subterranean burial chamber. Their function paralleled that of the boats represented on tomb walls: to symbolically provide transportation in the afterlife. The number and types of model boats vary from tomb to tomb, but they fall into certain broad categories, including funerary barks, processional boats, transport vessels, kitchen barges, and skiffs for hunting and fishing.[19] Like the models of agriculture and crafts, the boat models were not intended to be realistic. For example, the sailors and other occupants are disproportionately large for the hulls, the oars are too short to have reached the water, and the masts are too small to be functional. Nevertheless, the models offer a good deal of information about the construction and furnishing of ancient Egyptian boats.

The Djehutynakhts were particularly well equipped for their voyage to the netherworld with a fleet of fifty-eight boats, the largest ever discovered in an Egyptian tomb. The vessels have a distinctly provincial quality when compared with the more detailed and carefully constructed boat models found at sites such as Thebes, but the lively poses of their crews successfully convey a sense of bustling activity and energy. Despite the fact that the boats had been haphazardly strewn around the burial chamber by the ancient grave robbers, their position suggested that many of them were originally set on top of Governor Djehutynakht's outer coffin (fig. 61, p. 99).

Thirty-six of the Djehutynakhts' boat models are similar enough in style and technique to suggest that they were acquired as a set or at least came from the same workshop (figs. 126–128). Made of locally available acacia wood and painted in red, black, yellow, and white, they range in size from 58 to 62 centimeters (about 22½ to 24½ inches) and represent wooden transport vessels, each occupied by a crew of six sailors or eight oarsmen. The hulls, painted yellow, are shallow, and a framework of beams painted in red supports the white deck. A central beam runs down the center of the hull, and transverse beams run across it. The steering oar is lashed to a vertical stanchion driven into the last of the transverse beams, resting in a chock at the stern. The crew consists of a pilot who stands in the prow watching for sandbars and other hazards, a helmsman who sits in the stern and maneuvers the steer-

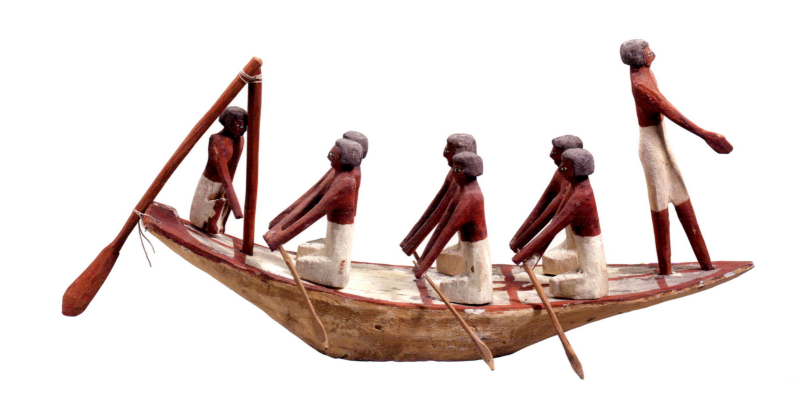

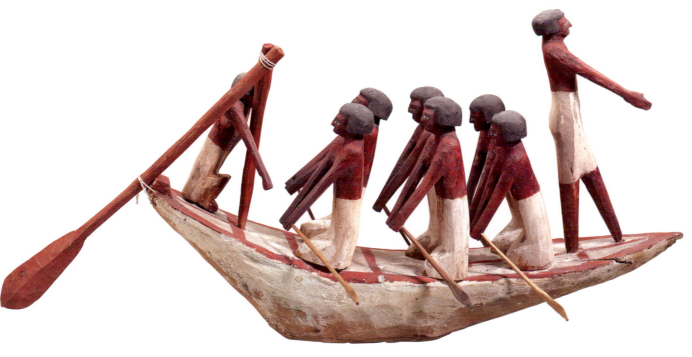

Fig. 127. Model of a boat being rowed, late Dynasty 11–early Dynasty 12, 2010–1961 B.C.

Fig. 128. Model of a boat being rowed, late Dynasty 11–early Dynasty 12, 2010–1961 B.C.

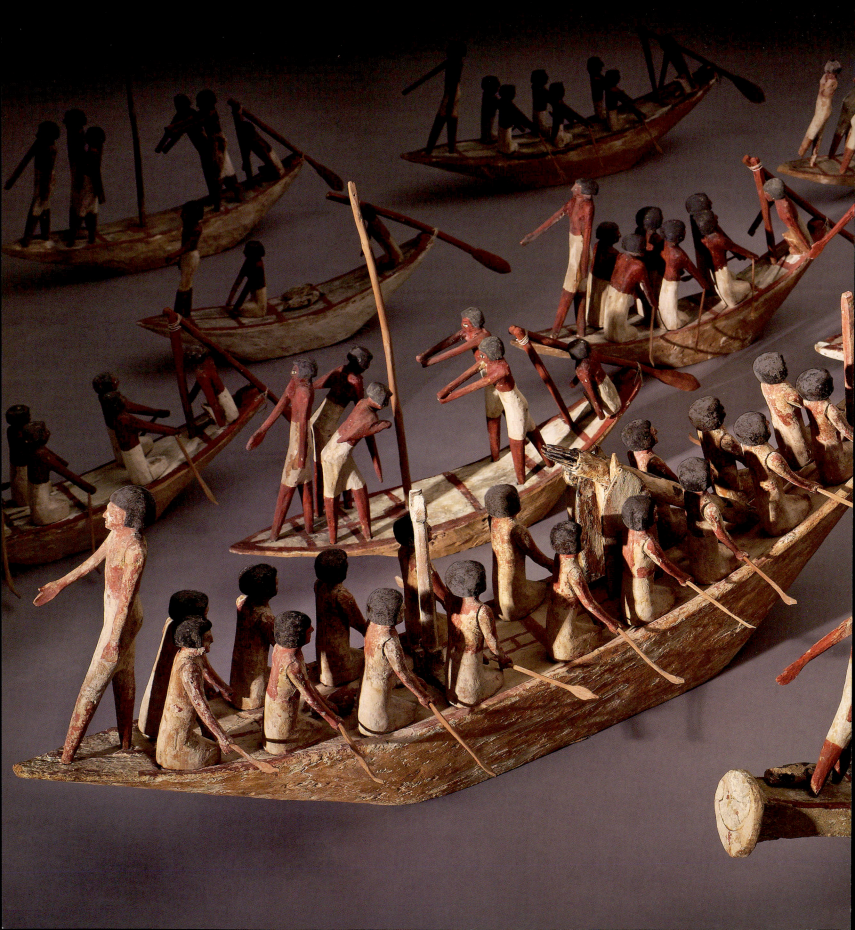

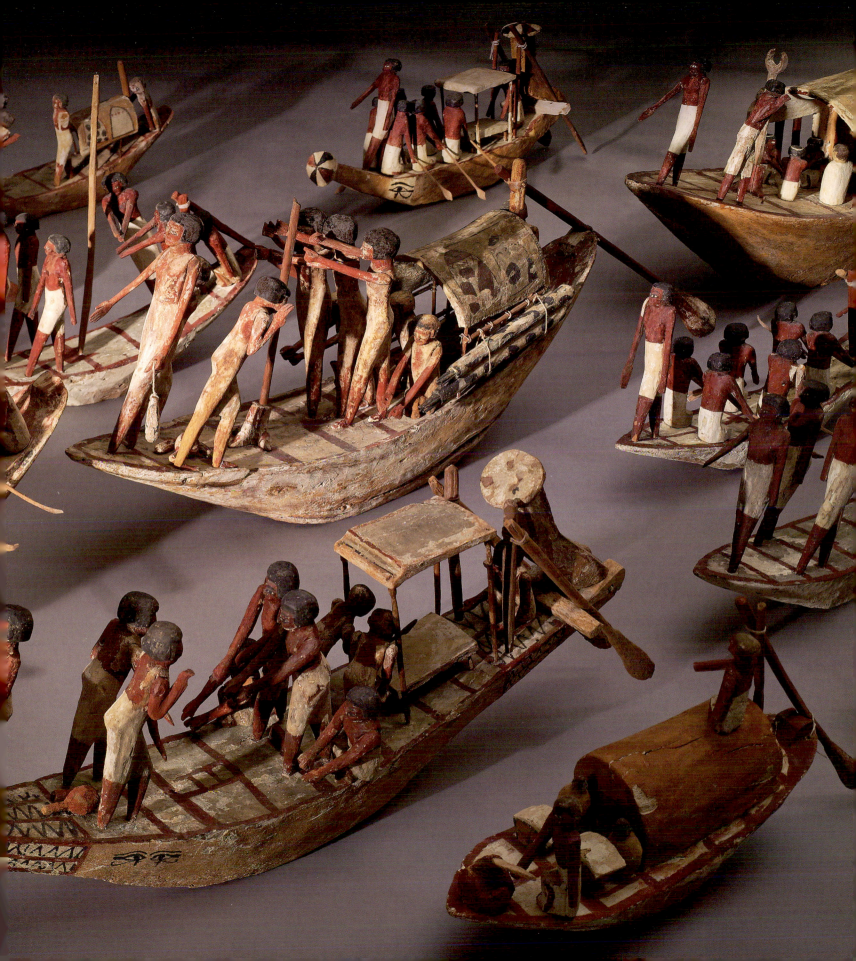

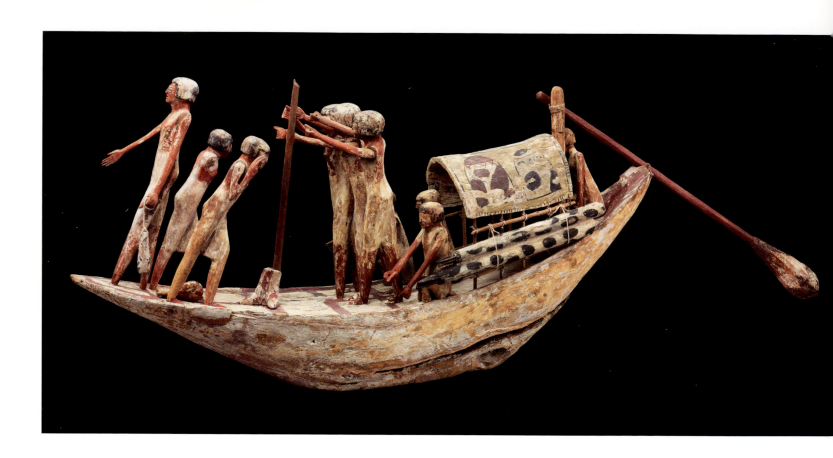

Fig. 129. Model of a transport boat with a portable cabin, late Dynasty 11–early Dynasty 12, 2010–1961 B.C.

ing oar, and six sailors who either row or tend the sail depending upon which direction the boat is headed. Boats navigating the Nile took advantage of prevailing winds off the Mediterranean to sail southward, but they stowed the mast and rowed when traveling northward. This pattern was so well understood by the Egyptians that the hieroglyphic symbol for "northward" was a ship being rowed, and that for "southward" was a ship under sail. In tomb decoration, the same vessel typically appears twice, once moving in each direction. Likewise, tombs tended to be furnished with at least two boat models, one southbound and the other northbound. The Djehutynakhts' set includes eighteen northbound and eighteen southbound boats.

In addition to these basic transport boats, the fleet includes four vessels equipped with portable cabins in which to travel in comfortable shade. Three of these boats are similar in size and style to the thirty-eight

examples without cabins, and the fourth is considerably more detailed and larger at 1 meter (about 3½ feet) in length (fig. 129). The model cabins represent curved canopies of fabric or leather supported by frameworks of poles. Painted on each cabin are representations of four cowhide shields (two on each side), suggesting that the boats might be headed out on a military or hunting expedition. The largest and best-preserved example portrays a ship in the process of being launched. Unlike most of the others, it has a very deep hull with a relatively low prow and high stern. Nine crossbeams painted in red support the hull. The mast, driven through the third crossbeam, sits in a three-legged support with two legs attached to the crossbeam and the third set at a perpendicular angle into the central beam. The pilot stands at the prow holding a rope attached to a bumper that in life would have been covered in cowhide to cushion the boat when it bumped against its dock. Behind him, two sailors face

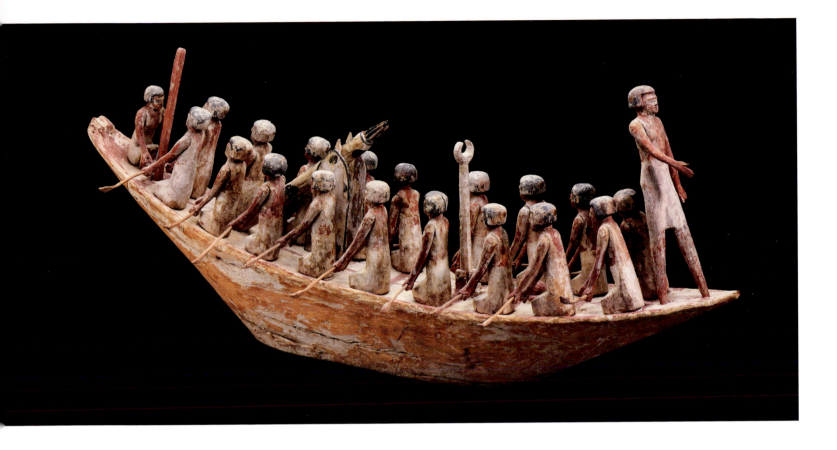

backward, leaning on what originally would have been sounding poles used to measure the water's depth and push the boat away from sandbars. The remaining five sailors work to hoist the now-missing sail. In the stern, the helmsman sits on the red poop deck manning a long and elaborately painted steering oar. A pair of long quivers holding spears hangs from the side of the cabin, and the post and mallet used to secure the ship onshore lie on the deck near the prow.

Another large boat model from the tomb, similar in size to the ship undergoing launch, represents a military boat headed north down the Nile (fig. 130). Eighteen men facing the stern row the vessel, the pilot faces forward in the bow directing them, and the helmsman occupies his typical position at the elevated stern. A white-painted fork in the center of the ship would have supported the lowered mast. About a third of the way from the stern is a large quiver holding spears and a pair of long shields, all

painted to represent cowhide. Models of similar shields were also found in the tomb, along with models portraying marching troops holding cowhide quivers and shields.

Two of the boat models depict kitchen barges, which do not include sailors and would have been towed (figs. 131–132). In life, such boats would have accompanied Djehutynakht and his sailors during voyages so they could provide food and beverages. In the afterlife, like the models of bakeries and breweries, they were intended to sustain the *ka*. The kitchen barges are painted red to represent boats made of wood, with the decks painted white, the beam framework red, and the sides of the hull yellow. In both models, a round-topped cabin for food storage occupies the deck toward the stern. In the better-preserved example (fig. 131), a man seated in the prow tends a cooking fire. On the deck behind him is a pair of food crates and a pair of beer jars with mud stoppers, not unlike actual pots found in the tomb. The helmsman in

Fig. 130. Model of a military transport boat, late Dynasty 11–early Dynasty 12, 2010–1961 B.C.

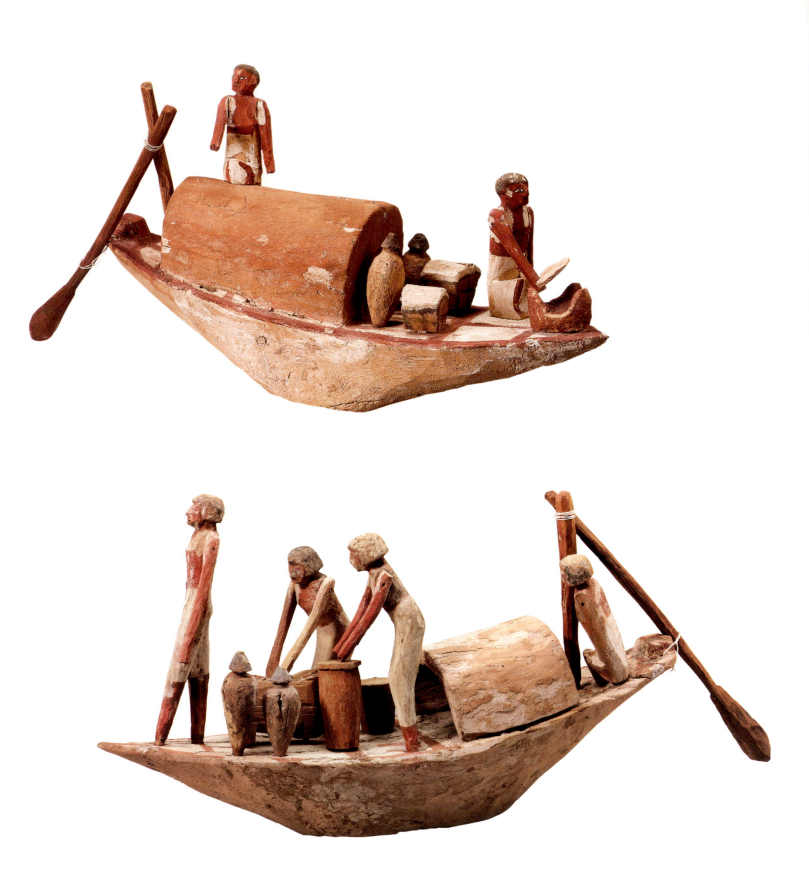

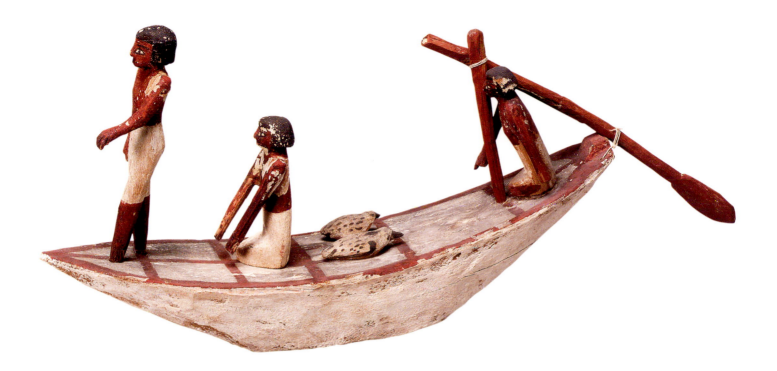

this case operates the rudder from atop the cabin. The crew of the second kitchen boat is occupied with the production of bread and beer (fig. 132). The preserved crew includes the pilot and a pair of figures grinding grain and preparing mash.

Also intended to furnish food for the deceased is a pair of models portraying the shallow wooden skiffs used for hunting marsh birds (fig. 133). Each boat was manned by a crew of three, including the pilot, the helmsman, and a crouching figure of a man who may either have been paddling the skiff or using a net to collect the fallen waterfowl. In both examples the hunt has already met with success, as a pair of captured birds sits in the center of the deck.

Boats also played a major role in Egyptian funerary beliefs.[20] In pharaonic times, royal mortuary complexes from the Early Dynastic Period through the Middle Kingdom sometimes incorporated full-size boats to allow the king to accompany Ra on his ritual journey. Such boat burials are attested from Abydos, Giza, Abusir, Abu Rowash, and Dahshur. The Old Kingdom Pyramid Texts describe the deceased king's travels on "the winding waterway," and

the Middle Kingdom's Book of Two Ways illustrates exactly such a route. Certain boat models are therefore directly related to the funeral and journey to the afterlife.

Two types of journeys shown in nonroyal tomb chapels specifically involve the postmortem transport of the deceased. First, especially during the Middle Kingdom, the dead were believed to make a symbolic pilgrimage to the sanctuary of Abydos, the perceived burial place of Egypt's principal funerary god, Osiris. Second, as part of the funeral procession, the body was transported on the Nile to the cemetery. The mummy is shown resting on a bier beneath a canopy and attended by priests who read spells or offer incense. The Djehutynakhts' tomb chapel would almost certainly have included such scenes had the superstructure survived.

Seven of their boat models represent papyrus funerary barks (fig. 134). Although these vessels were actually made of wood by the Middle Kingdom, as is indicated by the decks painted red and white on the models, their design imitates a boat constructed of papyrus bundles. They have a distinctive form with wide, low hulls and sickle-shaped sterns that curve sharply upward and inward. The prow

Fig. 131. Model of a kitchen boat, late Dynasty 11–early Dynasty 12, 2010–1961 B.C.

Fig. 132. Model of a kitchen boat, late Dynasty 11–early Dynasty 12, 2010–1961 B.C.

Fig. 133. Model of a fowling boat, late Dynasty 11–early Dynasty 12, 2010–1961 B.C.

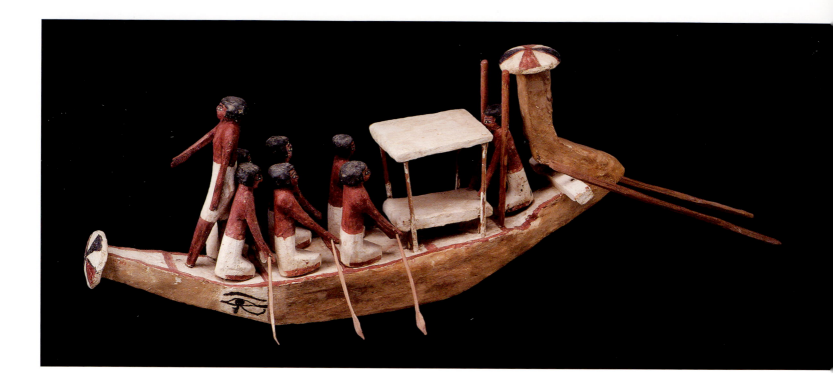

Fig. 134. Model of a funerary boat, late Dynasty 11–early Dynasty 12, 2010–1961 B.C.

and stern are carved and painted to represent the bundled ends of the papyrus stalks from which the hull is made. Painted on the prow, and sometimes the stern as well, is a pair of sacred *wedjat* eyes, intended to guide the vessel safely through the precarious journey to the afterlife. Near the stern, a bier for the mummy rests beneath a flat-topped canopy supported by four poles. In none of the models is the mummy itself preserved. Eight to ten men comprise the crew of the funerary boats. Seated beneath the upturned stern, the helmsman operates a pair of steering oars that could be lashed to stanchions when not in use. The pilot acts as lookout, and the remaining sailors man the sails or oars as needed.

The two largest and most carefully made funerary boat models appear to have formed a pair representing the same boat on its northward and southward journey (fig. 135). The hulls are painted yellow, with red and black zigzag lines representing the lashing used to secure the papyrus. A pair of *wedjat* eyes adorns each side of the prow. Beneath a shrine-shaped canopy is a funerary bed covered with spotted animal hide. Along with the crew, the boats carry a pair of priests with characteristic shaven heads, who

bend over the bier administering to the now-missing mummy. The southbound sailboat is the better preserved of the pair. Like the large transport boat in the tomb, it is getting under way. Two of the sailors lean forward to push the boat away from shore with poles (now missing) while the others raise the sail. At their feet are the post used to secure the prow rope when the boat was moored and the mallet used to drive it into the ground.

Three boat models are a type known as pilgrimage boats, which portray the deceased seated and wrapped in a cloak either inside or in front of a vaulted cabin or canopy, probably en route to Abydos.[21] The largest of the pilgrimage boats, at just over 1 meter (about 3½ feet) long, is furnished with a vaulted cabin that occupies half the deck (fig. 136). The boat's yellow hull is very deep, with a sharply pointed bow and a deck detailed in red and white. The cabin consists of an interior room closed off by a pair of hinged doors with an open canopy in front. The canopy, painted yellow with black details to represent stitched leather or canvas and supported in front by six poles painted red to represent wood, houses a table and a chest. The cloaked figure of Djehutynakht sits in the shade

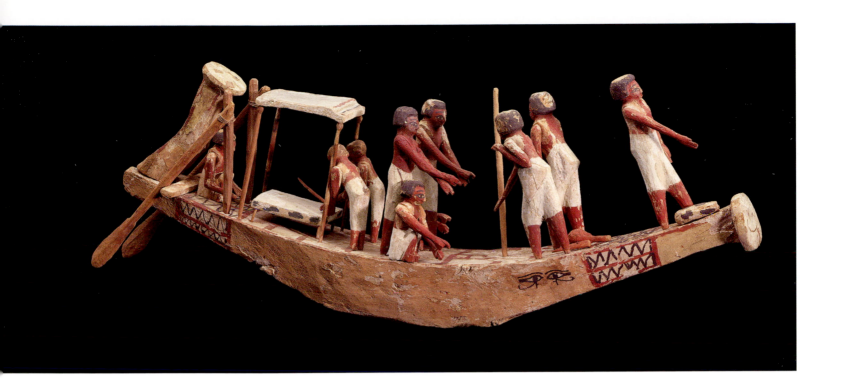

of the canopy, assisted by three attendants. The boat is not under sail, and a fork for holding the lowered mast rests in the mast support. The four-man crew includes the pilot, two crewmen, who lean against now-missing poles to propel the vessel, and the helmsman, who operates the steering oar from a position atop the cabin.

Conclusions about the Djehutynakhts' model corpus as we know it now can be made only by considering the long and tumultuous journey it has traveled in time and space. It is important to remember that the tomb was reentered with the presumed later burial of Governor Djehutynakht, plundered subsequently at least once, hurriedly excavated under severe time pressure by the Harvard–MFA team, and then left to languish in storage from 1915 to 1921 until the dangers presented by World War I made the seas safe again for their shipment to Boston. Whereas the finest pieces and select other examples were restored and put on view almost immediately after their arrival, many of the rest awaited conservation and study for almost a hundred years. It is impossible to know for certain whether part of the model corpus was stolen, destroyed, unrecognized, or lost during that time.

Nevertheless, the Djehutynakhts' models can be reasonably dated to the brief flourish of model production that spanned Egypt's late Eleventh to early Twelfth Dynasties based on the similarity of content and style to models from other tombs of that period. The all-male procession, for example, features full-bodied, crowded figures that are similar to models from the recently discovered tomb of Henu at Deir el-Bersha, which has been attributed to the Eleventh Dynasty following the reunification of Egypt under Mentuhotep II.[22] The much more complex and sophisticated Bersha Procession is closer to the models of Meketra from Thebes, whose burial is now thought to have taken place under Amenemhat I, although he served under previous kings as well.[23] The Djehutynakhts therefore are likely to have lived at approximately the same time as Meketra or slightly later, with the governor's death around the end of the reign of Amenemhat I.

Of all the most popular model types, the Djehutynakhts' lacked only a scene of cattle slaughter, perhaps an oversight.[24] Their corpus also included rare examples, such as scenes of brick making and processions of soldiers.[25] Despite the large number of models overall,

Fig. 135. Model of a funerary boat, late Dynasty 11–early Dynasty 12, 2010–1961 B.C.

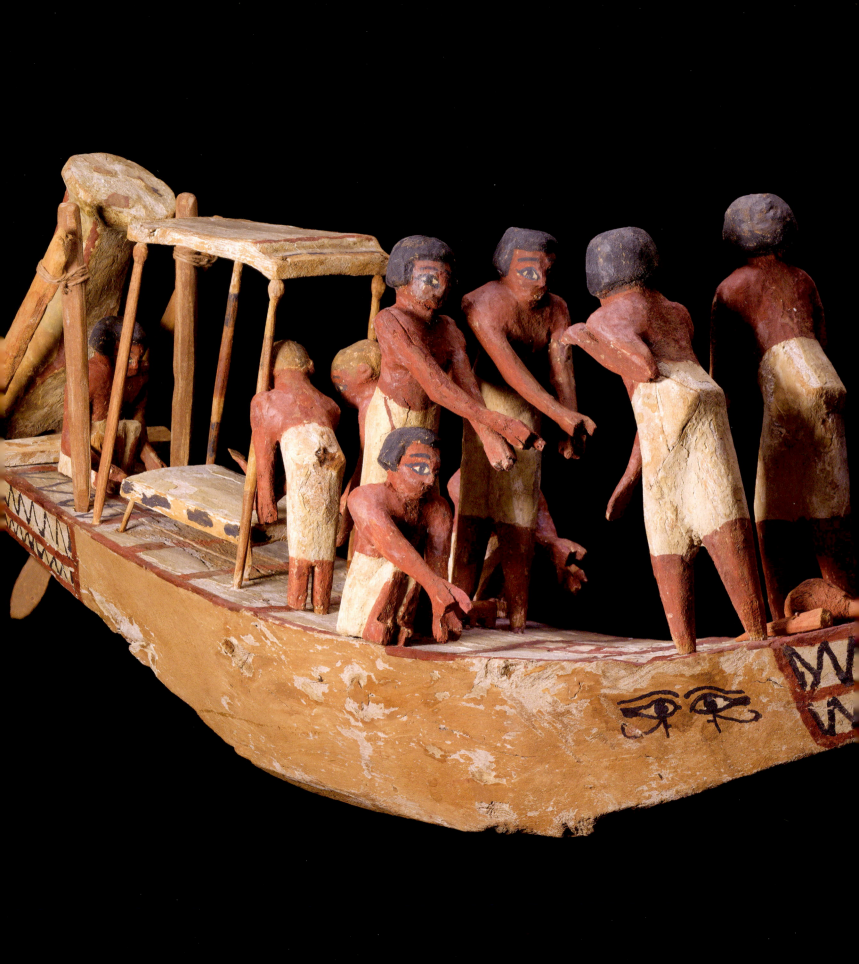

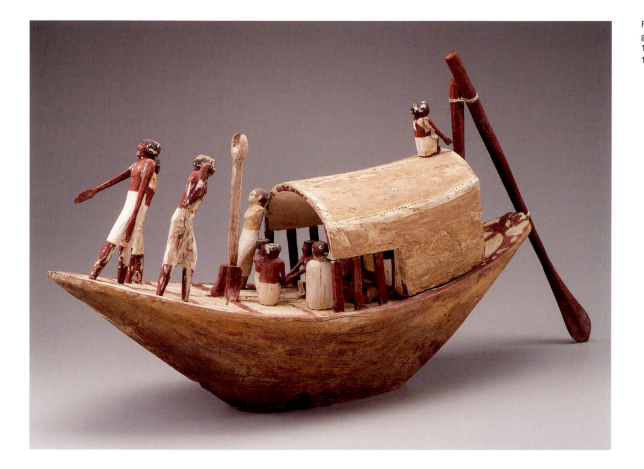

Fig. 136. Model of a pilgrimage boat, late Dynasty 11–early Dynasty 12, 2010–1961 B.C.

each model tends to have the fewest possible figures needed to accomplish the task depicted, and with the exception of the Bersha Procession, each element was made in a summary fashion. This situation suggests that the Djehutynakhts chose to have a greater number of models rather than painstakingly carved and complex examples. Whether the need for haste or economy drove the choice, we will never know. These characteristics of the other models make the Bersha Procession, with its exquisite and sophisticated detailing and modeling, stand out all the more. It is difficult to imagine that the craftsmen who made them are the same. The quality of the Bersha Procession suggests it was made by one of the finest artists in the country at the time, one who may have worked for the king. Because something

as fragile as painted wood sculpture assembled from many components would not have traveled well, we might imagine that the king sent an artist to the Hare nome to make the Bersha Procession (and the governor's outer coffin).

Deir el-Bersha has the dual blessing of being located in one of the widest and most agriculturally fertile areas of the Nile Valley and being flanked by the wadi that leads to the rich Hatnub travertine quarries. In addition, its high cliffs provided miles of visibility that was particularly valuble in defensive operations. As the governor of such a wealthy and strategically important nome, Djehutynakht's support must have been critical for the king both militarily and politically; in return, the governor was richly rewarded.

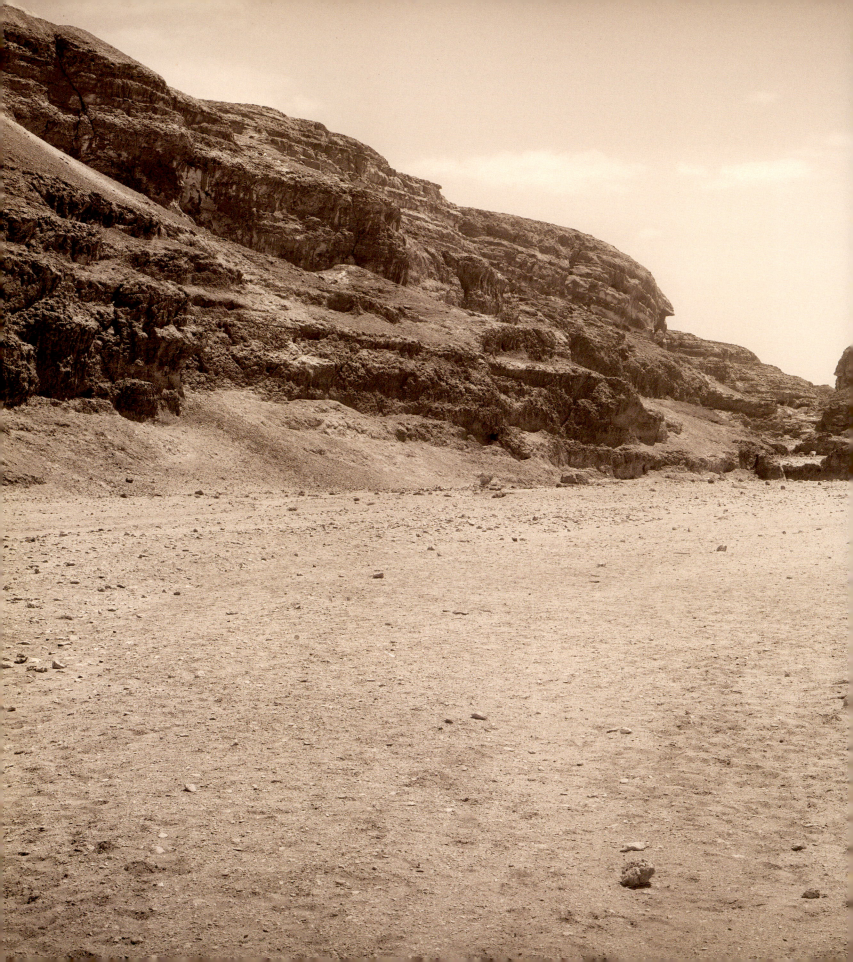

PART THREE:

APPENDICES

THE MUMMIFIED HEAD OF TOMB 10A

PAUL H. CHAPMAN AND RAJIV GUPTA

THE ONLY SUBSTANTIAL HUMAN remains found in the plundered tomb of the Djehutynakhts were a naked torso thrown into a corner of the burial chamber and a mummified head that lay on the lid of the nomarch's coffin. Based on morphometric criteria, the excavators determined the torso to be female. They assumed that the head belonged to the nomarch's wife as well.[1] Although it had been violently torn from the neck, the head was still enclosed in its original linen wrappings, which had been carefully molded over the skin to re-create the features of the deceased (fig. 137). The wrappings and skin were deficient over a triangular area at the back of the head and thereby exposed the underlying bone; the bone, however, was undisturbed. The defect in the wrappings undoubtedly occurred well after the mummification process was completed, presumably as a consequence of rough handling or deliberate mutilation. Otherwise, the skin of the entire head, including the face and scalp, was intact.

In 1984 investigators studied the head radiographically using plain X-rays and computerized tomography (CT).[2] Contrary to the assumption of the original excavators, the results led these investigators to suggest that the skull is male. The issue remains unresolved. Those studies revealed destruction of the ethmoid sinuses and part of the sphenoid sinus. The anterior walls of the maxillary sinuses and inferior orbital rims were noted to be defective, and the adjacent zygomas possibly fractured. All of these abnormalities were considered to have occurred when the brain was removed through the ethmoid and sphenoid sinuses using the maxillary sinuses on both sides as routes of access. Such a procedure would have been a unique example of this type of excerebration (brain removal) and contrary to the later common practice of removing the brain through the ethmoid sinuses via the nasal cavity.

More recently, in 2005, Museum curators had the Djehutynakht head reexamined using advanced CT technology (fig. 138).[3] With a spatial resolution of 200 microns or less, the method provided images and three-dimensional reconstructions that shed important new light on the head. Excerebration had indeed been performed through the ethmoid sinuses at the time of mummification, but the route of entry was through the nasal cavity rather than through the maxillary sinuses. This conclusion is based on the absence of the nasal turbinates on the left side, where the ethmoid defect is asymmetrically larger as well. The brain removal had been done by a practiced hand in a fashion similar to that commonly used from the New Kingdom onward, making this example of the procedure one of the earliest known. The skill with which it was done, however, implies a well-established technique, even at this early point. In addition, a second opening had been made in the occipital skull base as another route of entry for removing the brain from the posterior part of the cranial cavity. There is only one other known example of this second procedure; it was performed on a Middle Kingdom female mummy from the pyramid of Amenemhat III at Dahshur.[4] Transnasal excerebration had also been performed in that individual.

In addition to the skeletal changes related to brain removal from the anterior and posterior skull base, the Djehutynakht head exhibited extensive bilateral mutila-

tions of the facial skeleton, which had been carried out in a systematic, highly practiced manner.[5] Previously, investigators in the 1984 study had concluded that the disruption of the maxillary sinuses was done to gain access to the ethmoid sinuses for brain removal. However, the ultrahigh-resolution images from the 2005 study revealed that the bones of the medial walls and roofs of the orbits on both sides were intact, precluding any access to either the ethmoid sinuses or the intracranial cavity from the maxillary sinuses. In fact, removing the anterior walls of the maxillary sinuses was done in conjunction with excising contiguous bones of the facial skeleton and jaw, all of which was unrelated to brain removal. The zygomas had been disrupted bilaterally, the right completely removed, and the left driven posteriorly and medially into the infratemporal fossa. Both zygomatic arches had also been excised. At the base of each zygomatic arch, where it attaches to the temporal bone just anterior to the temporomandibular joint, the articular tubercles of these joints are fragmented, suggesting a direct impact by a sharp instrument. Another remarkable finding was that the coronoid processes of the mandible had been sharply detached and removed bilaterally. The lack of healing of the bone cuts indicates that it was done after death. Similarly, the undisturbed state of the overlying wrappings is compelling evidence that the procedure was carried out before interment (fig. 139).

Because these mutilations of the facial skeleton and jaw have no known parallel in the archaeological record of Egypt, there is no existing body of information to explain how and why they were performed. Regardless, any speculation must account for the fact that they were systematic and deliberate. Their remarkable symmetry alone is evidence that they were intentional. Also, the transection of mandibular bone with a bladed instrument was clearly intended to remove each coronoid process. Immediately behind these structures, irregular fragmentation of the margins of both temporomandibular joints suggests that once the mandibular bone had been cut, the blade was driven farther back along the same axis. In addition, with the exception of

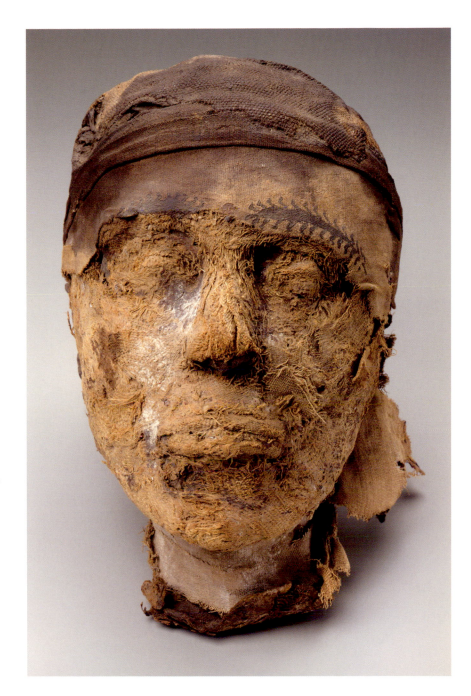

Fig. 137. Head of the Djehutynakht mummy, late Dynasty 11–early Dynasty 12, 2010–1961 B.C.

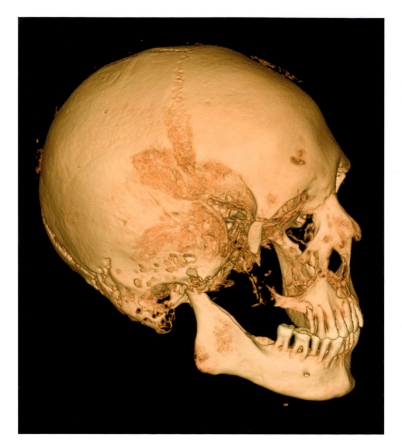

Fig. 138. Computerized tomography (CT) imaging of the Djehutynakht skull. Image courtesy of Rajiv Gupta.

Fig. 139. Model highlighting skeletal structures removed from the Djehutynakht skull. Image courtesy of Paul H. Chapman.

the displaced fragment of the left zygoma, all of the bones had been completely removed on both sides. This remarkable feat was accomplished without disturbing the overlying skin; it remains intact. The relevant skeletal elements could have been reached through the mouth; the first step would have been to remove the anterior wall of the maxillary sinus through an incision behind the upper lip. Such a procedure is a standard surgical approach to the maxillary sinuses in practice today. Once that had been done, the embalmer would have had wide access to the zygomas and zygomatic arches in order to remove them. Finally, a chisel-like instrument could be positioned against the coronoid process in the space behind the last molar and driven posteriorly to detach that structure as well. The instrument might then be advanced as far as the

temporomandibular joint, transecting the remaining muscle and ligament attached to the mandible.

Although one can reasonably infer the method of performing these mutilations, their purpose is quite obscure. From an anatomic perspective, a unifying element is how functionally important these structures are to jaw movement. Specifically, the zygomas, zygomatic arches, and coronoid processes all represent the primary sites of attachment for the large muscles responsible for jaw closure. Their removal would effectively cause the jaw to become slack and mobile. Because the procedure was carried out during preparation of the body for wrapping and burial, it is likely that it related to some aspect of the mortuary ritual, perhaps the important Opening of the Mouth ceremony.

DATING TOMB 10A

LAWRENCE M. BERMAN, DENISE M. DOXEY, AND RITA E. FREED

DESPITE THE IMPORTANCE of tomb 10A, its date has remained uncertain over the many years since its discovery. Dows Dunham, assistant curator in the Department of Egyptian Art at the Museum of Fine Arts, Boston, first brought the Djehutynakhts' tomb to public attention in a short article in 1921. He dated it to "about 2000 B.C." but did not explain why, as the dating of the tomb was not his focus at the time.[1] In 1949 Dunham and William Stevenson Smith jointly authored an article in which they compared the interior of Governor Djehutynakht's outer coffin with paintings in Djehutyhotep's tomb at Deir el-Bersha and Ukhhotep III's tomb at Meir, which are dated to the reign of Senwosret III (1878–1841 B.C.).[2] In subsequent publications, Smith restated the conclusion that the coffin dates from approximately the same period and added the tomb of Wahka II at Qaw el-Kebir from the reign of Amenemhat III (1844–1797 B.C.) as an additional stylistic comparison.[3] Some of the great mid-twentieth-century historians of Egyptian art, including Cyril Aldred, Hans Wolfgang Müller, and Henry George Fischer, agreed, at least in passing remarks, with Smith's dating and rationale.[4] In 1968 Governor Djehutynakht's outer coffin was the main focus of a book by Edward Terrace, who, like Smith, dated the coffin to Senwosret III on the basis of its stylistic similarity to the paintings in the tombs of Djehutyhotep and Ukhotep III.[5] The dating of tomb 10A to the reign of Senwosret III remained unchallenged until 1981, when Edward Brovarski, relying mainly on paleographical evidence, placed it in late Dynasty 11.[6] Since that time, most scholars accept a date between Dynasty 11 and early Dynasty 12 on the basis of both philological and archaeo-logical evidence.[7] With the opportunity provided by the first dedicated exhibition of the material from tomb 10A, the recent conservation work this event has made possible, and the willingness of the current mission to Deir el-Bersha to reopen the tomb, we are now able, finally, to consider the tomb in its entirety.

AN ART HISTORICAL VIEWPOINT

The ancient Egyptians had no word for art and no concept of art for art's sake; an object with no other purpose than to decorate or please the eye had no place in Egyptian thought. Connoisseurship, however, was consistent with the Egyptian way. In a large private tomb that was no doubt created by many artists, the hand of a master is almost always visible in the depiction of the most important subject, the tomb's owner. In the Djehutynakhts' tomb, the two finest objects are the Bersha Procession and Governor Djehutynakht's outer coffin. Although they are not dated, they may be compared with other fine works with known reign dates. In addition, because the depiction of the human figure in Egyptian art progressed—from representations with elongated legs, high waists, and heads that were proportionally too small for their bodies during the First Intermediate Period, to a return to the naturalistic proportions of the Old Kingdom shortly after the reunification of Upper and Lower Egypt and for the duration of Dynasty 12 in the Middle Kingdom—the degree to which sculptures adhere to that canon of proportion may be used as a means of determining their dates.

The figures in the Bersha Procession and those painted on the interior of Governor Djehutynakht's outer cof-

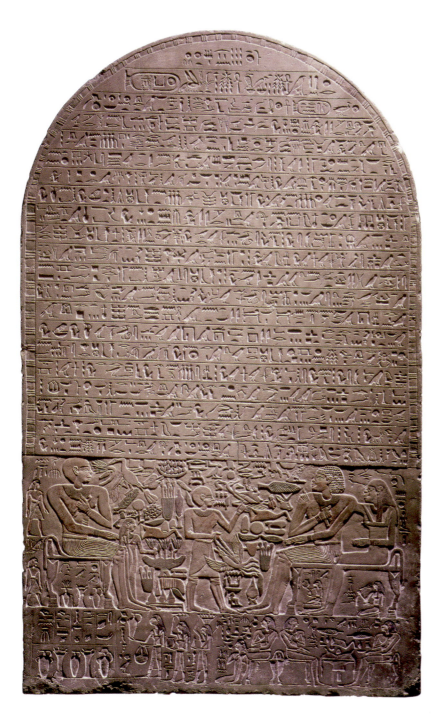

Fig. 140. Stele of Mery,
Dynasty 12, reign of
Senwosret I, 1971–1926 B.C.
Musée du Louvre, Paris, C3.
Photograph Béatrice Hatala /
Réunion des Musées
Nationaux / Art Resource,
New York.

fin, particularly the owner and the priest, display proportions in keeping with the post-reunification style (figs. 70 and 113, pp. 116 and 153). The delicacy, naturalism, and quality of both objects can only be the work of an experienced, highly specialized master artist (or artists). Moreover, the adherence to the later body proportions and the sophisticated execution of carving and painting indicate that Governor Djehutynakht was interred during or after the period in which artists had comfortably mastered the naturalistic style of the Old Kingdom. This period cannot have been any earlier than the final years of Mentuhotep II's reign and is far more likely to have occurred several decades later. We therefore have a *terminus post quem* for the procession and the coffin in the late Eleventh Dynasty.

The outer coffin's interior painting is particularly noteworthy for the artist's skillful rendering of minute details and impressionistic handling of color. The complex and varied patterning of the false door, the precisely outlined feathers and subtle changes of color on the birds, and the use of light and dark shades of the same color to differentiate Governor Djehutynakht's near and far leg are just a few details that highlight the skill of this true master. The overall painterliness of the work, however, is not unique. The use of delicate brushstrokes, the juxtaposition of light and dark hues of the same color to separate different elements, and shading to create depth are also found on the wafer-thin reliefs from the tomb of Meketra in Thebes.[8] Meketra's career began under Mentuhotep II, but he is now believed to have served the state into the early years of Amenemhat I's reign.[9] The delicacy of the painting in Meketra's tomb and its use of varied hues of the same color, which are not attested on stone prior to Dynasty 12, are among the arguments for placing it in the later reign.[10] The similarity of these paintings to those on the coffin from tomb 10A lends support for pushing the date of the Djehutynakhts' tomb into this reign as well.

We can also compare the arrangement and relative scale of the painted offerings on Governor Djehutynakht's outer coffin with offering scenes on stelae and tomb walls that are dated by cartouche to a specific reign (or reigns). On the Djehutynakht coffin, the offerings are carefully organized so that different items are placed close to but

not touching each other, and so little, if any, negative space remains. In the area between the priest and the first vertical column of inscription, for example, the entire space is occupied by food, beverage, flower, or hieroglyph. And whereas the artist paid careful attention to creating naturalistic effects, he showed no concern for relative scale. The leeks atop the offering table are as tall as the governor, and the lotus cluster is as tall as the priest.

Private stelae dated to the reign of Mentuhotep II of Dynasty 11 show either very few offerings or offerings organized on their own individual baselines; therefore they are not comparable with the offering scenes on Governor Djehutynakht's coffin.[11] Little private material survives from the reigns of the next kings, Mentuhotep III and Mentuhotep IV, but a royal example, a relief from a temple at Tod built under Mentuhotep III, shows the king beside a densely packed pile of offerings organized in a tight column (fig. 38, p. 70).[12] Whereas the filling of every available space is similar to the offering scene on Governor Djehutynakht's outer coffin, the material on the Tod relief is arranged in a much more rigid, studied manner. For the closest comparison, we must look to a private stele that bears the cartouches of King Amenemhat I and his son Senwosret I, together with a year date of nine (fig. 140).[13] Its offering scene resembles that of the coffin in both the arrangement of the objects and the disregard for relative proportions. Later in Dynasty 12, offerings depicted on stelae tend to decrease in number and do not fill all the available space.[14] By the time of the reign of Senwosret III, many stelae contain few, if any, offerings. Therefore, based on a comparison with dated private stelae, we can determine that Governor Djehutynakht's outer coffin is most similar to those from the last years of the reign of Amenemhat I, which corresponds to the time of his coregency with Senwosret I.

Offering scenes in a number of private tombs located between Saqqara and Thebes and dated or attributed to the reign of Amenemhat I also compare favorably with that of Governor Djehutynakht's outer coffin. At Saqqara, offerings around the tomb owner in the chapel of Ihy display a similar *horror vacui*, although they are organized in a more deliberate manner.[15] Unfortunately, no paint is pre-

served. At Meir, in the tomb of Senbi, the owner sits beside an offering table and a very densely packed, varied group of offerings, which also fill all the available space.[16] His son Ukhhotep I's tomb at Meir from the time of Senwosret I displays a similar spacing of the offerings, although they are fewer and larger.[17]

Material from a different Deir el-Bersha tomb provides additional, albeit indirect, clues. Tomb 5, belonging to a nomarch named Ahanakht, lies just south of tomb 10A. Reliefs there show two different stylistic trends, one displaying the proportions of the pre-reunification period in Dynasty 11, and the other showing the post-reunification canon adopted from Old Kingdom models and other iconographic aspects that link it to the Memphite area.[18] Based on these features, Ahanakht's tomb can be attributed to late Dynasty 11, when artists trained in the pre-reunification style were still working but others accessed and copied the style and iconography of the Old Kingdom capital.[19] Paint is preserved on a few of the reliefs in Ahanakht's tomb. A goose atop a clump of papyrus plants on the south wall of the outer chamber exhibits the same delicate feathering and skilled blending of hues as the

Fig. 141. Relief of geese on papyrus plants, Deir el-Bersha, tomb 5 (Ahanakht), outer chamber, late Dynasty 11, 2010–1991 B.C. Image courtesy of Katholieke Universiteit Leuven Mission to Dayr al-Barshā.

Fig. 142. Illustration of a
seal amulet and beads on
original cord (late Dynasty
11–early Dynasty 12,
2010–1961 B.C.

geese on Governor Djehutynakht's outer coffin (fig. 141).[20] Ahanakht had a son named Djehutynakht.[21] Although it was a common name at Deir el-Bersha, if the Djehutynakht of tomb 10A was the son of Ahanakht, it is possible that the same artist painted both Ahanakht's tomb and his son's outer coffin.[22] If Ahanakht's tomb was decorated some years following Egypt's reunification, it is unlikely that Djehutynakht's was created later than the reign of Amenemhat I, since that king ruled for thirty years.

The Djehutyhotep paintings display a similar color palette and painterly techniques to the Djehutynakht coffin. However, the Djehutyhotep works lack the delicacy of Djehutynakht's; its figures are wooden, cookie-cutter images of one another, completely lacking in the naturalism and spontaneity of tomb 10A's coffin paintings. At Meir, although subtle shading and the translucency created by selectively placing one paint shade over another certainly occurs in the tomb of Ukhhotep III, it is likewise found earlier, in the tomb of Senbi.[23]

The art historical evidence thereby provides several clues to the dating of Governor Djehutynakht's burial. Based on the proportions of the figures both in the Bersha Procession and on the outer coffin, it cannot have taken place prior to the final years of Mentuhotep II's reign. The number and organization of the offerings on the coffin in the scene beside the tomb owner and the priest most closely resemble those found on private stelae and tombs from the reign of Amenemhat I. The delicacy and skillful manipulation of color seen on both the procession and the outer coffin are also consistent with that date.

— R. E. F.

THE ARCHAEOLOGICAL EVIDENCE

In the absence of written documentation, a tomb's date can often be established by studying archaeological evidence, such as pottery, jewelry, and models. Although the damage caused by ancient grave robbers limits the amount of evidence available from the Djehutynakhts' burial chamber, that which survives furnishes important clues to the date of their deaths. However, because it is likely that the Djehutynakhts accumulated grave goods over a number of years, the archaeological evidence can narrow the tomb's date only to within a generation or less.

Tomb 10A's wide variety of models indicates that its owners lived in the early Middle Kingdom, since models of agriculture and crafts went out of fashion after the middle of Dynasty 12.[24] Model boats continued to be included in tombs long afterward, but in later times they were largely limited to funerary and procession boats. Scholars who have compared the style of the Djehutynakhts' boats with two-dimensional representations on tomb chapel walls have reached conflicting conclusions. Some have argued that the style of the hulls indicates the Djehutynakhts' boats must predate the reunification of Egypt in Dynasty 11,[25] but more recent studies have shown that models featured such hulls after they stopped appearing in tomb scenes, well into Dynasty 12.[26] Likewise, the type of food

models from the Djehutynakhts' tomb cannot yield a precise date. Cartonnage trays of model food have been found in several tombs at Deir el-Bersha ranging in date from Dynasty 11 to the reign of Senwosret III in Dynasty 12.[27] The militaristic nature of model shields, arrows, and weapons reflects a trend most evident during the First Intermediate Period and early Middle Kingdom; the presence of such models in tomb 10A suggests that the Djehutynakhts probably lived before the middle of Dynasty 12.

Most of the Djehutynakhts' jewelry was stolen, and much of what remains is of little value in dating the tomb. A glazed steatite scarab found on its original cord with an assortment of beads is the best extant piece of jewelry from the tomb for dating purposes, but the evidence it provides is inconclusive. The decoration of stylized, intertwined lotus plants emerging from a basket bears a resemblance to the hieroglyphic symbol for "unification" (fig. 142). Such emblems appeared on scarabs in Dynasty 11, but since they continue to be found into the Second Intermediate Period (about 1640–1550 B.C.), in Dynasty 15, the scarab cannot provide a date for the Djehutynakhts.[28]

Pottery furnishes some of the best chronological information from archaeological sites, since unlike precious jewelry it was not usually passed from generation to generation and did not tempt grave robbers. However, the usefulness of early Middle Kingdom pottery for dating purposes is somewhat limited; regional workshops produced such a variety of shapes during the period that scholars find it difficult to establish clear patterns of development. In addition, many sites in the areas of central Egypt near Deir el-Bersha were not scientifically excavated, and findings on the pottery they yielded have never been fully published. Compounding the problem is the fact that the Djehutynakhts' tomb contained little pottery that may be used for comparison in any case. The large storage jars found in a niche at the entrance to the burial chamber provide the strongest archaeological evidence for the tomb's date (figs. 90–91, p. 138). The tall jars, wheel-made of well-fired Nile silt clay, have an elongated oval shape with rounded bottoms and the widest part located approximately halfway up the jar. The necks are short, with fairly wide openings and outwardly rolled rims. The best

parallels for jars with this overall shape and proportions come from very early in the Middle Kingdom, from late Dynasty 11 through the reign of Amenemhat I.[29]

The archaeological evidence from tomb 5 of Ahanahkt may be useful in our efforts to date tomb 10A. Based on the similarity between the coffins and canopic chests in tombs 5 and 10A, it seems likely that Djehutynakht succeeded Ahanakht as governor of the Hare nome. Pottery from Ahanakht's tomb suggests that he was buried in Dynasty 11, sometime after the reunification, and the current excavators of Deir el-Bersha have argued convincingly that he spent a fairly long career in the service of Mentuhotep II (and perhaps his successors) in the early years of the Middle Kingdom.[30] It is therefore reasonable to assume that Ahanakht's successor, quite possibly the Governor Djehutynakht buried in tomb 10A, lived at the very end of Dynasty 11 and into Dynasty 12, and served as nomarch during the reign of Amenemhat I.

— D. M. D.

THE EVIDENCE OF THE COFFINS AND THE INSCRIPTIONS

In 1968 Edward Terrace wrote: "The date of Djehutynekht's tomb is based solely on the style of the paintings of his outer coffin."[31] The picture is different today. If we have learned anything from our study of the material from tomb 10A, it is that we have to look at all of it, and not only at the masterpieces. We cannot privilege one type of evidence over another. We have to consider the coffins and canopic chests (both their decoration and their inscriptions), the models, the pottery, and the other finds as an ensemble. Only then can we attempt to fix the tomb's date.

Unfortunately, the inscriptions on the coffins are not the sort that provides evidence of a date. Biographical information, notable events in Governor Djehutynakht's career, and references to the king under whom he served would have been recorded, if at all, in the tomb chapel, which has not survived. Funerary texts on coffins—offering formulas, edge inscriptions, Coffin Texts, and Pyramid

Texts—are not concerned with such things. We do not even have the names of the parents.

The overall layout and decorative scheme of the Djehutynakhts' coffins, however, do tell us something. Decorated wooden coffins from Middle Kingdom sites are sufficiently numerous, and show enough quantifiable features, to be classified into groups that show a chronological development. This kind of analysis helps us to narrow down the period in which the Djehutynakhts lived. The richly decorated interior of Governor Djehutynakht's outer coffin is of limited use for dating purposes because of its unusual features. The simple pattern of the exterior, which it shares with his inner coffin and the coffins of his wife, provides a wider basis for comparison.

The coffins from tomb 10A comprise a wonderfully complete and self-contained set. As Edward Brovarski first pointed out in 1981, the coffins of Governor and Lady Djehutynakht are typologically among the earliest of the Deir el-Bersha coffins.[32] Harco Willems also places them in his earliest grouping, Group A, which includes the coffin fragments of Satmeket, the coffins of Ahanakht, and the coffin of Kay (brother of Djehutynakht V).[33] Although all of these coffins have common characteristics and are clearly related, none of them can be dated by independent means. Unfortunately, no coffins survive from tomb 2 (the Tomb of the Colossus) of Djehutyhotep II, the only nomarch whose tomb inscriptions preserve the names of the kings he served: Amenemhat II, Senwosret II, and Senwosret III. A number of the coffins of his subordinates, buried in the forecourt of his tomb, have been preserved, however, and working back typologically from them, the earliest of the Deir el-Bersha coffins would come from the end of the Eleventh Dynasty. Anything earlier would leave an uncomfortably large gap in our documentation, which, though not impossible, is improbable, since the material is so abundant.[34] The closest stylistic parallels to the Djehutynakhts' coffins from other Middle Kingdom sites come from Herakleopolis and Thebes; they also appear to be no earlier than the late Eleventh Dynasty.[35]

As Governor Djehutynakht's tomb inscriptions have not survived, we must look elsewhere for evidence indicating the period in which he lived. Fortunately, we do not have to look far. The governors of the Hare nome regularly left inscriptions at the travertine quarries at Hatnub when they went there to quarry stone, and these sometimes refer to contemporary political events. Interest focuses on the inscriptions of Nehri I, which mention a battle at a place called Shedyetsha (present location unknown). Other inscriptions at Hatnub also speak of or allude to trouble in the land. One speaks mysteriously of "the terror of the king's house." Although an earlier generation of Egyptologists dated these events to about 2040 B.C., when Mentuhotep II was striving to unite Upper and Lower Egypt, current scholarship increasingly favors a date of about 2000 B.C., during the transition from Dynasty 11 to Dynasty 12. There is reason to believe that Amenemhat I's rise to power was opposed.[36] Djehutynakht enters here. Nehri I had a son called Djehutynakht who was also a nomarch. If our governor Djehutynakht was Djehutynakht V, the son of Nehri, he would have been in office at the end of the reign of Amenemhat I. A predecessor of Nehri was Ahanakht, who was in office in the last decades of the Eleventh Dynasty. Brovarski, Willems, and Denise Doxey have all observed a close resemblance between the coffins of Ahanakht and Governor Djehutynakht.[37] Ahanakht also had a son called Djehutynakht. If our governor Djehutynakht was Djehutynakht IV, the son of Ahanakht, he would have been in office at the very end of the Eleventh Dynasty and quite possibly into the beginning of Amenemhat I's reign.[38] The Deir el-Bersha coffins span the period between the end of the Eleventh Dynasty and the middle of the Twelfth. The coffins from tomb 10A are among the earliest. Governor Djehutynakht of tomb 10A was either the fourth or the fifth nomarch of that name. If the former, as now seems most likely, he would have been a contemporary of Meketra.

— L. M. B.

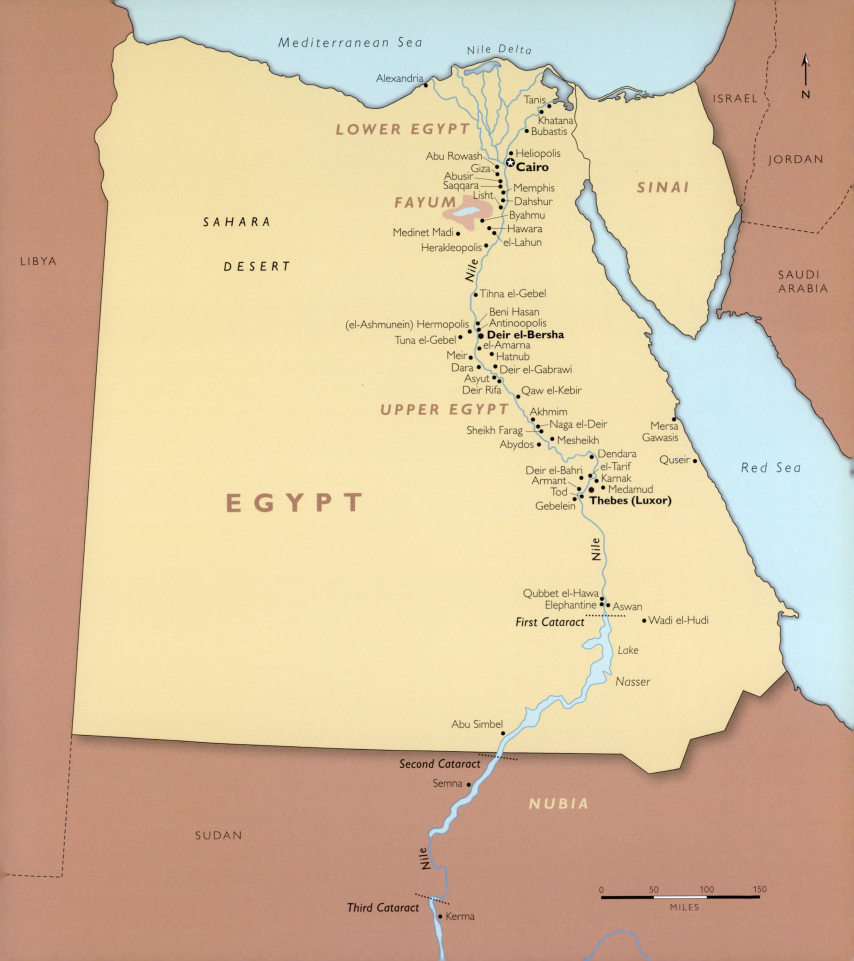

Mediterranean Sea

Nile Delta

ISRAEL

JORDAN

Alexandria

Tanis

Khatana
Bubastis

LOWER EGYPT

SINAI

Abu Rowash
Heliopolis
Giza
★ **Cairo**

Abusir
Saqqara
Memphis
Lisht
Dahshur

FAYUM

Byahmu

SAHARA

Medinet Madi

Hawara
el-Lahun

Herakleopolis

DESERT

Nile

Tihna el-Gebel

Beni Hasan
(el-Ashmunein) Hermopolis
Antinoopolis
Deir el-Bersha
Tuna el-Gebel
el-Amarna
Meir
Hatnub
Dara
Deir el-Gabrawi
Asyut
Deir Rifa
Qaw el-Kebir

UPPER EGYPT

Akhmim
Naga el-Deir
Sheikh Farag
Mesheikh
Abydos

Mersa
Gawasis

Quseir

Red Sea

Dendara
el-Tarif
Deir el-Bahri
Karnak
Armant
Medamud
Tod
Thebes (Luxor)
Gebelein

EGYPT

SAUDI
ARABIA

LIBYA

Nile

Qubbet el-Hawa
Elephantine
Aswan
First Cataract
Wadi el-Hudi

Lake

Nasser

Abu Simbel

Second Cataract

Semna

NUBIA

SUDAN

Nile

Third Cataract
Kerma

N

0 50 100 150
MILES

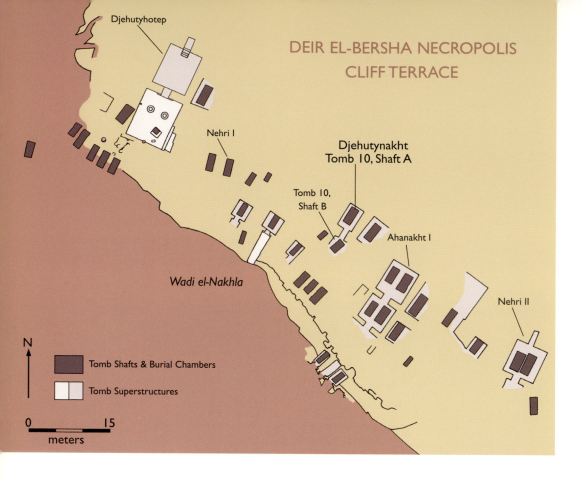

Fig. 144. Plan of the elite cliff terrace, Deir el-Bersha necropolis. Plan courtesy of Katholieke Universiteit Leuven Mission to Dayr al-Barshā.

DEIR EL-BERSHA NECROPOLIS CLIFF TERRACE

Djehutyhotep

Nehri I

Djehutynakht Tomb 10, Shaft A

Tomb 10, Shaft B

Ahanakht I

Nehri II

Wadi el-Nakhla

N

■ Tomb Shafts & Burial Chambers

□ Tomb Superstructures

0 15
meters

Fig. 145. Schematic plan of Deir el-Bersha tomb 10A, adapted by Jennifer Marsh from the Museum of Fine Arts, Boston, Department of Art of the Ancient World files and Edward L. B. Terrace, *Egyptian Paintings of the Middle Kingdom*, 13. Colorized by Nicholas S. Picardo.

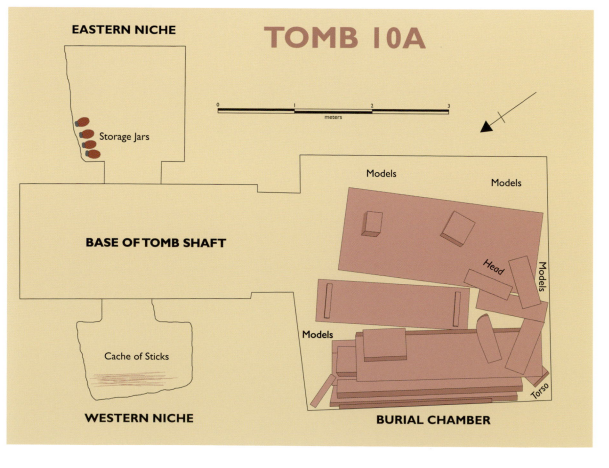

EASTERN NICHE

TOMB 10A

0 1 2 3
meters

Storage Jars

Models

Models

BASE OF TOMB SHAFT

Head

Models

Models

Cache of Sticks

Torso

WESTERN NICHE

BURIAL CHAMBER

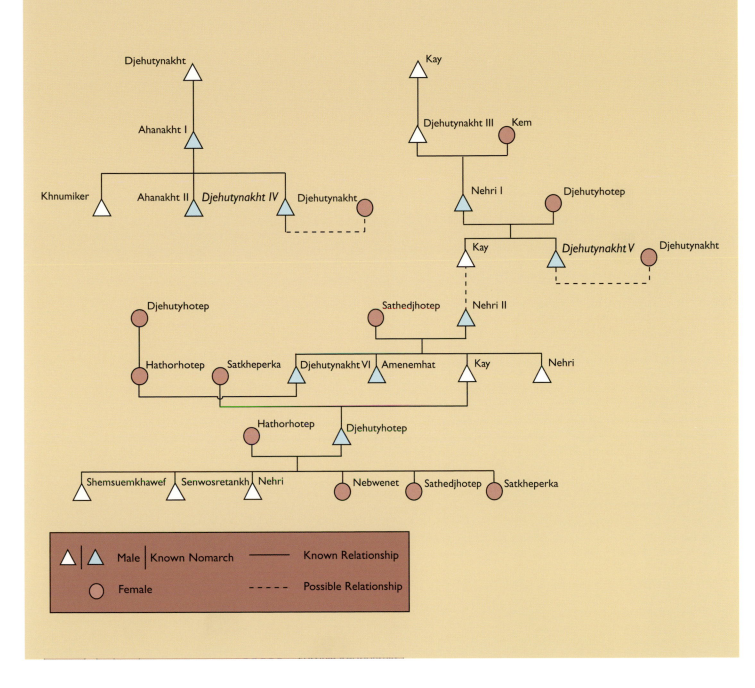

Fig. 146. Genealogical chart of the Middle Kingdom nomarchs of Deir el-Bersha, adapted by Nicholas S. Picardo from Harco Willems, *Chests of Life*, 71.

NOTES

MIDDLE KINGDOM HISTORY, POLITICS, AND SOCIAL ORGANIZATION

1. For details relating to the following historical overview, see Gae Callender, "The Middle Kingdom Renaissance (c. 2055–1650 BC)," in *The Oxford History of Ancient Egypt*, ed. Ian Shaw (Oxford: Oxford University Press, 2000), 148–83; Wolfram Grajetzki, *The Middle Kingdom of Ancient Egypt* (London: Duckworth, 2006); Detlef Franke, "The Middle Kingdom in Egypt," in *Civilizations of the Ancient Near East*, ed. Jack M. Sasson (New York: Simon and Schuster; Macmillan, 1995), 735–47; Stephan Seidlmayer, "The First Intermediate Period," in *The Oxford History of Ancient Egypt*, ed. Ian Shaw (Oxford: Oxford University Press, 2000), 118–47. Grajetzki's treatment is notable for its enumeration of specific source material that provides the basis of Middle Kingdom historiography.

2. Barbara Bell, "The Dark Ages in Ancient History I: The First Dark Age in Egypt," *American Journal of Archaeology* 75 (1971): 1–7, 19–24. The literary, possibly revisionist nature of much evidence for a prolonged famine in the late Old Kingdom/First Intermediate Period may result in an exaggerated picture for ideological reasons.

3. See Juan Carlos Moreno Garcia, *Études sur l'administration, le pouvoir et l'idéologie en Égypte, de l'Ancien au Moyen Empire*, Ægyptiaca Leodiensia (Liège: C.I.P.L., 1997), especially 25–85.

4. Currently there is no fully accepted opinion as to whether Dynasties 7–8 more accurately comprise the late Old Kingdom or the early First Intermediate Period. The former opinion is preferred here, since the location of the capital did not change.

5. Mark Lehner, *The Complete Pyramids* (London: Thames and Hudson, 1997), 164.

6. Eva Martin-Pardey, *Untersuchungen zur Ägyptischen Provinzialverwaltung bis zum Ende des Alten Reiches*, Hildesheimer Ägyptologische Beiträge 1 (Hildesheim: Gebrüder Gerstenberg, 1976), 16–18.

7. Examples are in Miriam Lichtheim's *Ancient Egyptian Autobiographies Chiefly of the Middle Kingdom: A Study and an Anthology*, Orbis Biblicus et Orientalis 84 (Freiburg: Universitätsverlag/ Vandenhoeck & Ruprecht, 1988), 21–29.

8. Stephan J. Seidlmayer, "The Relative Chronology of the First Intermediate Period," in *Ancient Egyptian Chronology*, ed. Erik Hornung, Rolf Krauss, and David Warburton (Leiden: Brill, 2006), 164.

9. Arguments for the former attribution are those of Jaromir Malek, "King Merykare and His Pyramid," in *Hommages á Jean Leclant*, vol. 4, *Varia*, Bibliothéque d'Étude 106 (Cairo: Institut Français d'Archéologie Orientale, 1994), 203–14. The latter work currently awaits scholarly publication and review, but the proposition is not new. See Jocelyn Berlandini, "La Pyramide 'Reunée' de Sakkara-Nord et le roi Ikaouhor-Mankaouhor," *Revue d'Égyptologie* 31 (1979): 3–28.

10. Khui may have gone so far as to call himself king. See Ahmed Bey Kamal, "Fouilles á Dara et á Qoçéîr el-Amarna," *Annales du Service des Antiquités de l'Égypte* 12 (1912): 128–33. The building's status as a pyramid and its attribution to Khui are subject to disagreement. See Lehner, *Complete Pyramids*, 164–65; Seidlmayer, "First Intermediate Period," 143–44.

11. For the titulary and activities of Nebhepetra Mentuhotep II, see Labib Habachi, "King Nebhepetre Mentuhotp: His Monuments, Place in History, Deification and Unusual Representations in the Form of Gods," *Mitteilungen des Deutsches Archäologisches Institut Abteilung Kairo* 19 (1963): 16–52; Dieter Arnold, "Zur frühen Namensformen des Königs Mntw-ḥtp Nb-ḥpt-Rˁ," *Mitteilungen des Deutsches Archäologisches Institut Abteilung Kairo* 24 (1969): 38–42; Jürgen von Beckerath, *Handbuch der ägyptischen Königsnamen*, Münchner Ägyptologische Studien 49 (Mainz: Philipp von Zabern, 1999), 78–79.

12. Herbert E. Winlock, *The Slain Soldiers of Neb-ḥepet-rē Mentu-ḥotpe*, Publications of the Metropolitan Museum of Art Egyptian Expedition 16 (New York: Metropolitan Museum of Art,

1945), 1–24, plates 1–3, 6–10. For a recent challenge to this interpretation of the tomb, see Carola Vogel, "Fallen Heroes?—Winlock's 'Slain Soldiers' Reconsidered," *Journal of Egyptian Archaeology* 89 (2003): 239–45.

13. Miriam Lichtheim, *Ancient Egyptian Literature*, vol. 1, *The Old and Middle Kingdoms* (Berkeley: University of California Press, 1975), 113–15.

14. Details of Amenemhat's early history are discussed by Dorothea Arnold in "Amenemhat I and the Early Twelfth Dynasty at Thebes," *Metropolitan Museum Journal* 26 (1991): 5–16.

15. Felix Arnold, "Settlement Remains at Lisht-North," in *House and Palace in Ancient Egypt*, ed. Manfred Bietak (Vienna: Österreichischen Akademie der Wissenschaften, 1996), 13–21.

16. William Kelly Simpson, ed., *The Literature of Ancient Egypt: An Anthology of Stories, Instructions, Stelae, Autobiographies, and Poetry* (New Haven: Yale University Press, 2003), 168–69.

17. For the *Story of Sinuhe*, see ibid., 54–66, especially 55–56.

18. Ibid., 169.

19. The father-son relationship between Amenemhat II and Senwosret II is hypothetical. For the full genealogy of Dynasty 12, see Aidan Dodson and Dyan Hilton, *The Complete Royal Families of Ancient Egypt* (London: Thames and Hudson, 2004), 92–99. The practice of coregency in the Middle Kingdom is still not accepted by all for every possible instance. Stephen Quirke advances the proposition that the smooth succession of Dynasty 12 may be more of an anomaly in Egyptian history than a rule. See Stephen Quirke, *The Administration of Egypt in the Late Middle Kingdom* (New Malden, Surrey: SIA Publishing, 1990), 138.

20. Dietrich Wildung, "Looking Back into the Future: The Middle Kingdom as a Bridge to the Past," in *"Never Had the Like Occurred": Egypt's View of Its Past*, ed. John Tait, Encounters with Ancient Egypt (London: UCL Press, 2003), 62–65.

21. Dieter Arnold, "Hypostyle Halls of the Old and Middle Kingdom?" in *Studies in Honor of William Kelly Simpson*, vol. 1, ed. Peter Der Manuelian (Boston: Museum of Fine Arts, 1996), 39–54.

22. Seidlmayer, "First Intermediate Period," 132.

23. Pierre Lacau and Henri Chevrier, *Une chapelle de Sésostris Ier à Karnak* (Cairo: Institut Français d'Archéologie Orientale, 1956), 26–134, plates 2–3, 12–41.

24. Ibid., 220–35, plates 3, 42.

25. Ibid., 21–28.

26. See James P. Allen, "The High Officials of the Early Middle Kingdom," in *The Theban Necropolis: Past, Present and Future*, ed. Nigel Strudwick and John H. Taylor (London: British Museum, 2003), 14–29, especially the conclusions in 25–26, 29. Harco Willems, *Dayr al-Barshā I: The Rock Tombs of Djehutinakht (No. 17K74/1), Khnumnakht (No. 17K74/2), and Iha (No. 17K74/3)*, Orientalia Lovaniensia Analecta 155 (Leuven: Peeters, 2007), 100–109.

27. For a discussion of these and others, including Akhmim, Tihna el-Gebel, and Kom el-Khalwa (Fayum), see Harco Willems, *Les textes des sarcophages et la démocratie: Éléments d'une histoire culturelle du Moyen Empire Égyptien; Quatre conférences présentées à l'École Pratique des Hautes Études, Section des Sciences Religieuses, Mai 2006* (Paris: Cybèle, 2008), 52–54.

28. For a genealogy of Deir el-Bersha's governing family line, see Harco Willems, *Chests of Life: A Study of the Typology and Conceptual Development of Middle Kingdom Standard Class Coffins*, Mededelingen en Verhandelingen van het Vooraziatisch-Egyptisch Genootschap "Ex Oriente Lux" 25 (Leiden: Ex Oriente Lux, 1988), 71.

29. Allen, "High Officials of the Early Middle Kingdom," 21–26; Willems, *Dayr al-Barshā I*, 100–109.

30. For a discussion of the primary Djehutynakhts of Deir el-Bersha and their numbering conventions,
see Marleen De Meyer, "Old Kingdom Rock Tombs at Dayr al-Barshā: Archaeological and Textual Evidence of Their Use and Reuse in Zones 4 and 7" (PhD diss., Katholieke Unversiteit Leuven, 2008), 1:100–110.

31. Rudolf Anthes, *Die Felseninschriften von Hatnub*, Untersuchungen zur Geschichte und Altertumskunde Ägyptens 9 (Leipzig: J. C. Hinrichs, 1928), 67, 72–73, graffiti 31 and 42.

32. Ibid., 91–96; Harco Willems, "The Nomarchs of the Hare Nome and Early Middle Kingdom History," *Jaarbericht Ex Oriente Lux* 28 (1983–1984), 95–101.

33. Compare the dating positions of Edward Brovarski, "Tomb Owners," in Sue D'Auria, Peter Lacovara, and Catharine H. Roehrig, eds., *Mummies and Magic: An Introduction to Egyptian Funerary Beliefs* (Boston: Museum of Fine Arts, 1988), 109–110; Brovarski, "Ahanakht of Bersheh and the Hare Nome in the First Intermediate Period and Middle Kingdom," in *Studies in Ancient Egypt, the Aegean, and the Sudan: Essays in Honor of Dows Dunham on the Occasion of His 90th Birthday, June 1, 1980*, ed. William Kelly Simpson and Whitney M. Davis (Boston: Museum of Fine Arts, 1981), 22–30; Willems, "Nomarchs of the Hare Nome," 80–102; Willems, *Dayr al-Barshā I*, 84–88.

34. Brovarski in "Ahanakht of Bersheh," 23, suggests that the consistent omission might derive from concerns for space or from superstition.

35. Stephen Quirke, *Titles and Bureaux of Egypt, 1850–1700 B.C.*, Egyptology 1 (London: Golden House Publications, 2004), 111–12.

36. Brovarski, "Tomb Owners," 110; Valérie Selve, "Les fonctions religieuses des nomarques au Moyen Empire," *Cahiers de Recherches de l'Institut de Papyrologie et Égyptologie de Lille* 15 (1993): 73–80.

37. Percy E. Newberry, *Beni Hasan*, part 1, Archaeological Survey of Egypt Memoir 1 (London: Egypt Exploration Fund, 1893); Newberry, *Beni Hasan*, part 2, Archaeological Survey of Egypt Memoir 2 (London: Egypt
Exploration Fund, 1894); Newberry, *El Bersheh*, part 1, *The Tomb of Tehuti-Hetep*, Archaeological Survey of Egypt Memoir 3 (London: Egypt Exploration Fund, 1895); F. L. Griffith and Percy E. Newberry, *El Bersheh*, part 2, Archaeological Survey of Egypt Memoir 4 (London: Egypt Exploration Fund, 1896).

38. For a variety of these scenes in a single, well-preserved tomb, discussed individually, see Janice Kamrin, *The Cosmos of Khnumhotep II at Beni Hasan*, Studies in Egyptology (London: Kegan Paul International, 1999), 53–137.

39. For the complete translation, see Simpson, *Literature of Ancient Egypt*, 431–37. See also Stephen Quirke, "'Townsmen'" in the Middle Kingdom: On the Term s n niwt tn in the Lahun Temple Accounts," *Zeitschrift für Ägyptische Sprache und Altertumskunde* 118 (1991): 147–49.

40. Anthes, *Die Felseninschriften von Hatnub*, 67; Brovarski, "Ahanakht of Bersheh," 22 and n. 24; Detlef Franke, "The Career of Khnumhotep III of Beni Hasan and the So-Called 'Decline of the Nomarchs,'" in *Middle Kingdom Studies*, ed. Stephen Quirke (New Malden, Surrey: SIA Publishing, 1991), 54–55.

41. For this process, see Jorgen Pødemann Sørensen, "Divine Access: The So-Called Democratization of Egyptian Funerary Literature as a Socio-Cultural Process," in *The Religion of the Ancient Egyptians: Cognitive Structures and Popular Expressions; Proceedings of Symposia in Uppsala and Bergen 1987 and 1988*, ed. Gertie Englund, Uppsala Studies in Ancient Mediterranean and Near Eastern Civilizations 20 (Uppsala: University of Uppsala, 1989), especially 110–14.

42. Flinders Petrie, *Antaeopolis: The Tombs of Qau* (London: British School of Archaelogy, 1930), 1–7, plates 3, 6, 14; Hans Steckeweh, *Die Fürstengräber von Qâw*, Veröffentlichungen der Ernst von Sieglin-Expedition in Ägypten 6 (Leipzig: J. C. Hinrichs'sche Buchhandlung, 1936), 10–44, noting especially the discussion on 43–44.

43. For detailed explanations of this system, see Christopher J. Eyre, "Feudal Tenure and Absentee Landlords," in *Grund und Boden in Altägypten (Rechtliche und Socio-Öknomische Verhältnisse)*, ed. Schafik Allam, Untersuchungen zum Rechtsleben in Alten Ägypten 2 (Tübingen: Selbstverlag des Herausgebers, 1994), 107–14; Eyre, "Peasants and 'Modern' Leasing Strategies in Ancient Egypt," *Journal of Social and Economic History of the Orient* 40, no. 4 (1997): 381–86; Mark Lehner, "The Fractal House of Pharaoh: Ancient Egypt as a Complex Adaptive System, a Trial Formulation," in *Dynamics in Human and Primate Societies: Agent-Based Modeling of Social and Spatial Processes*, ed. T. A. Kohler and G. J. Gumerman (New York: Oxford University Press, 2000), 315–18.

44. See George A. Reisner, "The Tomb of Hepzefa, Nomarch of Siût," *Journal of Egyptian Archaeology* 5 (1918): 81–82. The translation here comes from James P. Allen, *The Heqanakht Papyri*, Metropolitan Museum of Art Egyptian Expedition 27 (New York: Metropolitan Museum of Art, 2002), 106.

45. For a thorough discussion of Djefaihapi's contracts and their value, see Anthony J. Spalinger, "A Redistributive Pattern at Assiut," *Journal of the American Oriental Society* 105 (1985): 7–19.

46. Allen, *Heqanakht Papyri*, 121–33.

47. Ibid., 16–17.

48. Ibid., especially 107–17.

49. Rolf Gundlach, "Wadi Hammamat," *Lexikon der Ägyptologie*, vol. 6 (Wiesbaden: Otto Harrassowitz, 1986): 1106.

50. For a survey of quarrying and mining sites and practices, see Ian Shaw, "Pharaonic Quarrying and Mining: Settlement and Procurement in Egypt's Marginal Regions," *Antiquity* 68 (1994): 108–18.

51. For further details on the fortress system, see Ann L. Foster, "Forts and Garrisons," in *The Oxford Encyclopedia of Ancient Egypt*, ed. Donald B. Redford (Oxford: Oxford University Press, 2001); Barry J. Kemp, *Ancient Egypt: Anatomy of a Civilization* (New York: Routledge, 1989), 166–78; Bruce B. Williams, "Nubian Forts," in *Encyclopedia of the Archaeology of Ancient Egypt*, ed. Kathryn A. Bard (London: Routledge, 1999), 574–79.

52. Lichtheim, *Ancient Egyptian Literature* 1:119.

53. Paul C. Smither, "The Semnah Despatches," *Journal of Egyptian Archaeology* 32 (1945): 3–10.

54. Guillemette Andreu, Marie-Hélène Rutschowscaya, and Christiane Ziegler, *Ancient Egypt at the Louvre*, trans. Lisa Davidson (Paris: Hachette, 1997), 91–92; Geneviève Pierrat-Bonnefois, "The Tôd Treasure" in *Beyond Babylon:*

Art, Trade, and Diplomacy in the Second Millennium B.C., ed. Joan Aruz, Kim Benzel, and Jean M. Evans (New York: Metropolitan Museum of Art, 2008), 65–67.

55. Hartwig Altenmüller and Ahmed M. Moussa, "Die Inschrift Amenemhets II. aus Dem Ptah-Tempel von Memphis: Ein Vorbericht," *Studien zur Altägyptischen Kultur* 18 (1991): 1–48; Donald B. Redford, *Egypt, Canaan, and Israel in Ancient Times* (Princeton: Princeton University Press, 1992), 78–80; Jaromir Malek and Stephen Quirke, "Memphis, 1991: Epigraphy," *Journal of Egyptian Archaeology* 78 (1992): 13–18.

56. For a discussion of this scene and a summary of interpretations, with references, see Kamrin, *Cosmos of Khnumhotep II at Beni Hasan*, 93–96; and more recently in broader context, Silvia Rabehl, "Eine Gruppe von Asiaten im Grab Chnumhoteps II. (BH 3): Tradierung eines Bildmotivs in den Felsgräbern des Mittleren Reiches von Beni Hassan," *Imago Aegypti* 1 (2005): 86–95.

57. The development of Egyptian and Syro-Palestinian relations during the Middle Kingdom is summarized by Manfred Bietak in *Avaris, the Capital of the Hyksos: Recent Excavations at Tell El-Dab'a* (London: British Museum Press, 1996); Redford, *Egypt, Canaan, and Israel in Ancient Times*, 71–97.

58. Kathryn A. Bard and Rodolfo Fattovich, eds., *Harbor of the Pharaohs to the Land of Punt: Archaeological Investigations at Mersa/Wadi Gawasis, Egypt, 2001–2005* (Naples: Università degli Studi di Napoli "l'Orientale," 2007), 130–31, 250–51.

59. Ronald J. Leprohon, "Administrative Titles in Nubia in the Middle Kingdom," *Journal of the American Oriental Society* 113 (1993): 423–35.

60. For detailed discussions of the new system, compare the treatment of source material by William C. Hayes, "Notes on the Government of Egypt in the Late Middle Kingdom," *Journal of Near Eastern Studies* 12 (1953): 31–39; Hayes, *A Papyrus of the Late Middle Kingdom in the Brooklyn Museum [Papyrus Brooklyn 35.1446]* (New York: Brooklyn Museum, 1972 [1955]); Quirke, *Administration of Egypt in the Late Middle Kingdom*; Quirke, *Titles and Bureaux of Egypt*.

61. Quirke, *Administration of Egypt in the Late Middle Kingdom*, 54; Ronald J. Leprohon, "Royal Ideology and State Administration in Pharaonic Egypt," in *Civilizations of the Ancient Near East* (New York: Scribner, 1995), 282–83; Hayes, "Notes on the Government of Egypt in the Late Middle Kingdom," 31–33.

62. See David B. O'Connor, "The 'Cenotaphs' of the Middle Kingdom at Abydos," in *Mélanges*

Gamal Eddin Mokhtar, ed. Paule Posener-Kriéger, vol. 2, Bibliothéque d'Étude 97 (Cairo: Institut Français d'Archéologie Orientale, 1985), 161–77; William Kelly Simpson, *The Terrace of the Great God at Abydos: The Offering Chapels of Dynasties 12 and 13*, Publications of the Pennsylvania-Yale Expedition to Egypt 5 (New Haven: Peabody Museum of Natural History of Yale University and University Museum of the University of Pennsylvania, 1974), 2–14.

63. Anthony Leahy, "A Protective Measure at Abydos," *Journal of Egyptian Archaeology* 75 (1989): 41–60.

64. Quirke, "'Townsmen' in the Middle Kingdom," 141–49.

65. See Janet Richards, *Society and Death in Ancient Egypt: Mortuary Landscapes of the Middle Kingdom* (Cambridge: Cambridge University Press, 2005), passim, but especially the concluding summary in 176–80.

66. Eugene Cruz-Uribe, "The Fall of the Middle Kingdom," *Varia Aegyptiaca* 3 (1987): 111.

67. Ibid.; Franke, "Career of Khnumhotep III," 52–55.

68. Leprohon, "Royal Ideology and State Administration in Pharaonic Egypt," 282.

69. For a complete discussion of Khnumhotep III and the "decline" of the nomarchs as described here, see Franke, "Career of Khnumhotep III," 56–65.

70. Kemp, *Anatomy of a Civilization*, 149–67.

71. See the discussions of Charles C. van Siclen III, "The Mayors of Basta in the Middle Kingdom," in *Akten des Vierten Internationalen Ägyptologen Kongresses, München 1985*, vol. 4, *Studien zur Altägyptishen Kultur Beihefte* (Hamburg: Helmut Buske, 1988), 187–94; Josef Wegner, "Excavations at the Town of 'Enduring-Is-the-Throne-of-Khakaure-Maa-Kheru-in-Abydos': A Preliminary Report on the 1994 and 1997 Seasons," *Journal of the American Research Center in Egypt* 35 (1998): 21–26; Charles C. van Siclen III, "Remarks on the Middle Kingdom Palace at Tell Basta," in *House and Palace in Ancient Egypt*, ed. Manfred Bietak (Vienna: Österreichischen Akademie der Wissenschaften, 1996), 239–46; Josef Wegner, "Echoes of Power: The Mayor's House of Ancient *Wah-Sut*," *Expedition* 48, no. 2 (2006): 31–36.

72. For a comparison of the two primary chronologies and relevant references, see Thomas Schneider, "The Relative Chronology of the Middle Kingdom and the Hyksos Period (Dyns. 12–17)," in *Ancient Egyptian Chronology*, ed. Erik Hornung,

Rolf Krauss, and David Warburton (Leiden: Brill, 2006), 175–81.

73. Stephen Quirke, "Royal Power in the 13th Dynasty," in *Middle Kingdom Studies*, ed. Stephen Quirke (New Malden, Surrey: SIA Publishing, 1991), 123–26, 129–39.

74. Lehner, *Complete Pyramids*, 184–87.

75. For a survey of royal monuments and trends that suggest what is missing from the record, see Dawn McCormack, "The Significance of Royal Funerary Architecture in the Study of Thirteenth Dynasty Kingship," in *The Second Intermediate Period (13th–17th Dynasties), Current Research, Future Prospects*, ed. W. V. Davies (London: British Museum Press, forthcoming).

76. For a recent overview of the Hyksos, their origins, and the Second Intermediate Period, see Eliezer Oren, ed., *The Hyksos: New Historical and Archaeological Perspectives* (Philadelphia: University of Pennsylvania Press, 1997).

77. Franke, "Career of Khnumhotep III," 55.

FUNERARY BELIEFS AND PRACTICES IN THE MIDDLE KINGDOM

1. For a full translation and additional discussion of the texts, see Raymond O. Faulkner, *The Ancient Egyptian Pyramid Texts* (Oxford: Clarendon Press, 1969).

2. Werner Forman and Stephen Quirke, *Hieroglyphs and the Afterlife in Ancient Egypt* (Norman: University of Oklahoma Press, 1996), 111–35.

3. Dorothea Arnold, "Amenemhat I and the Early Twelfth Dynasty at Thebes," *Metropolitan Museum Journal* 26 (1991): 5–48.

4. Mark Lehner, in *The Complete Pyramids* (London: Thames and Hudson, 1997), 169–87, provides an overview of the development of Dynasty 12 royal pyramids, from which much of the following discussion is adapted.

5. Dieter Arnold, *The Pyramid of Senwosret I* (New York: Metropolitan Museum of Art Egyptian Expedition, 1988).

6. Lehner, *Complete Pyramids*, 176.

7. Metropolitan Museum of Art, *The Metropolitan Museum of Art: Egypt and the Ancient Near East* (New York: Metropolitan Museum of Art, 1987), 38–41.

8. Dieter Arnold, *The Pyramid Complex of Senwosret III at Dahshur: Architectural Studies* (New York: Metropolitan Museum of Art Egyptian Expedition, 2002).

9. Josef Wegner, *The Mortuary Temple of Senwosret III at Abydos* (New Haven: Yale Egyptological Seminar, 2007).

10. Dieter Arnold, *Der Pyramidenbezirk des Königs Amenemhet III. in Dahschur* (Mainz: Philipp von Zabern, 1987).

11. Inge Uytterhoeven and Ingrid Blom-Böer, "New Light on the Egyptian Labyrinth: Evidence from a Survey at Hawara," *Journal of Egyptian Archaeology* 88 (2002): 111–20.

12. Dieter Arnold, "Middle Kingdom Mastabas at Dahshur," *Egyptian Archaeology* 21 (2002): 38–40.

13. Guillemette Andreu, Marie-Hélène Rutschowscaya, and Christiane Ziegler, *Ancient Egypt at the Louvre*, trans. Lisa Davidson (Paris: Hachette, 1997), 74–75.

14. Edna Russman, *Eternal Egypt: Masterworks of Ancient Art from the British Museum* (Berkeley: University of California Press, 2001), 94.

15. Ronald J. Leprohon, *Stelae I: The Early Dynastic Period to the Late Middle Kingdom*, vol. 2 of *Corpus Antiquitatum Aegyptiacarum, Museum of Fine Arts, Boston* (Mainz: Philipp von Zabern, 1985), 175–78.

16. Ibid., 18–20.

17. Ibid., 86–89.

18. A. Tooley, "Middle Kingdom Burial Customs: A Study of Wooden Models and Related Material" (PhD diss., University of Liverpool, 1989), 369.

19. Ibid., 49–50.

20. Salima Ikram and Aidan Dodson, *The Mummy in Ancient Egypt: Equipping the Dead for Eternity* (London: Thames and Hudson, 1998), 156.

21. Sue D'Auria, Peter Lacovara, and Catharine H. Roehrig, eds., *Mummies and Magic: The Funerary Arts of Ancient Egypt* (Boston: Museum of Fine Arts, 1988), 117–18.

22. Ikram and Dodson, *Mummy in Ancient Egypt*, 167–69; D'Auria, Lacovara, and Roehrig *Mummies and Magic*, 119.

23. Janine Bourriau, "Patterns of Change in Burial Customs during the Middle Kingdom," in *Middle Kingdom Studies*, ed. Stephen Quirke (New Malden, Surrey: SIA Publishing, 1991), 3–20.

24. Tooley "Middle Kingdom Burial Customs"; Bourriau, "Patterns of Change."

25. Harco Willems discusses these changes in detail in *Chests of Life: A Study of the Typology and Conceptual Development of Middle Kingdom Standard Class Coffins* (Leiden: Ex Oriente Lux, 1988), 22–23.

26. Bourriau, "Patterns of Change," 11–16.

27. D'Auria, Lacovara, and Roehrig, *Mummies and Magic*, 127–28.

28. Andreu, Rutschowscaya, and Ziegler, *Ancient Egypt at the Louvre*, 88–90.

29. William Kelly Simpson, *The Terrace of the Great God at Abydos: The Offering Chapels of Dynasties 12 and 13* (New Haven: Peabody Museum of Natural History of Yale University and University Museum of the University of Pennsylvania, 1974), 6–13; Denise Doxey, *Egyptian Nonroyal Epithets in the Middle Kingdom: A Social and Historical Analysis* (Leiden: Brill, 1998), 15–16.

30. Simpson, *Terrace of the Great God at Abydos*, 17, plates 11–13; Miriam Lichtheim, *Ancient Egyptian Autobiographies Chiefly of the Middle Kingdom: A Study and an Anthology*, vol. 1 (Freiburg: Universitätsverlag Freiburg Schweiz and Vandehoeck and Ruprecht, 1998), 106–11.

31. Doxey, *Egyptian Nonroyal Epithets in the Middle Kingdom*, 5.

32. Ronald J. Leprohon, "The Personnel of the Middle Kingdom Funerary Stelae," *Journal of the American Research Center in Egypt* 15 (1978): 33–38.

33. William Kelly Simpson, *Inscribed Material from the Pennsylvania-Yale Excavations at Abydos* (New Haven: Peabody Museum of Natural History of Yale University and University of Pennsylvania Museum of Archaeology and Anthropology, 1995), 33–55.

ART OF THE MIDDLE KINGDOM

1. Gae Callender, "Middle Kingdom Renaissance," in *Oxford History of Ancient Egypt*, ed. Ian Shaw (Oxford: Oxford University, 2000), 152. For an illustration of the relief fragment (Brooklyn 54.49), see Richard Fazzini, Robert Bianchi, James Romano, and Donald Spanel, *Ancient Egyptian Art in the Brooklyn Museum* (New York: Thames and Hudson, 1989), 17.

2. For a detailed overview of the canon of proportion, see Gay Robins, *Proportion and Style in Ancient Egyptian Art* (Austin: University of Texas, 1994).

3. A colonnade relief is illustrated in Edna Russmann's *Eternal Egypt: Masterworks of Ancient Art from the British Museum* (London: British Museum, 2001), 87.

4. Many of these reliefs were repainted after the Amarna Period, so the paint we see now may not be original.

5. Textual evidence supports this conclusion. For an overview of the texts, see Rita E. Freed, "The

Development of Middle Kingdom Egyptian Relief: Sculptural Schools of Dynasty XI with an Appendix on the Trends of Early Dynasty XII" (PhD diss., New York University, 1984), especially 159–60.

6. Henry Fischer, "An Example of Memphite Influence in a Theban Stela of the Eleventh Dynasty," *Artibus Asiae* 22 (1959): 240–52.

7. He is depicted as Osiris in contexts above- and belowground, seated and standing. For an example of one of these sculptures, see Mohamed Saleh and Hourig Sourouzian, *The Egyptian Museum Cairo* (Mainz: Philipp von Zabern, 1987), no. 67.

8. For Mery's other statue, see Russmann, *Eternal Egypt*, 90, fig. 48.

9. Freed, "The Development of Middle Kingdom Egyptian Relief," 178; and Wolfram Grajetzki, *The Middle Kingdom in Egypt* (London: Duckworth, 2006), 20.

10. Dorothea Arnold, "Amenemhat I and the Early Twelfth Dynasty at Thebes," *Journal of the Metropolitan Museum of Art* 26 (1991): 18–20. The date of the move remains controversial; see Callender, "Middle Kingdom Renaissance," 159.

11. For a discussion of the coregency question, see particularly Arnold, "Amenemhat I," 42n47; and Callender, "Middle Kingdom Renaissance," 160.

12. Arnold, "Amenemhat I," 30.

13. Cairo J d'E 60520; illustrated in Cyril Aldred, "Some Royal Portraits of the Middle Kingdom in Ancient Egypt," *Metropolitan Museum Journal* 13 (1970): 9, fig. 13.

14. Rita E. Freed, "Observations on the Dating and Decoration of the Tombs of Ihy and Hetep," in *Abusir and Saqqara in the Year 2000*, ed. Miroslav Bárta and Jaromir Krejčí (Prague: Academy of Sciences of the Czech Republic, Oriental Institute, 2000), 212.

15. Rita E. Freed, "A Private Stela from Naga ed-Deir and Relief Style of the Reign of Amenemhat I," in *Studies in Ancient Egypt, the Aegean, and the Sudan: Essays in Honor of Dows Dunham on the Occasion of His 90th Birthday, June 1, 1980*, ed. William Kelly Simpson and Whitney M. Davis (Boston: Museum of Fine Arts, 1981), 71ff.; Grajetzki, *Middle Kingdom in Egypt*, 32.

16. For an illustration of Hetep's block statue, see Cyril Aldred, *Middle Kingdom Art in Ancient Egypt* (London: Alec Tiranti, 1950), no. 36.

17. For an overview, see Regine Schulz, *Die Entwicklung und Bedeutung des kuboiden Statuentypus*, vols. 1–2 (Hildesheim: Gerstenberg,

1992). With regard to the idea of a chair, see Aldred, *Middle Kingdom Art*, 43–44. For an illustration of a man in a carrying chair from the nearby tomb of Mereruka, see Jean Leclant, *Ägypten: Das Alte und das Mittlere Reich* (Munich: Beck, 1978), 234, fig. 225. For its connection to rebirth, see Arne Eggebrecht, "Zur Bedeutung des Würfelhockers," in *Festgabe für Dr. Walter Will, Ehrensenator der Universität München, zum 70. Geburtstag am 12. November 1966*, ed. S. Lauffer (Cologne: Carl Heymanns, 1966), 143–63.

18. Karl Joachim Seyfried, *Beiträge zu den Expeditionen des Mittleren Reiches in die Ost-Wüste* (Hildesheim: Gerstenberg, 1981), 250; see also William Kelly Simpson, "Sesostris I," in *Lexikon der Ägyptologie*, vol. 5, ed. Wolfgang Helck, Eberhard Otto, and Wolfhart Westendorf (Wiesbaden: Harrassowitz, 1984), col. 892; and Callender, "Middle Kingdom Renaissance," 161.

19. Hans Gerhardt Evers, *Staat aus dem Stein*, vol. 1 (Munich: Bruckmann, 1929), plates 36–38, 45; and vol. 2, 96–99. The Alexandria statue is identified as Senwosret I primarily on the basis of its similarity to the Tanis statues.

20. Evers, *Staat aus dem Stein*, vol. 1, plate 35B.

21. An exception is a particularly expressive and powerful image from Lisht, now in the Metropolitan Museum of Art (14.3.6), illustrated in Dietrich Wildung and Günter Burkard's *Ägypten 2000 v. Chr. Die Geburt des Individuums* (Munich: Hirmer, 2000), 79.

22. Callender, "Middle Kingdom Renaissance," 162.

23. Simpson, *Lexikon der Ägyptologie*, vol. 5, col. 896; and Dietrich Wildung, "Ein Würfelhocker des Generals Nes-Month," *Mitteilungen des Deutschen Archäologischen Instituts Abteilung Kairo* 37 (1981): 507 and n. 14.

24. The tomb was robbed in antiquity. Fragments of an approximately half-life-size statue of the nomarch and the well-preserved statue of his wife were buried in the tomb of a Nubian chieftain in Kerma, Sudan, probably during Egypt's Second Intermediate Period. For the original tomb, see Jochem Kahl, *Ancient Asyut: The First Synthesis after 300 Years of Research* (Wiesbaden: Harrossowitz, 2007), 88ff.

25. Grajetski, *Middle Kingdom*, 42; and Simpson, *Lexikon der Ägyptologie*, vol. 5, col. 895.

26. Grajetski, *Middle Kingdom*, 46–47.

27. Biri Fay, *The Louvre Sphinx and Royal Sculpture from the Reign of Amenemhat II* (Mainz: von Zabern, 1996), 7, 11, 15, and 38ff.

28. Callender, "Middle Kingdom Renaissance," 164.

29. William Kelly Simpson, *Terrace of the Great God at Abydos: The Offering Chapels of Dynasties 12 and 13* (New Haven: Peabody Museum of Natural History of Yale University and University Museum of the University of Pennsylvania, 1974), 27–28.

30. Ibid., 26–27.

31. Rita E. Freed, "Stela Workshops of Early Dynasty 12," in *Studies in Honor of William Kelly Simpson*, ed. Peter Manuelian (Boston: Museum of Fine Arts, 1996), 324ff.

32. William Matthew Flinders Petrie, Guy Brunton, and Mary Ann Murray, *Lahun II* (London: British School of Archaeology in Egypt, 1923), plates 16–19.

33. Cairo CG 381-2; illustrated in Evers, *Staat aus dem Stein*, vol. 1, plates 72–75.

34. Christiane Ziegler, "Une nouvelle statue royale du Moyen Empire au Musée du Louvre: La Reine Khénémet-Nefer-Hedjet-Ouret," *Monuments et mémoires de la fondation Eugène Piot* 80 (2001).

35. Rita E. Freed and Jack A. Josephson, "A Middle Kingdom Masterwork in Boston: MFA 2002.609," in *Archaism and Innovation: Studies in the Culture of Middle Kingdom Egypt*, ed. David Silverman, William Kelly Simpson, and Josef Wegner (New Haven: Yale University Press, and Philadelphia: University of Pennsylvania Museum of Archaeology and Anthropology, 2009), 1–14.

36. Fay, *Louvre Sphinx*, 44–45 and plates 58–60. The sphinx found at Abu Rowash is altered and not clearly female; see Fay, 62–63 and plates 83a–d; and a Middle Kingdom female sphinx head in the Metropolitan Museum is too fragmentary to be precisely dated.

37. Josef Wegner, "Chronology of the Senwosret III–Amenemhat III Royal Succession," *Journal of Near Eastern Studies* 55 (1996): 3ff.

38. Felicitas Polz, "Die Bildnisse Sesostris' III. und Amenemhets III. Bemerkungen zur königlichen Rundplastik der späten 12. Dynastie," *Mitteilungen des Deutsches Archäologisches Institut Abteilung Kairo* 51 (1995): 234, 237.

39. Jacques Vandier, *Manuel d'archéologie égyptienne*, vol. 3 (Paris: Picard, 1958), 184–86.

40. For Dahshur, see Dietrich Wildung, *Sesostris und Amenemhet: Ägypten im mittleren Reich* (Munich: Hirmer, 1984), 176, fig. 151; for Abydos, see Josef Wegner, "South Abydos: Burial Place of the Third Senwosret? Old and New Excavations at the Abydene Complex of Senwosret III," *KMT* 6, no. 2 (1995), 66; for Medamud, see F. Bisson de la Roque and J. J. Clère, *Les fouilles de Médamoud (1928)* (Cairo: Institut Français d'Archéologie Orientale, 1929), plate 4, 1 and 2.

41. F. Bisson de la Roque, *Rapport sur les fouilles de Médamoud (1929)* (Cairo: Institut français d'archéologie orientale, 1930). For another Medamud example contrasting the young and old Senwosret III, see Bisson de la Roque and Clère, *Les fouilles de Médamoud*, plates 4.1 and 4.2.

42. Simpson, *Terrace of the Great God at Abydos*, 28, plate 2 upper left and plate 3 upper left.

43. See Wegner, "Chronology of the Senwosret III–Amenemhat III."

44. Detlef Franke, "The Middle Kingdom in Egypt," in *Civilizations of the Ancient Near East*, ed. Jack Sasson (New York: Scribner, 1995), 745.

45. For examples of more youthful images, see Evers, *Staat aus dem Stein*, vol. 1, plates 102–3, and Aldred, "Some Royal Portraits," figs. 21–22 (incorrectly identified as Senwosret III).

46. Ronald Leprohon, "The Reign of Amenemhat III" (PhD diss., University of Toronto, 1980), 217, 272n175.

47. Rita E. Freed, "Another Look at the Sculpture of Amenemhat III," *Revue d'Égyptologie* 53 (2002): 111.

48. On the different sphinx types in Amenemhat III's reign, see Rita Freed, "Defending Connoisseurship: A Thrice Reinscribed Sphinx of Dynasty XII," in *Leaving No Stones Unturned: Essays on the Ancient Near East and Egyptian Honor of Donald P. Hansen*, ed. E. Ehrenberg (Winona Lake: Eisenbrauns, 2002), 77–88.

49. Callender, "Middle Kingdom Renaissance," 169–70.

50. Freed, "Another Look at the Sculpture of Amenemhat III," 115–17.

51. Cairo, CG 395; illustrated in Saleh and Sourouzian, *The Egyptian Museum Cairo*, no. 103.

52. Callender, "Middle Kingdom Renaissance," 170.

53. Guy Brunton, "A Monument of Amenemhat IV," *Annales du service des antiquités de l'Égypte* 39 (1939): 177–79 and plates 23–24.

54. On one of her three known statues genders are merged. She wears a feminine sheath dress over which is a high-waist male kilt, a *nemes* double-lobed amulet previously worn by her male predecessors. See Louvre E 27135 illustrated in Elisabeth Delange's *Catalogue des statues égyptiennes du Moyen Empire* (Paris: Editions de la Réunion des musées nationaux, 1987), 30–31.

55. W. Vivian Davies, *A Royal Statue Reattributed* (London: British Museum, 1981), 21–34; and for the joining of the torso from the Hekaib sanctuary with a head in Vienna, see B. Fay, "Amenemhat V– Vienna/Assuan," *Mitteilungen des Deutsches Archäologisches Institut Abteilung Kairo* 44 (1988).

56. Good examples are the statue of the treasurer Gebu, Ny Carlsberg Glyptotek Copenhagen AEIN 27, and the vizier Sobekemsaf, Kunsthistorisches Museum Vienna ÄS 5051/5801, illustrated in Wildung and Burkard, *Ägypten 2000 v. Chr.*, 159 and 147 respectively.

57. Simpson, *Terrace*, plates 81 top, 56, and 62, for example.

58. Ibid., plate 40, top right and left.

59. Jack Cooney, "Equipment for Eternity," *Bulletin of the Brooklyn Museum* 12, no. 2 (Winter 1951): 2, fig. 1.

60. Arnold, "Amenemhat I," 20–21.

DISCOVERING DEIR EL-BERSHA

All unpublished documents cited here come from the Archives of the Museum of Fine Arts, Boston.

1. See also Rita E. Freed, Lawrence M. Berman, and Denise M. Doxey, *MFA Highlights: Arts of Ancient Egypt* (Boston: MFA Publications, 2003), 83–85.

2. F. Vansleb, *The Present State of Egypt; or, A new Relation of a Late Voyage into that Kingdom, Performed in the Years 1672 and 1673* (London: John Starkey, 1678), 238–39.

3. Maurice Martin, "Le journal de Vansleb en Egypte," *Bulletin de l'Institut Français d'Archéologie Orientale* 97 (1997): 191, fig. 12.

4. Even today Vansleb does not receive due credit for his observations, though pointed out long ago by Gaston Camille Charles Maspero in "Bershéh et Sheikh-Saîd," *Bibliothèque égyptologique contenant les œuvres des égyptologues français dispersées dans divers recueils et qui n'ont pas encore été réunies jusqu'à ce jour* 28 (1912): 199–200. But see now Marleen De Meyer, "Old Kingdom Rock Tombs at Dayr al-Barshā" (PhD diss. Katholieke Universiteit Leiden, 2008), 1:5–6.

5. Terence M. Russell, *The Discovery of Egypt: Vivant Denon's Travels with Napoleon's Army* (Stroud, UK: Sutton Publishing, 2005), 125–27.

6. Charles Leonard Irby and James Mangles, *Travels in Egypt and Nubia, Syria, and the Holy Land* (London: John Murray, 1844; repr. n.p.: Elibron Classics, 2004), 152.

7. J. Gardner Wilkinson, *The Manners and Customs of the Ancient Egyptians*, 3 vols. (London: J. Murray, 1837), 3:328. For Wilkinson and his milieu, see Jason Thompson, *Sir Gardner Wilkinson and His Circle* (Austin: University of Texas Press, 1992).

8. J. Gardner Wilkinson, *Modern Egypt and Thebes: Being a Description of Egypt; Including the Information Required for Travellers in that Country* (London: John Murray, 1843), 64–65.

9. Mary Broderick, A. H. Sayce, and H. G. Lyons, *A Handbook for Travellers in Lower and Upper Egypt,* (London: John Murray, 1896), 693.

10. Maspero, "Bershéh et Sheikh-Saîd," 200, cited in De Meyer, "Old Kingdom Rock Tombs," 1:11; A. H. Sayce, "The Discovery of the Tel El-Amarna Tablets," *American Journal of Semitic Languages and Literatures* 33, no. 2 (January 1917): 89–90.

11. Patricia Spencer, ed., *The Egypt Exploration Society: The Early Years* (London: Egypt Exploration Society, 2007), 90–91; W. V. Davies, "Djehutyhotep's Colossus Inscription and Major Brown's Photograph," in *Studies in Egyptian Antiquities: A Tribute to T. G. H. James*, ed. W. V. Davies (London: British Museum Publications, 1999), 29–35.

12. Charles Edwin Wilbour, *Travels in Egypt (December 1880 to May 1891): Letters of Charles Edwin Wilbour*, ed. Jean Capart (Brooklyn, NY: Brooklyn Museum, 1936), 583.

13. Percy E. Newberry, *Egypt Exploration Fund: Report of Fifth Ordinary General Meeting, 1890–91* (London: Kegan Paul, Trench, Trübner, [1892]), 21.

14. Percy E. Newberry, *El Bersheh*, part 1, *The Tomb of Tehuti-Hetep*, Archaeological Survey of Egypt 3 (London: Egypt Exploration Fund, 1895); Newberry, *El Bersheh*, part 2, Archaeological Survey of Egypt 4 (London: Egypt Exploration Fund, 1896). For Howard Carter, see Nicholas Reeves and John H. Taylor, *Howard Carter before Tutankhamun* (London: British Museum, 1992), 30–31.

15. Georges Daressy, "Fouilles de Deir el Bircheh (novembre–décembre 1897)," *Annales du Service des Antiquités de l'Égypte* 1 (1900): 17–43; Ahmed Bey Kamal, "Fouilles à Déir-el-Barsheh," *Annales du Service des Antiquités de l'Égypte* 2 (1901): 14–43.

16. For example, the coffin of Sepi; see Daressy, "Fouilles de Deir el Bircheh," 39; Mohamed Saleh and Hourig Sourouzian, *The Egyptian Museum Cairo* (Mainz: Philipp von Zabern, 1987), no. 95.

17. Coffins of Gua, acquired by the British Museum in 1899; see Werner Forman and Stephen Quirke, *Hieroglyphs and the Afterlife in Ancient Egypt* (Norman: University of Oklahoma Press, 1996), 90.

18. Ahmed Bey Kamal, "Fouilles à Deir-el-Barché exécutés dans les six premiers mois de l'année par M. Antonini de Mallawi," *Annales du Service des Antiquités de l'Égypte* 3 (1902): 276–82. Perhaps from these excavations come three wooden models of daily life acquired by the MFA in 1903 from

the well-known Cairo dealer Panayotis Kyticas: MFA 03.1649a–d, a pair of oxen with driver; MFA 03.1650, a procession of men carrying water skins; and MFA 03.1648, a granary, deaccessioned in 1975 (now Memphis State University 2981.1.11). For images of the first two objects, see the Web site of the Museum of Fine Arts, Boston, under "Collections, Advanced Search" at http://www.mfa .org/collections/search_art.asp (accessed February 18, 2009).

19. Minutes of MFA trustees' meeting, May 15, 1914.

20. George A. Reisner to Morris Gray (MFA president), May 12, 1915.

21. This account and the following accounts of daily events, unless otherwise noted, derive from the excavation diary.

22. Hanford Lyman Story's notes on Deir el-Bersha season, 1915.

23. George A. Reisner cable, May 2, 1915.

24. Hanford Lyman Story to George A. Reisner, May 12, 1915.

25. Ahmed Said's excavation diary, May 12, 1915.

THE COFFINS AND CANOPIC CHESTS OF TOMB 10A

1. Harco Willems, *Chests of Life: A Study of the Typology and Conceptual Development of Middle Kingdom Coffins* (Leiden: Ex Oriente Lux, 1988), 238–42.

2. Harco Willems, *Les textes des sarcophages et la démocratie: Eléments d'une histoire culturelle du Moyen Empire égyptien* (Paris: Editions Cybele, 2008), 167–72.

3. Ibid.

4. Willems, *Chests of Life*.

5. "We got out the rest of the coffins which were in tunnel No. 10A and when we were trying to remove the wooden boards of which the coffin was made without breaking them we found that they were tied together with a wire from the inside. We managed to get them out without any damage." Ahmed Said's excavation diary, May 13, 1915, Museum of Fine Arts, Boston, Archives.

6. It took twenty workmen to lift the lid of Djehutynakht's outer coffin. H. Lyman Story to George Reisner, May 12, 1915, Art of the Ancient World Department curatorial files, Museum of Fine Arts, Boston.

7. Edward L. B. Terrace, *Egyptian Paintings of the Middle Kingdom: The Tomb of Djehuty-Nekht* (New York: George Braziller, 1969).

8. The Coffin Texts spells were published in seven volumes between 1935 and 1961 by Adriaan de Buck, *The Egyptian Coffin Texts*, Oriental Institute Publications 34, 49, 64, 67, 73, 81, 87 (Chicago: University of Chicago Press, 1935–1961).

9. The Pyramid Texts inscribed on Middle Kingdom coffins have been published by James P. Allen, *Middle Kingdom Copies of Pyramid Texts*, vol. 8, *The Egyptian Coffin Texts*, Oriental Institute Publications 132 (Chicago: University of Chicago Press, 2006).

10. Leonard H. Lesko, *Index of the Spells on Egyptian Middle Kingdom Coffins and Related Documents* (Berkeley: B. C. Scribe Publications, 1979), 16–22.

11. Silke Grallert, "The Mitre Inscriptions on Coffins of the Middle Kingdom: A New Set of Texts for Rectangular Coffins?" in *Life and Afterlife in Ancient Egypt during the Middle Kingdom and Second Intermediate Period*, ed. Silke Grallert and Wolfram Grajetski (London: Golden House Publications, 2007), 35–80.

12. Ibid., 45.

13. Willems, *Chests of Life*, 202.

14. An abbreviated version of Coffin Text 925: "O Companion, open the chest and bring ointment before N's face for N in all his dignities and in all his places which he desires; may he have happiness yonder with the god, with Anubis and with his double, (even) N." See Willems, *Chests of Life*, 195n69.

15. Pyramid Text 77; James P. Allen, *The Egyptian Pyramid Texts* (Atlanta: Society of Biblical Literature, 2005), 22.

16. Pigment analysis by William J. Young and Florence E. Whitmore, in *Egyptian Paintings*, by Terrace, 167.

17. A fine example is the sarcophagus of Meresankh II in the Museum of Fine Arts, Boston (27.441a–b); see Dows Dunham, "New Installation in the Egyptian Department," *Museum of Fine Arts Bulletin* 25, no. 152 (December 1927): 97; for an image of the sarcophagus, see also the Web site of the Museum of Fine Arts, Boston, under "Collections, Advanced Search" at http://www.mfa .org/collections/search_art.asp (accessed February 18, 2009).

18. Edna R. Russmann, "The Motif of Bound Papyrus Plants and the Decorative Program in Mentuemhat's First Court," *Journal of the American Research Center in Egypt* 32 (1995): 117–26. Another early instance occurs above the doorways of the roughly contemporary house models of Meketra, symbolizing that these are not real doors but funerary false doors; see Russmann,

121–22; also Werner Forman and Stephen Quirke, *Hieroglyphs and the Afterlife in Ancient Egypt* (Norman: University of Oklahoma Press, 1996), 87.

19. Willems, in *Chests of Life*, 178, mentions only four other examples from the early Middle Kingdom: one from Aswan (Cairo CG 28127), one from Gebelein (Turin 15.774), and two from Thebes (Cairo JE 47355 and London, British Museum EA 29570). Also the limestone sarcophagi of Kawit and Ashait from the temple of Mentuhotep II at Deir el-Bahri, in Cairo; see Mohamed Saleh and Hourig Sourouzian, *The Egyptian Museum Cairo* (Mainz: Philipp von Zabern, 1987), nos. 68–69. Each of these sarcophagi is composed of six separate slabs of stone like wooden coffins.

20. Richard H. Wilkinson, *Reading Egyptian Art: A Hieroglyphic Guide to Ancient Egyptian Painting and Sculpture* (London: Thames and Hudson, 1992), 125.

21. Marleen de Meyer et al., "The Role of Animals in the Funerary Rites at Dayr al-Barshā," *Journal of the American Research Center in Egypt* 42 (2005–2006): 67–68.

22. From Coffin Text 464; R. O. Faulkner, *The Ancient Egyptian Coffin Texts*, vol. 2, *Spells 355–787* (Warminster: Aris and Phillips, 1977), 90.

23. From Coffin Text 201; Faulkner, *The Ancient Egyptian Coffin Texts*, vol. 1, *Spells 1–354* (Warminster: Aris and Phillips, 1973), 201.

24. From Coffin Text 202; Faulkner, *Ancient Egyptian Coffin Texts* 1:202.

25. From Coffin Texts 349, 426, 684, 207, 215, 210, 432, 433, 215, and 569.

26. From Coffin Text 221; Faulkner, *Ancient Egyptian Coffin Texts* 1:175.

27. James P. Allen, *Middle Kingdom Copies of Pyramid Texts*, 214–15.

28. Sue D'Auria, Peter Lacovara, and Catharine H. Roehrig, eds., *Mummies and Magic: The Funerary Arts of Ancient Egypt* (Boston: Museum of Fine Arts, 1988), 127–28; Peter Robinson, "'As for Them Who Know Them, They Shall Find Their Paths': Speculations on Ritual Landscapes in the Book of the Two Ways," in *Mysterious Lands*, ed. David O'Connor and Stephen Quirke (London: University College London Press, 2003), 151.

29. Stephen Quirke, *Ancient Egyptian Religion* (London: British Museum Press, 1992), 157–58; Forman and Quirke, *Hieroglyphs and the Afterlife*, 68–69.

30. Terrace, *Egyptian Paintings*, commentary to plate 37.

31. Ibid., 35.

32. Coffin Texts 75–80.

33. James P. Allen, *Genesis in Egypt: The Philosophy of Ancient Egyptian Creation Accounts*, Yale Egyptological Studies 2 (New Haven: Yale Egyptological Seminar, 1988), 14–27.

34. Ibid., 23–24.

35. Terrace, *Egyptian Paintings*, 36.

36. Pyramid Texts 25, 32, 82–96, and 108–71.

37. Coffin Texts 267, 423, 430, 425, 435–36, 434, 192–93, 207–8, 216, 205–6, 210, 355, 172, 353, 440, and 424.

38. From spell 423; Faulkner, *Ancient Egyptian Coffin Texts* 2:69.

39. Leonard Lesko has identified four versions of the Book of Two Ways, which he calls A, A-B, B, and C. Governor Djehutynakht's outer coffin has A, Governor Djehutynakht's inner coffin has A-B, and Lady Djehutynakht's inner coffin has B. None of these is complete. The first (B1Bo) and third (B4Bo) are much abridged, and the second (B2Bo) breaks off before the end. See Leonard H. Lesko, "Some Observations on the Composition of the *Book of the Two Ways*," *Journal of the American Oriental Society* 91 (January–March 1971): 33–34, figs. 3–4.

40. Coffin Text 1029; R. O. Faulkner, *The Ancient Egyptian Coffin Texts*, vol. 3, *Spells 788–1185* (Warminster: Aris and Phillips, 1978), 127.

41. Spell 1035, not present on this coffin, reads: "I have passed over the paths of Rostau, whether on water or on land, and these are the paths of Osiris." Similarly, spell 1074 (line 148) reads: "The paths by water and by land which belong to Rostau."

42. Leonard H. Lesko, "Ancient Egyptian Cosmogonies and Cosmology," in *Religion in Ancient Egypt: Gods, Myths, and Personal Practice*, ed. Byron E. Shafer (Ithaca: Cornell University Press, 1991), 119.

43. Coffin Texts 1054, 1053, 1041, 1044.

44. Gua's coffin is now in the British Museum; see Forman and Quirke, *Hieroglyphs and the Afterlife*, 90.

45. Metropolitan Museum of Art 30.8.218; see Joan Aruz, Kim Benzel, Jean M. Evans, eds., *Beyond Babylon: Art, Trade, and Diplomacy in the Second Millennium B.C.* (New York: Metropolitan Museum of Art, 2008), 147, no. 86.

46. Robinson, "As for Them Who Know Them," 159.

47. Coffin Text 1042; Faulkner, *Ancient Egyptian Coffin Texts* 3:134.

48. Coffin Texts 1066, 1065, 1059, 1057, 1056.

49. Coffin Text 1065; Faulkner, *Ancient Egyptian Coffin Texts* 3:142.

50. Howard Carter and Alan H. Gardiner, "The Tomb of Ramses IV and the Turin Plan of a Royal Tomb," *Journal of Egyptian Archaeology* 4 (1917): 137.

51. From Coffin Text 1072; Faulkner, *Ancient Egyptian Coffin Texts* 3:145.

52. From Coffin Text 1099; Faulkner, *Ancient Egyptian Coffin Texts* 3:155.

53. Miriam Lichtheim, *Ancient Egyptian Literature*, vol. 1, *The Old and Middle Kingdoms* (Berkeley: University of California Press, 1975), 133–24.

54. Katherine Eaton, "A 'Mortuary Liturgy' from the *Book of the Dead*, with Comments on the Nature of the 3ḫ-spirit," *Journal of the American Research Center in Egypt* 42 (2005–2006): 89.

55. Pyramid Texts 72–77, 25.

56. Pyramid Texts 220–22; Allen, *Genesis in Egypt*, 40.

57. Jan Assmann, *The Search for God in Ancient Egypt* (Ithaca: Cornell University Press, 2001), 278–92.

58. From Coffin Text 7; Faulkner, *Ancient Egyptian Coffin Texts* 1:3–4.

59. 41.421b has "this [feminine] Djehuhtynakht" on the interior (the exterior has no inscription); 21.422 has "the honored one [feminine] Djehuty-nakht" on the exterior (the interior has no inscription). Photographs taken in the field associate lid 41.421b with box 41.421a, and clearly the excavators felt they belonged together. The original object register in Boston, however, was later annotated to the effect that 41.422 (which seems not to have been reassembled until after the objects had arrived) is the lid to 41.421a. Lid 41.422 is the one shown here on the box in the photograph. According to the object's condition report by Gwynne Ryan, there is fire damage (presumably from the fire aboard the *Clan Murdoch*) along one of the interior joints, indicating that the pieces of the lid were still separate at the time of the fire. Furthermore, there are no expedition photographs of 41.422, which also suggests that the lid was not reassembled.

60. This is not unusual. The canopic box from tomb 19B (MFA 21.420) goes one step further; its side walls are composed of three layers.

61. See Maarten J. Raven, "Egyptian Concepts of the Orientation of the Human Body," *Journal of Egyptian Archaeology* 91 (2005): 37–53.

62. From Coffin Text 523; see Faulkner, *Ancient Egyptian Coffin Texts* 2:150.

63. Faulkner, *Ancient Egyptian Coffin Texts* 2:151, spell 524. Nomarch Amenemhat was buried in tomb 3 at Deir el-Bersha. This tomb was excavated by Egyptian archaeologist Ahmed Bey Kamal. His canopic chest is in the Cairo Museum.

64. De Buck, *Coffin Texts* 6:117, top right.

65. Edward Brovarski, *Canopic Jars,* Corpus Antiquitatum Aegyptiacarum, Museum of Fine Arts Boston, fascicle 1 (Mainz: Philipp von Zabern, 1978), introduction.

66. R. B. Parkinson, *Voices from Ancient Egypt: An Anthology of Middle Kingdom Writings* (London: British Museum Press, 1991), 147–48.

THE DJEHUTYNAKHTS' BURIAL GOODS

1. Sue D'Auria, Peter Lacovara, and Catharine H. Roehrig, eds., *Mummies and Magic: The Funerary Arts of Ancient Egypt* (Boston: Museum of Fine Arts, 1988), 117.

2. Angela Tooley, "Middle Kingdom Burial Customs: A Study of Wooden Models and Related Material" (PhD diss., University of Liverpool, 1989), 289.

3. D'Auria, Lacovara, and Roehrig, *Mummies and Magic*, 116.

4. Geoffrey Graham, "Insignias," in *The Oxford Encyclopedia of Ancient Egypt*, vol. 2, ed. Donald B. Redford (New York: Oxford University Press, 1999), 163.

5. Ibid., 165.

6. Regarding the original function of restraining serpents, see ibid., 166.

7. Henry G. Fischer, "Notes on Sticks and Staves in Ancient Egypt," *Metropolitan Museum Journal* 13 (1978), 5–7.

8. Graham, "Insignias," 166.

9. William C. Hayes, *The Scepter of Egypt: A Background for the Study of Egyptian Antiquities in The Metropolitan Museum of Art*, part 1, *From the Earliest Times to the End of the Middle Kingdom* (New York: Metropolitan Museum of Art, 1953), 281–82.

10. Graham, "Insignias," 166.

11. D'Auria, Lacovara, and Roehrig, *Mummies and Magic*, 117.

12. Ibid., 112.

13. Mary Ann Murray, "Cereal Production and Processing," in *Ancient Egyptian Materials and Technology*, ed. Paul Nicholson and Ian Shaw (Cambridge: Cambridge University Press, 2000), 516–17.

THE DJEHUTYNAKHTS' MODELS

1. For a discussion of models from this period, see Angela Tooley, *Egyptian Models and Scenes* (Princes Risborough, Buckinghamshire: Shire Publications, 1995), especially 49–50, 61–62.

2. Precise dating of post–Old Kingdom tombs with models is often difficult, and recent scholarship has pushed many of those formerly assumed to be from the First Intermediate Period into the late Eleventh–early Twelfth Dynasty period. See Dorothea Arnold, "The Architecture of Meketre's Slaughterhouse and Other Early Twelfth Dynasty Wooden Models," in *Structure and Significance: Thoughts on Ancient Egyptian Architecture*, ed. Peter Jánosi (Vienna: Österreichischen Akademie der Wissenschaften, 2005), especially 36, 43.

3. For the models of Mentuhotep II, see Arnold, "Architecture of Meketre's Slaughterhouse," 28.

4. Angela Tooley, "Middle Kingdom Burial Customs: A Study of Wooden Models and Related Material" (PhD diss., University of Liverpool, 1989), 383; and Tooley, *Egyptian Models*, 25.

5. Tooley, "Middle Kingdom Burial Customs," 66.

6. Tooley, *Egyptian Models*, 45–46.

7. Museum of Fine Arts, Boston, 20.1120, illustrated in *Mistress of the House, Mistress of Heaven: Women in Ancient Egypt*, ed. Anne K. Capel and Glenn Markoe (New York: Hudson Hills, 1996), 66; and 20.1121, illustrated in *Mummies and Magic: The Funerary Arts of Ancient Egypt*, ed. Sue D'Auria, Peter Lacovara, and Catharine Roehrig (Boston: Museum of Fine Arts, 1988), no. 52. Both of these statuettes come from Deir el-Bersha tomb 19B, the tomb of Nehri, probably the son of the Djehutynakhts of tomb 10A.

8. Edward Terrace first noted this similarity in his publication on the coffin; see Edward L. B. Terrace, *Egyptian Paintings of the Middle Kingdom* (New York: George Braziller, 1967).

9. Arnold, "Architecture of Meketre's Slaughterhouse," 51 and n. 205.

10. The tomb of Mesekhty at Asyut, which is of approximately the same date, contained a greater number of soldiers in total, but they were grouped in only two processions. The processions are in the collection of the Egyptian Museum in Cairo, CG 257 and 258.

11. Tooley, in *Egyptian Models*, 50, suggests they were even too fat to stand.

12. D'Auria, Lacovara, and Roehrig, *Mummies and Magic*, 113.

13. Tooley, *Egyptian Models*, 36; and Tooley, "Middle Kingdom Burial Customs," 93.

14. For an analysis of model granaries, see Arnold, "Architecture of Meketre's Slaughterhouse."

15. Tooley, *Egyptian Models*, 45.

16. Ibid., 43.

17. Mogens Jørgensen, *Tomb Treasures from Ancient Egypt* (Copenhagen: Ny Carlsberg Glyptotek, 2002), 36; and Museum of Fine Arts, Boston, *Egypt's Golden Age* (Boston: Museum of Fine Arts, 1982), 51–52.

18. D'Auria, Lacovara, and Roehrig, *Mummies and Magic*, 114.

19. For further discussion of Egyptian boats, see Herbert E. Winlock, *Models of Daily Life in Ancient Egypt* (Cambridge, Mass.: Harvard University Press, 1955); and Dilwyn Jones, *Boats* (Austin: University of Texas Press, 1995).

20. For information about the religious significance of boats, see Jones, *Boats*, 12–20; and Cheryl Ward, *Sacred and Secular: Ancient Egyptian Ships and Boats* (Philadelphia: University of Pennsylvania Museum Publications, 2000).

21. Tooley, "Middle Kingdom Burial Customs," 145–52.

22. Ibid.

23. Arnold, "Architecture of Meketre's Slaughterhouse," especially 43.

24. D'Auria, Lacovara, and Roehrig, *Mummies and Magic*, 113.

25. Brick-making models are attested at Deir el-Bersha in the tomb of Henu and in the tomb of Beni Hasan; for Henu, see Marleen de Meyer, "Old Kingdom Rock Tombs at Dayr al-Barshā" (PhD diss., Katholieke Universiteit Leuven, 2008), plate 305; for Beni Hasan, see Tooley, *Egyptian Models*, 44. Soldier processions are otherwise known from the tomb of Mesekhty at Asyut (attributed to the time of Mentuhotep II); see Tooley, *Egyptian Models*, 36.

THE MUMMIFIED HEAD OF TOMB 10A

1. Edward L. B. Terrace, *Egyptian Paintings of the Middle Kingdom: The Tomb of Djehuty-nekht* (New York: George Braziller, 1968), 22.

2. Sue D'Auria, Peter Lacovara, and Catharine H. Roehrig, eds., *Mummies and Magic: The Funerary Arts of Ancient Egypt* (Boston: Museum of Fine Arts, 1988), 111–12.

3. Rajiv Gupta et al., "Ultra-High Resolution Flat-Panel Volume CT: Fundamental Principles, Design Architecture, and System Characterization," *European Radiology* 16 (2006): 1191–1205.

4. Evzen Strouhal, "Embalming Excerebration in the Middle Kingdom," in *Science in Egyptology*, ed. R. A. David (Manchester, England: Manchester University Press, 1986), 141–54.

5. A detailed description of the anatomic findings may be found in "High-Resolution Imaging of an Ancient Egyptian Mummified Head: New Insights into the Mummification Process," by Rajiv Gupta et al., *American Journal of Neuroradiology* 29 (2008): 705–13.

DATING TOMB 10A

1. Dows Dunham, "The Tomb of Dehuti-Nekht and His Wife," *Bulletin of the Museum of Fine Arts, Boston* 19 (1921): 43.

2. Dows Dunham and William Stevenson Smith, "A Middle Kingdom Painted Coffin from Deir el Bersheh," in *Scritti in onore di Ippolito Rosellini pubblicati cure dell'Università di Pisa*, vol. 1 (Pisa: Industrie Grafiche V. Lischi e Figli, 1949), 266.

3. William Stevenson Smith, "Paintings of the Egyptian Middle Kingdom at Bersheh," *American Journal of Archaeology* 55 (1951): 322; Smith, *The Art and Architecture of Ancient Egypt* (London: Penguin, 1965), 108.

4. Cyril Aldred, *Middle Kingdom Art in Ancient Egypt* (London: Tiranti, 1950), 47, nos. 48–49; Hans Wolfgang Müller, *Alt-ägyptische Malerei* (Berlin: Safari, 1959), 24; Henry George Fischer, "Flachbildkunst des Mitteren Reiches," in *Das Alte Ägypten*, ed. Claude Vandersleyen (Berlin: Propyläen, 1975), 295, 302.

5. Edward Terrace, *Middle Kingdom Painting* (New York: Allen and Unwin, 1968), 50.

6. Edward Brovarski, "Ahanakht of Bersheh and the Hare Nome in the First Intermediate Period and Middle Kingdom," in *Studies in Ancient Egypt, the Aegean, and the Sudan: Essays in Honor of Dows Dunham on the Occasion of His 90th Birthday, June 1, 1980*, ed. William Kelly Simpson and Whitney M. Davis (Boston: Museum of Fine Arts, 1981), 24n75.

7. Among them are William Kelly Simpson in his revisions of William Stevenson Smith, *The Art and Architecture of Ancient Egypt*, revised with additions by William Kelly Simpson (London: Penguin, 1981), 197; Harco Willems, *Chests of Life: A Study of the Typology and Conceptual Development of Middle Kingdom Coffins* (Leiden: Ex Oriente Lux, 1988), 70–71; and Angela Tooley, "Middle Kingdom Burial Customs: A Study of Wooden Models and Related Items" (PhD diss., University of Liverpool, 1989), 40.

8. Unfortunately, only fragments of the reliefs remain. For illustrations of the main ones, see Dorothea Arnold, "Amenemhat I and the Early Twelfth Dynasty at Thebes," *Metropolitan Museum Journal* 26 (1991): 21, discussion on 23, and figs. 24–26. The tomb is best known for its superb models, which are now divided between the Metropolitan Museum and the Egyptian Museum, Cairo.

9. Ibid.

10. Ibid., 23 and 46n123. Arnold cites the Djehutynakht outer coffin as an example of the pre–Dynasty 12 occurrence of varied hues of the same color of paint on wood. On the Eleventh Dynasty dating of the Djehutynakht coffin, she was probably following Brovarski; see Brovarski, "Ahanakht of Bersheh and the Hare Nome," 14–30.

11. Examples are included in the collections of the Turin Egyptian Museum and Metropolitan Museum of Art. See Turin Egyptian Museum 1447, illustrated in Museo Egizio di Torino's *Civilta' degli Egizi: Le credenze religiose* (Milan: Electa Spa, 1988), 104; and MMA 57.95, illustrated in Henry Fischer's "An Example of Memphite Influence in a Theban Stela of the Eleventh Dynasty," *Artibus Asiae* 22 (1959): 241.

12. Louvre E 15113, illustrated in Fernand Bisson de la Roque's *Tôd (1934–1935)* (Cairo: Insitut français d'archéologie orientale, 1937), 2, plate 26.

13. Also illustrated in William Kelly Simpson's *The Terrace of the Great God at Abydos: The Offering Chapels of Dynasties 12 and 13* (New Haven: Peabody Museum of Natural History of Yale University and University Museum of the University of Pennsylvania, 1974), plate 15, top.

14. See, for example, Simpson's *Terrace of the Great God at Abydos,* plates 10–12 (Senwosret I), 18 and 35 (Amenemhat II), and 1 (Senwosret III).

15. For a discussion of the tomb and its dating to Amenemhat I, see Rita E. Freed, "Observations on the Dating and Decoration of the Tombs of Ihy and Hetep at Saqqara," and David Silverman, "Middle Kingdom Tombs in the Teti Pyramid Cemetery," in *Abusir and Saqqara in the Year 2000,* ed. Miroslav Bárta and Jaromír Krejčí (Prague: Academy of Sciences of the Czech Republic, Oriental Institute, 2000), 207–14 and 259–82 respectively.

16. Tomb B1; see Aylward Blackman, *The Rock Tombs of Meir,* vol. 1 (London: Egypt Exploration Fund, 1914), 8 and plate 9.

17. Aylward Blackman, *The Rock Tombs of Meir,* part 2 (London: Egypt Exploration Fund, 1915), plates 6 and 10.

18. Rita E. Freed, "Art Historical Overview," in *Bersheh Reports,* vol. 1, ed. David Silverman (Boston: Museum of Fine Arts, 1992).

19. Ibid., 56. Other scholars place it slightly later or slightly earlier; see 56nn116–17 of Freed's "Art Historical Overview."

20. Ibid., 56–59.

21. At least seven Djehutynakhts are known from Deir el-Bersha from Dynasty 9 in the First Intermediate Period until the reign of Senwosret III in Dynasty 12 of the Middle Kingdom; see Brovarski, "Ahanakht of Bersheh and the Hare Nome," especially 29, fig. 13. Ahanakht's father was also named Djehutynakht; see Brovarski, "Ahanakht of Bersheh and the Hare Nome," 16.

22. Djehutynakht IV; see Freed, "Art Historical Overview," 59 and n. 119.

23. For Ukhhotep III, see Aylward Blackman and Michael Apted, *The Rock Tombs of Meir,* part 6 (London: Egypt Exploration Society, 1953), plate 20; and Terrace, *Middle Kingdom Painting,* plate 48. For Senbi, see Blackman, *The Rock Tombs of Meir,* vol. 1, plate 30.

24. Janine Bourriau, "Patterns of Change in Burial Customs in the Middle Kingdom," in *Middle Kingdom Studies,* ed. Stephen Quirke (New Malden, Surrey: SIA Publishing, 1991), 11.

25. Donald Spanel, "Ancient Egyptian Boat Models of the Herakleopolitan Period and Eleventh Dynasty," *Studien zur altägyptischen Kultur* 12 (1985): 246.

26. Tooley, "Middle Kingdom Burial Customs," 164–65.

27. Ibid., 302.

28. Raphael Giveon, *Scarabs from Recent Excavations in Israel* (Göttingen: Vandenhoeck & Ruprecht, 1988), 55, 91.

29. Susan Allen and Dorothea Arnold of the Metropolitan Museum of Art provided this estimate of the pottery's date; e-mail message to Denise M. Doxey, February 13, 2009.

30. Harco Willems, *Dayr al-Barshā*, vol. 1 (Leuven: Peeters Publishers, 2007), 87.

31. Edward L. B. Terrace, "The Entourage of an Egyptian Governor," *Bulletin of the Museum of Fine Arts, Boston* 66, no. 343 (1968): 8.

32. Brovarski, "Ahanakht of Bersheh and the Hare Nome," 23–25.

33. Satmeket's coffin fragments are Museum of Fine Arts, Boston 21.968–969 from tomb 10B; Ahanakht's coffins are Philadelphia E 16218A–B and E 16217A–B from tomb 5; and Kay's is Cairo CG 28094; see Willems, *Chests of Life,* 70–74.

34. Harco Willems, "The Nomarchs of the Hare Nome and Early Middle Kingdom History," *Jaarbericht Ex Oriente Lux* 28 (1983–84): 94; Willems refutes Brovarski's paleographical evidence of an earlier date on 86–88.

35. Willems, *Chests of Life,* 101–2 (Herakleopolis), 110–14 (Thebes), and 188.

36. Arnold, "Amenemhat I," 18–20; Donald B. Redford, *Egypt, Canaan, and Israel in Ancient Times* (Princeton: Princeton University Press, 1992), 73–74.

37. Brovarski, "Ahanakht of Bersheh and the Hare Nome," 23–25; Willems, "Nomarchs of the Hare Nome," 93; and Denise M. Doxey, "Funerary Equipment from Deir el-Bersha in the Museum of Fine Arts, Boston," in *Archaism and Innovation: Studies in the Culture of Middle Kingdom Egypt,* ed. David Silverman and Josef Wegner (New Haven: Yale University Press, and Philadelphia: University of Pennsylvania Museum of Archaeology and Anthropology, 2009), 347–49.

38. Willems, *Chests of Life,* 71–72.

Fig. 147. Model of five
female offering bearers,
late Dynasty 11–early
Dynasty 12, 2010–1961
B.C.

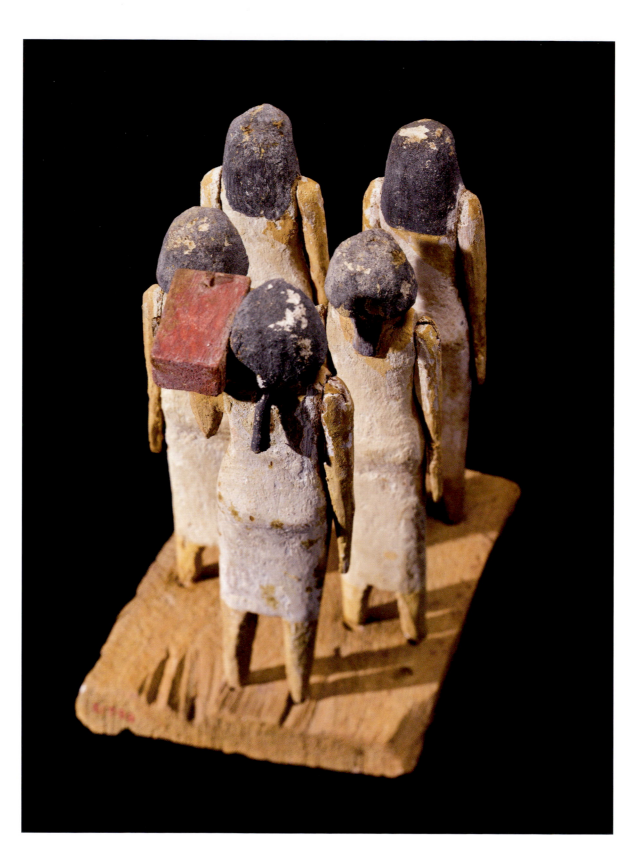

FIGURE ILLUSTRATIONS

Unless otherwise noted, all objects illustrated in this catalogue are part of the Museum of Fine Arts, Boston's collection of Egyptian art. Illustration numbers followed by an asterisk () indicate objects that are also part of the exhibition "The Secrets of Tomb 10A: Egypt 2000 B.C.," organized by the MFA from October 18, 2009 to May 16, 2010. All measurements are provided as height x width x depth unless otherwise noted.*

MIDDLE KINGDOM HISTORY, POLITICS, AND SOCIAL ORGANIZATION

Fig. 1*
Relief of Mentuhotep II, Dynasty 11, reign of Mentuhotep II, 2061–2010 B.C., limestone, Thebes, Deir el-Bahri, mortuary temple of Mentuhotep II, 25.5 x 35 x 12 cm (10¹⁄₁₆ x 13¾ x 4¾ in.), Egypt Exploration Fund by subscription, 06.2472

Fig. 2
Senwosret I, Dynasty 12, reign of Senwosret I, 1971–1926 B.C., granodiorite with feldspar inclusions, height 78.5 cm (30⅞ in.), British Museum, London, EA 44. Image © The Trustees of the British Museum.

Fig. 3
The White Chapel of Senwosret I, Dynasty 12, reign of Senwosret I, 1971–1926 B.C., limestone, Thebes, Karnak. Photograph by Lawrence M. Berman.

Fig. 4
Granary scene, Dynasty 12, reign of Senwosret I, 1971–1926 B.C., Beni Hasan, tomb 2 (Amenemhat). From Ippolito Rosellini, *I monumenti dell'Egitto e della Nubia disegnati dalla spedizione scientifico-letteraria toscana in Egitto; distribuiti in ordine di materie*, vol. 2 (Pisa: Presso N. Capurro e c., 1832–44), plate 34.

Fig. 5
Wine-making scene, First Intermediate Period–early Middle Kingdom, Dynasty 11, 2140–1991 B.C., Beni Hasan, tomb 17 (Khety). From Ippolito Rosellini, *I monumenti dell'Egitto e della Nubia disegnati dalla spedizione scientifico-letteraria toscana in Egitto; distribuiti in ordine di materie*, vol. 2 (Pisa: Presso N. Capurro e c., 1832–44), plate 37.

Fig. 6
The nomarch's retinue, Dynasty 12, reign of Senwosret II–Senwosret III, 1897–1841 B.C., limestone, Deir el-Bersha, tomb 2 (Djehutyhotep), 37 x 169 cm (14⁹⁄₁₆ x 66⁹⁄₁₆ in.), British Museum, London, EA 1147. Image © The Trustees of the British Museum.

Fig. 7
Scene of moving the colossal statue of the nomarch Djehutyhotep, Dynasty 12, reign of Senwosret II–Senwosret III, 1897–1841 B.C., limestone, Deir el-Bersha, tomb 2 (Djehutyhotep). From Ippolito Rosellini, *I monumenti dell'Egitto e della Nubia disegnati dalla spedizione scientifico-letteraria toscana in Egitto; distribuiti in ordine di materie*, vol. 2 (Pisa: Presso N. Capurro e c., 1832–44), plate 48.

Fig. 8
Scene of receiving a caravan of Asiatics, Dynasty 12, reign of Amenemhat II, 1929–1892 B.C., Beni Hasan, tomb 3 (Khnumhotep II). From Prisse d'Avennes, *Histoire de l'art égyptien d'après les monuments, depuis les temps les plus reculés jusqu'à la domination romaine*, vol. 2 (Paris: A. Bertrand, 1878–1879), plate 47.

FUNERARY BELIEFS AND PRACTICES IN THE MIDDLE KINGDOM

Fig. 9
View of Deir el-Bahri. Photograph by Lawrence M. Berman.

Fig. 10
View of Lisht, Pyramid of Senwosret I, Dynasty 12, reign of Senwosret I, 1971–1926 B.C. Photograph by Nicholas S. Picardo.

Fig. 11
Monumental relief of a Horus falcon, Dynasty 12, reign of Senwosret I, 1971–1926 B.C., limestone, Lisht, pyramid temple of Senwosret I, 61 x 73 x 19.8 cm (24 x 28¾ x 7¹³⁄₁₆ in.), Received from the Metropolitan Museum of Art, by exchange, 37.590

Fig. 12
Jewelry of Sithathoryunet, Dynasty 12, reign of Senwosret II–Amenemhat III, about 1897–1797 B.C., el-Lahun, tomb 8, gold, amethyst, and diorite, length 14.5–81 cm (5¹¹⁄₁₆–31⅞ in.), The Metropolitan Museum of Art, New York, Purchase, Rogers Fund and Henry Walters Gift, 16.1.6–7, 16.1.14a–15a. Image © The Metropolitan Museum of Art

Fig. 13
Reconstructions of rock-cut tomb 2 (Djehutyhotep) and tomb 3 (Amenemhat) at Deir el-Bersha. Image courtesy of Katholieke Universiteit Leuven Mission to Dayr al-Barshā.

Fig. 14
Stele of Meny, First Intermediate Period, Dynasty 9, about 2100 B.C., limestone, Dendara, 52.5 x 68.5 x 9.5 cm (20¹¹⁄₁₆ x 26¹⁵⁄₁₆ x 3¾ in.), Egypt Exploration Fund by subscription, 98.1034

Fig. 15*
Stele of Wadjsetji and Merirtyfy, First Intermediate Period, Dynasties 9–11, about 2100–2040 B.C., limestone, Mesheikh, tomb 101, 54 x 71 x 9.5 cm (21¼ x 27¹⁵⁄₁₆ x 3¾ in.), Harvard University–Boston Museum of Fine Arts Expedition, 12.1479

Fig. 16*
Stele of Seniankhu and Iy, Dynasty 12, reign of Amenemhat III, 1844–1797 B.C., limestone, Sheikh Farag, tomb SF 217, 55.1 x 41.9 x 7.6 cm (21¹¹⁄₁₆ x 16½ x 3 in.), Harvard University–Boston Museum of Fine Arts Expedition, 13.3844

Fig. 17*
Statue of Wepwawetemhat, First Intermediate Period–Middle Kingdom, probably late Dynasty 11, 2140–1991 B.C., wood, Asyut, tomb 14, 112 x 23.1 x 71.1 cm (44⅛ x 9⅛ x 28 in.), Emily Esther Sears Fund, 04.1780

Fig. 18*
Statuette of Nakht, late Dynasty 11 or early Dynasty 12, 2040–1878 B.C., wood, Asyut, tomb 7 (Nakht), height 29 cm (11⁷⁄₁₆ in.), Emily Esther Sears Fund, 04.1775

Fig. 19*
Coffin of Menqabu, First Intermediate Period, probably early Dynasty 11, 2140–2040 B.C., wood, possibly from Farshut, 57 × 195 × 42 cm (22⁷⁄₁₆ × 76¾ × 16⁹⁄₁₆ in.), Emily Esther Sears Fund, 03.1631a–b

Fig. 20
Plaster form of the mummy of Wah, Dynasty 12, reign of Amenemhat I, about 1975 B.C., plaster, original from Thebes, The Metropolitan Museum of Art, New York, Rogers Fund, 1940, 20.3.203. Image © The Metropolitan Museum of Art.

Fig. 21*
Set of sixteen articles of jewelry, Dynasty 11, 2140–1991 B.C., faience, amethyst, carnelian, green stone, silver, shell, and bone, Naga el-Deir, tomb N 453 B, Harvard University–Boston Museum of Fine Arts Expedition, 21.970–21.985

Fig. 22*
Mummy mask, Dynasty 11–early Dynasty 12, 2140–1926 B.C., cartonnage, height 60 cm (23⅝ in.), Edward J. and Mary S. Holmes Fund, 1987.54

Fig. 23
Canopic jar lid, late Dynasty 12–early Dynasty 13, 1820–1740 B.C., indurated limestone, height 16.5 × diameter 17.8 cm (6½ × 7 in.), Museum purchase with funds from the Egyptian Curator's Fund, anonymous gifts, and donated by Janet Maffei, Jonathan and Judy Keyes, Paul Chapman, Philippa D. Shaplin, Zareen Taj Mirza, David and Linda DiCecco, and Mr. and Mrs. Charles A. Butts, Jr., 2008.640

Fig. 24
Shawabty, late Dynasty 12 to Dynasty 13, 1878–1640 B.C., limestone, Naga el-Deir, Sheikh Farag, tomb SF 42 C, height 11.9 cm (4¹¹⁄₁₆ in.), Harvard University–Boston Museum of Fine Arts Expedition, 13.3587

Fig. 25
Shawabty of Queen Neferu with miniature coffin, Dynasty 11, reign of Mentuhotep II, 2040–2010 B.C., wax, wood, and linen, Deir el-Bahri, tomb of Queen Neferu, figurine length 8.1 cm (3³⁄₁₆ in.), coffin length 18.4 cm (7¼ in.), Received from the Metropolitan Museum of Art, by exchange, 37.550a–c

Fig. 26*
Coffin of the Lady of the House Neby, Dynasty 12, 1991–1783 B.C., wood, Beni Hasan, tomb 294, 51.4 × 214 × 51.4 cm (84¼ × 20¼ × 20¼ in.), Gift of the Beni Hasan Excavations Center, 04.2058

Fig. 27*
Group statue of Ukhhotep II and his family, Dynasty 12, reign of Senwosret II or III, 1897–1841 B.C., granodiorite, Meir, tomb C1,

37 × 38.1 × 7.6 cm (14⁹⁄₁₆ × 15 × 3 in.), Gift of the Egypt Exploration Fund by exchange, 1973.87

Fig. 28
Ivory wand, Dynasty 13, 1783–about 1640 B.C., ivory, said to be from Naqada, length 62.5 cm (24⅝ in.), Sears Fund with additions, 03.1703

Fig. 29
Hippopotamus figurine, Dynasty 11–13, 2040–about 1640 B.C., faience, Dra Abu el-Naga, 12.7 × 8.1 × 20.5 cm (5 × 3³⁄₁₆ × 8¹⁄₁₆ in.), Musée du Louvre, Paris, E 7709. Photograph Hervé Lewandowski / Réunion des Musées Nationaux / Art Resource, New York.

Fig. 30
Stele of Intef, Dynasty 12, reign of Senwosret I, 1971–1926 B.C., limestone, 66 × 36.8 cm (26 × 14½ in.), British Museum, London, EA 581. Image © The Trustees of the British Museum.

Fig. 31
Carved slab from the funerary chapel of Sehetepibra, Dynasty 13, 1783–about 1640 B.C., stone, 30.5 × 42 cm (12 × 16⁹⁄₁₆ in.), The Metropolitan Museum of Art, New York, Rogers Fund, 1965, 65.120.1. Image © The Metropolitan Museum of Art.

Fig. 32
Carved slab from the funerary chapel of Sehetepibra, Dynasty 13, 1783–about 1640 B.C., stone, likely from Abydos, 30.5 × 48 cm (12 × 18¹¹⁄₁₆ in.), The Metropolitan Museum of Art, New York, Rogers Fund, 1965, 65.120.2. Image © The Metropolitan Museum of Art.

ART OF THE MIDDLE KINGDOM

Fig. 33
The Royal Favorite Kemsit, Dynasty 11, reign of Mentuhotep II, 2061–2010 B.C., limestone, Deir el-Bahri, funerary temple of Mentuhotep II, 37.5 × 35.4 cm (14¾ × 13¹⁵⁄₁₆ in.), British Museum, London, EA 1450. Image © The Trustees of the British Museum.

Fig. 34
Mentuhotep II embraced by Montu, Dynasty 11, reign of Mentuhotep II, 2040–2010 B.C., limestone, Deir el-Bahri, funerary temple of Mentuhotep II, 79 × 53.5 cm (31⅛ × 21¹⁄₁₆ in.), British Museum, London, EA 1397. Image © The Trustees of the British Museum.

Fig. 35
Mentuhotep II as Osiris, Dynasty 11, reign of Mentuhotep II, about 2061–2010 B.C., sandstone, paint, height 252 cm (99³⁄₁₆ in.), The Metropolitan Museum of Art, New York, Rogers Fund, 1926, 26.3.29. Image © The Metropolitan Museum of Art.

Fig. 36
Seated statue of Mery, Dynasty 11, reign of Mentuhotep II, 2061–2010 B.C., limestone, Thebes, height 58.1 cm (22⅞ in.), British Museum, London, EA 37895. Image © The Trustees of the British Museum.

Fig. 37*
Osiride statue of Mentuhotep III, reinscribed for Merenptah, Dynasty 11, reign of Sankhkara Mentuhotep III, 2010–1998 B.C., sandstone, Armant, temple of Montu, height 213 cm (83⅞ in.), Egypt Exploration Society in recognition of a contribution to the Robert Mond Expedition from the Harriet Otis Cruft Fund, 38.1395

Fig. 38
Relief of Mentuhotep III, Dynasty 11, reign of Mentuhotep III, 2010–1998 B.C., limestone, Tod, temple of Montu, 102 × 81 × 15 cm (40³⁄₁₆ × 31⅞ × 5⅞ in.), Musée du Louvre, Paris, E 15113. Image © Musée du Louvre / Angèle Dequier.

Fig. 39
Seated statue of Senwosret I, Dynasty 12, reign of Senwosret I, 1971–1926 B.C., limestone, Lisht, funerary temple of Senwosret I, 200 × 58.4 × 123 cm (78¾ × 23 × 48⁷⁄₁₆ in.), Egyptian Museum, Cairo, CG 414. Photograph © Jürgen Liepe.

Fig. 40
Relief fragment depicting foreigners and a battle scene, Dynasty 12, reign of Senwosret I, about 1961–1917 B.C., limestone, paint, 22 × 22 cm (8¹¹⁄₁₆ × 8¹¹⁄₁₆ in.), The Metropolitan Museum of Art, New York, Rogers Fund, 1913, 13.253.3. Image © The Metropolitan Museum of Art.

Fig. 41*
Statue of Lady Sennuwy, Dynasty 12, reign of Senwosret I, 1971–1926 B.C., granodiorite, Nubia, Kerma, tumulus K III, hall A, 172 × 116.5 cm (67¹¹⁄₁₆ × 45⅞ in.), Harvard University–Boston Museum of Fine Arts Expedition, 14.720

Fig. 42
Seated statue of Intef, Dynasty 12, reign of Senwosret I, 1971–1926 B.C., limestone, likely from Abydos, height 64.8 cm (25½ in.), British Museum, London, EA 461. Image © The Trustees of the British Museum.

Fig. 43
Statuette of Amenemhat II, Dynasty 12, reign of Amenemhat II, 1929–1892 B.C., granodiorite, Nubia, Semna, 23.2 × 15.7 × 10.6 cm (9⅛ × 6³⁄₁₆ × 4³⁄₁₆ in.), Harvard University–Boston Museum of Fine Arts Expedition, 29.1132

Fig. 44
Seated statue of the steward of Sehetepibra-ankh, Dynasty 12, reign of Amenemhat II, 1929–1892 B.C., limestone, South Lisht, height 95.5 × 27 × 55.5 cm

(37½ x 10⅝ x 21⅞ in.), The Metropolitan Museum of Art, New York, Rogers Fund and Edward S. Harkness Gift, 1924, 24.1.45. Image © The Metropolitan Museum of Art.

Fig. 45
Senwosret II, Dynasty 12, reign of Senwosret II, 1897–1878 B.C., granite, said to be from Memphis (Mit Rahina), height 35 cm (13¾ in.), Ny Carlsberg Glyptotek, Copenhagen, ÆIN 659. Photograph by Ole Haupt.

Fig. 46
Head of a female sphinx, mid–Dynasty 12, 1897–1878 B.C., quartzite, said to be from Matariya, 27 x 24 x 22 cm (10⅝ x 9⁷⁄₁₆ x 8¹¹⁄₁₆ in.), Partial gift of Magda Saleh and Jack A. Josephson in honor of Dr. Rita E. Freed, Norma Jean Calderwood Curator of Ancient Egyptian, Nubian, and Near Eastern Art and museum purchase with funds from the Florence E. and Horace L. Mayer Funds, Egyptian Curator's Fund, Marilyn M. Simpson Fund, Norma Jean and Stanford Calderwood Discretionary Fund, Mr. and Mrs. James M. Vaughn, Jr., The Vaughn Foundation Fund, Egyptian Deaccession Fund, Mr. and Mrs. John H. Valentine, Jane Marsland and Judith A. Marsland Fund, Ernest Kahn Fund, Susan Cornelia Warren Fund, Samuel Putnam Avery Fund, Mary L. Smith Fund, John Wheelock Elliot and John Morse Elliot Fund, Mary E. Moore Gift, Mrs. James Evans Ladd, Frank Jackson and Nancy McMahon, Alice M. Bartlett Fund, Benjamin Pierce Cheney Donation, Frank M. and Mary T. B. Ferrin Fund, Meg Holmes Robbins, Mr. and Mrs. Mark R. Goldweitz, Allen and Elizabeth R. Mottur, Barbara and Joanne Herman, Clark and Jane Hinkley, Walter and Celia Gilbert, Mr. and Mrs. Gorham L. Cross, Mr. and Mrs. Miguel de Bragança, Honey Scheidt, Mr. and Mrs. G. Arnold Haynes and Margaret J. Faulkner, 2002.609

Fig. 47
Sphinx of Senwosret III, Dynasty 12, reign of Senwosret III, 1878–1841 B.C., gneiss, Thebes, length 73 cm (28¾ in.), The Metropolitan Museum of Art, New York, Gift of Edward S. Harkness, 1917, 17.9.2. Image © The Metropolitan Museum of Art.

Fig. 48
Head of a nobleman (The Josephson Head), late Dynasty 12, 1878–1841 B.C., quartzite, possibly from Memphis, 18.5 x 24 x 21 cm (7⁵⁄₁₆ x 9⁷⁄₁₆ x 8¼ in.), Partial gift of Magda Saleh and Jack A. Josephson and Museum purchase with funds donated by the Florence E. and Horace L. Mayer Funds, Norma Jean and Stanford Calderwood Discretionary Fund, Norma Jean Calderwood Acquisition Fund, Marilyn M. Simpson Fund, Otis

Norcross Fund, Helen and Alice Colburn Fund, William E. Nickerson Fund, Egyptian Curator's Fund, Frederick Brown Fund, Elizabeth Marie Paramino Fund in memory of John F. Paramino, Boston Sculptor, Morris and Louise Rosenthal Fund, Arthur Tracy Cabot Fund, Walter and Celia Gilbert Acquisition Fund, Marshall H. Gould Fund, Arthur Mason Knapp Fund, John Wheelock Elliot and John Morse Elliot Fund, de Bragança Egyptian Purchase Fund, Brian J. Brille Acquisition Fund, Barbara W. and Joanne A. Herman Fund, MFA Senior Associates and MFA Associates Fund for Egyptian Acquisitions, and by exchange from an anonymous gift, 2003.244

Fig. 49
Head of Amenemhat III, Dynasty 12, reign of Amenemhat III, 1844–1797 B.C., greywacke, provenance unknown, height 46 cm (18⅛ in.), Ny Carlsberg Glyptotek, Copenhagen, ÆIN 924. Photograph by Ole Haupt.

Fig. 50
Sphinx of Amenemhat III, Dynasty 12, reign of Amenemhat III, 1844–1979 B.C., granodiorite, Tanis, Egyptian Museum, Cairo, CG 394. Photograph © Jürgen Liepe.

Fig. 51
Double statue of the high priests of Ptah, Sehetepibra-ankhnedjem and his son, Nebpu, Dynasty 12, reign of Senwosret III, 1878–1841 B.C., quartzite, Memphis, 92 x 55 x 30 cm (36¼ x 21⅝ x 11¹³⁄₁₆ in.), Musée du Louvre, Paris, A 47. Photograph Hervé Lewandowski / Réunion des Musées Nationaux / Art Resource, New York.

Fig. 52
Block statue of Senwosretsenbefny, Dynasty 12, reign of Senwosret III–Amenemhat III, about 1878–1797 B.C., quartzite, provenance unknown, 68.6 x 41.9 x 48.3 cm (27 x 16½ x 19 in.), Brooklyn Museum, New York, Charles Edwin Wilbour Fund, 39.602. Photo courtesy of Brooklyn Museum.

Fig. 53
Statuette of a man and his wife, Dynasty 13, 1783–1640 B.C., granodiorite, Nubia, Semna, 15.7 x 11.3 cm (6³⁄₁₆ x 4⁷⁄₁₆ in.), Harvard University–Boston Museum of Fine Arts Expedition, 24.892

DISCOVERING DEIR EL-BERSHA

Fig. 54
King Menkaura, the goddess Hathor, and the deified Hare nome, Old Kingdom, Dynasty 4, reign of Menkaura, 2490–2472 B.C., greywacke, Giza, Menkaura Valley Temple, 84.5 x 43.5 x 49 cm (33¼ x 17⅛ x 19⁵⁄₁₆ in.), Harvard University–Boston Museum of Fine Arts Expedition, 09.200

EARLY DISCOVERIES

Fig. 55
View of the portico of the temple of Thoth at Hermopolis (el-Ashmunein) as it appeared in 1798. From *Description de l'Égypte, ou, Recueil des observations et des recherches qui ont été faites en Égypte pendant l'expédition de l'armée française*, 2nd edition, vol. 4 (Paris: C. L. F. Panckoucke, 1822), plate 51.

THE HARVARD UNIVERSITY–MUSEUM OF FINE ARTS, BOSTON, EXCAVATIONS

Fig. 56
George Andrew Reisner, June 26, 1933, Harvard University–Boston Museum of Fine Arts Expedition Photograph B8331 NS. Photograph by Dahi Ahmed.

Fig. 57
Said Ahmed Said and son at Gammai. From Dows Dunham, *Recollections of an Egyptologist* (Boston: Museum of Fine Arts, 1972), 16.

Fig. 58
The Harvard University–Boston Museum of Fine Arts Expedition, work in progress clearing stones from tombs 2 and 3, April 4, 1915, Harvard University–Boston Museum of Fine Arts Expedition Photograph C6771. Photograph by Mohammed Shadduf.

Fig. 59
View down the shaft of tomb 10A, April 30, 1915, Harvard University–Boston Museum of Fine Arts Expedition Photograph C6800. Photograph by Mohammed Shadduf.

Fig. 60
Cedar coffin in the entrance to the burial chamber of tomb 10A (viewed from shaft), May 2, 1915, Harvard University–Boston Museum of Fine Arts Expedition Photograph C6807. Photograph by Mohammed Shadduf.

Fig. 61
Pile of models and other objects in situ, found between the east wall of tomb 10A and the outer coffin of Governor Djehutynakht, May 11, 1915, Harvard University–Boston Museum of Fine Arts Expedition Photograph C6825. Photograph by Mohammed Shadduf.

Fig. 62
Remains of a human torso in the southwest corner of the burial chamber of tomb 10A, May 7, 1915, Harvard University–Boston Museum of Fine Arts Expedition Photograph C6820. Photograph by Mohammed Shadduf.

Fig. 63
The Middle Kingdom cemetery at Deir el-Bershha today. Photograph courtesy of Katholieke Universiteit Leuven Mission to Dayr al-Barshā.

Fig. 64
Archaeological work in progress at Deir el-Bersha by members of the Katholieke Universiteit Leuven Mission team. Photograph courtesy of Katholieke Universiteit Leuven Mission to Dayr al-Barshā.

Fig. 65
Modern map of Wadi el-Nakhla and environs, created by Mary Reilly after an image provided by Katholieke Universiteit Leuven Mission to Dayr al-Barshā.

THE COFFINS AND CANOPIC CHESTS OF TOMB 10A

Fig. 66
Inner and outer coffins of Governor Djehutynakht in situ (viewed from the burial shaft), tomb 10A, May 3, 1915, Harvard University–Boston Museum of Fine Arts Expedition Photograph C6810. Photograph by Mohammed Shadduf.

Fig. 67*
Front panel (exterior view) of Governor Djehutynakht's outer coffin, late Dynasty 11–early Dynasty 12, 2010–1961 B.C., cedar, Deir el-Bersha, tomb 10, shaft A, 115 x 263 cm (45¼ x 103⁹⁄₁₆ in.), Harvard University–Boston Museum of Fine Arts Expedition, 20.1822

Fig. 68
An edge inscription on the head panel of Governor Djehutynakht's inner coffin, late Dynasty 11–early Dynasty 12, 2010–1961 B.C., cedar, Deir el-Bersha, tomb 10, shaft A, Harvard University–Boston Museum of Fine Arts Expedition, 21.962b

Fig. 69*
Head panel (interior view) of Governor Djehutynakht's outer coffin, late Dynasty 11–early Dynasty 12, 2010–1961 B.C., cedar, Deir el-Bersha, tomb 10, shaft A, 105 x 100 cm (41⁵⁄₁₆ x 39³⁄₈ in.), Harvard University–Boston Museum of Fine Arts Expedition, 20.1824

Fig. 70
Front panel (interior view) of Governor Djehutynakht's outer coffin, late Dynasty 11–early Dynasty 12, 2010–1961 B.C., cedar, Deir el-Bersha, tomb 10, shaft A, 115 x 263 cm (45¼ x 103⁹⁄₁₆ in.), Harvard University–Boston Museum of Fine Arts Expedition, 20.1822

Fig. 71
Detail with false door, front panel (interior view) of Governor Djehutynakht's outer coffin, Harvard University–Boston Museum of Fine Arts Expedition, 20.1822

Fig. 72
Detail with ducks, front panel (interior view) of Governor Djehutynakht's outer coffin, Harvard University–Boston Museum of Fine Arts Expedition, 20.1822

Fig. 73
Detail with offering bearers holding live ducks, front panel (interior view) of Governor Djehutynakht's outer coffin, Harvard University–Boston Museum of Fine Arts Expedition, 20.1822

Fig. 74*
Back panel (interior view) of Governor Djehutynakht's outer coffin, late Dynasty 11–early Dynasty 12, 2010–1961 B.C., cedar, Deir el-Bersha, tomb 10, shaft A, 115 x 262 cm (45¼ x 103⅛ in.), Harvard University–Boston Museum of Fine Arts Expedition, 20.1823

Fig. 75
Detail of a lapis lazuli broadcollar with counterpoise, scepters, weapons, staves, and a beaded apron from the object frieze on the back panel (interior view) of Governor Djehutynakht's outer coffin, Harvard University–Boston Museum of Fine Arts Expedition, 20.1823

Fig. 76*
Lid (underside view) of Governor Djehutynakht's outer coffin, late Dynasty 11–early Dynasty 12, 2010–1961 B.C., cedar, Deir el-Bersha, tomb 10, shaft A, 115 x 262 cm (45¼ x 103⅛ in.), Harvard University–Boston Museum of Fine Arts Expedition, 20.1826

Fig. 77*
Inner coffin of Governor Djehutynakht (frontal view), late Dynasty 11–early Dynasty 12, 2010–1961 B.C., cedar, Deir el-Bersha, tomb 10, shaft A, 80 x 224.1 x 75 cm (31½ x 88¼ x 29½ in.), Harvard University–Boston Museum of Fine Arts Expedition, 21.962a

Fig. 78
Detail of front panel (interior view) of Governor Djehutynakht's inner coffin, Harvard University–Boston Museum of Fine Arts Expedition, 21.962a

Fig. 79
Detail of back panel (interior view) of Governor Djehutynakht's inner coffin, Harvard University–Boston Museum of Fine Arts Expedition, 21.962a

Fig. 80
Detail of the Book of Two Ways, back panel (interior view) of Governor Djehutynakht's inner coffin, Harvard University–Boston Museum of Fine Arts Expedition, 21.962a

Fig. 81*
Head panel (interior view) of Governor Djehutynakht's inner coffin, late Dynasty 11–early Dynasty 12, 2010–1961 B.C., cedar, Deir el-Bersha, tomb 10, shaft A, 66 x 65 cm (26 x 25⁹⁄₁₆ in.),

Harvard University–Boston Museum of Fine Arts Expedition, 21.962b

Fig. 82
Disassembled panels of the middle and inner coffins of Lady Djehutynakht in situ, May 5, 1915, Harvard University–Boston Museum of Fine Arts Expedition Photograph B2484. Photograph by Mohammed Shadduf.

Fig. 83a*
Middle coffin of Lady Djehutynakht (interior view of the front panel with false door), late Dynasty 11–early Dynasty 12, 2010–1961 B.C., cedar, Deir el-Bersha, tomb 10, shaft A, 89 x 243 x 85 cm (35¹⁄₁₆ x 95¹¹⁄₁₆ x 33⁷⁄₁₆ in.), Harvard University–Boston Museum of Fine Arts Expedition, 21.964

Fig. 83b
Middle coffin of Lady Djehutynakht (interior view of the back panel with object frieze), Harvard University–Boston Museum of Fine Arts Expedition, 21.964

Fig. 83c*
Inner coffin of Lady Djehutynakht (interior view of the back panel), late Dynasty 11–early Dynasty 12, 2010–1961 B.C., cedar, Deir el-Bersha, tomb 10, shaft A, 56.5 x 205.5 x 52.5 cm (22¼ x 80⅞ x 20¹¹⁄₁₆ in.), Harvard University–Boston Museum of Fine Arts Expedition, 21.966

Fig. 84*
Detail of the head panel (interior view) of Lady Djehutynakht's middle coffin, Harvard University–Boston Museum of Fine Arts Expedition, 21.964

Fig. 85*
Canopic box and lid of Lady Djehutynakht, late Dynasty 11–early Dynasty 12, 2010–1961 B.C., wood, Deir el-Bersha, tomb 10, shaft A, box 59.7 x 54.6 x 53 cm (23½ x 21½ x 20⅞ in.), lid 53.5 x 51.5 cm (21¹⁄₁₆ x 20¼ in.), Harvard University–Boston Museum of Fine Arts Expedition, 21.421a, 21.422

Fig. 86*
Canopic box with preserved hieroglyphs, late Dynasty 11–early Dynasty 12, 2010–1961 B.C., wood, Deir el-Bersha, tomb 19, shaft B, 56 x 52.5 x 53.5 cm (22¹⁄₁₆ x 20¹¹⁄₁₆ x 21¹⁄₁₆ in.), Harvard University–Boston Museum of Fine Arts Expedition, 21.420

Fig. 87
Interior of Lady Djehutynakht's canopic box, Harvard University–Boston Museum of Fine Arts Expedition, 21.421a

Fig. 88*
Canopic box lid of Lady Djehutynakht (underside view), late Dynasty 11–early Dynasty 12, 2010–1961 B.C., wood, Deir el-Bersha, tomb 10, shaft A, Width x height x depth: 8 x 53.7 x 52.4 (3⅛ x 21⅛ x 20⅝ in.), Harvard University–Boston Museum of Fine Arts Expedition, 21.421b

Fig. 89*
Canopic jar and lid, late Dynasty 11–early Dynasty 12, 2010–1961 B.C., cartonnage, Deir el-Bersha, tomb 10, shaft A, jar height 29.8 cm x diameter 17.8 cm (11¾ x 7 in.), lid height 12.1 cm x diameter 7 cm (4¾ x 2¾ in.), Harvard University–Boston Museum of Fine Arts Expedition, 21.424, 21.425

THE DJEHUTYNAKHTS' BURIAL GOODS

Fig. 90
Stoppered storage jars in situ, eastern niche of tomb 10A, May 2, 1915, Harvard University–Boston Museum of Fine Arts Expedition Photograph C6806. Photograph by Mohammed Shadduf.

Fig. 91*
Storage jar with mud stopper, late Dynasty 11–early Dynasty 12, 2010–1961 B.C., pottery, Deir el-Bersha, tomb 10, shaft A, height 39 cm (15⅜ in.), Harvard University–Boston Museum of Fine Arts Expedition, 21.939

Fig. 92*
Model *hes* jars, late Dynasty 11–early Dynasty 12, 2010–1961 B.C., travertine (Egyptian alabaster), Deir el-Bersha, tomb 10, shaft A, height 14.2–15.2 cm (5⁹⁄₁₆–6 in.), Harvard University–Boston Museum of Fine Arts Expedition, 21.908–21.912

Fig. 93*
Model *hes* jars on a wooden base, late Dynasty 11–early Dynasty 12, 2010–1961 B.C., travertine (Egyptian alabaster), Deir el-Bersha, tomb 10, shaft A, height of jars 10–10.4 cm (3¹⁵⁄₁₆–4⅛ in.), Harvard University–Boston Museum of Fine Arts Expedition, 21.897a–e

Fig. 94*
Model conical bread loaves on a wooden base, late Dynasty 11–early Dynasty 12, 2010–1961 B.C., travertine (Egyptian alabaster), Deir el-Bersha, tomb 10, shaft A, height of loaves 8.4–10 cm (3⁵⁄₁₆–3¹⁵⁄₁₆ in.), Harvard University–Boston Museum of Fine Arts Expedition, 21.901a–21.901c, 21.901e

Fig. 95*
Model table and five model vessels, late Dynasty 11–early Dynasty 12, 2010–1961 B.C., wood and faience, Deir el-Bersha, tomb 10, shaft A, table 9.9 x 16.8 x 22.7 cm (3⅞ x 6⅝ x 8¹⁵⁄₁₆ in.), height of vessels 2.5–8.1 cm (1–3³⁄₁₆ in.), Harvard University–Boston Museum of Fine Arts Expedition, 21.388a–d, 21.390, 21.840

Fig. 96*
Model food, produce, and bowl, late Dynasty 11–early Dynasty 12, 2010–1961 B.C., cartonnage, Deir el-Bersha, tomb 10, shaft A, length .8–18.5 cm (⁵⁄₁₆ – 7⁵⁄₁₆ in.), Harvard University–Boston Museum of Fine Arts Expedition, 21.442, 21.465, 21.467a–c, 21.470, 21.475, 21.937

Fig. 97*
Cache of sticks in situ, western niche of tomb 10A, May 2, 1915, Harvard University–Boston Museum of Fine Arts Expedition Photograph C6805. Photograph by Mohammed Shadduf.

Fig. 98*
Model mace, late Dynasty 11–early Dynasty 12, 2010–1961 B.C., wood, Deir el-Bersha, tomb 10, shaft A, length 46 cm (18⅛ in.), Harvard University–Boston Museum of Fine Arts Expedition, 21.814

Fig. 99*
Model *was*-scepter, late Dynasty 11–early Dynasty 12, 2010–1961 B.C., wood, Deir el-Bersha, tomb 10, shaft A, length 48 cm (18⅞ in.), Harvard University–Boston Museum of Fine Arts Expedition, 21.440

Fig. 100*
Iryt-r staffs, late Dynasty 11–early Dynasty 12, 2010–1961 B.C., Deir el-Bersha, tomb 10, shaft A, length 68–68.2 cm (26¾–26⅞ in.), Harvard University–Boston Museum of Fine Arts Expedition, 21.439a–e, 21.848a–b

Fig. 101*
Two jointed or bent staffs, late Dynasty 11–early Dynasty 12, 2010–1961 B.C., Deir el-Bersha, tomb 10, shaft A, length 18.1 cm (7⅛ in.), Harvard University–Boston Museum of Fine Arts Expedition, 21.846a–b

Fig. 102*
One of a pair of wooden paddles, late Dynasty 11–early Dynasty 12, 2010–1961 B.C., wood, Deir el-Bersha, tomb 10, shaft A, length 71 cm (27¹⁵⁄₁₆ in.), Harvard University–Boston Museum of Fine Arts Expedition, 21.441a

Fig. 103*
Headrest, late Dynasty 11–early Dynasty 12, 2010–1961 B.C., wood, Deir el-Bersha, tomb 10, shaft A, height 16.7 cm (6⁹⁄₁₆ in.), Harvard University–Boston Museum of Fine Arts Expedition, 21.454a–c

Fig. 104*
Model headrest, late Dynasty 11–early Dynasty 12, 2010–1961 B.C., travertine (Egyptian alabaster), Deir el-Bersha, tomb 10, shaft A, height 15 cm (5⅞ in.), Harvard University–Boston Museum of Fine Arts Expedition, 21.907a–c

Fig. 105*
Box, late Dynasty 11–early Dynasty 12, 2010–1961 B.C., wood, Deir el-Bersha, tomb 10, shaft A, 17.5 x 25 x 18.5 cm (6⅞ x 9¹³⁄₁₆ x 7⁵⁄₁₆ in.), Harvard University–Boston Museum of Fine Arts Expedition, 21.843a–b

Fig. 106*
Broadcollar, late Dynasty 11–early Dynasty 12, 2010–1961 B.C., faience, Deir el-Bersha, tomb 10,

shafts A and B, 54 x 15 cm (21¼ x 5⅞ in.), Harvard University–Boston Museum of Fine Arts Expedition, 21.11771

Fig. 107*
Bundle of model arrows, late Dynasty 11–early Dynasty 12, 2010–1961 B.C., wood, Deir el-Bersha, tomb 10, shaft A, length 54 cm (21¼ in.), Harvard University–Boston Museum of Fine Arts Expedition, 21.438

Fig. 108*
Model shields, late Dynasty 11–early Dynasty 12, 2010–1961 B.C., Deir el-Bersha, tomb 10, shaft A, height 12.6–13.8 cm (4¹⁵⁄₁₆–5⁷⁄₁₆ in.), Harvard University–Boston Museum of Fine Arts Expedition, 21.430–21.433

Fig. 109*
Model axe, late Dynasty 11–early Dynasty 12, 2010–1961 B.C., wood, Deir el-Bersha, tomb 10, shaft A, length 26.5 cm (10⁷⁄₁₆ in.), Harvard University–Boston Museum of Fine Arts Expedition, 21.845

Fig. 110*
Model hoe, late Dynasty 11–early Dynasty 12, 2010–1961 B.C., wood, Deir el-Bersha, tomb 10, shaft A, length 46 cm (18⅛ in.), Harvard University–Boston Museum of Fine Arts Expedition, 21.833

Fig. 111*
Statuette of Governor Djehutynakht, late Dynasty 11–early Dynasty 12, 2010–1961 B.C., wood, Deir el-Bersha, tomb 10, shaft A, height 26 cm (10¼ in.), Harvard University–Boston Museum of Fine Arts Expedition, 20.1126

Fig. 112*
Statuette of Lady Djehutynakht, late Dynasty 11–early Dynasty 12, 2010–1961 B.C., wood, Deir el-Bersha, tomb 10, shaft A, height 28.5 cm (11¼ in.), Harvard University–Boston Museum of Fine Arts Expedition, 20.1127

THE DJEHUTYNAKHTS' MODELS

Fig. 113*
Model of a procession of offering bearers (The Bersha Procession), late Dynasty 11–early Dynasty 12, 2010–1961 B.C., wood, Deir el-Bersha, tomb 10, shaft A, 42. 5 x 66.4 x 8.6cm (16¾ x 26⅛ x 3⅜ in.), Harvard University–Boston Museum of Fine Arts Expedition, 21.326

Fig. 114*
Models of female offering bearers, late Dynasty 11–early Dynasty 12, 2010–1961 B.C., wood, Deir el-Bersha, tomb 10, shaft A, height 35–41 cm (13¾–16⅛ in.), Harvard University–Boston Museum of Fine Arts Expedition, 21.418, 21.484, 21.881–21.884

Fig. 115*
Model of two scribes, late Dynasty 11–early Dynasty 12, 2010–1961 B.C., wood, Deir el-Bersha, tomb 10, shaft A, length 20.8 cm (8 3/16 in.), Harvard University–Boston Museum of Fine Arts Expedition, 21.875

Fig. 116*
Model of a procession of three overseers, late Dynasty 11–early Dynasty 12, 2010–1961 B.C., wood, Deir el-Bersha, tomb 10, shaft A, length 18.8 cm (7 3/8 in.), Harvard University–Boston Museum of Fine Arts Expedition, 21.887

Fig. 117*
Model of a procession of male offering bearers, late Dynasty 11–early Dynasty 12, 2010–1961 B.C., wood, Deir el-Bersha, tomb 10, shaft A, length 64.5 cm (25 3/8 in.), Harvard University–Boston Museum of Fine Arts Expedition, 21.12494

Fig. 118*
Model of a procession of soldiers, late Dynasty 11–early Dynasty 12, 2010–1961 B.C., wood, Deir el-Bersha, tomb 10, shaft A, 18 x 39.5 x 12.5 cm (7 1/16 x 15 9/16 x 4 15/16 in.), Harvard University–Boston Museum of Fine Arts Expedition, 21.803

Fig. 119*
Models of cattle being fed by hand, late Dynasty 11–early Dynasty 12, 2010–1961 B.C., wood, Deir el-Bersha, tomb 10, shaft A, length 30–33 cm (11 13/16–13 in.), Harvard University–Boston Museum of Fine Arts Expedition, 21.16702, 21.819, 21.413, 21.823

Fig. 120*
Model scene of workers plowing a field, late Dynasty 11–early Dynasty 12, 2010–1961 B.C., wood, Deir el-Bersha, tomb 10, shaft A, length 54 cm (21 1/4 in.), Harvard University–Boston Museum of Fine Arts Expedition, 21.408

Fig. 121*
Model of a granary, late Dynasty 11–early Dynasty 12, 2010–1961 B.C., wood, Deir el-Bersha, tomb 10, shaft A, 27 x 29 x 28.5 cm (10 5/8 x 11 7/16 x 11 1/4 in.), Harvard University–Boston Museum of Fine Arts Expedition, 21.409

Fig. 122*
Model scene of bakers and brewers, late Dynasty 11–early Dynasty 12, 2010–1961 B.C., wood, Deir el-Bersha, tomb 10, shaft A, 24.3 x 22 x 28 cm (9 9/16 x 8 11/16 x 11 in.), Harvard University–Boston Museum of Fine Arts Expedition, 21.886

Fig. 123*
Model scene of weavers, late Dynasty 11–early Dynasty 12, 2010–1961 B.C., wood, Deir el-Bersha, tomb 10, shaft A, 27 x 40.5 x 14 cm (10 5/8 x 15 15/16 x 5 1/2 in.), Harvard University–Boston Museum of Fine Arts Expedition, 21.891

Fig. 124*
Model scene of carpenters, late Dynasty 11–early Dynasty 12, 2010–1961 B.C., wood, Deir el-Bersha, tomb 10, shaft A, 27.5 x 18 x 23 cm (10 13/16 x 7 1/16 x 9 1/16 in.), Harvard University–Boston Museum of Fine Arts Expedition, 21.412

Fig. 125*
Model scene of brick-makers, late Dynasty 11–early Dynasty 12, 2010–1961 B.C., wood, Deir el-Bersha, tomb 10, shaft A, 25.5 x 54.5 x 17.4 cm (21 7/16 x 10 1/16 x 6 7/8 in.), Harvard University–Boston Museum of Fine Arts Expedition, 21.411

Fig. 126*
Model of a boat under sail, late Dynasty 11–early Dynasty 12, 2010–1961 B.C., wood, Deir el-Bersha, tomb 10, shaft A, 51 x 72 x 17 cm (20 1/16 x 28 3/8 x 6 11/16 in.), Harvard University–Boston Museum of Fine Arts Expedition, 21.822

Fig. 127*
Model of a boat being rowed, late Dynasty 11–early Dynasty 12, 2010–1961 B.C., wood, Deir el-Bersha, tomb 10, shaft A, 30 x 67 x 27 cm (11 13/16 x 26 3/8 x 10 5/8 in.), Harvard University–Boston Museum of Fine Arts Expedition, 21.870

Fig. 128*
Model of a boat being rowed, late Dynasty 11–early Dynasty 12, 2010–1961 B.C., wood, Deir el-Bersha, tomb 10, shaft A, 33 x 71 x 22 cm (13 x 27 15/16 x 8 11/16 in.), Harvard University–Boston Museum of Fine Arts Expedition, 21.483

Fig. 129*
Model of a transport boat with a portable cabin, late Dynasty 11–early Dynasty 12, 2010–1961 B.C., wood, Deir el-Bersha, tomb 10, shaft A, 49 x 127 x 23 cm (19 5/16 x 50 x 9 1/16 in.), Harvard University–Boston Museum of Fine Arts Expedition, 21.877

Fig. 130*
Model of a military transport boat, late Dynasty 11–early Dynasty 12, 2010–1961 B.C., wood, Deir el-Bersha, tomb 10, shaft A, 44 x 120 x 40 cm (17 5/16 x 47 1/4 x 15 3/4 in.), Harvard University–Boston Museum of Fine Arts Expedition, 21.407

Fig. 131*
Model of a kitchen boat, late Dynasty 11–early Dynasty 12, 2010–1961 B.C., wood, Deir el-Bersha, tomb 10, shaft A, 31 x 61 x 15 cm (12 3/16 x 24 x 5 7/8 in.), Harvard University–Boston Museum of Fine Arts Expedition, 21.494

Fig. 132*
Model of a kitchen boat, late Dynasty 11–early Dynasty 12, 2010–1961 B.C., wood, Deir el-Bersha, tomb 10, shaft A, 31 x 67 x 14 cm (12 3/16 x 26 3/8 x 5 1/2 in.), Harvard University–Boston Museum of Fine Arts Expedition, 21.800

Fig. 133*
Model of a fowling boat, late Dynasty 11–early Dynasty 12, 2010–1961 B.C., wood, Deir el-Bersha, tomb 10, shaft A, 28 x 59 x 10 cm (11 x 23 1/4 x 3 15/16 in.), Harvard University–Boston Museum of Fine Arts Expedition, 21.890

Fig. 134*
Model of a funerary boat, late Dynasty 11–early Dynasty 12, 2010–1961 B.C., wood, Deir el-Bersha, tomb 10, shaft A, 32 x 72 x 27 cm (12 5/8 x 28 3/8 x 10 5/8 in.), Harvard University–Boston Museum of Fine Arts Expedition, 21.829

Fig. 135*
Model of a funerary boat, late Dynasty 11–early Dynasty 12, 2010–1961 B.C., wood, Deir el-Bersha, tomb 10, shaft A, 38 x 100 x 19 cm (14 15/16 x 39 3/8 x 7 1/2 in.), Harvard University–Boston Museum of Fine Arts Expedition, 21.880

Fig. 136*
Model of a pilgrimage boat, late Dynasty 11–early Dynasty 12, 2010–1961 B.C., wood, Deir el-Bersha, tomb 10, shaft A, 55 x 111 x 29 cm (21 5/8 x 43 11/16 x 11 7/16 in.), Harvard University–Boston Museum of Fine Arts Expedition, 21.406a–b

APPENDIX A: THE MUMMIFIED HEAD OF TOMB 10A

Fig. 137*
Head of the Djehutynakht mummy, late Dynasty 11–early Dynasty 12, 2010–1961 B.C., human remains, linen, Deir el-Bersha, tomb 10, shaft A, height 20 cm (7 7/8 in.), Harvard University–Boston Museum of Fine Arts Expedition, 21.11767

Fig. 138
Computerized tomography (CT) imaging of the Djehutynakht skull. Image courtesy of Rajiv Gupta.

Fig. 139
Model highlighting skeletal structures removed from the Djehutynakht skull. Image courtesy of Paul H. Chapman.

APPENDIX B: DATING TOMB 10A

Fig. 140
Stele of Mery, Dynasty 12, reign of Senwosret I, 1971–1926 B.C., limestone, Abydos, 95 x 65 cm (37 3/8 x 25 9/16 in.), Musée du Louvre, Paris, C3. Photograph Béatrice Hatala / Réunion des Musées Nationaux / Art Resource, New York.

Fig. 141
Relief of geese on papyrus plants, Deir el-Bersha, tomb 5 (Ahanakht), outer chamber, late Dynasty 11, 2010–1991 B.C., limestone. Image courtesy of Katholieke Universiteit Leuven Mission to Dayr al-Barshā.

Fig. 142*
Illustration of a seal amulet and beads on original cord (late Dynasty 11–early Dynasty 12, 2010–1961 B.C., lapis lazuli, carnelian, glazed steatite, and cord, Deir el-Bersha, tomb 10, shaft A, length of seal 2.2 cm (⅞ in.), Harvard University–Boston Museum of Fine Arts Expedition, 21.10558). Museum of Fine Arts, Boston, Department of Art of the Ancient World files.

APPENDIX C: MAPS AND CHARTS

Fig. 143
Map of Egypt, created by Mary Reilly after Erik Hornung and Betsy M. Bryan, eds., *The Quest for Immortality*, xv.

Fig. 144
Plan of the elite cliff terrace, Deir el-Bersha necropolis. Image courtesy of Katholieke Universiteit Leuven Mission to Dayr al-Barshā.

Fig. 145
Schematic plan of Deir el-Bersha tomb 10A, adapted by Jennifer Marsh from the Museum of Fine Arts, Boston, Department of Art of the Ancient World files and Edward L. B. Terrace, *Egyptian Paintings of the Middle Kingdom*, 13. Colorized by Nicholas S. Picardo.

Fig. 146
Genealogical chart of the Middle Kingdom nomarchs of Deir el-Bersha, adapted by Nicholas S. Picardo from Harco Willems, *Chests of Life*, 71.

Fig. 147
Model of five female offering bearers, late Dynasty 11–early Dynasty 12, 2010–1961 B.C., wood, Deir el-Bersha, tomb 10, shaft A, length 19.5 cm (7¹¹⁄₁₆ in.), Harvard University–Boston Museum of Fine Arts Expedition, 21.888.

pp. 14–15
J. P. Sébah (1838–1890), *Tombs of Beni Hasan*, photograph, 26.5 x 34.8 cm (10⁷⁄₁₆ x 13¹¹⁄₁₆ in.), Gift of Francis Lee Higginson, 2001.473.

pp. 168–69
Model boats, late Dynasty 11–early Dynasty 12, 2010–1961 B.C., wood, Deir el-Bersha, tomb 10, shaft A, Harvard University–Boston Museum of Fine Arts Expedition, 21.406a–b, 21.407, 21.417, 21.483, 21.494, 21.822, 21.824, 21.827–21.830, 21.870, 21.877, 21.879, 21.880, 21.890.

pp. 178–79
View of the Wadi el-Nakhla, April 7, 1915, Harvard University–Boston Museum of Fine Arts Expedition Photograph A2199 NS. Photograph by Mohammed Shadduf.

OTHER OBJECTS

The following objects from the Museum of Fine Arts, Boston's collections are included in the exhibition "The Secrets of Tomb 10A: Egypt 2000 B.C." but are not illustrated. The objects are listed in the order in which they were accessioned.

Concave beaker, Dynasty 12, 1991–1783 B.C., serpentine, el-Kab, height 8.4 cm (3⁵⁄₁₆ in.), Egyptian Research Account by subscription, 97.1022

Straight sided beaker with lid, First Intermediate Period or Middle Kingdom, 2100–1640 B.C., travertine (Egyptian alabaster), Asyut, height 18.5 cm (7⁵⁄₁₆ in.), Sears Fund with additions, 04.1887

Relief from the funerary temple of Nebhepetra Mentuhotep II, Dynasty 11, reign of Mentuhotep II, 2061–2010 B.C., limestone, Thebes, Deir el-Bahri, 48 x 42 cm (18⅞ x 16⁹⁄₁₆ in.), Egypt Exploration Fund by subscription, 07.532

Beaded collar with amulets, Dynasty 11–13, 2061–1640 B.C., glazed steatite, gold, electrum, Sheikh Farag, tomb SF 43, length 18.5 cm (7⁵⁄₁₆ in.), Harvard University–Boston Museum of Fine Arts Expedition, 13.3609

Kohl jar with lid, 2061–1640 B.C., agate, Sheikh Farag, tomb SF 168, height 3.6 x diameter 4 cm (1⁷⁄₁₆ x 1⁹⁄₁₆ in.), Harvard University–Boston Museum of Fine Arts Expedition, 13.3692a–b

Concave beaker, 2061–1640 B.C., stone, Sheikh Farag, tomb SF 42, height 7 cm (2¾ in.), Harvard University–Boston Museum of Fine Arts Expedition, 13.3912

Female figurine, late Dynasty 11–Dynasty 12, 2040–1783 B.C., wood, Deir el-Bersha, tomb 19, shaft B, 27 x 3.4 x 4.8 cm (10⅝ x 1⁵⁄₁₆ x 1⅞ in.), Harvard University–Boston Museum of Fine Arts Expedition, 20.1120

Female figurine, late Dynasty 11–Dynasty 12, 2040–1783 B.C., wood, Deir el-Bersha, tomb 19, shaft B, 18.6 x 5.7 x 3.2 cm (7⁵⁄₁₆ x 2¼ x 1¼ in.), Harvard University–Boston Museum of Fine Arts Expedition, 20.1121

Slender shouldered jar with flaring neck (*hes* jar), Dynasty 11, 2140–1991 B.C., bronze, Deir el-Bersha, height 13.5 cm (5⁵⁄₁₆ in.), Harvard University–Boston Museum of Fine Arts Expedition, 20.1129

Foot panel of Governor Djehutynakht's outer coffin, late Dynasty 11–early Dynasty 12, 2010–1961 B.C., cedar, Deir el-Bersha, tomb 10, shaft A, 115 x 116 x 16 cm (45¼ x 45¹¹⁄₁₆ x 6⁵⁄₁₆ in.), Harvard University–Boston Museum of Fine Arts Expedition, 20.1825

Base of Governor Djehutynakht's outer coffin, late Dynasty 11–early Dynasty 12, 2010–1961 B.C.,

wood, Deir el-Bersha, tomb 10, shaft A, 10 x 242.5 x 96.5 cm (3¹⁵⁄₁₆ x 95½ x 38 in.), Harvard University–Boston Museum of Fine Arts Expedition, 20.1827

Model *hes* jars, late Dynasty 11–early Dynasty 12, 2010–1961 B.C., stone, Deir el-Bersha, tomb 10, shaft A, each height 4 x diameter 1.3 cm (1⁹⁄₁₆ x ½ in.), Harvard University–Boston Museum of Fine Arts Expedition, 21.377–378

Model *hes* jar, late Dynasty 11–early Dynasty 12, 2010–1961 B.C., wood and gold leaf, Deir el-Bersha, tomb 10, shaft A, height 3.3 x diameter 1.1 cm (1⁵⁄₁₆ x ⁷⁄₁₆ in.), Harvard University–Boston Museum of Fine Arts Expedition, 21.379

Bracelet, late Dynasty 11–early Dynasty 12, 2010–1961 B.C., Gold, Deir el-Bersha, tomb 10, shaft A, 6.1 x 0.8 cm (2⅜ x ⁵⁄₁₆ in.), Harvard University–Boston Museum of Fine Arts Expedition, 21.386

Model table, late Dynasty 11–early Dynasty 12, 2010–1961 B.C., Deir el-Bersha, tomb 10, shaft A, wood, 1.5 x 16.5 x 7.6 cm (⁹⁄₁₆ x 6½ x 3 in.), Harvard University–Boston Museum of Fine Arts Expedition, 21.388e

Model *hes* jars, late Dynasty 11–early Dynasty 12, 2010–1961 B.C., faience, Deir el-Bersha, tomb 10, shaft A, each height 7.9–8.2 x diameter 1.8–2 cm (3⅛–3¼ x ¹¹⁄₁₆–¹³⁄₁₆ in.), Harvard University–Boston Museum of Fine Arts Expedition, 21.389a–d

Spearhead, late Dynasty 11–early Dynasty 12, 2010–1961 B.C., bronze, Deir el-Bersha, tomb 10, shaft A, length 14 cm (5½ in.), Harvard University–Boston Museum of Fine Arts Expedition, 21.404

Model of a granary, late Dynasty 11–early Dynasty 12, 2010–1961 B.C., wood, Deir el-Bersha, tomb 10, shaft A, 25.5 x 27 cm (10⅛ x 10⅝ in.), Harvard University–Boston Museum of Fine Arts Expedition, 21.410

Model of a pilgrimage boat, late Dynasty 11–early Dynasty 12, 2010–1961 B.C., wood, Deir el-Bersha, tomb 10, shaft A, 29 x 59 x 13 cm (11⁷⁄₁₆ x 23¼ x 5⅛ in.), Harvard University–Boston Museum of Fine Arts Expedition, 21.415

Model of a boat being rowed, late Dynasty 11–early Dynasty 12, 2010–1961 B.C., wood, Deir el-Bersha, tomb 10, shaft A, 30 x 61 x 11 cm (11¹³⁄₁₆ x 24 x 4⁵⁄₁₆ in.), Harvard University–Boston Museum of Fine Arts Expedition, 21.416

Model of a boat being rowed, late Dynasty 11–early Dynasty 12, 2010–1961 B.C., wood, Deir el-Bersha, tomb 10, shaft A, 25 x 79 x 31 cm (9¹³⁄₁₆ x 31⅛ x 12¾₆ in.), Harvard University–Boston Museum of Fine Arts Expedition, 21.417

Mummy mask, late Dynasty 11 or early Dynasty 12, 2010–1961 B.C., cartonnage, Deir el-Bersha, tomb 10, shaft A, 42 x 34 x 1 cm (16⁹⁄₁₆ x 13³⁄₈ x ³⁄₈ in.), Harvard University–Boston Museum of Fine Arts Expedition, 21.423

Linen cloth, late Dynasty 11–early Dynasty 12, 2010–1961 B.C., linen, Deir el-Bersha, tomb 10, shaft A, 328 x 110 cm (129¹⁄₈ x 43⁵⁄₁₆ in.), Harvard University–Boston Museum of Fine Arts Expedition, 21.426

Model shield, late Dynasty 11–early Dynasty 12, 2010–1961 B.C., wood, Deir el-Bersha, tomb 10, shaft A, height 15.9 cm (6¼ in.), Harvard University–Boston Museum of Fine Arts Expedition, 21.427

Model shield, late Dynasty 11–early Dynasty 12, 2010–1961 B.C., wood, Deir el-Bersha, tomb 10, shaft A, height 15.7 cm (6³⁄₁₆ in.), Harvard University–Boston Museum of Fine Arts Expedition, 21.428

Model arrows, late Dynasty 11–early Dynasty 12, 2010–1961 B.C., wood and copper, Deir el-Bersha, tomb 10, shaft A, length 10.5 cm (4¹⁄₈ in.), Harvard University–Boston Museum of Fine Arts Expedition, 21.434a–d

Model arrow, late Dynasty 11–early Dynasty 12, 2010–1961 B.C., wood, Deir el-Bersha, tomb 10, shaft A, length 137 cm (53¹⁵⁄₁₆ in.), Harvard University–Boston Museum of Fine Arts Expedition, 21.435

Model bows or arrows, late Dynasty 11–early Dynasty 12, 2010–1961 B.C., wood, Deir el-Bersha, tomb 10, shaft A, length 58.1 cm (22⁷⁄₈ in.), Harvard University–Boston Museum of Fine Arts Expedition, 21.436

Bundle of model arrows, late Dynasty 11–early Dynasty 12, 2010–1961 B.C., wood, Deir el-Bersha, tomb 10, shaft A, length 57 cm (22⁷⁄₁₆ in.), Harvard University–Boston Museum of Fine Arts Expedition, 21.437

One of a pair of wooden paddles, late Dynasty 11–early Dynasty 12, 2010–1961 B.C., wood, Deir el-Bersha, tomb 10, shaft A, 58 x 12.5 cm (22¹³⁄₁₆ x 4¹⁵⁄₁₆ in.), Harvard University–Boston Museum of Fine Arts Expedition, 21.441b

Headrests, late Dynasty 11–early Dynasty 12, 2010–1961 B.C., wood, Deir el-Bersha, tomb 10, shaft A, each 21.2 x 24 cm (8³⁄₈ x 9⁷⁄₁₆ in.), Harvard University–Boston Museum of Fine Arts Expedition, 21.452–453

Eye from a mummy mask, late Dynasty 11–early Dynasty 12, 2010–1961 B.C., cartonnage, bone, copper, Deir el-Bersha, tomb 10, shaft A, 2 x 4.5 x 0.8 cm (¹³⁄₁₆ x 1¾ x ⁵⁄₁₆ in.), Harvard University–Boston Museum of Fine Arts Expedition, 21.471

Model of a bolt of cloth, late Dynasty 11–early Dynasty 12, 2010–1961 B.C., cartonnage, Deir el-Bersha, tomb 10, shaft A, 13.2 x 6.4 cm (5³⁄₁₆ x 2½ in.), Harvard University–Boston Museum of Fine Arts Expedition, 21.473

Model of a boat being rowed, late Dynasty 11–early Dynasty 12, 2010–1961 B.C., wood, Deir el-Bersha, tomb 10, shaft A, 22 x 36 x 10 cm (8¹¹⁄₁₆ x 14³⁄₁₆ x 3¹⁵⁄₁₆ in.), Harvard University–Boston Museum of Fine Arts Expedition, 21.485

Model of a boat under sail, late Dynasty 11–early Dynasty 12, 2010–1961 B.C., wood, Deir el-Bersha, tomb 10, shaft A, 27 x 59 x 11 cm (10⁵⁄₈ x 23¼ x 4⁵⁄₁₆ in.), Harvard University–Boston Museum of Fine Arts Expedition, 21.487

Model of a boat being rowed, late Dynasty 11–early Dynasty 12, 2010–1961 B.C., wood, Deir el-Bersha, tomb 10, shaft A, 34 x 59 x 29 cm (13³⁄₈ x 23¼ x 11⁷⁄₁₆ in.), Harvard University–Boston Museum of Fine Arts Expedition, 21.488

Model of a transport boat with portable cabin, late Dynasty 11–early Dynasty 12, 2010–1961 B.C., wood, Deir el-Bersha, tomb 10, shaft A, 30 x 61 x 11 cm (11¹³⁄₁₆ x 24 x 4⁵⁄₁₆ in.), Harvard University–Boston Museum of Fine Arts Expedition, 21.489

Model of a pilgrimage boat, late Dynasty 11–early Dynasty 12, 2010–1961 B.C., wood, Deir el-Bersha, tomb 10, shaft A, 31 x 57 x 14 cm (12³⁄₄ x 22⁷⁄₁₆ x 5½ in.), Harvard University–Boston Museum of Fine Arts Expedition, 21.490

Model of a boat, late Dynasty 11–early Dynasty 12, 2010–1961 B.C., wood, Deir el-Bersha, tomb 10, shaft A, 16 x 60 x 12 cm (6⁵⁄₁₆ x 23⁵⁄₈ x 4¾ in.), Harvard University–Boston Museum of Fine Arts Expedition, 21.491

Model of a boat being rowed, late Dynasty 11–early Dynasty 12, 2010–1961 B.C., wood, Deir el-Bersha, tomb 10, shaft A, 24 x 56 x 10 cm (9⁷⁄₁₆ x 22¹⁄₁₆ x 3¹⁵⁄₁₆ in.), Harvard University–Boston Museum of Fine Arts Expedition, 21.492

Model of a boat being rowed, late Dynasty 11–early Dynasty 12, 2010–1961 B.C., wood, Deir el-Bersha, tomb 10, shaft A, 28 x 69 x 22 cm (11 x 27³⁄₁₆ x 8¹¹⁄₁₆ in.), Harvard University–Boston Museum of Fine Arts Expedition, 21.493

Model of a boat under sail, late Dynasty 11–early Dynasty 12, 2010–1961 B.C., wood, Deir el-Bersha, tomb 10, shaft A, 31 x 57 x 12 cm (12³⁄₄ x 22⁷⁄₁₆ x 4¾ in.), Harvard University–Boston Museum of Fine Arts Expedition, 21.495

Model of a boat, late Dynasty 11–early Dynasty 12, 2010–1961 B.C., wood, Deir el-Bersha, tomb 10, shaft A, 13 x 56 x 10 cm (5¹⁄₈ x 22¹⁄₁₆ x 3¹⁵⁄₁₆ in.),

Harvard University–Boston Museum of Fine Arts Expedition, 21.496

Model of a boat under sail, late Dynasty 11–early Dynasty 12, 2010–1961 B.C., wood, Deir el-Bersha, tomb 10, shaft A, 30 x 59 x 11 cm (11¹³⁄₁₆ x 23¼ x 4⁵⁄₁₆ in.), Harvard University–Boston Museum of Fine Arts Expedition, 21.497

Canopic jar lid in the shape of a human head, late Dynasty 11–early Dynasty 12, 2010–1961 B.C., wood, Deir el-Bersha, tomb 10, shaft A, height 16.5 x diameter 15.7 cm (6½ x 6³⁄₁₆ in.), Harvard University–Boston Museum of Fine Arts Expedition, 21.498

Model of a boat being rowed, late Dynasty 11–early Dynasty 12, 2010–1961 B.C., wood, Deir el-Bersha, tomb 10, shaft A, 12 x 48 x 11 cm (4¾ x 18⁷⁄₈ x 4⁵⁄₁₆ in.), Harvard University–Boston Museum of Fine Arts Expedition, 21.500

Model of a boat under sail, late Dynasty 11–early Dynasty 12, 2010–1961 B.C., wood, Deir el-Bersha, tomb 10, shaft A, 30 x 57 x 11 cm (11¹³⁄₁₆ x 22⁷⁄₁₆ x 4⁵⁄₁₆ in.), Harvard University–Boston Museum of Fine Arts Expedition, 21.801

Model of a fowling boat, late Dynasty 11–early Dynasty 12, 2010–1961 B.C., wood, Deir el-Bersha, tomb 10, shaft A, 23 x 47 x 11 cm (9¹⁄₁₆ x 18½ x 4⁵⁄₁₆ in.), Harvard University–Boston Museum of Fine Arts Expedition, 21.802

Model of a procession of soldiers, late Dynasty 11–early Dynasty 12, 2010–1961 B.C., wood, Deir el-Bersha, tomb 10, shaft A, 18 x 39.5 x 12.5 cm (7¹⁄₁₆ x 15⁹⁄₁₆ x 4¹⁵⁄₁₆ in.), Harvard University–Boston Museum of Fine Arts Expedition, 21.803

Model sandals, late Dynasty 11–early Dynasty 12, 2010–1961 B.C., wood, Deir el-Bersha, tomb 10, shaft A, length 27.6 cm (10⁷⁄₈ in.), Harvard University–Boston Museum of Fine Arts Expedition, 21.804a–b

Model sandals, late Dynasty 11–early Dynasty 12, 2010–1961 B.C., wood, Deir el-Bersha, tomb 10, shaft A, length 28.5 cm (11¼ in.), Harvard University–Boston Museum of Fine Arts Expedition, 21.805a–b

Model of a procession of soldiers, late Dynasty 11–early Dynasty 12, 2010–1961 B.C., wood, Deir el-Bersha, tomb 10, shaft A, length 53.5 cm (21¹⁄₁₆ in.), Harvard University–Boston Museum of Fine Arts Expedition, 21.806

Model of a bakery and brewery, late Dynasty 11–early Dynasty 12, 2010–1961 B.C., wood, Deir el-Bersha, tomb 10, shaft A, length 39.5 cm (15⁹⁄₁₆ in.), Harvard University–Boston Museum of Fine Arts Expedition, 21.807

Model of a granary, late Dynasty 11–early Dynasty 12, 2010–1961 B.C., wood, Deir el-Bersha, tomb 10, shaft A, Width x height: 25 x 21 cm (9 $^{13}/_{16}$ x 8 $^{1}/_{4}$ in.), Harvard University–Boston Museum of Fine Arts Expedition, 21.808

Box, late Dynasty 11–early Dynasty 12, 2010–1961 B.C., wood, plaster, Deir el-Bersha, tomb 10, shaft A, 18.2 x 38.2 x 30.7 cm (7 $^{3}/_{16}$ x 15 $^{1}/_{16}$ x 12 $^{1}/_{16}$ in.), Harvard University–Boston Museum of Fine Arts Expedition, 21.817

Model of a boat under sail, late Dynasty 11–early Dynasty 12, 2010–1961 B.C., wood, Deir el-Bersha, tomb 10, shaft A, 31 x 59 x 12 cm (12 $^{3}/_{16}$ x 23 $^{1}/_{4}$ x 4 $^{3}/_{4}$ in.), Harvard University–Boston Museum of Fine Arts Expedition, 21.818

Model of a boat being rowed, late Dynasty 11–early Dynasty 12, 2010–1961 B.C., wood, Deir el-Bersha, tomb 10, shaft A, 30 x 58 x 11 cm (11 $^{13}/_{16}$ x 22 $^{13}/_{16}$ x 4 $^{5}/_{16}$ in.), Harvard University–Boston Museum of Fine Arts Expedition, 21.820

Model of men making bricks, late Dynasty 11–early Dynasty 12, 2010–1961 B.C., wood, Deir el-Bersha, tomb 10, shaft A, length 56 cm (22 $^{1}/_{16}$ in.), Harvard University–Boston Museum of Fine Arts Expedition, 21.821

Model of a boat under sail, late Dynasty 11–early Dynasty 12, 2010–1961 B.C., wood, Deir el-Bersha, tomb 10, shaft A, 31 x 61 x 12 cm (12 $^{3}/_{16}$ x 24 x 4 $^{3}/_{4}$ in.), Harvard University–Boston Museum of Fine Arts Expedition, 21.824

Model of a boat under sail, late Dynasty 11–early Dynasty 12, 2010–1961 B.C., wood, Deir el-Bersha, tomb 10, shaft A, 47 x 67 x 17 cm (18 $^{1}/_{2}$ x 26 $^{3}/_{8}$ x 6 $^{11}/_{16}$ in.), Harvard University–Boston Museum of Fine Arts Expedition, 21.825

Model of a boat under sail, late Dynasty 11–early Dynasty 12, 2010–1961 B.C., wood, Deir el-Bersha, tomb 10, shaft A, 32 x 63 x 13 cm (12 $^{5}/_{8}$ x 24 $^{13}/_{16}$ x 5 $^{1}/_{8}$ in.), Harvard University–Boston Museum of Fine Arts Expedition, 21.826

Model of a boat under sail, late Dynasty 11–early Dynasty 12, 2010–1961 B.C., wood, Deir el-Bersha, tomb 10, shaft A, 32 x 67 x 13 cm (12 $^{5}/_{8}$ x 26 $^{3}/_{8}$ x 5 $^{1}/_{8}$ in.), Harvard University–Boston Museum of Fine Arts Expedition, 21.827

Model of a boat under sail, late Dynasty 11–early Dynasty 12, 2010–1961 B.C., wood, Deir el-Bersha, tomb 10, shaft A, 33 x 67 x 13 cm (13 x 26 $^{3}/_{8}$ x 5 $^{1}/_{8}$ in.), Harvard University–Boston Museum of Fine Arts Expedition, 21.828

Model of a transport boat with a portable cabin, late Dynasty 11–early Dynasty 12, 2010–1961 B.C., wood, Deir el-Bersha, tomb 10, shaft A, 30 x 64 x 13 cm (11 $^{13}/_{16}$ x 25 $^{3}/_{16}$ x 5 $^{1}/_{8}$ in.), Harvard University–Boston Museum of Fine Arts Expedition, 21.830

Model of men herding cattle, late Dynasty 11–early Dynasty 12, 2010–1961 B.C., wood, Deir el-Bersha, tomb 10, shaft A, 26 x 63 x 18 cm (10 $^{1}/_{4}$ x 24 $^{13}/_{16}$ x 7 $^{1}/_{16}$ in.), Harvard University–Boston Museum of Fine Arts Expedition, 21.831

Mallet, late Dynasty 11–early Dynasty 12, 2010–1961 B.C., wood, Deir el-Bersha, tomb 10, shaft A, length 32 cm (12 $^{5}/_{8}$ in.), Harvard University–Boston Museum of Fine Arts Expedition, 21.832

Model hoe, late Dynasty 11–early Dynasty 12, 2010–1961 B.C., wood, Deir el-Bersha, tomb 10, shaft A, length 47.8 cm (18 $^{13}/_{16}$ in.), Harvard University–Boston Museum of Fine Arts Expedition, 21.834a–b

Model of a funerary boat, late Dynasty 11–early Dynasty 12, 2010–1961 B.C., wood, Deir el-Bersha, tomb 10, shaft A, 28 x 83 x 13 cm (11 x 32 $^{11}/_{16}$ x 5 $^{1}/_{8}$ in.), Harvard University–Boston Museum of Fine Arts Expedition, 21.838

Model table, late Dynasty 11–early Dynasty 12, 2010–1961 B.C., wood, Deir el-Bersha, tomb 10, shaft A, 12.8 x 19.4 x 15.8 cm (5 $^{1}/_{16}$ x 7 $^{5}/_{8}$ x 6 $^{1}/_{4}$ in.), Harvard University–Boston Museum of Fine Arts Expedition, 21.839

Model table, late Dynasty 11–early Dynasty 12, 2010–1961 B.C., wood, Deir el-Bersha, tomb 10, shaft A, 13 x 19 x 15.5 cm (5 $^{1}/_{8}$ x 7 $^{1}/_{2}$ x 6 $^{1}/_{8}$ in.), Harvard University–Boston Museum of Fine Arts Expedition, 21.841

Iryt-r staff, late Dynasty 11–early Dynasty 12, 2010–1961 B.C., wood, Deir el-Bersha, tomb 10, shaft A, length 71 x diameter 2 cm (27 $^{15}/_{16}$ x $^{13}/_{16}$ in.), Harvard University–Boston Museum of Fine Arts Expedition, 21.848c

Model of a boat under sail, late Dynasty 11–early Dynasty 12, 2010–1961 B.C., wood, Deir el-Bersha, tomb 10, shaft A, 34 x 62 x 18 cm (13 $^{3}/_{8}$ x 24 $^{7}/_{16}$ x 7 $^{1}/_{16}$ in.), Harvard University–Boston Museum of Fine Arts Expedition, 21.871

Model of a funerary boat, late Dynasty 11–early Dynasty 12, 2010–1961 B.C., wood, Deir el-Bersha, tomb 10, shaft A, 29 x 70 x 11 cm (11 $^{7}/_{16}$ x 27 $^{9}/_{16}$ x 4 $^{5}/_{16}$ in.), Harvard University–Boston Museum of Fine Arts Expedition, 21.872

Model of a boat being rowed, late Dynasty 11–early Dynasty 12, 2010–1961 B.C., wood, Deir el-Bersha, tomb 10, shaft A, 28 x 57 x 9 cm (11 x 22 $^{7}/_{16}$ x 3 $^{9}/_{16}$ in.), Harvard University–Boston Museum of Fine Arts Expedition, 21.873

Model of a boat being rowed, late Dynasty 11–early Dynasty 12, 2010–1961 B.C., wood, Deir el-Bersha, tomb 10, shaft A, 28 x 53 x 11 cm (11 x 20 $^{7}/_{8}$ x 4 $^{5}/_{16}$ in.), Harvard University–Boston Museum of Fine Arts Expedition, 21.874

Model of a boat under sail, late Dynasty 11–early Dynasty 12, 2010–1961 B.C., wood, Deir el-Bersha, tomb 10, shaft A, 32 x 66 x 13 cm (12 $^{5}/_{8}$ x 26 x 5 $^{1}/_{8}$ in.), Harvard University–Boston Museum of Fine Arts Expedition, 21.878

Model of a boat being rowed, late Dynasty 11–early Dynasty 12, 2010–1961 B.C., wood, Deir el-Bersha, tomb 10, shaft A, 31 x 76 x 21 cm (12 $^{3}/_{16}$ x 29 $^{15}/_{16}$ x 8 $^{1}/_{4}$ in.), Harvard University–Boston Museum of Fine Arts Expedition, 21.879

Model of a funerary boat, late Dynasty 11–early Dynasty 12, 2010–1961 B.C., wood, Deir el-Bersha, tomb 10, shaft A, length 57 cm (22 $^{7}/_{16}$ in.), Harvard University–Boston Museum of Fine Arts Expedition, 21.885

Model of a funerary boat, late Dynasty 11–early Dynasty 12, 2010–1961 B.C., wood, Deir el-Bersha, tomb 10, shaft A, 28 x 60 x 14 cm (11 x 23 $^{5}/_{8}$ x 5 $^{1}/_{2}$ in.), Harvard University–Boston Museum of Fine Arts Expedition, 21.889

Model of a funerary boat, late Dynasty 11–early Dynasty 12, 2010–1961 B.C., wood, Deir el-Bersha, tomb 10, shaft A, 34.3 x 90.2 x 17.8 cm (13 $^{1}/_{2}$ x 35 $^{1}/_{2}$ x 7 in.), Harvard University–Boston Museum of Fine Arts Expedition, 21.893

Model bows and arrows, late Dynasty 11–early Dynasty 12, 2010–1961 B.C., wood, Deir el-Bersha, tomb 10, shaft A, length 73 cm (28 $^{3}/_{4}$ in.), Harvard University–Boston Museum of Fine Arts Expedition, 21.894

Model of a transport boat with a portable cabin, late Dynasty 11–early Dynasty 12, 2010–1961 B.C., wood, Deir el-Bersha, tomb 10, shaft A, 30 x 57 x 13 cm (11 $^{13}/_{16}$ x 22 $^{7}/_{16}$ x 5 $^{1}/_{8}$ in.), Harvard University–Boston Museum of Fine Arts Expedition, 21.895

Set of four model *hes* jars and base, late Dynasty 11–early Dynasty 12, 2010–1961 B.C., travertine (jars) and wood (base), Deir el-Bersha, tomb 10, shaft A, jar height 10.4–11.6 cm (4 $^{1}/_{8}$–4 $^{9}/_{16}$ in.), Harvard University–Boston Museum of Fine Arts Expedition, 21.896a–e

Set of four model *hes* jars and base, late Dynasty 11–early Dynasty 12, 2010–1961 B.C., travertine and wood, Deir el-Bersha, tomb 10, shaft A, jar height 10.8–12 cm (4 $^{1}/_{4}$–4 $^{3}/_{4}$ in.), Harvard University–Boston Museum of Fine Arts Expedition, 21.898a–e

Set of four model vessels and base, late Dynasty 11–early Dynasty 12, 2010–1961 B.C., travertine and wood, Deir el-Bersha, tomb 10, shaft A, vessel height 6.7–10.5 cm (2 $^{5}/_{8}$–4 18 in.), Harvard University–Boston Museum of Fine Arts Expedition, 21.899a–e

Model bread loaf and base, late Dynasty 11–early Dynasty 12, 2010–1961 B.C., travertine and wood, Deir el-Bersha, tomb 10, shaft A, bread height 18.5 x diameter 5.5 cm (7⁵⁄₁₆ x 2³⁄₁₆ in.), Harvard University–Boston Museum of Fine Arts Expedition, 21.902a–b

Model bread loaf and base, late Dynasty 11–early Dynasty 12, 2010–1961 B.C., travertine and wood, Deir el-Bersha, tomb 10, shaft A, bread height 10.8 cm (4¼ in.), Harvard University–Boston Museum of Fine Arts Expedition, 21.903a–b

Model offering vessel and base, late Dynasty 11–early Dynasty 12, 2010–1961 B.C., travertine and wood, Deir el-Bersha, tomb 10, shaft A, vessel height 7.5 x diameter 8 cm (2¹⁵⁄₁₆ x 3⅛ in.), Harvard University–Boston Museum of Fine Arts Expedition, 21.904a–b

Model offering tray and base, late Dynasty 11–early Dynasty 12, 2010–1961 B.C., Deir el-Bersha, tomb 10, shaft A, tray 4 x 15 x 14.5 cm (1⁹⁄₁₆ x 5⅞ x 5¹¹⁄₁₆ in.), base 4 x 26.5 x 14.5 cm (1⁹⁄₁₆ x 10⁷⁄₁₆ x 5¹¹⁄₁₆ in.), Harvard University–Boston Museum of Fine Arts Expedition, 21.905a–b

Model headrest, late Dynasty 11–early Dynasty 12, 2010–1961 B.C., travertine (Egyptian alabaster), Deir el-Bersha, tomb 10, shaft A, height 17.1 cm (6¾ in.), Harvard University–Boston Museum of Fine Arts Expedition, 21.906a–c

Model bag-shaped jar with flaring rim, 2040–1640 B.C., stone, Deir el-Bersha, tomb 19, shaft B debris, height 4 cm (1⁹⁄₁₆ in.), Harvard University–Boston Museum of Fine Arts Expedition, 21.914

Storage jar with mud stopper, late Dynasty 11–early Dynasty 12, 2010–1961 B.C., pottery, Deir el-Bersha, tomb 10, shaft A, height 40 x diameter 19 cm (15¾ x 7½ in.), Harvard University–Boston Museum of Fine Arts Expedition, 21.938

Storage jar with mud stopper, late Dynasty 11–early Dynasty 12, 2010–1961 B.C., pottery, Deir el-Bersha, tomb 10, shaft A, height 39 cm (15⅜ in.), Harvard University–Boston Museum of Fine Arts Expedition, 21.940

Foot from a model of a goose, late Dynasty 11–early Dynasty 12, 2010–1961 B.C., wood, Deir el-Bersha, tomb 10, shaft A, length 12.1 cm (4¾ in.), Harvard University–Boston Museum of Fine Arts Expedition, 21.941

Head from a model of a goose, late Dynasty 11–early Dynasty 12, 2010–1961 B.C., wood, Deir el-Bersha, tomb 10, shaft A, length 9 cm (3⁹⁄₁₆ in.), Harvard University–Boston Museum of Fine Arts Expedition, 21.942

Lid of Governor Djehutynakht's inner coffin, late Dynasty 11–early Dynasty 12, 2010–1961 B.C., cedar, Deir el-Bersha, tomb 10, shaft A, 224 x 75.5 cm (88³⁄₁₆ x 29¾ in.), Harvard University–Boston Museum of Fine Arts Expedition, 21.963

Lid of Lady Djehutynakht's middle coffin, late Dynasty 11–early Dynasty 12, 2010–1961 B.C., cedar, Deir el-Bersha, tomb 10, shaft A, 243.5 x 84 cm (95⅞ x 33⅛ in.), Harvard University–Boston Museum of Fine Arts Expedition, 21.965

Lid of Lady Djehutynakht's inner coffin, late Dynasty 11–early Dynasty 12, 2010–1961 B.C., cedar, Deir el-Bersha, tomb 10, shaft A , 205.5 x 49 cm (80⅞ x 19⁵⁄₁₆ in.), Harvard University–Boston Museum of Fine Arts Expedition, 21.967

String of beads, late Dynasty 11–early Dynasty 12, 2010–1961 B.C., faience, silver, Deir el-Bersha, tomb 10, shaft A, length 17.7 cm (6¹⁵⁄₁₆ in.), Harvard University–Boston Museum of Fine Arts Expedition, 21.10547

String of beads, late Dynasty 11–early Dynasty 12, 2010–1961 B.C. , carnelian, silver, Deir el-Bersha, tomb 10, shaft A, length 7.6 cm (3 in.), Harvard University–Boston Museum of Fine Arts Expedition, 21.10550

Broadcollar, Dynasty 12, 1991–1783 B.C., Faince, steatite, Deir el-Bersha, tomb 5 E, depth 12.7 cm (5 in.), Harvard University–Boston Museum of Fine Arts Expedition, 21.10552

Mirror handle, late Dynasty 11–early Dynasty 12, 2010–1961 B.C., wood, Deir el-Bersha, tomb 10, shaft A, 15.3 x 10.5 x 1.3 cm (6 x 4⅛ x ½ in.), Harvard University–Boston Museum of Fine Arts Expedition, 21.11770

Broadcollar, 2040–1640 B.C., faience, Deir el-Bersha, 15 x 35 cm (5⅞ x 13¾ in.), Harvard University–Boston Museum of Fine Arts Expedition, 21.11811

Model boat, late Dynasty 11–early Dynasty 12, 2010–1961 B.C., wood, Deir el-Bersha, tomb 10, shaft A, 18 x 63 x 10 cm (7¹⁄₁₆ x 24¹³⁄₁₆ x 3¹⁵⁄₁₆ in.), Harvard University–Boston Museum of Fine Arts Expedition, 21.12491

Model of a boat being rowed, late Dynasty 11–early Dynasty 12, 2010–1961 B.C., wood, Deir el-Bersha, tomb 10, shaft A, 16 x 60 x 12 cm (6⁵⁄₁₆ x 23⅝ x 4¾ in.), Harvard University–Boston Museum of Fine Arts Expedition, 21.12492

Model of a boat under sail, late Dynasty 11–early Dynasty 12, 2010–1961 B.C., wood, Deir el-Bersha, tomb 10, shaft A, 15 x 59 x 9 cm (5⅞ x 23¼ x 3⁹⁄₁₆ in.), Harvard University–Boston Museum of Fine Arts Expedition, 21.12493

Model boat, late Dynasty 11–early Dynasty 12, 2010–1961 B.C., wood, Deir el-Bersha, tomb 10, shaft A, 16 x 62 x 11 cm (6⁵⁄₁₆ x 24⁷⁄₁₆ x 4⁵⁄₁₆ in.), Harvard University–Boston Museum of Fine Arts Expedition, 21.12495

Model of a pilgrimage boat, late Dynasty 11–early Dynasty 12, 2010–1961 B.C., wood, Deir el-Bersha, tomb 10, shaft A, 18 x 54 x 14 cm (7¹⁄₁₆ x 21¼ x 5½ in.), Harvard University–Boston Museum of Fine Arts Expedition, 21.12496

Model of a boat under sail, late Dynasty 11–early Dynasty 12, 2010–1961 B.C., wood, Deir el-Bersha, tomb 10, shaft A, 24 x 65 x 13 cm (9⁷⁄₁₆ x 25⁹⁄₁₆ x 5⅛ in.), Harvard University–Boston Museum of Fine Arts Expedition, 21.12497

Four fragments of a walking stick, late Dynasty 11–early Dynasty 12, 2010–1961 B.C., wood, Deir el-Bersha, tomb 10, shaft A, length 19–44 cm (7½–17⁵⁄₁₆ in.), Harvard University–Boston Museum of Fine Arts Expedition, 21.16685.1–21.16685.4

Eight handles from a model axes, late Dynasty 11–early Dynasty 12, 2010–1961 B.C., wood, Deir el-Bersha, tomb 10, shaft A, length 27.1 cm (10¹¹⁄₁₆ in.), Harvard University–Boston Museum of Fine Arts Expedition, 21.16686–21.16693

Four bundles of reed sticks, late Dynasty 11–early Dynasty 12, 2010–1961 B.C., wood, Deir el-Bersha, tomb 10, shaft A, western niche, length maximum 99 cm (39 in.), Harvard University–Boston Museum of Fine Arts Expedition, 21.16694.1–21.16694.4

Storage jar with mud stopper, late Dynasty 11–early Dynasty 12, 2010–1961 B.C., pottery, Deir el-Bersha, tomb 10, shaft A, height 39.6 x diameter 22.2 cm (15⁹⁄₁₆ x 8¾ in.), Harvard University–Boston Museum of Fine Arts Expedition, 21.16695

Model adze, late Dynasty 11–early Dynasty 12, 2010–1961 B.C., reed, Deir el-Bersha, tomb 10, shaft A, length 13.5 cm (5⁵⁄₁₆ in.), Harvard University–Boston Museum of Fine Arts Expedition, 21.16696

Model of a man feeding an ox, late Dynasty 11–early Dynasty 12, 2010–1961 B.C., wood, Deir el-Bersha, tomb 10, shaft A, 27.8 x 8 cm (10¹⁵⁄₁₆ x 3⅛ in.), Harvard University–Boston Museum of Fine Arts Expedition, 21.16697

Hooked staff, late Dynasty 11–early Dynasty 12, 2010–1961 B.C., wood, Deir el-Bersha, tomb 10, shaft A, length 41.4 cm (16⁵⁄₁₆ in.), Harvard University–Boston Museum of Fine Arts Expedition, 21.16698

Model of a man feeding an ox, late Dynasty 11–early Dynasty 12, 2010–1961 B.C., wood, Deir el-Bersha, tomb 10, shaft A, 35.3 x 6 cm (13⅞ x 2⅜ in.), Harvard University–Boston Museum of Fine Arts Expedition, 21.16699

Model of a man feeding an ox, late Dynasty 11–early Dynasty 12, 2010–1961 B.C., wood, Deir el-Bersha, tomb 10, shaft A, 28.5 x 7 cm (11¼ x 2¾ in.), Harvard University–Boston Museum of Fine Arts Expedition, 21.16700

Stick or club, late Dynasty 11–early Dynasty 12, 2010–1961 B.C., wood, Deir el-Bersha, tomb 10, shaft A, length 65.4 x diameter 6 cm (25¾ x 2⅜ in.), Harvard University–Boston Museum of Fine Arts Expedition, 21.16701

Model of a man feeding an ox, late Dynasty 11–early Dynasty 12, 2010–1961 B.C., wood, Deir el-Bersha, tomb 10, shaft A, 24 x 8 cm (9⁷⁄₁₆ x 3⅛ in.), Harvard University–Boston Museum of Fine Arts Expedition, 21.16703

Model of a boat being rowed, late Dynasty 11–early Dynasty 12, 2010–1961 B.C., wood, Deir el-Bersha, tomb 10, shaft A, 13 x 58 x 10 cm (5⅛ x 22¹³⁄₁₆ x 3¹⁵⁄₁₆ in.), Harvard University–Boston Museum of Fine Arts Expedition, 21.16704

Model of a boat under sail, late Dynasty 11–early Dynasty 12, 2010–1961 B.C., wood, Deir el-Bersha, tomb 10, shaft A, 23 x 57 x 11 cm (9¹⁄₁₆ x 22⁷⁄₁₆ x 4⁵⁄₁₆ in.), Harvard University–Boston Museum of Fine Arts Expedition, 21.16705

Model of a man feeding an ox, late Dynasty 11–early Dynasty 12, 2010–1961 B.C., wood, Deir el-Bersha, tomb 10, shaft A, 27.5 x 7.8 cm (10¹³⁄₁₆ x 3¹⁄₁₆ in.), Harvard University–Boston Museum of Fine Arts Expedition, 21.16706

Fragments of model plants, late Dynasty 11–early Dynasty 12, 2010–1961 B.C., cartonnage, Deir el-Bersha, tomb 10, shaft A, Harvard University–Boston Museum of Fine Arts Expedition, 21.16707

Bowl, late Dynasty 11–early Dynasty 12, 2010–1961 B.C., pottery, Deir el-Bersha, tomb 10, shaft A, height 7 x diameter 37 cm (2¾ x 14⁹⁄₁₆ in.), Harvard University–Boston Museum of Fine Arts Expedition, 21.16708

Model of a boat being rowed, late Dynasty 11–early Dynasty 12, 2010–1961 B.C., wood, Deir el-Bersha, tomb 10, shaft A, 19 x 61 x 11 cm (7½ x 24 x 4⁵⁄₁₆ in.), Harvard University–Boston Museum of Fine Arts Expedition, 21.21881

Model of a boat being rowed, late Dynasty 11–early Dynasty 12, 2010–1961 B.C., wood, Deir el-Bersha, tomb 10, shaft A, 13 x 56 x 9 cm (5⅛ x 22¹⁄₁₆ x 3⁹⁄₁₆ in.), Harvard University–Boston Museum of Fine Arts Expedition, 21.21882

Spouted jar, 2040–1640 B.C., pottery, Sheikh Farag, tomb 19, height 14.5 x diameter 16 cm (5¹¹⁄₁₆ x 6⁵⁄₁₆ in.), Harvard University–Boston Museum of Fine Arts Expedition, 23.1523

Amulet of Horus as a falcon, Dynasty 11–13, 2140–1640 B.C., gold and garnet, 3.3 x 3.4 cm (1⁵⁄₁₆ x 1⁵⁄₁₆ in.), Gift of William Lawrence and his children in memory of Julia Cunningham Lawrence, 27.853

Hippopotamus amulet, Dynasty 12, 1991–1783 B.C., gold, 1.5 x 2.7 cm (⁹⁄₁₆ x 1¹⁄₁₆ in.), Gift of William Lawrence and his children in memory of Julia Cunningham Lawrence, 27.854

Necklace with pendant, 2040–about 1640 B.C., gold, Uronarti (Nubia), cemetery, tomb 3, length 21 cm (8¼ in.), Harvard University–Boston Museum of Fine Arts Expedition, 31.787

Kohl jar with monkeys in relief, Middle Kingdom–Second Intermediate Period, 1991–1550 B.C., anhydrite, Thebes, height 5.5 x diameter 5.8 cm (2³⁄₁₆ x 2⁵⁄₁₆ in.), John Wheelock Elliot Fund, 49.1073

Ointment jar in the form of a trussed duck, Middle Kingdom–Second Intermediate Period, Dynasty 12–17, 1991–1550 B.C., anhydrite, Egypt, 15 x 6.2 x 7.4 cm (5⅞ x 2⁷⁄₁₆ x 2¹⁵⁄₁₆ in.), Gift of Horace L. Mayer, 65.1749

Relief of the Lady Wadjkaues, Dynasty 12, reign of Senwosret I, 1971–1926 B.C., limestone, Deir el-Bersha, tomb 3, 37 x 59 x 4.5 cm (14⁹⁄₁₆ x 23¼ x 1¾ in.), Seth K. Sweetser Fund, 1972.984

Kohl jar, Dynasty 12–13, 1991–1640 B.C., obsidian and gold, Egypt, height 2.9 x diameter 2.9 cm (1⅛ x 1⅛ in.), Gift of Mrs. Horace L. Mayer, 1973.663

Aldred, Cyril. *Middle Kingdom Art in Ancient Egypt.* London: A. Tiranti, 1950.

———. "Some Royal Portraits of the Middle Kingdom in Ancient Egypt." *Metropolitan Museum Journal* 3 (1970): 27–50.

Allen, James P. *Genesis in Egypt: The Philosophy of Ancient Egyptian Creation Accounts.* Yale Egyptological Studies 2. New Haven: Yale Egyptological Seminar, 1988.

———. "Some Theban Officials of the Early Middle Kingdom." In *Studies in Honor of William Kelly Simpson.* Vol. 1, edited by Peter der Manuelian, 1–26. Boston: Museum of Fine Arts, 1996.

———. *The Heqanakht Papyri.* Metropolitan Museum of Art Egyptian Expedition 27. New York: Metropolitan Museum of Art, 2002.

———. "The High Officials of the Early Middle Kingdom." In *The Theban Necropolis: Past, Present and Future*, edited by Nigel Strudwick and John H. Taylor, 14–29. London: British Museum, 2003.

———. *The Egyptian Pyramid Texts.* Writings from the Ancient World 23. Atlanta: Society of Biblical Literature, 2005.

———. *The Egyptian Coffin Texts.* Vol. 8, *Middle Kingdom Copies of Pyramid Texts.* Oriental Institute Publications 132. Chicago: The Oriental Institue of the University of Chicago, 2006.

Andreu, Guillemette, Marie-Hélène Rutschowscaya, and Christiane Ziegler. *Ancient Egypt at the Louvre.* Translated by Lisa Davidson. Paris: Hachette, 1997.

Andrews, Carol. *Ancient Egyptian Jewelry.* London: British Museum Publications, 1990.

Anthes, Rudolf. *Die Felseninschriften von Hatnub.* Untersuchungen zur Geschichte und Altertumskunde Ägyptens 9. Leipzig: J. C. Hinrichs, 1928.

Arnold, Dieter. "Zur frühen Namensformen des Königs Mnṯw-ḥtp Nb-ḥpt-Rꜥ." *Mitteilungen des Deutsches Archäologisches Institut Abteilung Kairo* 24 (1969): 38–42.

———. *The Temple of Mentuhotep at Deir el Bahari.* New York: Metropolitan Museum of Art, 1979.

———. *Der Pyramidenbezirk des Königs Amenemhet III. in Dahschur.* Mainz: Phillip von Zabern, 1987.

———. *The Pyramid of Senwosret I.* Vol. 1, *The South Cemeteries of Lisht.* New York: Metropolitan Museum of Art, 1988.

———. "Hypostyle Halls of the Old and Middle Kingdom?" In *Studies in Honor of William Kelly Simpson.* Vol. 1, edited by Peter der Manuelian, 39–54. Boston: Museum of Fine Arts, 1996.

———. "Middle Kingdom Mastabas at Dahshur." *Egyptian Archaeology* 21 (2002): 38–40.

———. *The Pyramid Complex of Senwosret III at Dahshur: Architectural Studies.* New York: Metropolitan Museum of Art Egyptian Expedition, 2002.

Arnold, Dorothea. "Amenemhat I and the Early Twelfth Dynasty at Thebes." *Metropolitan Museum Journal* 26 (1991): 5–48.

———. "The Architecture of Meketre's Slaughterhouse and Other Early Twelfth Dynasty Wooden Models." In *Structure and Significance: Thoughts on Ancient Egyptian Architecture*, edited by Peter Jánosi, 1–76. Vienna: Österreichischen Akademie der Wissenschaften, 2005.

Aruz, Joan, Kim Benzel, and Jean M. Evans, eds. *Beyond Babylon: Art, Trade, and Diplomacy in the Second Millennium B.C.* Exh. cat. New York: Metropolitan Museum of Art, 2008.

Assmann, Jan. *The Search for God in Ancient Egypt.* Ithaca: Cornell University Press, 2001.

Bard, Kathryn A., ed. *Encyclopedia of the Archaeology of Ancient Egypt.* New York: Routledge, 1999.

Barta, Winfried. *Das Selbstzeugnis eines altägyptischen Künstler.* Berlin: B. Hessling, 1970.

Bisson de la Roque, F., and J. J. Clère. *Les fouilles de Médamoud (1928).* Cairo: Institut français d'archéologie orientale, 1929.

———. *Rapport sur les fouilles de Médamoud (1929).* Cairo: Institut français d'archéologie orientale, 1930.

———. *Tôd (1934–1935).* (Cairo: Insitut français d'archéologie orientale, 1937).

Blackman, Aylward. *The Rock Tombs of Meir.* Vol. 1, *The Tomb-chapel of Ukh-Hotpf's Son Senbi.* Part 2,

The Tomb-chapel of Senbi's Son Ukh-Hotp (B, no. 2). Part 3, *The Tomb-chapel of Ukh-hotp, Son of Uhk-hotp and Mersi (B, No. 4).* London: Egyptian Exploration Fund, 1914–1915.

Blackman, Aylward, and M. Apted. *The Rock Tombs of Meir.* Part 5, *The Tomb-chapel A, No. 1 (That of Ni-'ankh-Pepi the Black), A, No. 2 (That of Pepi'onkh with the "Good Name" of Heny the Black), D, No. 1 (That of Pepi), and E, Nos. 1–4 (Those of Meniu, Nenki, Pepi'onkh and Tjetu).* Part 6, *The Tomb-chapels of Ukhhopte son of Iam (A, No. 3), Senbi Son Ukhhopte Son of Senbi (B, No. 3), and Ukhhopte son Ukhhopte and Heny-Hery-Ib (C, No. 1).* London: Egypt Exploration Fund, 1953.

Bourriau, Janine. "Patterns of Change in Burial Customs during the Middle Kingdom." In *Middle Kingdom Studies*, edited by Stephen Quirke, 3–20. New Malden, Surrey: SIA Publishing, 1991.

Breasted, James Henry. *Ancient Records of Egypt: Historical Documents from the Earliest Times to the Persian Conquest.* London: Histories and Mysteries of Man, 1988.

Broderick, Mary, A. H. Sayce, and H. G. Lyons. *A Handbook for Travellers in Lower and Upper Egypt.* London: John Murray, 1896.

Brovarski, Edward. *Canopic Jars.* Corpus Antiquitatum Aegyptiacarum, Museum of Fine Arts, Boston, Fascicle 1. Mainz: Philipp von Zabern, 1978.

———. "Ahanakht of Bersheh and the Hare Nome in the First Intermediate Period and Middle Kingdom." In *Studies in Ancient Egypt, the Aegean, and the Sudan: Essays in Honor of Dows Dunham on the Occasion of His 90th Birthday, June 1, 1980*, edited by William Kelly Simpson and Whitney M. Davis, 14–30. Boston: Museum of Fine Arts, 1981.

Brunton, Guy. "A Monument of Amenemhet IV." *Annales du Service des Antiquités de l'Égypte* 39 (1939): 49–53.

Callender, Gae. "The Middle Kingdom Renaissance (c. 2055–1650 BC)." In *The Oxford History of Ancient Egypt*, edited by Ian Shaw, 148–83. Oxford: Oxford University Press, 2000.

Capel, Anne K., and Glenn Markoe, eds. *Mistress of the House, Mistress of Heaven: Women in Ancient Egypt.* New York: Hudson Hills, 1996.

Cooney, John D. "Equipment for Eternity: Objects from Egyptian Tombs." *Bulletin of the Brooklyn Museum* 12, no. 2 (Winter 1951): 1–12

Cottevielle-Giraudet, Remy. *Rapport sur les fouilles de Médamoud (1931)*. Cairo: Institut français d'archéologie orientale, 1933.

Cruz-Uribe, Eugene. "The Fall of the Middle Kingdom." *Varia Aegyptiaca* 3 (1987): 107–11.

Daressy, Georges. "Fouilles de Deir el Bircheh (novembre–décembre 1897)." *Annales du Service des Antiquités de l'Égypte* 1 (1900): 17–43.

D'Auria, Sue, Peter Lacovara, and Catharine H. Roehrig, eds. *Mummies and Magic: An Introduction to Egyptian Funerary Beliefs*. Exh. cat. Boston: Museum of Fine Arts, 1988.

Davies, W. Vivian. *A Royal Statue Reattributed*. London: British Museum, 1981.

———. "Djehutyhotep's Colossus Inscription and Major Brown's Photograph." In *Studies in Egyptian Antiquities: A Tribute to T. G. H. James*, edited by W. Vivian Davies, 29–158. London: British Museum Publications, 1999.

de Buck, Adriaan. *The Egyptian Coffin Texts*. Vols. 1–7. Oriental Institute Publications 34, 49, 64, 67, 73, 81, 87. Chicago: University of Chicago Press, 1935–1961.

Delange, Elisabeth. *Catalogue des statues égyptiennes du Moyen Empire*. Paris: Editions de la Réunion des musées nationaux, 1987.

de Meyer, Marleen. "Old Kingdom Rock Tombs at Dayr al-Barshā: Archaeological and Textual Evidence of Their Use and Reuse in Zones 4 and 7." PhD diss., Katholieke Unversiteit Leuven, 2008.

de Meyer, Marleen, et al. "The Role of Animals in the Funerary Rites at Dayr al-Barshā." *Journal of the American Research Center in Egypt* 42 (2005–2006): 45–71.

Dodson, Aidan, and Dyan Hilton. *The Complete Royal Families of Ancient Egypt*. London: Thames and Hudson, 2004.

Doxey, Denise M. *Egyptian Non-royal Epithets in the Middle Kingdom: A Social and Historical Analysis*. Leiden: Brill, 1998.

———. "Funerary Equipment from Deir el-Bersha in the Museum of Fine Arts, Boston." In *Recent Perspectives on Egypt's Middle Kingdom*, edited by D. P. Silverman and J. W. Wegner. New Haven: Yale University Press, forthcoming.

Dunham, Dows. "The Tomb of Dehuti-Nekht and His Wife." *Bulletin of the Museum of Fine Arts, Boston* 19, no. 114 (1921): 43–46.

———. "New Installation in the Egyptian Department." *Bulletin of the Museum of Fine Arts, Boston* 25, no. 152 (1927): 96–98.

———. *Naga ed Der Stelae of the First Intermediate Period*. Boston: Museum of Fine Arts, 1937.

Dunham, Dows, and William S. Smith. "A Middle Kingdom Painted Coffin from Deir el Bersheh." In *Scritti in onore di Ippolito Rosellini pubblicati cure dell'Università di Pisa*. Vol. 1, 263–268. Pisa: Industrie Grafiche V. Lischi e Figli, 1949.

Eaton, Katherine. "A 'Mortuary Liturgy' from the *Book of the Dead* with Comments on the Nature of the 3ḫ-spirit." *Journal of the American Research Center in Egypt* 42 (2005–2006): 81–94.

Eggebrecht, Arne, "Zur Bedeutung des Würfelhockers." In *Festgabe für Dr. Walter Will, Ehrensenator der Universität München, zum 70. Geburstag am 12. November 1966*, edited by S. Lauffer, 143–63. Cologne: Carl Heymanns, 1966.

Evers, Hans Gerhard. *Staat aus dem Stein*. Vols. 1–2. Munich: F. Bruckmann, 1929.

Faulkner, Raymond O. *The Ancient Egyptian Pyramid Texts*. Oxford: Clarendon Press, 1969.

———. *The Ancient Egyptian Coffin Texts*. Vol. 1, *Spells 1–354*. Warminster: Aris and Phillips, 1973.

———. *The Ancient Egyptian Coffin Texts*. Vol. 2, *Spells 355–787*. Warminster: Aris and Phillips, 1977.

———. *The Ancient Egyptian Coffin Texts*. Vol. 3, *Spells 788–1185*. Warminster: Aris and Phillips, 1978.

Fay, Biri. "Amenemhat V–Vienna/Assuan." *Mitteilungen des Deutsches Archäologisches Institut Abteilung Kairo* 44 (1988): 67–78.

———. *The Louvre Sphinx and Royal Sculpture from the Reign of Amenemhet II*. Mainz: Philipp von Zabern, 1996.

———. "Missing Parts." In *Chief of Seers: Egyptian Studies in Memory of Cyril Aldred*, edited by E. Goring, N. Reeves, and J. Ruffle, 97–112. London: Kegan Paul International, 1997.

Fazzini, Richard, Robert Bianchi, James Romano, and Donald Spanel. *Ancient Egyptian Art in the Brooklyn Museum* (New York: Thames and Hudson, 1989.

Fazzini, Richard, James F. Romano, and Madeleine E. Cody. *Art for Eternity: Masterworks from Ancient Egypt*. Brooklyn: Brooklyn Museum of Art, 1999.

Fischer, Henry G. "An Example of Memphite Influence in a Theban Stela of the Eleventh Dynasty." *Artibus Asiae* 22 (1959): 240–52.

———. "Flachbildkunst des Mittleren Reiches." In *Das Alte Ägypten*, edited by Claude Vandersleyen, 292–303. Propyläen Kunstgeschichte 15. Berlin: Propyläen, 1975.

———. "Notes on Sticks and Staves in Ancient Egypt." *Metropolitan Museum Journal* 13 (1978): 5–32.

Forman, Werner, and Stephen Quirke. *Hieroglyphs and the Afterlife in Ancient Egypt*. Norman: University of Oklahoma Press, 1996.

Foster, Ann L. "Forts and Garrisons." In *The Oxford Encyclopedia of Ancient Egypt*, edited by Donald B. Redford, 552–59. Oxford: Oxford University Press, 2001.

Franke, Detlef. *Personendaten aus dem Mittleren Reich*. Wiesbaden: Harrassowitz, 1984.

———. "The Career of Khnumhotep III of Beni Hasan and the So-Called 'Decline of the Nomarchs.'" In *Middle Kingdom Studies*, edited by Stephen Quirke, 51–67. New Malden, Surrey: SIA Publishing, 1991.

———. "The Middle Kingdom in Egypt." In *Civilizations of the Ancient Near East*, edited by Jack M. Sasson, 735–48. New York: Simon and Schuster Macmillan, 1995.

Freed, Rita E. "A Private Stela from Naga ed-Der and Relief Style of the Reign of Amenemhet I." In *Studies in Ancient Egypt, the Aegean, and the Sudan: Essays in Honor of Dows Dunham on the Occasion of His 90th Birthday, June 1, 1980*, edited by William Kelly Simpson and Whitney M. Davis, 68–76. Boston: Museum of Fine Arts, 1981.

———. "The Development of Middle Kingdom Egyptian Relief: Sculptural Schools of Late Dynasty XI with an Appendix on the Trends of Early Dynasty XII." PhD diss., New York University, 1984.

———. "Art Historical Overview." In *Bersheh Reports I*, edited by David Silverman, 51–64. Boston: Museum of Fine Arts, 1992.

———. "Stela Workshops of Early Dynasty 12." In *Studies in Honor of William Kelly Simpson*. Vol. 1, edited by Peter der Manuelian, 297–336. Boston: Museum of Fine Arts, 1996.

———. "Relief Styles of the Nebhepetre Montuhotep Funerary Temple Complex." In *Chief of Seers: Egyptian Studies in Memory of Cyril Aldred*, edited by Elizabeth Goring, Nicholas Reeves, and John Ruffle, 148–63. London: Kegan Paul International, 1997.

———. "Observations on the Dating and Decoration of the Tombs of Ihy and Hetep at Saqqara." In *Abusir and Saqqara in the Year 2000*, edited by Miroslav Bárta and Jaromír Krejčí, 207–14. Prague: Academy of Sciences of the Czech Republic, Oriental Institute, 2000.

———. "Another Look at the Sculpture of Amenemhat III." *Revue d'Égyptologie* 53 (2002): 103–36.

———. "Defending Connoisseurship: A Thrice Reinscribed Sphinx of Dynasty XII." In *Leaving No Stones Unturned: Essays on the Ancient Near East and Egypt in Honor of Donald P. Hansen*, edited by E. Ehrenberg, 77–88. Winona Lake: Eisenbrauns, 2002.

Freed, Rita E., Lawrence M. Berman, and Denise M. Doxey. *MFA Highlights: Arts of Ancient Egypt*. Boston: MFA Publications, 2003.

Freed, Rita E., and Jack A. Josephson. "A Middle Kingdom Masterwork in Boston: MFA 2002.609." In *Archaism and Innovation: Studies in the Culture of Middle Kingdom Egypt*, edited by David Silverman, William Kelly Simpson, and Josef Wegner. New Haven: Yale University Press, and Philadelphia: University of Pennsylvania Museum of Archaeology and Anthropology, 2009.

Garstang, John. *The Burial Customs of Ancient Egypt*. Liverpool: Constable, 1907.

Graham, Geoffrey. "Insignias." In *The Oxford Encyclopedia of Ancient Egypt*. Vol. 2, edited by Donald B. Redford, 163–67. New York: Oxford University Press, 1999.

Grajetzki, Wolfram. *The Middle Kingdom of Ancient Egypt*. London: Duckworth, 2006.

Grallert, Silke. "The Mitre Inscriptions on Coffins of the Middle Kingdom: A New Set of Texts for Rectangular Coffins?" In *Life and Afterlife in Ancient Egypt during the Middle Kingdom and Second Intermediate Period*, edited by Silke Grallert and Wolfram Grajetski, 35–80. London: Golden House Publications, 2007.

Gupta, Rajiv, et al. "Ultra-High Resolution Flat-Panel Volume CT: Fundamental Principles, Design Architecture, and System Character-ization." *European Radiology* 16 (2006): 1191–1205.

———. "High-Resolution Imaging of an Ancient Egyptian Mummified Head: New Insights into the Mummification Process." *American Journal of Neuroradiology* 29 (2008): 705–13.

Habachi, Labib. "Khata'na-Qantir: Importance." *Annales du Service des Antiquités de l'Égypte* 52 (1952): 443–559.

———. "King Nebhepetre Menthuhotp: His Monuments, Place in History, Deification and Unusual Representations in the Form of Gods." *Mitteilungen des Deutsches Archäologisches Institut Abteilung Kairo* 19 (1963): 16–52.

———. *Elephantine*. Vol. 4, *The Sanctuary of Hekaib*. Archäologische Veröffentlichungen 33. Mainz: Philipp von Zabern, 1985.

Hayes, William C. "Notes on the Governement of Egypt in the Late Middle Kingdom." *Journal of Near Eastern Studies* 12 (1953): 31–39.

———. *The Scepter of Egypt: A Background for the Study of the Egyptian Antiquities in the Metropolitan Museum of Art*. Part 1, *From the Earliest Times to the End of the Middle Kingdom*. New York: Metropolitan Museum of Art, 1953.

———. *A Papyrus of the Late Middle Kingdom in the Brooklyn Museum [Papyrus Brooklyn 35.1446]*. New York: Brooklyn Museum, 1972 [1955].

Hornung, Erik and Betsy M. Bryan, eds. *The Quest for Immortality: Treasures of Ancient Egypt*. Washington, DC: National Gallery of Art, 2002.

Ikram, Salima, and Aidan Dodson. *The Mummy in Ancient Egypt: Equipping the Dead for Eternity*. London: Thames and Hudson, 1998.

Irby, Charles Leonard, and James Mangles. *Travels in Egypt and Nubia, Syria, and the Holy Land*. London: John Murray, 1844. Reprint, n.p.: Elibron Classics, 2004.

Jones, Dilwyn. *Boats*. Egyptian Bookshelf. Austin: University of Texas Press, 1995.

Jørgensen, Mogens. *Tomb Treasures from Ancient Egypt*. Copenhagen: Ny Carlsberg Glyptotek, 2002.

Kahl, Jochem. *Ancient Asyut: The First Synthesis after 300 Years of Research*. Wiesbaden: Harrassowitz, 2007.

Kamal, Ahmed Bey. "Fouilles à Déïr-el-Barsheh." *Annales du Service des Antiquités de l'Égypte* 2 (1901): 14–43.

———. "Fouilles à Deir-el-Barché exécutés dans les six premiers mois de l'année par M. Antonini de Mallawi." *Annales du Service des Antiquités de l'É-gypte* 3 (1902): 276–82.

———. "Fouilles à Dara et à Qoçéïr El-Amarna." *Annales du Service des Antiquités de l'Égypte* 12 (1912): 128–42.

Kamrin, Janice. *The Cosmos of Khnumhotep II at Beni Hasan*. Studies in Egyptology. London: Kegan Paul International, 1999.

Kelley, Allyn L. *The Pottery of Ancient Egypt: Dynasty I to Roman Times*. Toronto: Royal Ontario Museum, 1976.

Kemp, Barry J. *Ancient Egypt: Anatomy of a Civilization*. New York: Routledge, 1989.

Lacau, Pierre, and H. Chevrier. *Une chapelle de Sésostris Ier à Karnak*. Cairo: Institut français d'archéologie orientale, 1956–69.

Lange, Hans, and H. Schäfer. *Grab- und Denksteine des mittleren Reiches im Museum von Kairo*. Berlin: Reichsdruckerei, 1902.

Leclant, Jean. *Ägypten: Das Alte und das Mittlere Reich*. Munich: Beck, 1978.

Lehner, Mark. *The Complete Pyramids of Ancient Egypt*. London: Thames and Hudson, 1997.

Leprohon, Ronald J. "The Personnel of the Middle Kingdom Funerary Stelae." *Journal of the American Research Center in Egypt* 15 (1978): 33–38.

———. "The Reign of Amenemhat III." PhD diss., University of Toronto, 1980.

———. *Stelae I: The Early Dynastic Period to the Late Middle Kingdom*. Corpus Antiquitatum Aegyptiacarum, Museum of Fine Arts, Boston, Fascicle 2. Mainz: Philipp von Zabern, 1985.

———. "Royal Ideology and State Administration in Pharaonic Egypt." In *Civilizations of the Ancient Near East*, edited by Jack M. Sasson, 273–87. New York: Scribner, 1995.

Lesko, Leonard H. "Some Observations on the Composition of the *Book of Two Ways*." *Journal of the American Oriental Society* 91 (1971): 30–43.

———. *The Ancient Egyptian Book of Two Ways*. Berkeley: University of California Press, 1977.

———. *Index of the Spells on Egyptian Middle Kingdom Coffins and Related Documents*. Berkeley: B. C. Scribe Publications, 1979.

———. "Ancient Egyptian Cosmogonies and Cosmology." In *Religion in Ancient Egypt: Gods, Myths, and Personal Practice*, edited by Byron E. Shafer, 88–122. Ithaca: Cornell University Press, 1991.

Lichtheim, Miriam. *Ancient Egyptian Literature*. Vol. 1, *The Old and Middle Kingdoms*. Berkeley: University of California Press, 1975.

———. *Ancient Egyptian Autobiographies Chiefly of the Middle Kingdom: A Study and an Anthology*. Orbis Biblicus et Orientalis 84. Freiburg, Switzerland: Universitätsverlag Freiburg Schweiz and Vandehoeck and Ruprecht, 1988.

Lloyd, Alan B. "The Great Inscription of Khnumhotpe II at Beni Hasan." In *Studies in Pharaonic Religion and Society in Honour of J. Gwyn Griffiths*, edited by Alan B. Lloyd, 21–36. London: Egypt Exploration Society, 1992.

Martin, Maurice. "Le journal de Vansleb en Egypte." *Bulletin de l'Institut Français d'Archéologie Orientale* 97 (1997): 181–92.

McCormack, Dawn. "The Significance of Royal Funerary Architecture in the Study of Thirteenth Dynasty Kingship." In *The Second Intermediate Period (13th–17th Dynasties): Current Research, Future Prospects*, edited by W. V. Davies. London: British Museum Press, forthcoming.

Metropolitan Museum of Art. *The Metropolitan Museum of Art: Egypt and the Ancient Near East*. New York: Metropolitan Museum of Art, 1987.

Müller, H. W. *Alt-ägyptische Malerei*. Berlin: Safari, 1959.

Murray, Mary Ann. "Cereal Production and Processing." In *Ancient Egyptian Materials and Technology*, edited by Paul Nicholson and Ian Shaw, 505–36. Cambridge: Cambridge University Press, 2000.

Museum of Fine Arts, Boston. *Egypt's Golden Age*. Exh. cat. Boston: Museum of Fine Arts, 1982.

Newberry, Percy E. *Egypt Exploration Fund: Report of Fifth Ordinary General Meeting, 1890–91*. London: Kegan Paul, Trench, Trıbner, [1892?].

———. *Beni Hasan*. Part 1. Archaeological Survey of Egypt Memoir 1. London: Egypt Exploration Fund, 1893.

———. *Beni Hasan*. Part 2. Archaeological Survey of Egypt Memoir 2. London: Egypt Exploration Fund, 1894.

———. *El Bersheh*. Part 1, *The Tomb of Tehuti-Hetep*. Archaeological Survey of Egypt Memoir 3. London: Egypt Exploration Fund, 1895.

———. *El Bersheh*. Part 2. Archaeological Survey of Egypt Memoir 4. London: Egypt Exploration Fund, 1896.

O'Connor, David B. "The 'Cenotaphs' of the Middle Kingdom at Abydos." In *Mélanges Gamal Eddin Mokhtar*. Vol. 2, edited by Paule Posener-Kriéger, 161–78. Bibliothèque d'étude 97. Cairo: Institut français d'archéologie orientale, 1985.

Parkinson, R. B. *Voices from Ancient Egypt: An Anthology of Middle Kingdom Writings*. London: British Museum Press, 1991.

Petrie, Flinders. *Antaeopolis: The Tombs of Qau*. London: British School of Archaelogy, 1930.

Petrie, William Matthew Flinders, Guy Brunton, and Mary Ann Murray. *Lahun II*. London: British School of Archaeology in Egypt, 1923.

Piankoff, Alexandre, and J. J. Clère. "A Letter to the Dead on a Bowl in the Louvre." *Journal of Egyptian Archaeology* 20 (1934): 57–61.

Pierrat-Bonnefois, Geneviève. "The Tôd Treasure." In *Beyond Babylon: Art, Trade, and Diplomacy in the Second Millennium B.C.*, edited by Joan Aruz, Kim Benzel, and Jean M. Evans, 65–67. New York: Metropolitan Museum of Art, 2008.

Pinch, Geraldine. *Magic in Ancient Egypt*. Austin: University of Texas Press, 1994.

Polz, Felicitas. "'Die Bildnisse Sesostris' III. und Amenemhets III: Bemerkungen zur königlichen Rundplastik der späten 12. Dynastie." *Mitteilungen des Deutsches Archäologisches Institut Abteilung Kairo* 51 (1995): 227–54.

Quirke, Stephen. *The Administration of Egypt in the Late Middle Kingdom*. New Malden, Surrey: SIA Publishing, 1990.

———. "'Townsmen' in the Middle Kingdom: On the Term s n niwt tn in the Lahun Temple Accounts." *Zeitschrift für Ägyptische Sprache und Altertumskunde* 118 (1991): 141–49.

———. "Royal Power in the 13th Dynasty." In *Middle Kingdom Studies*, edited by Stephen Quirke, 123–39. New Malden, Surrey: SIA Publishing, 1991.

———. *Ancient Egyptian Religion*. London: British Museum Press, 1992.

———. *Titles and Bureaux of Egypt, 1850–1700 B.C.* Egyptology 1. London: Golden House Publications, 2004.

Quirke, Stephen, ed. *Middle Kingdom Studies*. New Malden, Surrey: SIA Publishing, 1991.

Raven, Maarten J. "Egyptian Concepts of the Orientation of the Human Body." *Journal of Egyptian Archaeology* 91 (2005): 35–37.

Redford, Donald B. *Egypt, Canaan, and Israel in Ancient Times*. Princeton: Princeton University Press, 1992.

Reisner, George Andrew. "The Tomb of Hepzefa, Nomarch of Siût." *Journal of Egyptian Archaeology* 5 (1918): 79–98.

Richards, Janet. *Society and Death in Ancient Egypt: Mortuary Landscapes of the Middle Kingdom*. Cambridge: Cambridge University Press, 2005.

Robins, Gay. *Proportion and Style in Ancient Egyptian Art*. Austin: University of Texas, 1994.

———. *The Art of Ancient Egypt*. London: British Museum Press, 1997.

Robinson, Peter. "'As for them who know them, they shall find their paths': Speculations on Ritual Landscapes in the 'Book of the Two Ways.'" In *Mysterious Lands*, edited by David O'Connor and Stephen Quirke, 139–60. London: University College London Press, 2003.

Romano, J. "Block Statue of Senwesret-Senbefny." In *Ancient Egyptian Art in the Brooklyn Museum*, edited by Richard Fazzini et al., 22. New York: Thames and Hudson, 1989.

Roth, Ann Macy, and Catharine H. Roehrig. "The Bersha Procession: A New Reconstruction." *Journal of the Museum of Fine Arts* 1 (1989): 31–40.

Russell, Terence M. *The Discovery of Egypt: Vivant Denon's Travels with Napoleon's Army*. Stroud, UK: Sutton Publishing, 2005.

Russmann, Edna R. *Eternal Egypt: Masterworks of Ancient Art from the British Museum*. Exh. cat. Berkeley: University of California Press, 2001.

Saleh, Mohammed, and Hourig Sourouzian. *The Egyptian Museum Cairo: Official Catalogue*. Mainz: Philipp von Zabern, 1987.

Schneider, Thomas. "The Relative Chronology of the Middle Kingdom and the Hyksos Period (Dyns. 12–17)." In *Ancient Egyptian Chronology*, edited by Erik Hornung, Rolf Krauss, and David Warburton, 168–96. Leiden: Brill, 2006.

Schulz, Regine. *Die Entwicklung und Bedeutung des kuboiden Statuentypus*. Vols. 1–2. Hildesheimer Ägyptologische Beiträge 33–34. Hildesheim: Gerstenberg, 1992.

Seidlmayer, Stephan J. "The First Intermediate Period." In *The Oxford History of Ancient Egypt*, edited by Ian Shaw, 118–47. Oxford: Oxford University Press, 2000.

———. "The Relative Chronology of the First Intermediate Period." In *Ancient Egyptian Chronology*, edited by Erik Hornung, Rolf Krauss, and David Warburton, 159–67. Leiden: Brill, 2006.

Seyfried, Karl-Joachim. *Beiträge zu den Expeditionen des Mittleren Reiches in die Ost-Wüste*. Hildesheim: Gerstenberg, 1981.

Shaw, Ian. "Pharaonic Quarrying and Mining: Settlement and Procurement in Egypt's Marginal Regions." *Antiquity* 68 (1994): 108–19.

Silverman, David P. "Middle Kingdom Tombs in the Teti Pyramid Cemetery." In *Abusir and Saqqara in the Year 2000*, edited by Miroslav Bárta and Jaromír Krejčí, 259–82. Prague: Academy of Sciences of the Czech Republic, Oriental Institute, 2000.

Simpson, William Kelly. "Polygamy in Egypt in the Middle Kingdom?" *Journal of Egyptian Archaeology* 60 (1974): 100–105.

———. *The Terrace of the Great God at Abydos: The Offering Chapels of Dynasties 12 and 13*. Publications of the Pennsylvania-Yale Expedition to Egypt 5. New Haven: Peabody Museum of Natural History of Yale University and University Museum of the University of Pennsylvania, 1974.

———. "Sesostris I." In *Lexikon der Ägyptologie*. Vol. 5, edited by Wolfgang Helck, Eberhard Otto, and Wolfhart Westendorf, 890–99. Wiesbaden: Harrassowitz, 1984.

———. "Lepsius Pyramid LV at Dahshur: The Mastaba of Si-Ese, Vizier of Amenemhat II." In *Pyramid Studies and Other Essays Presented to I. E. S. Edwards*, edited by John Baines, T. G. H. James, A. Leahy, and A. F. Shore, 57–60. London: Egypt Exploration Society, 1988.

Simpson, William Kelley, ed. *The Literature of Ancient Egypt: An Anthology of Stories, Instructions, Stelae, Autobiographies, and Poetry*. New Haven: Yale University Press, 2003.

Simpson, William Kelley, and David O'Connor. *Inscribed Material from the Pennsylvania-Yale Excavations at Abydos*. Publications of the Pennsylvania-Yale Expedition to Egypt 6. New Haven: Peabody Museum of Natural History of Yale University and University of Pennsylvania Museum of Archaeology and Anthropology, 1995.

Smith, William S. "Paintings of the Egyptian Middle Kingdom at Bershe." *American Journal of Archaeology* 55 (1951): 321–32.

———. *The Art and Architecture of Ancient Egypt*. Revised with additions by W. K. Simpson. London: Penguin, 1981.

Sørensen, Jorgen Pødemann. "Divine Access: The So-Called Democratization of Egyptian Funerary Literature as a Socio-Cultural Process." In *The Religion of the Ancient Egyptians: Cognitive Structures and Popular Expressions; Proceedings of Symposia in Uppsala and Bergen, 1987 and 1988*, edited by Gertie Englund, 109–25. Uppsala Studies in Ancient Mediterranean and Near Eastern Civilizations. Uppsala: University of Uppsala 20, 1989.

Sourouzian, Hourig. "Standing Royal Colossi of the Middle Kingdom Reused by Ramesses II." *Mitteilungen des Deutsches Archäologisches Institut Abteilung Kairo* 44 (1988): 229–54.

———. "Features of Early Twelfth Dynasty Royal Sculpture." *Bulletin of the Egyptian Museum* 2 (2005): 103–24.

Spalinger, Anthony J. "Sobekhotep IV." In *Lexikon der Ägyptologie.* Vol. 5, edited by Wolfgang Helck, Eberhard Otto, and Wolfhart Westendorf, 1041–48. Wiesbaden: Harrassowitz 1984.

———. "A Redistributive Pattern at Assiut." *Journal of the American Oriental Society* 105 (1985): 7–11.

Spanel, Donald. "Ancient Egyptian Boat Models of the Herakleopolitan Period and Eleventh Dynasty." *Studien zur altägyptischen Kultur* 12 (1985).

———. *Beni Hasan in the Herakleopolitan Period.* Ottawa: National Library of Canada, 1985.

Spencer, A. Jeffrey. *Death in Ancient Egypt.* Harmondsworth: Penguin, 1982.

Spencer, Patricia, ed. *The Egypt Exploration Society: The Early Years.* London: Egypt Exploration Society, 2007.

Steckeweh, Hans. *Die Fürstengräber von Qâw.* Veröffentlichungen der Ernst von Sieglin-Expedition in Ägypten 6. Leipzig: J. C. Hinrichs'sche Buchhandlung, 1936.

Taylor, John. *Egyptian Coffins.* Shire Egyptology 11. Princes Risborough, Buckinghamshire: Shire, Publications, 1989.

Terrace, Edward. *Egyptian Paintings of the Middle Kingdom: The Tomb of Djehuty-Nekht.* New York: George Braziller, 1967.

———. *Middle Kingdom Painting.* London: Allen and Unwin, 1968.

———. "The Entourage of an Egyptian Governor." *Bulletin of the Museum of Fine Arts, Boston* 66, no. 343 (1968): 5–27.

Terrace, Edward, and H. Fischer. *Treasures of Egyptian Art from the Cairo Museum.* Boston: Museum of Fine Arts, 1970.

Tooley, Angela. "Middle Kingdom Burial Customs: A Study of Wooden Models and Related Material." PhD diss., University of Liverpool, 1989.

———. *Egyptian Models and Scenes.* Shire Egyptology 22. Princes Risborough, Buckinghamshire: Shire Publications, 1995.

Uytterhoeven, Inge, and Ingrid Blom-Böer. "New Light on the Egyptian Labyrinth: Evidence from a Survey at Hawara." *Journal of Egyptian Archaeology* 88 (2002): 111–20.

van Siclen III, Charles C. "The Mayors of Basta in the Middle Kingdom." In *Akten des vierten Internationalen Ägyptologen Kongresses, München 1985.* Vol. 4, *Studien zur Altägyptishen Kultur Beihefte,* 187–94. Hamburg: Helmut Buske, 1988.

———. "Remarks on the Middle Kingdom Palace at Tell Basta." In *House and Palace in Ancient Egypt,* edited by Manfred Bietak, 239–46. Vienna: Österreichischen Akademie der Wissenschaften, 1996.

Vandier, Jacques. *Manuel d'archeologie égyptienne.* Vol. 3. Paris: Picard, 1958.

Vansleb, F. *The Present State of Egypt; or, A New Relation of a Late Voyage into That Kingdom, Performed in the Years 1672 and 1673.* London: John Starkey, 1972 [1678].

Vernus, Pascal. "La stele C3 du Louvre." *Revue d'Égyptologie* 25 (1973): 217–34.

von Beckerath, Jürgen. "Amenemhet V." In *Lexikon der Ägyptologie.* Vol. 1, edited by Wolfgang Helck, Eberhard Otto, and Wolfhart Westendorf, 192. Wiesbaden: Harrassowitz, 1973.

Ward, Cheryl. *Sacred and Secular: Ancient Egyptian Ships and Boats.* Philadelphia: University of Pennsylvania Museum Publications, 2000.

Wegner, Josef. "South Abydos: Burial Place of the Third Senwosret? Old and New Excavations at the Abydene Complex of Senwosret III." *KMT: A Modern Journal of Ancient Egypt* 6, no. 2 (1995): 58–71.

———. "Excavations at the Town of 'Enduring-Is-the-Throne-of-Khakaure-Maa-Kheru-in-Abydos': A Preliminary Report on the 1994 and 1997 Seasons." *Journal of the American Research Center in Egypt* 35 (1998): 1–44.

———. "Echoes of Power: The Mayor's House of Ancient *Wah-Sut.*" *Expedition* 48, no. 2 (2006): 31–36.

———. *The Mortuary Temple of Senwosret III at Abydos.* Publication of the Pennsylvania-Yale Expedition to Egypt 8. New Haven: Yale Egyptological Seminar, 2007.

Wilbour, Charles Edwin. *Travels in Egypt (December 1880 to May 1891): Letters of Charles Edwin Wilbour,* edited by Jean Capart. Brooklyn: Brooklyn Museum, 1936.

Wildung, Dietrich. "Ein Würfelhocker des Generals Nes-Month." *Mitteilungen des Deutsches Archäologisches Institut Abteilung Kairo* 37 (1981): 503–7.

———. *Sesostris und Amenemhet: Ägypten im Mittleren Reich.* Munich: Hirmer 1984.

———. "Looking Back into the Future: The Middle Kingdom as a Bridge to the Past." In *"Never Had the Like Occurred": Egypt's View of Its Past,* edited by John Tait, 61–78. London: UCL Press, 2003.

Wildung, Dietrich, and Günter Burkard. *Ägypten 2000 v. Chr.: Die Geburt des Individuums.* Munich: Hirmer, 2000.

Wilkinson, J. Gardner. *The Manners and Customs of the Ancient Egyptians.* 3 vols. London: J. Murray, 1837.

———. *Modern Egypt and Thebes: Being a Description of Egypt; Including the Information Required for Travellers in that Country.* London: John Murray, 1843.

Wilkinson, Richard H. *Reading Egyptian Art: A Hieroglyphic Guide to Ancient Egyptian Painting and Sculpture.* London: Thames and Hudson, 1992.

———. *The Complete Temples of Ancient Egypt.* New York: Thames and Hudson, 2000.

Willems, Harco. "The Nomarchs of the Hare Nome and Early Middle Kingdom History." *Jaarbericht van het Vooraziatisch-Egyptisch Genootschap Ex Oriente Lux* 28 (1983–1984): 80–102.

———. *Chests of Life: A Study of the Typology and Conceptual Development of Middle Kingdom Standard Class Coffins.* Mededelingen en Verhandelingen van het Vooraziatisch-Egyptisch Genootschap Ex Oriente Lux. Leiden: Ex Oriente Lux, 1988.

———. "Deir el Bersheh: A Preliminary Report." *Göttinger Miszellen* 110 (1989): 75–95.

———. *Dayr al-Barshā I: The Rock Tombs of Djehutinakht (No. 17K74/1), Khnumnakht (No. 17K74/2), and Iha (No. 17K74/3).* Orientalia Lovaniensia Analecta 155. Leuven: Peeters, 2007.

———. *Les Textes des Sarcophages et la démocratie: Éléments d'une histoire culturelle du Moyen Empire égyptien; Quatre conférences présentées á l'École pratique des hautes études, section des sciences religieuses, Mai 2006.* Paris: Cybèle, 2008.

Williams, Bruce B. "Nubian Forts." In *Encyclopedia of the Archaeology of Ancient Egypt,* edited by Kathryn A. Bard, 574–79. London: Routledge, 1999.

Winlock, Herbert E. *Models of Daily Life in Ancient Egypt.* Cambridge, MA: Harvard University Press, 1955.

Ziegler, Christiane. "Une nouvelle statue royale du Moyen Empire au Musée du Louvre: La reine Khénémet-Nefer-Hedjet-Ouret." *Monuments et Mémoires de la Fondation Eugène Piot* 80 (2001): 11–34.

———. *Queens of Egypt.* Paris: Somogy Art Publishers, 2008.